Richard ...

Mark Cocker was born in 1959 and lives and
works in Norwich. He is co-author of a
biography of the naturalist Brian Hodgson and
a contributor to the 'Country Diary' column in
the *Guardian*.

MARK COCKER

Richard Meinertzhagen

SOLDIER, SCIENTIST
AND SPY

Mandarin

A Mandarin Paperback

RICHARD MEINERTZHAGEN

First published in Great Britain 1989
by Martin Secker & Warburg Limited
This edition published 1990
by Mandarin Paperbacks
Michelin House, 81 Fulham Road, London SW3 6RB

Mandarin is an imprint of the Octopus Publishing Group

Copyright © 1989 by Mark Cocker

A CIP catalogue record for this book
is available from the British Library
ISBN 0 7493 0284 4

The publishers would like to thank The Seven Pillars of Wisdom Trust for
permission to quote from *The Seven Pillars of Wisdom* by T.E. Lawrence
(Jonathan Cape, 1935): Century Hutchinson for permission to quote
from *The Business of War* by General Sir John Kennedy
(Hutchinson, 1957) and Weidenfeld & Nicolson for permission to quote from
King George V by Kenneth Rose (Weidenfeld & Nicolson, 1983).

Printed in Great Britain
by Cox & Wyman Ltd, Reading

For Maria

Contents

Illustrations

The illustrations listed above are reproduced by permission of the Bodleian Library, Oxford. They are taken from the Meinertzhagen Diaries as follows: No 1 from Picture Volume, p 26; No 2 from Vol 5, p 19; No 3 from Vol 14, p 139; No 4 from Vol 16, p 25; No 5 from Vol 20, p 170; No 7 from Vol 21, p 75; No 8 from Vol 22, p 147; No 9 from Vol 22, p 145; No 10 from Vol 27, p 14; No 11 from Vol 30, p 66; No 12 from Vol 39, p 99; No 13 from Vol 40, p 68; No 14 from Vol 42, p 69; No 15 from Vol 44, p 155; No 16 from Vol 55, p 144; No 17 from Vol 73, p 159.

Acknowledgements

During the four years I have been working on this book I have met with the kindness and enjoyed the assistance of many people. I would like to acknowledge something of that debt. It strikes me as an almost universal truth that library and museum staff are patient and considerate people willing to be enthusiastic about projects not their own. This was certainly my experience at the British Museum (Natural History) both in London and Tring, at the Edward Grey Institute, the Imperial War Museum, the India Office Library, the Public Record Office, Rhodes House in Oxford, the Royal Commission for Historical Manuscripts, St Antony's College Middle East Centre, and the Weizmann Archive in Rehovot, Israel. In addition I would like to thank the following individuals: Dr Dean Amadon, Gary Allport, Robert Baldock, Pam and Vic Belfield, Dr Alan Bell, Jeremy and Nicholas Benson, Dr W. R. P. Bourne, Lesley Bryce, Barbara Cavanagh, Nehama Chalom, Dr John Charmley, Dr Phillip Clancey, Dr Paul Coathup, Dr Nigel Collar, Gerald Crowson, Dr Euan Dunn, Sir Hugh and Lady Elliot, Lynn Gardenchild, Dr C. J. O. Harrison, John Hatt, Eric Hosking, P. A. D. Hollom, Dr Martin Kelsey, J. D. Macdonald, John Morley, Caroline and Thomas Muir, Peregrine Pollen, Nigel Redman, Simon Reynolds, Miriam Rothschild, Brian Sage, Rodney and Theresa Searight, Richard Sexton, Eric Simms, Dr David Snow, Helen Taylor, Wilfred Thesiger, Anne Vale, Mr and Mrs N. J. P. Wadley, Effie Warr, Dr Bernard Wasserstein, Jeremy Wilson. I also wish to express my gratitude to the Trustees for the estate of the late Richard Meinertzhagen for their kind co-operation.

There is an inner circle of people without whose kindness, consideration, and assistance the book would not have been possible. In this group I number Dan Franklin, Andrew Lownie, Ran and Gill Meinertzhagen, Nicholas Meinertzhagen, and Rodney Martins; also, and especially, Derek Goodwin for his enthusiastic support and advice. Finally, I acknowledge something of my debt to my partner, Mary Muir, for her tireless support both moral and material throughout.

A Silent Laughing
Masterful Man

On 9 June 1958 a distinguished-looking eighty-year-old Richard Meinertz-hagen was present at the 12th International Ornithological Congress in Helsinki, Finland. This was the ninth he had attended during the course of his long life, and he was by then one of the elder statesmen of international ornithology. In the course of the proceedings he fell into brief conversation with a young Canadian, who remarked on the fact that Meinertzhagen shared the same unusual surname with the author of a book the Canadian had recently read entitled *Kenya Diary, 1902–06*. This work, published in the previous year, recounted the exciting and at times gruesome adventures of a tough young officer of the Royal Fusiliers, on active service in the early years of Britain's protectorate in East Africa. The man went on to tell his renowned companion what a terrible, bloodthirsty book it was; then, sensing a possible *faux pas*, inquired whether Richard Meinertzhagen and the author were members of the same family. Listening throughout with silent good humour to these damning criticisms of his most recent publication, Meinertzhagen reassured his friend that he was only a 'distant relation'.[1]

The following year, shortly after Meinertzhagen's *Middle East Diary* had been released, the author received a letter from a Richard Graves, who complained bitterly that he, Meinertzhagen, had mispelt his name as 'Greaves' in the book. In revenge, the plaintiff went on to deride Meinertzhagen's own name, pointing out that 'save as belonging to a moderately successful staff officer and an ornithologist, it is unknown'.[2]

Fortunately, Meinertzhagen, an avid collector of humorous anecdotes, preserved both these tales in his diary. For they illustrate most clearly one of the central difficulties that he has presented to those who have attempted to describe or assess his achievements – the multiplicity of his interests. Most appraisals have been undeniably one-sided, the authors finding it problematic to connect the many threads: the soldier with the student of mallophaga, the ornithologist with the anti-Soviet intelligence agent, the passionate Zionist with the natural scientist meticulously recording the ground speed of a black mamba or a gyr falcon's level flight. Representative

of this partial treatment is the biography by Jon Lord, *Duty, Honour, Empire*, which breaks off in the subject's forty-eighth year – 1926, when his official career as a soldier and military adviser ended. Thus forty-one years of his life, predominantly taken up with natural history, Zionism, and intelligence work, were almost entirely undocumented.

Much of that which has been written about Meinertzhagen has taken its cue from the brief but brilliant pen portrait etched by T. E. Lawrence in *The Seven Pillars of Wisdom*.

> This . . . was Meinertzhagen, a student of migrating birds drifted into soldiering, whose hot immoral hatred of the enemy expressed itself as readily in trickery as in violence . . . Meinertzhagen knew no half measures. He was logical, an idealist of the deepest and so possessed by his convictions that he was willing to harness evil to the chariot of good. He was a strategist, a geographer, and a silent, laughing masterful man; who took as blithe a pleasure in deceiving his enemy (or his friend) by some unscrupulous jest, as in spattering the brains of a cornered mob of Germans one by one with his African knob-kerri. His instincts were abetted by an immensely powerful body and a savage brain, which chose the best way to its purpose, unhampered by doubt or habit.[3]

Meinertzhagen was deeply shocked when this curiously accurate image was held up before him and begged the author to expunge it from the book. There was certainly a good deal of extenuating detail that Lawrence had omitted, such as the aridity of Meinertzhagen's childhood, the failure of his first marriage, his pantheistic love of nature, and his opposition to many forms of injustice, both political and personal. It is interesting that others have also interpreted it as a highly critical description, and therefore an indication of antagonism between author and subject.[4] However, there is no evidence that Lawrence either saw it as, or intended it to be, a negative representation. In fact, others have found the author too full of relish for his blood-spattered description, which for them was confirmation of Lawrence's own bloodlust.[5] In some sense, however, both interpretations are correct: Lawrence was clearly troubled by Meinertzhagen's capacity for violence, and yet simultaneously in awe of the man's immense physical and spiritual energy, and of the dreadful certainty of his moral convictions.

Elsewhere in *The Seven Pillars of Wisdom* Lawrence wrote that the Semitic peoples – both Arabs and Jews:

> had no half-tones in their register of vision. They were a people of primary colours, or rather of black and white, who saw the world always

in contour. They were a dogmatic people, despising doubt, our modern crown of thorns. They did not understand our metaphysical difficulties, our introspective questionings. They knew only truth and untruth, belief and unbelief, without our hesitating retinue of finer shades.

. . . Sometimes inconsistents seemed to possess them in joint sway; but they never compromised: they pursued the logic of several incompatible opinions to absurd ends without perceiving the incongruity.[6]

Meinertzhagen was similarly lacking in a range of moral half-tones. The desire to search for life's grey areas – the hidden irony or inconsistencies in any situation or behaviour – to concede to doubts, or to strive for moral uniformity were all largely alien to his nature. His head rang with the words of Hales, his old Aysgarth headmaster: 'Don't stand there talking, do something.'[7] And at each fresh juncture where something was demanded of him, he chose a definite instinctive course, often a course that bore little relation to that which preceded it.

The events of a few months during Meinertzhagen's period at Quetta Staff College serve as a useful illustration. In March 1914, he complained bitterly about the practices of the local hunt. In the absence of foxes, a larger and more powerful canine – jackal – was chosen as a substitute quarry. In order to avoid unnecessary risk to the hounds, the hunt controllers released the jackals after crudely stitching the animals' lips together, rendering them completely defenceless. Meinertzhagen, without regard for the expense both in time and popularity amongst his peers, and at potential risk to his career prospects, pursued the issue relentlessly with his superiors. A stiff letter of complaint and an equally firm rebuttal were followed by a second letter demanding an end to the brutal practice. After this had also failed he approached the commander-in-chief of the Staff College, and when foiled by his apathy, Meinertzhagen wrote directly to Simla. Eventually, the Adjutant General of the Indian Army ordered the practice to stop and Quetta's chief to speak to the complainant. The latter, well satisfied with the outcome of his crusade, concluded: 'wherever I come across cruelty my nature makes me fight it regardless of the consequences'.[8]

Yet only a few months earlier Meinertzhagen had returned to his quarters after a day of lessons to discover his two polo ponies being brutally punished by his syce, one of them covered with weals and the other pegged to the ground spreadeagle with a rope biting deeply into the animal's flesh. In a fit of rage, Meinertzhagen seized the culprit, beat him severely and

finally struck him on the head with a polo mallet – a blow that later killed the man. In order to avoid possible prosecution, Meinertzhagen had his friend, the superintendent of police, hush up the case, seal off the man's house and declare him a plague victim.

The week's events at Quetta concluded on a note of scandal. A fellow officer discovered that he had been cuckolded by his wife and in a moment of depression had taken his own life. Meinertzhagen reviewed the incident in his diary and noted angrily that the woman's lover, one of his peers in the college, should have been hanged for murder.[9]

Just as he passed without a backward glance through these moral questions, Meinertzhagen moved freely amongst his multifarious interests with only an occasional sense of difficulty or confusion. Although it is convenient to treat his natural-historical work separately from his military career, it is important to realise that both of these, and in fact many other of his interests, were rolled together in one hectic, energetic whole. Botany, entomology, geography, and ornithology were all inextricably fused, and were in turn closely interwoven with his commitments as a soldier. Indeed, in later life it seems the former pursuits often provided a front for covert intelligence work. During the war, even in the heat of battle, Meinertzhagen found time for observing, collecting, and skinning migratory birds. In East Africa, prior to a successful raid on a German garrison on Lake Victoria, he spent the night huddled on the cliffs above the town discussing ducks with F. C. Selous, a fellow naturalist.[10] Conversely, in 1954, when Meinertzhagen had supposedly been retired for almost thirty years, he wrote to Reg Moreau, the editor of the British Ornithologists' Union:

> I am trying to 'wind up' my life in the sense that I am trying to tidy it up; but as I am Chairman of five Committees, and member of three others . . . [it] leaves me little time for 'winding up'. And after 76 years the material I have to wind up is extensive; and now comes Cott with pectinated claws, Erskine with Mau Mau, Amery with Suez Canal, Israel with all sorts of hedgehog conundrums, the Foreign Office with communism, taxonomy and moving all my collections to the British Museum which involves a choking dose of civil service red tape, Hemming and his long-winded vapour on Nomenclature and my own failing inability to concentrate over long periods.[11]

If there has been a falsifying tendency to divide Richard Meinertzhagen up according to one or another of his various preoccupations, it would perhaps be equally wrong to assume that in piling up details on all of these themes,

each on top of the other, one would arrive at a complete and satisfactory portrait of the man. The result would possibly be equally fragmented, a Cubist tangle of harsh lines and angles, geometrical patterns, disembodied abstractions. To conjure his image accurately one needs to pare down to essentials: a minimum of simple firm strokes for his finely chiselled features and his long, taut limbs; a knot of creases on the brow to suggest a certain emotional and intellectual intensity, the suggestion of a smile. And for the setting, a small stone at his feet to give scale and to evoke the bare, arid environments he celebrated; behind him, a single horizontal line midway across the wide page – the point of intersection between earth and sky.

1878–91
Annie Maria, She Sat on the Fire

Soldier, geographer, naturalist, author, ornithologist, traveller, big-game hunter – even anthropologist[1] – people often had trouble knowing exactly what to call Richard Meinertzhagen. His parents' initial problem was whether he should be Oliver, or perhaps Henry. They had chosen the former name to register his birth on 3 March 1878, but a subsequent disagreement arose between mother and father which prevented them using it at the christening. The issue, minor in itself, but indicating the deeper divisions that ran through their marriage, centred on the association which the name carried with Oliver Cromwell. Daniel Meinertzhagen considered him to have been a tyrant and regicide, while Georgina thought him a national hero and a defender of the British constitution. Eventually, she conceded to Daniel's insistence on a change of name, and it was agreed that the boy should be called after his maternal grandfather and god-parent, Richard Potter, the christening at All Saints Church, Ennismore Gardens in the parish of Knightsbridge, London confirming the decision.

The period leading up to Richard's birth had not been a happy one for his parents. Daniel, whose partnership in an important London banking firm, Frederick Huth and Company, necessitated his presence in the capital, where he rented a house in Rutland Gate, Knightsbridge. Georgina did not particularly care for London life and chose to spend most of 1877–78 at their second home at Wallop, near Stockbridge in Hampshire. Only ever able to see her husband at weekends, and with the responsibilities of a young family and the added burdens of yet another pregnancy, she felt desperately isolated in the country. She had few friends in Hampshire, and saw little of her own family, the Potters. Having spent the first twenty-three years of her life in a bustling household of nine sisters, Georgina had become accustomed to a busy domestic life and to constant and engaging companionship. Equally, the wide-ranging though eclectic nature of her education, together with the unconventional freedom of expression that she had previously enjoyed, had hardly equipped her with the self-effacing qualities demanded of a Victorian wife and mother.

Her parents, Richard and Lawrencina Potter, were both from non-conformist and politically radical northern business families, whose social elevation exemplified the rise of the industrial middle classes in the nineteenth century. In the first years of their marriage, Richard Potter had not initially followed his family's commercial traditions, but had settled down on his inheritance to the life of a country squire. However, the financial slump of 1847–8, two years before Georgina was born, and the loss of almost two-thirds of his £2,000 annual income served as the spur to his own active career. Within fifteen years Potter had proved himself an extremely gifted businessman, raising and extending the family's commercial interests onto an international scale. By 1863 he had become chairman of the Great Western Railway, as well as a director – later president – of the Grand Trunk Railway of Canada. To these positions he added substantial holdings in the timber industry, coal, and other British and continental railway companies. Characteral portraits of this skilful entrepreneur differ markedly. To his brother-in-law, Charles Macaulay – a man coaxed into marrying Richard Potter's slightly unbalanced sister, Mary[2] – he was crafty, even unscrupulous in business, and in his relations with his family he could be brutal and violent. In a letter to his daughter, Macaulay described how Potter once beat his dog for disobedience until its flanks were red with blood. However, to his famous socialist daughter, Beatrice Webb, he was 'generous and tolerant almost to a fault, he was the soul of genial kindliness and had at any rate with his family one of the sweetest tempers I have ever known'.[3]

All nine sisters confirmed this portrait of a model father and the fact that his domestic life, like theirs, was dominated by his wife's iron wilfulness. Lawrencina was a small, physically frail woman, sustained by a strong religious spirit, a rigid sense of moral duty, and an enormous capacity for work, both physical and mental. Although Richard Potter had enjoyed a formal education at London University and followed keenly national, political, and economic developments that touched on his business interests, he shared little of his wife's passion for abstract and religious speculation. It was largely her intellectual and artistic gifts that attracted a number of distinguished guests, like Brian Hodgson – the orientalist and ornithologist, Joseph Hooker – the botanist, Thomas Huxley, G. H. Lewes, George Eliot, and Herbert Spencer. The general atmosphere in the Potter household of philosophical and political debate, coupled with Lawrencina's serious efforts to ensure her nine daughters were widely

educated, gave the girls a good understanding of the social and intellectual life of their day.

Probably the most important educational influence on the Potter sisters was the popular philosopher, Herbert Spencer, who had been captivated by Richard's charm and stimulated by Lawrencina's conversation. He was a regular visitor to the family's several country homes and acted as a frequent, though informal, tutor for the girls. In her autobiographical work, *My Apprenticeship*, Beatrice Webb claimed that Spencer's challenging agnosticism provoked and shaped, to a large degree, the course of her intellectual development.[4] Long after their separation from the Potter household and their establishment of independent families, many of the other sisters, including Georgina, maintained close contact with Spencer – a measure of his lasting attachment to them, and also of their capacity to engage on equal terms one of the most prominent thinkers of the late nineteenth century. It is hardly surprising that this tradition of intellectual liberalism spawned nine daughters of unusual, if not formidable talents. They were proud, argumentative, sharp-witted rebels, inveterate supporters of the underdog, hypercritical of outsiders and scathing of what they considered sham or mean-spirited. A passion for good causes was by no means confined to Beatrice: several of them were pacifists, while almost all, in adult life, embraced to some degree the suffragist movement.

It was highly likely that nine girls, so distinctive, so attractive and intelligent, backed by their father's wealth and prestige, should attract a complement of distinguished husbands. Their respective marriages, linking them to a range of eminent politicians, bankers, lawyers, and doctors, seemed to document wholesale dynastic achievement. Of four politicians that had each married one of the sisters three received baronies; while, according to Beatrice Webb, four of the nine sisters, including Georgina, had husbands whose annual income at the turn of the nineteenth century exceeded £100,000.[5] There were forty-six offspring from ten marriages, nine of them the brothers and sisters of Richard Meinertzhagen. Yet marriage, for all the material and social fortune that it conferred, was a distinctly double-edged experience – particularly for such independently minded wives as the Potters – since it constrained them to purely domestic rôles in which their appetites and gifts found only partial satisfaction.

As mothers and wives they were seldom entirely successful, often distributing their affections unevenly. Passionate and undisguised favouritism amongst their own children, often coupled with a preference for their sisters' offspring, unbalanced family life. Richard Meinertzhagen

and his cousin by marriage, Malcolm Muggeridge, both diagnosed the characters of the Potter sisters as 'tragic'; they were restless women, unable, even unwilling, to feel contentment. Their large families and the worldly comforts and successes that surrounded them seemed little defence against inner dissatisfaction. According to Barbara Caine, the author of a study on the Potter sisters, three of them – Lawrencina, Blanche and Maggie – endured long years of unhappiness in middle age, estranged from either husbands or children, and in Lawrencina's case, both.[6] Blanche, for example, married to the eminent surgeon, William Cripps, was forced to embrace almost as a member of the family her husband's Italian mistress until this intolerable situation resulted in her suicide. It is an interesting coincidence that five of the seven sisters who became mothers died before their seventieth year. Only those who had occupations of their own, like Rosalind, or whose lives were absorbed with their husbands' in political activities, like Mary, Catherine, and Beatrice, lived to a truly old age.

Georgina Meinertzhagen, the mother of the largest family and also one of the most materially successful, seems to have conformed fully to this pattern of surface fortune masking an underlying discontent; much of her particular distress arising out of an unhappy marriage. Richard believed his mother's union to Daniel was the least successful of all the Potter marriages. During a family gathering in June 1893 after the death of their sister, Theresa, Beatrice's diary recorded a similar verdict: 'Georgie looked the saddest of the sisters – to her life has had little charm, though on the surface so prosperous; her marriage a big mistake.'[7]

Richard's autobiography, *Diary of a Black Sheep*, presents his parents as two people who, while sharing the same upper-middle-class background, values, and interests, were also deeply divided in temperament and attitudes, sometimes down to the finest detail. Georgina, born in 1850 and the fourth-eldest of the nine, was the proudest and least flexible of the sisters. She had a clear, cutting mind, a quick tongue, and a razor-edged sense of humour which often inadvertently wounded its target. For many years, on the anniversary of their marriage, Georgina would have two roasted geese prepared for their dinner, a joke which never amused her husband. Both of them were intellectually gifted: he had been to Oxford, and was a good classical scholar and linguist; she had written books on their family history, and plays for children. Steeped in Spencerian logic and philosophy, her mind enjoyed the challenge of political and theological debate. Daniel, on the other hand, avoided abstract thought. Herbert Spencer, who was a regular visitor to the Meinertzhagen home, bored him,

and once when George Bernard Shaw arrived with the Webbs at his home in Hampshire during a cycling tour, Daniel fled the house in despair. He saved his intellectual energies for his business practice. His weekends with the family were fallow periods when he could relax, go fishing or shooting. According to Richard Meinertzhagen he was a shy and retiring man, his mood was gentle, kindly. Visitors to the family home were struck firstly by the vivacious and intelligent mistress, not the master of the household. However, with his children he was frivolous and fun-loving; he had a good sense of humour, but his humour was benign, it never left its subject feeling uneasy.

Georgina's husband was the sixth in a continuous line of eight Daniel Meinertzhagens, the first of whom was the scion of a distinguished Cologne family that could trace its membership of the city's council to as early as 1402. After the Reformation the junior branch of the family had embraced Protestantism and had moved to Calvinist Bremen towards the close of the seventeenth century. There, the first Daniel rose to become a senator in Bremen's legislative council – an honour enjoyed by three successive Daniels. As a member of the Hanseatic League, Bremen enjoyed close commercial contact with England, and it was in this country that Daniel V, Richard Meinertzhagen's grandfather, eventually settled in 1826, after the Napoleonic Wars had destroyed the family's fortune. His integration into English society seems to have been swift, since he soon entered the banking house of Frederick Huth and Company, and married Huth's daughter, Amelia, six years later in 1833.

Huth himself was also of German descent, although there was a persistent family rumour that his ancestors were Spanish aristocrats. He had been a successful businessman in Corunna and had left the country, as a consequence of the Napoleonic invasion, with an enormous fortune of £200,000, the jewellery of the queen of Spain, and a concession to pay the salaries of all Spanish embassy and consulate staff throughout the world. In his *Diary of a Black Sheep*, Meinertzhagen appears to give some credence to the notion that his great-grandfather Huth was the illegitimate son of a Spanish grandee; a theory which the latter's youngest son, Louis (Clou), seemed to believe, and which certainly helped to explain the high degree of intimacy between a supposedly foreign businessman and the Spanish Crown.[8] However, subsequent investigations by members of the Meinertzhagen family have revealed that it was not Huth but his wife, Manuela Felipa Mayfren, who had connections with Spanish royalty. She was one of two illegitimate daughters born to the Spanish infante, Don

Gabriel, and had been brought up at the palace of the Duque de Veragua, whose wards the two girls had become. Apparently, Huth had agreed as a condition of his marriage to Manuela that he would also take care of her sister. Both royal children, therefore, escaped to England when he departed from Corunna in 1809. (It is an interesting aside on Richard Meinertzhagen's ancestry that the screen of secrecy drawn so carefully around Manuela's background deprived him of the knowledge that he was the great-great-grandson of one of the heirs to the Spanish throne.)

As soon as Huth had arrived in England, he settled down once again to making money and to establishing his family, proving himself equally successful in both enterprises. His eleven children (including two sets of girl twins) became the heart of a thriving family concern presided over by the sharp financial acumen of Huth himself. Many of his sons were scattered around the world to conduct business, while Daniel, his new son-in-law, managed affairs in London. If in life Huth had been a strict man with simple tastes and a strong dislike of ostentation, in death he was beneficent. His bequest of over £1,000,000 financed the construction of a number of large country houses by his sons, who, liberated from his strong parental control, were more willing to enjoy their family fortune. However, Huth's personal hand had been responsible for much of their success, and, although the company maintained a high international reputation right up until its demise in the 1930s, none of his descendants apart from Richard Meinertzhagen's own father, Daniel VI, showed the same sound, commercial instinct.

In his early manhood Daniel VI had baulked at the idea of a banking career, and after arguing with his father in 1866 when he was twenty-four, embarked upon the life of a gentleman of leisure. Daniel V generously indulged his son's rebellion, providing him with a flat in Albany, London, and an allowance of £2,000 a year – a substantial income in the second half of the nineteenth century. This supported a pleasure-seeking existence, regulated by bouts of hunting and shooting, the summer seasons in London, and frequent visits to fashionable continental cities, like Paris and Vienna. It was not until his father's death in 1869 that he re-entered Huths and settled down to an extremely successful career. Yet in spite of Daniel's obvious flair for banking, Huths had refused to accept him as an equal partner in the company for a number of years, arguing that profits were insufficient to support yet another principal. Rather ironically, it was his romantic engagement to Georgina that provided the circumstances to reverse their decision.

Daniel had been invited to the Potter home, Standish House, as a consequence of his business acquaintanceship with the father, and during his visit had been involved in a mysterious sporting accident. Actively encouraged by her parents, Georgina nursed Daniel during his convalescence and continued to see him on his return to London. Some months later, during a horse-riding excursion in Hyde Park, he proposed to her and she accepted. The other Potter sisters believed that Daniel was too conservative for Georgina's whimsical temperament, and that the high drama of their initial romance had blinded them to underlying incompatibility. However, it was her parents' warm approval, particularly her father's – possibly based on hard, financial calculation – that decided the outcome. Richard Potter, eager to ensure his daughter's financial security, and knowing of Huths' unwillingness to adopt his future son-in-law as a partner, quickly sought offers of partnership for him from other leading banking houses in the city, such as Frühling and Goschen. Huths recognised that if they did not act soon they might well lose their gifted employee and immediately accepted Daniel on equal terms. When he and Georgina walked down the aisle, therefore, on 9 September 1873, it seemed that their prospects were good.

However, in the long term it was the Potter sisters' prediction of unsuitability, not economic well-being, that proved the decisive factor in their future happiness. Daniel's conventional attitudes to women, his preferences for the fashionable society of London, sport and business, clashed dramatically with Georgina's broadly intellectual aspirations. And her frequent pregnancies, rather than bringing them closer together, seemed to lessen Daniel's interest in his wife and family, and to intensify her sense of isolation. Yet, in spite of this their family grew quickly: the first child, Daniel, the seventh in the line, was born on 21 November 1875, followed by a daughter, Barbara, on 3 October 1876. Richard's birth in 1878 preceded those of two daughters, Margaret (1880) and Lawrencina (1883), and a third son, Frederick (1881). The family of eight had by now outgrown its two residences in London and Hampshire, necessitating a move down the road in 1884 to a larger house at 25 Rutland Gate, and in 1885 they rented a spacious thirteenth-century abbey at Mottisfont, in the Test Valley.

The latter had been an Augustinian Priory, originally endowed in 1201, and had continued as a religious house until the dissolution of the monasteries in 1536 under Henry VIII. It then passed into the hands of Sir William Sandys, a Knight of the Garter and Lord Chamberlain to the

Crown, who converted it into his private residence. At the end of the seventeenth century the last Lord Sandys died childless, and bequeathed the estate to his sister, whose son, Sir Richard Mill, made extensive alterations to Mottisfont. Possession of the house was then juggled among a broken lineage until in 1884 it passed into the hands of a third cousin of the Mill family, a Mrs Vaudrey, who rented it out to Daniel Meinertzhagen the following year. The house, an unusual mix of medieval, Tudor, and Georgian styles, has been considered one of the finest and best-porportioned residences in the country, its character further enhanced by nine acres of lawn shaded by ancient cedars and planes. Although they spent a good deal of their time in London at Rutland Gate, the Meinertz-hagens, particularly Richard, came to look upon Mottisfont as their spiritual home. Indeed, long after they had vacated the property in 1900, it remained for him an almost sacred spot, to which he made pilgrimage each year.

With the lease for the abbey came an estate of 2,000 acres, providing a fine adventure playground for the full family of ten children. For the adults there were good shooting woods and many miles of the River Test, noted for the excellence of its trout-fishing. And all this came for the very reasonable sum of £320 a year. The lease agreed by the Meinertzhagens was unusual. Although it was broken down into seven-year periods, Daniel and his heirs could hold the estate in perpetuity, or could end their tenancy by giving a year's notice of quittance; Mrs Vaudrey, on the other hand, had no comparable powers of eviction, even at the end of a seven-year period. In keeping with the lease, the landlady herself was rather curious, one of her more eccentric habits being the use of her deceased husband's clothes, including his boots. She refused the Meinertzhagens permission to instal either electric light or central heating, and although Georgina had the latter fitted, Mrs Vaudrey ripped it out when the family left. Yet in spite of her eccentricities the old lady seemed to prosper, largely through the sale and development of her property around Southampton. A story particularly revealing of her character concerned her son Claude, who came to stay at Mottisfont during his university vacation. When Georgina asked him whether he liked his house, he was completely shocked to learn for the first time that the abbey belonged to his mother.

Despite the absence of modern amenities, the Meinertzhagens spared no expense on the running of the house. There were about twenty servants assisting in its internal management, while a battery of grooms, gardeners, and keepers attended to the estate itself. A clear indication of the size of the

work-force was given when Daniel provided a banquet for all the staff and tenants at Mottisfont on Queen Victoria's jubilee, and almost 300 people attended. The kitchen garden extended to seven acres and included twelve large hot-houses, all of which produced more fruit and vegetables than the household could consume. This excess and a similar surplus of game on the estate were exploited by the head-gardener and head-keeper, who organised the weekly sale of van-loads of stolen produce. Such flagrant corruption – earning the former £1,000 a year and the latter £300–£400 a year – passed virtually unnoticed beneath the Meinertzhagens' unwatchful eyes.

While Mottisfont, with its extensive woodlands and marshes, would provide the setting for Richard's boyhood natural-history outings, it was in London, at Rutland Gate, that his interest was first kindled, largely through contact with his mother's scientist friends. A neighbour and close acquaintance of Georgina from her Potter days was the biologist and cousin of Charles Darwin, Francis Galton – most famous for his work on eugenics and his early studies into fingerprints. Another old visitor to Standish House, Thomas Huxley, also remained in contact with Mrs Meinertzhagen. Richard remembered his visits to Huxley's home in St John's Wood, particularly one occasion when he met and scrambled onto the knees of an ancient and serene old man, by whose bushy eyebrows he had been captivated. Charles Darwin gently held the staring boy in his lap, until Huxley's daughter, Ethel, carried him off.

London also offered other opportunities to an aspiring natural scientist. At the natural history section of the British Museum the two Meinertzhagen boys, Dan and Richard, found a willing mentor in the curator of birds, Richard Bowdler Sharpe.[9] In 1886 they had arrived on the doorstep of the birdroom with a garganey, bought in Leadenhall Market, and rang the bell on the pretext that they wished to have it identified. Sharpe fell for their stratagem entirely and asked them in, giving them a guided tour of the museum's skin collection. From that day they were given an open invitation to visit, an offer which allowed them to meet the most eminent ornithologists of the day, like Dresser and Rothschild.[10] Sharpe took the trouble to encourage their youthful efforts, teaching them how to skin birds, and prompting them to start their own collection, which he frequently supplemented with donations. They were also regular visitors at London Zoo, and started to keep live birds at Mottisfont, eventually establishing a substantial collection of raptors.

It was probably Meinertzhagen's contact with Herbert Spencer that proved the most decisive catalyst to his interest in the natural sciences.

Spencer, although without a family of his own, was very fond of children, particularly girls, and continued the fatherly rôle he had enjoyed at the Potters' household with the sisters' own offspring, frequently asking them to 'lend' him some children. Dan and Richard were indifferent to the old sage's synthetic philosophy and frustrated by his excessive pedantry, which was often a cloak for his ignorance; but they would accompany him on natural-history outings, and were especially pleased when they discovered that his expertise as an ornithologist was less than their own. Inevitably, they preferred to draw him onto subjects where they felt strongest and delighted in correcting their tutor's misidentifications, or exposing his inaccuracies, and pointing out birds that his weak eyes could not see. In spite of this mischief they believed his efforts wasted on their sisters, and attempted to keep his time and attention for themselves. Spencer had a restless and inquisitive mind, and prompted the boys to ask questions about what they observed, and to set up small experiments to test their beliefs. They recorded the response of live birds to their stuffed counterparts, and noted the different call notes made in reaction to different stimuli. Spencer also presented Darwin's theories to them in child-sized spoonfuls, and gave them a general overview of the scientific discoveries of the day. Although he was never a strong advocate of too much metaphysics, Richard Meinertzhagen cites his contact with Spencer too frequently for anyone to be unsure about the profound effect it had on both his interest in natural history and his approach to it.[11]

It was appropriate that Richard's first school, at Aysgarth, near Bedale in Yorkshire, at which he started on 7 May 1886, should maintain his intimate contact with wild countryside and nature. Set in the most beautiful of the Yorkshire dales – Wensleydale – Aysgarth provided a very different and much harsher setting than the gently sloping, chalk-valley woodlands at Mottisfont. None the less, Richard adapted well, delighted particularly to be reunited with his elder brother, to whom he had the deepest attachment. When Dan had left for the same school in the previous year, Richard pined at his departure and begged to be allowed to join him. His parents finally agreed to his starting school early, and in the following spring Richard and Dan travelled northwards together, to be met at the station in Aysgarth by the assistant master, George Brooksbank. An early and spontaneous show of affection by this gentle schoolmaster won Richard's instant adoration, and despite a sixteen-year age difference the two remained loyal friends, until Brooksbank's death in 1934.

Established in 1877 by its first headmaster, the Reverend C. T. Hales, Aysgarth was a fairly new school, but with traditional Victorian values. Its teaching methods were limited to parrot-like repetition of lessons, giving little scope for individual creativity, and destined to instil in the boys only moderate enthusiasm for learning. The school's personality took its cue from the headmaster, who was principally interested in building character rather than developing brains. School-life was physically demanding and only the toughest could keep up the pace: during Richard's time at Aysgarth a long cross-country chase up and down the Yorkshire dales caused one young boy to collapse with a strained heart. The countryside around was rugged, and the climate cold and harsh, particularly in winter. Standards of hygiene were evidently not high, since Meinertzhagen recorded that epidemics were common. The one fortification for this rough, outdoor existence was the plentiful supply of good but predictable English food, for which Richard had an inexhaustible appetite. A high-cholesterol, high-carbohydrate diet of cold, boiled beef and dumplings, boiled mutton, suet pudding, mince meat and potatoes, treacle pudding, spotted dog, and bread and butter pudding was not intended to develop winsome, sophisticated young intellectuals, but to feed up the next generation of John Bulls. The school motto was '*Ex quercu, non ex salice*'; Hales's dream was a schoolful of embryo leaders.[12]

Life at Aysgarth suited Richard's wild, boisterous spirits perfectly, and he loved it. The focus on physical and outdoor activities and the extensive freedom the children were given matched his appetite for exploring the North Yorkshire moors, or birdwatching and botanising in Wensleydale. The school was also active in promoting an interest in natural history. Many boys, for example, kept herbariums, and when an eagle or a buzzard flew over Aysgarth everybody ran outside to see it. It was in Yorkshire that Richard remembered seeing his first otters, curlew, and snipe; it was also at Aysgarth, after two weeks' residence, that he killed his first bird – a red grouse, shot with a bow and arrow. And only a few weeks after this he had his first fight, with a bully called 'Cannibal', who claimed to eat little boys. On 15 June 1886, Richard sent the following intelligence report to his parents, describing the first of many victories:

A boy was cained [*sic*] yesterday and it has spoilt the rest of the term. Brown the Canibble broke one of my teeth and hurt my side. Sergent told me to go to Mrs. Humphrey and I did and he sent for Brown and his face was all bleeding where I hit him. We are both swollen much today but Brown is worst.[13]

An early interest in politics was cultivated by one of the schoolmasters, a man clearly not too concerned with presenting a balanced picture. During the elections of July 1886, Richard, taking his bearings from his teacher, emphatically defined his views in slogans scribbled on the school walls – 'I hate Mr. Gladstone'. His letter to his mother in September 1887 revealed a similar right-wing bias: 'Are you a Liberal because I asked Mr. Warmsley what a liberal was and he says he is a person who helps himself liberally to other peoples things. I told him you are a conservative and so am I.'[14]

When Richard suffered a simultaneous bout of measles and chicken pox in the Easter of 1889 his parents decided not to return him to Aysgarth in the following term. Instead, they enrolled him at Fonthill in Sussex, supposedly a more genial environment for the convalescent. However, it is difficult to imagine that considerations of health were the primary reason for the transfer. Richard was a robust child. He quickly recovered from his illness and could have taken the ordinary knocks of school life at Aysgarth in his stride. It is more likely that, with Dan's departure for Harrow imminent, they wished to bring their second son to a school more conveniently situated in the south of England. Whatever their motives, Richard was unwilling to be moved. He was popular with the teachers at Aysgarth, and had no wish to be parted from Dan. His letters home repeatedly begged his parents to allow him to stay; but the eleven-year-old's arguments fell on deaf ears.

This was doubly unfortunate, for, while Fonthill was a spacious Georgian building, set amongst wide lawns and beech woodland on the outskirts of East Grinstead, only a short train journey from London, it was not the quiet, convenient place of learning his parents had hoped for. The school was owned and run by two brothers, Walter and Ashton Radcliffe, their father having first established it in 1820. Both brothers, it seems, conformed to the Victorian type of schoolmaster, who delighted in the company of small boys, not so much for any rewards he might derive from nurturing his wards' healthy development, but because of the opportunities it afforded to abuse and terrorise other human beings without any fear of retaliation. Richard's was not an auspicious start at Fonthill. Within a few days he had floored an elder boy who had teased him with the nickname 'Beauty', and soon after that he was moved from a shared dormitory to a small room of his own. Trouble really first started when Walter, the senior of the two Radcliffes, overheard Richard reciting a nonsense rhyme to a friend:

> Annie Maria, she sat on the fire,
> The fire was too hot so she sat on a pot,
> The pot was too round so she sat on the ground,
> The ground was too flat so she sat on the cat
> And the cat ran away with Anne on her back.[15]

It would be difficult to imagine how the most prurient psychoanalyst could force a sexual interpretation upon this children's jingle, yet Walter Radcliffe wrote to Georgina Meinertzhagen complaining that her son had learnt 'pornographic poetry', and that he would have to take steps to isolate the spread of such poison.

Walter adopted a dual approach to deal with the problem. Firstly, his clandestine visits to the child's room at night involved some kind of homosexual interference that Richard, as an elderly man, would only hint at in his autobiography.[16] The second method, which took place in the classroom, involved sadistic beatings with a cane after the victim had failed to understand a question that he was never intended to answer. This deeply humiliating treatment continued for the rest of the summer term, three or four times a week, leaving his legs and buttocks striped with green and purple bruises, while his vest was sometimes glued to his back with the congealed blood. Unprovoked and inexplicable to the naive mind of a small boy, the attacks terrified and bewildered him. Repeated pleas to his parents asking them to come and save him from Radcliffe's sadistic treatment seemed to have little effect. Even when he returned home to Mottisfont in the summer vacation and his brother Daniel discovered and explained to their mother the extent and reasons for Richard's distress, she steadfastly refused to open her mind and heart to the suffering.

It is difficult to appreciate the reasoning behind Georgina's position with regard to the brutal treatment meted out to her son. There was no doubt that Richard was a determined and occasionally rebellious child, as evinced by his mother's letter to her husband soon after Dan's first departure for Aysgarth:

> Dick is still pining for Dan and says we are no consolation to him because I am grown-up and Bardie is black and a girl. Yesterday he went off by himself saying he would walk to Aysgarth and join Dan but a neighbour found him some two miles from here and brought him back fighting like a tiger to gain his freedom and continue his two hundred mile tramp without food or money. He is certainly determined. I think we must let him go early next year.[17]

Clearly she felt, and indeed told Richard in her letters, that he must have done something to deserve his punishment, and that he could avoid it by being well behaved. It was almost certain that the precise truth about what was happening at Fonthill, particularly Walter's nocturnal activities, was kept from her, both by Richard's embarrassed silence and Radcliffe's callous suppression of his pupil's letters. It is also important to remember that Georgina was an extremely proud woman. At the time of Richard's transfer from Aysgarth to Fonthill she had refused to hear her son's own wishes in the matter. In fact his letter, which contained the following plea, was destined simply to provoke her stubbornness: 'Please father may I stay here because I shall not like any other school and it is very bad for me to do what I dont want to do so I must stop here and Mr. Hales wants me to stop.'[18]

She was not a mother who enjoyed being proved wrong, least of all by a rebellious young 'tiger' like her second son. In addition, she was by then the mother of nine children, having just given birth to another daughter, Mary. Possibly focusing on the needs of her latest born, or wrapped up in the difficulties of her marital relations, she simply closed her mind to a barrage of pained requests, the full significance of which she did not really grasp. Besides, Walter Radcliffe's end-of-term report gave no hint of serious difficulties with Richard, other than the fact that 'he was inclined to be obstinate and wilful'. All this would simply have reinforced her deeply Victorian interpretation that Fonthill would do her son some good.

Meinertzhagen claimed that when he returned to his school for the autumn term there was murder in his heart, and he wrote to his brother on 24 September to ask what would happen if he killed Walter. Only two weeks later the system of intimidation resumed its familiar, gruesome pattern. An unanswerable question was followed by a threat of corporal punishment and the teacher's demand that the instrument of torture be brought to him. However, this time Richard took the initiative. He seized the large stick before it could be handed to Radcliffe and smashed it onto his head, then overturned the teacher's desk and threw the stick through the window. Although there were no immediate repercussions – in fact Ashton Radcliffe treated him with kindness and put him to bed for the afternoon, asking him to forget the whole affair – Walter came to his room in the evening and beat him once more. Matters eventually came to a head when Meinertzhagen escaped, running to the home of his father's friend, Sir Edward Blount,[19] who lived close to the school at Imberborne Manor where the boy had an open invitation to visit. The old man was deeply

shocked at the wounds on the child's back and legs and took up the issue with the school. In his *Diary of a Black Sheep* Meinertzhagen claimed that he was unaware of the exchange between his protector and the Radcliffes, but the following day he was accompanied by Sir Edward back to Fonthill, where no mention was ever made of his absence, nor was he subjected to beatings from then onwards.

In later life, his experiences in the first six months at Fonthill were a theme to which Meinertzhagen returned again and again in his diaries. Although collectively these entries confirm the persistence of his sense of anger and horror, and while they are all broadly similar, there is a number of small inconsistencies which it would be valuable to examine. Unfortunately, after extracting from his childhood diaries all the information he required to write his memoirs, Meinertzhagen destroyed the originals in 1942. It is therefore impossible to check the later versions written from memory, and the account published over seventy years later, in the *Diary of a Black Sheep*, against the hand-written and contemporary diary account of his life at Fonthill. One of these discrepancies centred on the implement Walter used to beat him. In his autobiography it was a large, thick holly stick, while in a diary entry in 1962 it was a wooden ruler.[20] Similarly, in the former he said that he never knew what happened nor did he witness the exchange between Sir Edward Blount and the two Radcliffes. However, in 1958 at his eightieth birthday celebrations, Meinertzhagen's speech recorded that he was quite definitely present at Blount's showdown with the masters and that the latter threatened them with criminal prosecution.[21]

It is also interesting to compare a number of extracts used in the *Diary of a Black Sheep*, the first of which he claimed was taken from a contemporary letter, the second from his original diary.

There is a small boy here called Kennedy and his mother came down today and took me out and Kennedy is very nice and makes chains of gold wire. Walter is horrid to him and beat him this term and made me come and watch. It was horrid and I was very sorry. I hate Walter because little Kennedy is a friend of mine and I hated seeing him beaten.[22]

I feel as though my body were an empty shell wandering about with no desire beyond to kill, my little soul, if I have one left, tucked away somewhere inside, smothered in shame, killed by cruelty, starved and bruised for lack of love.[23]

The marked differences in the style and quality of the passages, supposedly all written by an eleven year old, are puzzling. At the time of preparing the account of his early life during the Second World War, Meinertzhagen made reference to the paucity of material he had to work on. It is possible that some of the quotations were therefore supplemented or altered at a much later stage to flesh out the deficiencies of the original diary.

Other aspects of the Fonthill episode are similarly inexplicable. For instance, it is remarkable that his parents never came to learn the exact facts of his school-life in 1889 – even when one accepts that Radcliffe censored his letters – particularly when a third party like Sir Edward Blount could so easily have informed them. Meinertzhagen claimed that he had begged the old man not to tell them, a request with which he appears to have complied. However, one might have thought that Blount would have over-ridden the boy's wishes in so serious a matter as this. Equally, it is strange that his brother Dan, who, according to Beatrice Webb, was his mother's favourite,[24] remained unable to convince her of the truth of his brother's ordeal. Equally, one would have expected that any parent would be able to discriminate between punishment that was intended to be a corrective, and a series of beatings administered solely to relieve the sadistic tendencies of a pervert.

Whatever the answers to these questions there is no doubt that Walter Radcliffe's brutal treatment of Richard Meinertzhagen, sustained over a six-month period, had a profound effect upon him. Even in 1962, seventy-three years after the events, a visit to Fonthill was sufficient to trigger off the most harrowing memories:

> I stood on the very spot where I had been so cruelly beaten and where I eventually struck Walter with a heavy ruler and fled the house. And when I saw the portraits of Walter and Ashton all the horror and suffering flooded to my brain . . . A most un-Christian . . . desire for revenge overtook me. I am completely upset by my visit. Everything beastly in me came to the surface. I was beside myself with anger and hatred.[25]

Corporal punishment – even of the severity meted out by Radcliffe – was by no means exceptional in the late Victorian period: flogging was a frequent, almost natural, method of regulating behaviour in schools. Nor was Meinertzhagen Radcliffe's only victim. From the *Diary of a Black Sheep* it is apparent that at any one time the Radcliffes had a specially chosen subject on whom they vented their sadistic tendencies. That this behaviour

was so frequent an occurrence, and that neither teacher suffered any repercussions, indicates that most boys and their parents accepted these beatings without question. Even for Meinertzhagen, the significance of his first six months at Fonthill lay as much in the way it affected his relationship with his mother as in the severity of the punishments themselves. In the *Diary of a Black Sheep* the Fonthill episode forms an almost natural climax to the story of his childhood; and within it, Meinertzhagen seemed to place greatest emphasis on the moment when his mother, on seeing his back and legs covered in bruises and scabs, claimed that her son must have behaved very badly to deserve them.

> Even now I can feel the pain of that moment, when something seemed to leave me, something good; and something evil entered into my soul. Was it God who forsook me, and the devil who took his place. But whatever left me has never returned, neither have I been able to entirely cast out the evil which entered me at that moment.[26]

An appreciation of the events at Fonthill must surely be central to any understanding of Meinertzhagen's personality and later development. Perhaps already predisposed to solitude and private thought, Richard found it increasingly difficult after this time to communicate or participate fully in school life; while at home, his mother's lack of understanding initiated a breach between them that was never entirely resolved. Apart from with Dan, who seems to have acted as his confessor throughout his childhood, he felt unable to establish easy relationships with his other brothers and sisters. It was during this period that his mother gave him the nickname 'Black Sheep', a soubriquet that in her eyes his antisocial behaviour warranted, but which also served to reinforce amongst his siblings the idea that their brother Dick was a perverse and difficult loner. Richard Meinertzhagen's inability to show emotion openly, his secrecy, his intense loathing of cruelty and uncompromising devotion to the cause of the oppressed, both politically and on an individual basis, and almost paradoxically, his ready resort to violent solutions, are all dominant motivating forces in his life; and all have their roots in this period. He himself acknowledged the decisive impact of his second school, saying:

> The undeserved beatings and the sadistic treatment which were my lot in childhood so upset my mind that much of my present character can be traced back to Fonthill. My character was to some extent moulded on

cruelty . . . It drained me of honesty, love, and tolerance, it made me hostile to and suspicious of mankind, reserved unanxious to mix with others, preferring solitude and thought to the tittle-tattle of my fellow-creatures.[27]

1891–99
A Black Sheep

When Richard started at Harrow in September 1891 he was given an opportunity to forget his experiences at Fonthill. At his new school he was reunited with Dan, whose presence seemed to have a stabilising effect on him. They were now able to share a room, and outwardly his life came to resemble that of any other school boy. Weak at maths and bored by the classics, he enjoyed pranking with friends, ragging incompetent teachers, fighting with bullies; ball-games he found tedious, but boxing and swimming satisfied his energetic temperament. Most of all he enjoyed escaping into the countryside around Harrow-on-the-Hill, where he could go shooting for rabbits, or birdwatching. In spite of a rather rebellious streak, he was successful at his lessons and responded to appreciation and encouragement from his teachers. Although they were separated by three years, he was intent on catching up Dan's class, and spurred on by the thought of joining his brother, Richard advanced through six forms in three terms. At the end of the second year he had secured a place in the upper school, only two forms behind Dan. His letters home from this period talk of his successes and failures in the public-school boxing competition; the bloody nose he gave the Westminster boy; the way he won the school hundred yards; the water he swallowed when he came fourth in the school's mile-long swim. His poem entitled, 'Henry VIII's ode to Anne Boleyn', reveals a boy with a boy's sense of humour:

> I loved Anne Boleyn for with love I was drunk
> I cannot remember the thoughts which I thunk
> But I winked at her once and she at me wunk.
>
> You must kneel at my feet whispered Anne, and I knole.
> I asked her to smile at me once and she smole
> And then I felt happier than ever I fole.[1]

It was only when he returned home to Mottisfont that the legacy of Fonthill really rose to the surface. Many years later, Meinertzhagen claimed that the wedge which that time had driven between himself and his mother had

allowed their relationship to drift into one of mutual suspicion, and when preparing his autobiography, that the difficulties in their relations were his fault. 'I blame myself and my nature, which has always been that of an unyielding rebel and an uncompromising, insubordinate and defiant insurgent.' About his mother, he concluded:

> She influenced my life for good more than did any other person; I held her in greater respect and love than any other human being with whom I have ever come into contact, and even after death, almost fifty years ago, I feel her loss more than ever and often yearn for her love, her advice, and her care.[2]

Yet the portrait of his home life created by the excerpts from his childhood diary give no impression of his own culpability. On the contrary, his mother's harshness is presented as the cause of their conflict. Had he, perhaps, failed to include extracts and letters that presented her in a more positive light, and then out of a latent sense of guilt inserted the above passages? Since he destroyed his childhood diaries it is difficult to draw a firm conclusion. Certainly, they were two strong personalities and seemed almost destined to clash. Equally important, neither Daniel Meinertz-hagen nor Georgina found it easy to express their emotions, even to their children. According to their second son they shrank from kissing each other, and were reticent about holding hands. In later life the latter claimed that his mother, especially, craved warmth and affection from others, but felt unable to show love in return. A similar reserve filtered through to her children, particularly Richard, whose isolation during his ordeal at Font-hill served to intensify the process of repression. Gradually, a barrier of misunderstanding and pride interrupted the true flow of positive emotions between mother and son, neither of them apparently able to admit their true feelings. Georgina seems to have taken a perverse pleasure from humiliating Richard in front of guests, and constantly criticised him with her sisters and his own siblings. She did much to establish the idea that Richard was a black sheep, perhaps finding in that image of him as a sullen, moody, odd-man-out a certain justification for her rather arbitrary behaviour.

Like all the other Potter women, Georgina had favourites amongst her own children, as well as favourite nephews and nieces, often showering affection and interest on the children of her sisters that she might deny to her own offspring. Indeed, she was one of the most popular aunts of all the Potters. Partiality of this nature upset Richard, especially when he was

compared unfavourably with his cousin, William Playne, one of those his
mother particularly preferred. Typically, he was often more sympatheti-
cally treated by his aunts, who were pleasantly surprised to find that
Richard was quite unlike the jaundiced image they had received of him
from his mother. Margaret, who had married the politician, Henry
Hobhouse,[3] was one of those with whom Richard had a particularly good
relationship. During a visit to the Hobhouses in September 1897 he made
the following entry in his diary: 'Aunt Maggie surprised me this evening by
telling me she wished I was one of her children. I was so embarrassed that I
blushed for the first time in my life. She then told me that mother was quite
wrong about me and that she would write and tell her so.'[4] Even amongst
her husband's family Georgina spread the myth that her son was an
impossible rebel. When he went to stay with his father's two sisters, Tal
and Tid, in January 1895, they too were pleased to find a young man quite
unlike the monster his mother had painted:

> Tal tells me she cannot understand how Mother dare say such nasty
> things about me. Oh, I am getting so sick of all this criticism and I do
> wish Mother would not poison other people's minds against me. Tal
> said, 'I'm going to write to Georgie and tell her she's a very naughty
> woman and if she doesn't know a good Meinertzhagen when she sees
> one, she ought to be ashamed of herself.'[5]

Inevitably, Richard came increasingly to ally himself with the quieter,
more dependable spirit of the Meinertzhagens, finding in his father's
family a harbour from the erratic genius of the Potters. He was particularly
hurt when his mother's hypercritical mind began to snip away at Daniel's
qualities in front of the family; but Richard's vehement defence of his
absent father only seems to have served to divide him further from his
mother.

Amongst the full brood of ten children Georgina's particular favourite
was the eldest boy, Daniel. Although, like his younger brother, he was
rather intimidated by her sharp manner, Daniel seems to have avoided the
conflict that marked his mother's contact with Richard. He appears to have
been far more relaxed and tractable, and his quietness passed for responsi-
bility. Both parents trusted Dan, and allowed him to go on a long
expedition to Lapland in the summer of 1897, an adventure that they
denied to his brother. Comparisons were regularly made between the
behaviour of the two eldest sons, always in Daniel's favour, and whenever
the two boys were caught in the midst of any joint mischief it was the black

sheep who received the scolding. Yet Richard, although he was hurt by his mother's partiality, never seems to have resented Daniel for his good relations with her.

On the contrary, his affection for his brother was one of the most lasting and positive elements of his childhood, and, indeed, persisted throughout his adult life. Although Daniel died when Richard was only twenty, the latter wrote more about his elder brother than all his other eight siblings put together, without a single word of criticism, or any suggestion of conflict in their relations. He was in awe of his brother's artistic talents, his easy relations with his parents, the way he seemed able to avoid the trouble that was a constant in his own life. Next to Dan he must have felt himself clumsy, heavy-handed, loud-mouthed. Richard's pathetic diary entry after the former's unexpected and tragic death from peritonitis in 1898 reveals not only the deep sense of loss, but also the extent to which he felt himself eclipsed by his elder brother:

> I cannot believe that I shall never see Dan again. His was a better, much better, nature than mine. I must try and perpetuate his memory by trying to mould my character on his and give to my sorrowing father and mother some of the love which they always received from Dan. To me Dan will always be an inspiration. He had a most lovable nature and real talent. I must strive after that for only so can I help father and mother.[6]

This imagined sense of inferiority lay at the heart of his relations with his whole family and prompted him increasingly to take pleasure in his own company, natural history providing the ideal safety valve for his moods. Here, at least, was an environment – the physical and sensuous world of nature – where he felt at home and which lacked all the complications of human relations.

He developed an intimate familiarity with the marshes and woods around Mottisfont Abbey, claiming to have a name for every coppice, hedgerow, hollow tree, and patch of damp ground, often associating them with some childhood adventure. One of his favourite spots was an area of reedmarsh and bog called the Duck-ground. The two elder brothers felt that only they knew the route through the marsh, and it became a private wilderness, unvisited and unknown by others. In 1942, when Richard paid a visit to his childhood haunts, he found tins of food and cooking utensils that had remained untouched since he had left them there in the previous century. These wilder portions of the estate were extremely rich in wildlife, particularly birds and fish that lived in and around the River Test. A

heronry, lodged in some ancient, decaying trees, was visible from the boys' bedroom window, while the marshes attracted snipe, lapwings, and water rail. In the woods there were pheasant and woodcock. Winter brought peregrines, influxes of geese, swans, and duck. Barn owls and tawny owls, nightjars, and kingfishers all bred, and in the river there were otters.

Meinertzhagen developed an early passion for hunting and soon became a crack shot. However, he seems to have disliked formal covert shooting; as in ball-games it involved careful organisation and large-scale co-operation with others. His preference was always for the unorthodox – for snares and the stealth of the poacher. He favoured solitude, or a single, like-minded companion, usually Dan. His fishing also bore the same disregard for convention. His father, according to his admiring son one of the most skilful dry-fly fishermen in the area, made no attempt to civilise his sons. On occasions he would even encourage them, challenging them to catch more trout with a length of well-polished copper wire than he could take with his rod and line. The wager – a pound sterling for each pound that their catch exceeded his – cost Daniel Meinertzhagen £5, a month's salary for one of the gamekeepers. Other hunter-and-gatherer methods used by the two boys involved spearing fish at night by torchlight, or harpooning them from a punt while the fish rested under a lily-leaf. In autumn they would let down the water-level of the weir and gather up the large, stranded eels, which had been swimming downstream; their largest catch was 75 kg of fish in just two hours.[7]

As the boys entered their teens, ornithology began to take them further afield. In May 1891 Richard accompanied his father on a business trip to Budapest and found himself in the same hotel as many of those attending the Second Ornithological Congress. Richard Bowdler Sharpe, a long-standing mentor of the Meinertzhagen boys, introduced him to a number of Europe's most distinguished ornithologists, such as Henry Seebohm and Howard Saunders.[8] He was allowed to attend the lectures delivered in English, and wrote excitedly to his brother about 'a sort of ornithological House of Commons' where everyone talked birds from morning to night. In the summer holidays of 1883 Daniel Meinertzhagen gave his two sons £30 with which to visit Ireland. On 12 August they set out for the rocky inlets and bays of County Mayo, and devoted themselves to shooting and skinning the birds of Ireland's western coastline. After two weeks the boys ran out of money and were forced to return home. With only fifty-four poor-quality skins, holes in the seat of Richard's trousers, and a broken left barrel to his shotgun, they could hardly boast about their first ornithologi-

cal expedition. None the less, it had developed an ambition for travel – an ambition that only one of them was destined to fulfil.

Although Richard was undoubtedly less unusual and less of a black sheep than his mother attempted to suggest, or, perhaps, than he liked to imagine, it is clear why his parents found their second son something of a misfit. Both Daniel and Georgina Meinertzhagen had received excellent educations, and while the former lacked his wife's intellectual aspirations, they both enjoyed ballet, art, literature, and theatre. Their taste was for fine and expensive things. Daniel's life as a banker revolved around the city, the stock-exchange, calculations of profit or percentages; his idea of countryside was an evening by a sluggish river casting and recasting his flies. Their son, on the other hand, was neither commercially minded nor academic, his intelligence was a natural, instinctive sharpness, which his parents underestimated. They did not share his exuberant passion for the outdoors, nor for hunting; to them, harpooning fish with a home-made spear was simply 'atrocious sport'. Richard was unmindful of his dress, often coming to dinner in his dirty shooting clothes. Frequently he was arraigned by Georgina for the mud on his boots. On the odd occasion when he arrived at a relative's house for dinner dressed only in his punt-gun overalls, his hosts could laugh it off as a piece of amusing unconventionality, but for his mother, his constant lapses must have been deeply distressing.

Looking at their second son – his slim, powerful body, muscular shoulders, long athletic limbs, his big feet in grubby boots, and scruffy clothes – the Meinertzhagens would have seen little to suggest the successful merchant banker that they had hoped for. Any hint of disappointment they may have shown would only have excited the existing sense of inferiority that he felt. He wished desperately to please his parents, particularly his mother, and once, when Georgina bought six new colts in the New Forest that needed breaking, her son jumped at the opportunity. This was the kind of hard, physically demanding work at which he excelled. On completing the task he received £5 from his mother and wrote in his diary:

> My darling mother has given me five pounds for training her colts and she told me I had earned it over and over again. Oh! how lovely, for it is the first time I have ever done anything right at Mottisfont. I do hope mother will like me more now and realise that I am trying to please her.[9]

However, such moments appear to have been rare. Generally, his mother harped on about his unsociability, and his incompetence at dancing; while

a dislike of parties and balls, and a childhood proclamation that he would never marry, earned him a reputation as a misogynist.

In spite of these apparent shortcomings, his father held out in his wish that Richard should follow him into Huths, and hoped that time and a little business experience might polish up any rough edges. However, by 1897 it was already too late: his personality and interests were now too firmly established for him ever to have been interested in a banking career. From a very early age he set great store by good health and physical fitness. He was a keen boxer and swimmer, and an excellent horseman. At nineteen he was almost two metres tall and weighed 76 kg, while his appetite was enormous. Long hours lying motionless in a punt, or in a hide waiting for the wildfowl to fly in at dawn had left him inured to cold or discomfort. He disapproved of too much talking, dismissing it as gossip. During his days at Fonthill he had met Oscar Wilde at the house of Wilfred Blunt, a friend of his father. He understood little of the latter's conversation, but sensed in his lank hair, corpulent body, and flaccid face, the type of person he loathed.[10] His heroes were drawn from other spheres of endeavour, usually imperial conquerors like General Gordon and Cecil Rhodes.

His views were tough and uncompromising; he saw things in black and white, and his teenage remedies for political problems, in which he took an early interest, were invariably harsh, occasionally violent. A subscription to *The Times*, paid for by his father when he was only fourteen, kept him informed of contemporary issues – overseas news, with its tales of conflict and conquest, far more to his liking than the interminable talk involved in domestic politics. From the outset he was a Tory, pro-Salisbury and pro-Empire. He grew up believing that Gladstone had betrayed General Gordon at Khartoum, and claimed that this event developed in him a lifelong suspicion of liberalism.[11] The Dreyfus Case in 1894 did little to improve what was at best a low opinion of the Gallic nation, and even in old age he was passionate in his denunciation of 'French rottenness'. His opinion of the Germans was more ambivalent. Soon after he started at Harrow he was introduced to Kaiser Wilhelm II when his two aunts, Tid and Tal, had been asked to entertain the German monarch after a review of volunteers on Wimbledon Common. The meeting did little to alter his deep mistrust of the Kaiser, and by 1896 he claimed to have written in a destroyed childhood diary that war with Germany was then inevitable – a suspiciously accurate forecast for an eighteen-year-old. As a race he thought the Germans 'a homely people, kind, polite, helpful', far preferable as company to the Americans or French, a verdict which

was almost certainly influenced by his family's own Germanic origins.[12]

When Richard left Harrow at the end of 1895 the question of his career became an issue of importance for the Meinertzhagen family. Hoping to preempt their designs for him he wrote to his parents and asked to be allowed to go to university to study zoology. His father, however, refused permission, unwilling or unable to see in his second son a renowned ornithologist. The latter replied by enlisting the support of Bowdler Sharpe, Lord Lilford,[13] Ray Lankester, the director of the Natural History Museum, and a host of other distinguished ornithologists, all of whom petitioned Daniel Meinertzhagen to allow his son to follow the vocation of his choice. Bowdler Sharpe even guaranteed Richard a post in the British Museum, but his father was adamant: neither socially nor financially was science a suitable career for his son.

The professional zoologist could point to no long-standing or prestigious traditions in his field – despite the enormous mushrooming of interest in biology – and it remained largely an amateur's hobby, the pastime of leisured gentlemen and country vicars. And it was in these terms that Daniel viewed his son's request. At the moment, he argued in one of his letters, Richard enjoyed all the material benefits of his father's lucrative profession, but when obliged to make his own way in the world, his standard of living would inevitably fall if he pursued a scientific career. If his son pursued a career in the city, however, his father could help him a great deal. Thwarted in all his arguments, Richard resorted to threats: he would run off with a yellow-headed barmaid and have a mass of yellow-haired children! But even in humour his father refused to budge: 'When you have all those yellow-haired imps you will need to be a rich man to bring them up and educate them; and, moreover, barmaids make expensive wives. I have ten brown-haired children and they are expensive, but I shudder to think what they would be if they had yellow hair.'[14] Eventually, Richard capitulated with bad grace. 'Money! I would sooner be a penniless scientist with successful research to my credit than be a senior partner in Huths, my soul blighted by gold and ripe to die of cancer in the stomach at the age of 55. Alright, I'll start in the City but the day I'm 21, if I hate it, you must let me go.'[15]

It is impossible to calculate the final shape of Meinertzhagen's career had he been allowed to pursue a university course of his choice. In later life he stated that in spite of twenty-five years as a professional soldier, natural history had always been his main interest, and believed that his impact in this field would have been greater had he had the opportunity to choose.

Perhaps a university education would have allowed him to develop the literary ability, the lack of which he frequently lamented. Certainly, it would have offered him the stimulus of intelligent company and a chance to widen his frame of reference. For Meinertzhagen, this experience of intellectual expansion came much later in life, during and after the First World War when he was forty. Only then, he claimed, did he encounter literature and art, or enjoy daily contact with intelligent and constructive conversation. However, even had he enriched his mind in this way at a younger age, and perhaps drawn off some of his enormous energy onto an intellectual plane, it is unlikely that he would have been content in a sedentary, academic or administrative post, bound to a single desk and office.

His scientific work would, perhaps, have been deeper and of a wider scope, but his was not an entirely cerebral nature, completely absorbed by an internal world of mental creations. Although his intellect was constantly posing questions and probing for answers about scientific issues, he loved too the purely physical sensations of movement, and a sensuous contact with the tactile universe. Movement and action brought a kind of knowledge itself, invariably self-knowledge, and the latter form was often more satisfying to him than any simple accumulation of data. Such restless physicality would possibly have prevented him from making a substantially deeper mark on the world of science, and he would engage us, as he does now, more for what he did and who he was, rather than for what he thought.

For the moment, however, the life of action had to be postponed; in January 1896, just five weeks before his eighteenth birthday, he entered Huths as a junior clerk. Caged in a windowless cell in Tokenhouse Yard, surrounded by great ledgers and forced to wear a black frockcoat and top hat, he felt thoroughly miserable. He was unwilling to learn the banker's trade, and lack of interest led to apathy and frustration. Most of the time he pored over an atlas, looking up the places from which all the bills, letters, and invoices had come, and noted down those he wanted to visit. His renewed requests to be allowed to go to university urged Daniel to seek some kind of palliative; a trip to Göttingen in Germany in August 1896 providing a suitably agreeable diversion. The official reason was to learn the language, and then later to go to Bremen so that he could master the German side of the business.

Life as a foreigner in a small provincial city was not particularly exciting, but he had escaped the drudgery of Huths, and the Hanoverian forests

offered opportunities for hunting and ornithology. In Bremen he joined the firm of a large tobacco and cement importer called Meyer, and made up for any lack of amusement in his job by inventing mischief with a team of students, who shared his lodgings. A brush with the law after he had connived to steal the helmet of a policeman landed him in jail for the night and a fine in a magistrate's court. He was also challenged to a duel, a contest, which, for once, he chose to brush aside.

Christmas 1896 was spent with his family at Mottisfont; then back to Bremen. The short second visit, lasting less than two months, was the prelude to a new post in a firm of stockbrokers, Milbank and Company, on Threadneedle Street in London, where life resumed its familiar and miserable course. Urged to do so by his father, the principals of the firm attempted to soften their employee's resistance to a business career, being helpful and indulgent of his apathy. Daniel also tried bribery, encouraging banker friends, like Charles Goschen, to give his son huge orders on which he earned substantial commissions, one of these amounting to £80. Years later Richard learnt that his father intended to set him up in business with Goschen's son, Edward, together with an initial investment of £40,000. However, the project was doomed. In August 1897 Richard wrote:

> I do not think I can stand this life much longer. I am wasting my life and my youth. A stuffy office, no exercise, complete slavery and a future ruined by an atmosphere in which gold is the sole aim. I shall take the first opportunity to get out of it and if nothing turns up within six months I shall go to South Africa and join Rhodes.[16]

For some time he had nurtured the idea of a military career, and although it was not his first choice it had certain advantages. A university course in zoology would always demand his parents' support to pay for the fees, but to enter the army he needed no financial assistance. He also had a number of contacts who could help him. Colonel Willy Woods, a cantankerous old pig farmer with a large estate at Warnford in east Hampshire, was a friend and later a neighbour of the Meinertzhagens, and Richard had been shooting with him on numerous occasions. He had shown early sympathy and enthusiasm for the boy's military interest, and in December 1894 had invited him to a dinner with Cecil Rhodes, one of Richard's childhood heroes. The latter apparently took a shine to the tall, athletic school boy, quizzing him about life at Harrow and whether African affairs formed part of the curriculum. Richard had taken a keen personal interest in colonial issues, particularly the Matabele War, and had attended lectures by Henry

Morton Stanley,[17] whom he had invited to stay with his family at Mottis-font. Through his contact with the bird room at the British Museum, he had also made the acquaintance of Sir Harry Johnston,[18] an explorer and colonial administrator in Africa. Both these pioneers had inspired in him a deep longing to visit Africa, and when Rhodes offered to take Richard back with him, the latter was overawed.

Typically, Daniel Meinertzhagen had completely blocked the proposal, pointing out that his son had not yet finished his education. However, Richard had twice composed letters to Rhodes during his incarceration at Tokenhouse Yard, tearing them up at the last minute lest he should hurt his father's feelings by his rebellion. Adopting another stratagem, he had written to his parents whilst in Germany asking for permission to join the Hampshire Yeomanry, a part-time territorial army of which Woods was a colonel. His reasoning – that amateur soldiering might be acceptable to his father, and at the same time provide a springboard to a full military career – proved correct, and Daniel agreed.

In March 1897, through the assistance of Woods, the nineteen-year-old Meinertzhagen secured his commission in the Yeomanry as a second lieutenant. Sword drill and riding practice at Knightsbridge Barracks in the evenings proved a pleasant alternative to stockbroking, and in May of that year he joined his regiment in Winchester for manoeuvres. Here, he quickly drew the attention of General French,[19] one of the commanding officers, by his bold and imaginative stratagem. Commandeering the hay carts on Willy Woods' estate – where the manoeuvres were being held – he took off their wheels and positioned them across the route of the approaching Aldershot Cavalry. While the 'enemy' were engaged in clear-ing their path, Richard's side took them successfully in the flank. Woods, naturally, was not particularly amused to find his carts in pieces, but the general congratulated Meinertzhagen on his initiative and asked him to ride with him for the next few days.

Moving to an area only a few miles from Mottisfont, Meinertzhagen was asked to act as guide to a patrol, whose orders were to locate the enemy by night. He was completely familiar with the terrain and soon found the opponents' unguarded camp. Unversed in military etiquette, the enthusi-astic scout drew his sword and charged through the tents with his patrol in full pursuit. The enemy was taken completely by surprise and their horses stampeded in the ensuing panic. Eventually realising that their attack had been a complete breach of the rules governing manoeuvres, Meinertzhagen slunk off back to base and at 3.00 a.m. woke French and informed him of

the enemy position. The General responded by ordering an immediate attack, but on arrival at dawn they found the enemy camp in complete disarray, with soldiers scattered over the surrounding countryside trying to catch their horses. Both sides were forced to abandon the manoeuvres, and at the end-of-day conference the enemy officers – amongst whom were a young Edmund Allenby and Douglas Haig[20] – upbraided Meinertzhagen for his cavalier tactics. French, however, defended his protégé, saying that the others should not have been caught napping, and pointing out their good fortune that the attack had not been the real thing.

Meinertzhagen later claimed that the deep satisfaction he had found in this fortnight of hard-riding, quick-thinking action, the solicitous attention of French, and the latter's disappointment when he learnt of his unchosen but intended banking career, left him with the conviction that he had to join the army. Once back in his job in Threadneedle Street he acted swiftly, posting off a volley of letters to various family friends whom he felt might be able to assist. One of these, Major Buist, who worked at the War Office, eventually helped to secure him a commission as a second lieutenant in the Third Battalion West Yorkshire Regiment. It only then remained to break the news to his parents, which in the wake of Dan's tragic death proved a less difficult task than he had imagined.

Meinertzhagen's later account of his elder brother's brief illness was prefaced by a bizarre tale involving ghosts and ancient curses that has not entirely lost credibility with his immediate family. Although he professed himself to be immune to a belief in the occult, he showed definite relish for a good story. According to his autobiography, shortly after the Christmas of 1897, one of the happiest at Mottisfont, he and Dan were returning from shooting on the estate. Suddenly, the latter spotted somebody walk across the lawn and then jump into the sunken ditch. Richard never saw the figure, and although they chased after him they were unable to catch up. He claimed that in the morning they searched for footprints where the person had crossed the sodden ground, but failed to find any. A curse, of which both boys were aware, had reputedly been passed on the house by the last prior at the time of the abbey's dissolution, which foretold that the eldest son of the owner would die in his prime, and a ghost would appear to him as a sign of his impending death.[21] Apparently, the two boys agreed not to tell their parents, since two previous tenants, both eldest sons, had died unexpectedly at a young age, and a story of inexplicable figures ghosting across the lawn at dusk might alarm Daniel and Georgina.

Six weeks later Dan was dead. He had made a visit to Bremen at the end

of January to perfect his German as Richard had done two years previously, and after only two weeks developed appendicitis. His condition deteriorated and before his father could arrive he died on the Sunday morning, 13 February 1898. The effect on the family was profound. Richard claimed that neither of his parents ever fully recovered from it.

In their vulnerable state of mind they allowed to pass as a *fait accompli* Richard's decision to join the army. His father was even positively encouraging and promised to help all he could. His mother had already reconciled herself to the fact that Richard's character was unsuited to a business life, and now wished Louis, his younger brother, to take Dan's place in Huths. After passing two sets of examinations and undergoing several months of training in York and at Aldershot, Meinertzhagen was finally gazetted to the Royal Fusiliers in January 1899 and awaited his orders to sail for India, where his battalion was stationed. The intervening months were spent packing his belongings at Mottisfont, which the family was now preparing to leave. With all its memories of her dead son, the large old house had come to haunt Georgina, and although both Richard and his father wished to stay on, her desire to quit prevailed.

Meinertzhagen's childhood diary records that in the wake of Dan's death, and with his departure for India imminent, he had hoped that the circumstances were right for a reconciliation with his mother. When the moment came, however, it proved impossible to break the established pattern of their relations. On the eve of his journey he wrote:

> I knew Mother would speak to me this evening and I was prepared to throw myself into her arms. But she started by telling me I must learn not to sulk and that I must restrain my temper and cultivate better manners. I am not sulky, nor bad tempered nor bad mannered. This renewal of criticism when I expected love, froze me to silence and I at once became icy cold, desperately cold.[22]

They remained together for a time in a condition of awkward, embarrassed silence, their true feelings hidden beneath the rigid exteriors that both could assume at tender moments. The departing son was apparently 'bursting with a desire to kiss [his] mother over and over again', but she remained taut, closed to the last. Finally, she said, 'Well, I suppose there is nothing more to be said', and left the room.

The following day Meinertzhagen sailed for India. Within fifteen years both his parents would be dead, and during that period he would have been in England for little more than two and a half.

1902–06
The Kaidparak Hill Incident

In spite of the fact that his childhood had been so marked by unhappiness, Meinertzhagen was by nature an optimist, and his departure in 1899 for a new life in India had raised hopes of much greater happiness in the future. As he set off on board the SS *Rome* he was newly twenty-one. He had freshly creased the opening pages of a diary – the first of seventy-six volumes that together would chronicle in detail all but three of his sixty-seven years of adult life. On the initial pages he presented a résumé of his current situation. His parents' wishes to impose a business life upon him had been blocked, and he had secured the career of his choice, or, at least, his second choice; he would have his own income, while the new surroundings and his new friends in India would be a clean break with the past. He also acknowledged his faults: 'rather intolerant, liable to periods of depression misconstrued as sullenness, a sensitive nature, . . . and a dominant thirst for affection which has never been satisfied'.[1] However, given time, he would improve. He would be free of the relationships which had most inhibited his happiness – those with his family – and now hoped that the physical distance between them and a healthy lapse of time would allow for a beneficial adjustment on both sides.

Three months prior to his entrance of Bombay harbour on 18 April, another young man, with similarly fresh, untested ideals, and with intentions to change life, had taken office as the 24th Governor-General of India. George Nathaniel Curzon, Baron of Kedleston, and heir to the earldom of Scarsdale, was at thirty-nine the youngest Viceroy since Dalhousie. He had enjoyed a brilliant career at Eton and Oxford and punctuated his early life as a politician with four lengthy journeys in the East. His books and articles on his travels had won him a reputation as one of the leading authorities on oriental affairs, and after two spells as Under-Secretary of State, at the India Office and the Foreign Office, he assumed the mantle of Viceroy. Curzon was imbued with the sense that India was 'the strength and the greatness of England',[2] and that the British Empire was an agent for good unparalleled in world history. However, in his view the British administration in India, renowned for its unassailable integrity, had lost its previous

zeal to aid and reform a fifth of the world's humanity. It was Curzon's God-given task to reinvigorate Britain's imperial mission in India.

At the very moment of Meinertzhagen's disembarkation a storm was blowing up between the young reformer and the established military authorities that would stir up opposition amongst the Indian Army against Curzon for the duration of his office. In Rangoon on 2 April 1899, approximately twenty soldiers of the West Kent Regiment had raped an elderly Burmese woman. The senior officers of the regiment, with the connivance of the civil authorities, had attempted to conceal the crime and avoid a scandal. However, through the pages of an Indian-owned newspaper Curzon came to hear of the incident, and immediately ordered a fresh trial. When the accused were acquitted on a technicality, the Viceroy intervened personally, dismissing the offenders, and relieving some of the senior officers of their command. The whole regiment, to which the rapists had belonged, was then posted to Aden, one of the most unpleasant stations then held by the British.

At home Curzon was criticised for his severe and, some said, egotistical handling of the case; with the British in India he was immediately unpopular. They felt incidents like the cover-up in Rangoon were inevitable. Their small community – numbering no more then 70,000 troops and only 1,000 higher-ranking civil servants – was a tiny élite ruling over 300,000,000 souls. Famine and epidemics in recent years had carried off several millions of their Indian subjects, yet the impact of these natural calamities on the overall population was negligible. To seize on one small human error, an isolated exception in an otherwise impeccable record, seemed petty; worse, to go against your own race seemed unnatural. But Curzon inveighed against such élitism, arguing that by circumventing the law it undermined British authority, and thereby British rule in India. Fourteen years later Meinertzhagen would himself become involved in such an incident, and to escape possible prosecution would avail himself of the same double standards that Curzon had opposed in Rangoon. At the time, however, these matters of state were of little consequence to him, and as he travelled northwards by train to join his regiment it was merely the background chatter to his first experiences of an exciting new country.

His regiment, the Royal Fusiliers, was garrisoned in Rájputana in western India, near the city of Ajmer. In the early nineteenth century this had been an important strategic outpost for the British from which they had attempted to contain the region's fiercely independent clans. The Rajput princes, the warrior-leaders of the largely Hindu population, from

which the province took its name, had for centuries resisted imperial encroachment, either by the Muslim Moghuls or the East India Company. A political map of the region testified to the apparent success of their opposition in its confused tangle of lines, each one defining the borders of some tiny independent Rajput principality. As one travelled through the dusty, semi-desert landscape itself, one of the driest and hottest in all India, the myriad of fortified palaces and castles which seemed to bristle from the top of any small elevation gave some inkling of the region's turbulent and romantic past. Although by the time of Meinertzhagen's arrival the substance of Rajput political power had largely gone, their independence was often a legal fiction masking a pervasive British control, while the walls of their impressive hilltop lairs were simply the façades of abandoned ruins crumbling away to dust in the hot desert winds.

By Indian standards, Rajputana was not a particularly densely populated province. The summer heat was ferocious, the rains niggardly, occasionally non-existent. Far to the west lay the empty spaces known as the Thar Desert, an area of savannah ruined by millennia of overgrazing and drought, that inched steadily eastwards with glacial slowness. Fortunately for the British, the Aravalli hills, the remnants of one of the oldest mountains systems in the world, bisected the region on a south-west to north-east line between Gujarat and Delhi. The moderate elevation of these quartzite spurs and ridges offered slight release from the full impact of Rajputana's summer furnace. Ajmer itself and Nasirabad, the garrison-town for the Royal Fusiliers, stood on one of the more northerly of these hills, about 200 km from Delhi.

Apart from a sense that he was being very much criticised by his brother officers, Meinertzhagen adapted to his new life fairly rapidly. His major problem was the attention he drew from his senior officers, not for any outstanding gifts, but for his tendency to get involved in ludicrous adventures. The worst of these concerned an elephant, a female curiously known as Archibald, bought for him by his father's brother, Uncle Ernie. One morning, the young subaltern, realising that he was late for duty, decided to ride Archibald to the parade ground. Unfortunately, the elephant had built up such a pace in the race to be on time that the mahout was unable to stop her. She careered onto the parade ground just as the battalion was falling in, and startled the adjutant's pony as the officer tried to head her off. The adjutant was thrown to the ground and almost trampled to death, while the sergeant-major, screaming at the battalion to hold its ground, watched Archibald smash through the ranks and scatter

his troops in all directions. Eventually the elephant was brought under control and Meinertzhagen ordered to present himself before the commanding officer. After facing the full bluster of a red-faced colonel, who threatened a court martial and demanded Meinertzhagen get rid of Archibald – a decision that was later rescinded – the young offender came away with little more than a bruised ego.

Only a few months later he was back in front of a colonel, this time in the latter's garden on horseback, with his hogspear buried in the corpse of a fox and a pack of dogs tearing the unfortunate creature to shreds. Earlier in the afternoon some terriers had located the quarry in a culvert close to Meinertzhagen's bungalow. Leaping onto his pony bareback, he had immediately given chase, and in the excitement followed the fox over a series of mud walls without regard for his whereabouts. He had eventually come up with his victim in the colonel's compound, where the old gentleman sat on his verandah, viewing the proceedings in complete horror. Meinertzhagen apologised as best he could and backed off, picking up the bloody remains of the fox, his superior shouting furiously as he departed.[3]

The lack of seriousness suggested by these escapades did not give an accurate picture of Meinertzhagen's attitude to soldiering. In fact, he was scathing of the amateurish nature of his whole battalion, and felt the tactics they practised in assaulting an enemy position took no account of the strength of modern fire-power. The elaborate protocol governing officers' behaviour seemed to him equally obsolete. In mess it was forbidden to discuss military matters, and in a lax moment when he had attempted to do so he had been snubbed; on another occasion he was discovered reading a book on the subject and was asked to leave. It was forbidden to smoke in the ante-room, or to leave the mess until all the regiment's guests had gone to bed. When, after a long day's hunting, he had retired early, a fellow subaltern came to his room and tipped him out of bed for the insult offered to his messmates. According to Meinertzhagen, the same officer, convinced that he was a member of India's crack unit, fingered his rosary each morning whispering: 'Thank God I'm a Fusilier.' The former, contemptuous of such glib self-confidence, offered a far more sober judgement on his battalion's fighting abilities: 'The senior officers are hopeless, out-of-date, ignorant of what is required of them and no effort is made to teach young officers like myself.'[4]

The new Viceroy shared Meinertzhagen's doubts about the fighting capacity of the troops in India, who had not seen a major engagement since

the Second Afghan War almost twenty years earlier. Accustomed only to intermittent skirmishes with disorganised hilltribes using obsolete weapons, the Indian Army, Curzon felt, had slipped into a rut. When faced with a properly trained and equipped force of European soldiers they would be hopelessly defeated – a prediction accurately borne out by the succession of reverses in the first years of the Boer War. The Indian Army constituted one of the largest land-based forces in the Empire. Ever since the nationalist uprising of 1857 the Indian administration had insisted on a one-to-two ratio of British to native troops. Even so, a maximum of 70,000 was still a tiny force to police a continent the size of Europe, and to guard a frontier stretching the length of the highest mountain range in the world. Moreover, it barely did justice to India's immense economic importance: she was the biggest producer of food and raw material in the Empire, accounted for a tenth of all Britain's trade, and almost a seventh of all Britain's overseas investments.[5]

Yet, for all its material value and symbolic importance to late-Victorian imperialists, India would never come to hold the special appeal for Meinertzhagen which it did for so many of his contemporaries. He was unmoved by its celebrated exoticism, and was unable and unwilling to penetrate the subtleties of eastern character or custom. India was too diffuse and vague, too feminine ever to ensnare him. At twenty-one he was impervious to any of the intellectual or spiritual aspects of oriental life which brought satisfaction to so many Anglo-Indians. He wanted action, exciting action. At night he claimed to have prayed, 'Thou seest, dear Heavenly Father, the sad plight of Thy Servant Dick; grant him soon a nice little war, that he may better his condition, and continue to praise Thy Name.'[6]

If Meinertzhagen had prayed as he later claimed to have done, he would have been disappointed; for the only conflict in which he could have bettered himself was being fought 10,000 km away, against the Boer farmers of South Africa. But for all his perverse sense of disappointment over this lost opportunity, he was tolerably happy in Nasirabad. He had adjusted comfortably to a life without his family and had found his place in the elaborate pecking order amongst the junior officers. There was also plenty of hunting – a good substitute for military action – after pig, chinkara, jackal, and sandgrouse. He identified four great conditions for happiness: free exercise in the open air, an object of unceasing pursuit, a complete lack of ambition, the love of a good woman. If he had not yet achieved one of these, he still had a fairly good score. When he fell ill with

enteric fever and a temperature of a 102°F – a condition that forced him to spend five weeks in hospital – he was not particularly pleased to receive six months' leave to return home. 'I had much sooner stop with the battalion,' he complained, 'where I am more than happy.' But after little more than a year in India he set sail for England, while his battalion moved to Mandalay in Burma.

The period in England passed largely without incident, and found his family much as he had left it – a busy, self-contained unit, dominated by women. His experiences were neither deeply happy nor sad, although even this neutrality was something of a blow. His personal hope for improvements in his family relationships collided with the larger and unalterable reality that life in his absence had gone on more or less as normal. There were, however, small changes. A stone the size of a walnut, which had been removed from his father's kidney during an operation, was now polished, set and on display in Daniel's bedroom. Barbara, his eldest sister, always known as Bardie, had become engaged to Bernard Drake, a solicitor in the city, and a month after Richard's return the couple were married. In Scotland he shot his first stag. In London he attended his first British Ornithologists' Club dinner. Around the table were the great men of British bird painting, Archibald Thorburn and George Lodge, together with a host of other luminaries – Walter Rothschild and Bowdler Sharpe among them. On the fifth day of 1901 Meinertzhagen climbed aboard the SS *Assaye*, bound once again for the East.[7]

Three weeks after arrival in Maymyo in central Burma, he was ordered at short notice to take charge of the battalion's convalescents, who were being moved to a hill resort in southern India for the hot season. The Nilgiri Hills, a compact plateau of dense forest interspersed with rolling downland, served a similar purpose for the British in southern India as the Himalayan foothills did for those in the north. The capital of the area, Ootacamund – with its satellites, Coonor and Wellington – was a curious blend of Victorian gothic architecture and suburban Surrey villas. This was the British summer playground – a place for sport, hunting, club-life, for bridge, picnics, gossip and flirtation – where the visitors could idle away the months of May to October enfolded in the region's cool, sanitary, mountain air.

Meinertzhagen's duties in Wellington were light, and his interest in socialising small compared with his enthusiasm for the area's curious montane flora and fauna. The dense forest was rich in wildlife and he indulged to the full his taste for big-game hunting. He also started to collect

the region's delicate tree-orchids, its endemic birds – such as nilgiri pipit and nilgiri laughingthrush – snakes, and butterflies. In these activities Meinertzhagen seemed to combine a near-fatal mix of recklessness and an unusually strong propensity for accidents. Whilst trying to catch butterflies with a net he had fallen off a bridge and cracked several ribs. In June with three friends he went out in search of a tiger that had been lifting cattle from nearby villages. Splitting into two groups, they climbed trees in the hope that the big cat would come by beneath them. Some time later, hearing gunfire, Meinertzhagen and his colleague rushed off in the direction of the shooting and found the tiger lying in a clearing, apparently dead. One of the others had descended from his perch and started to twist its tail as if playing a barrel organ, while the other two danced round the corpse in celebration of their bag. Suddenly, without warning, the animal came back to life, roared and rose to its feet, swaying drunkenly. Cunningham, the one who had fired the original shots, was fortunately still up the tree and commenced rapid fire killing the tiger outright, while the others, Meinertzhagen amongst them, looked on in helpless terror.

On another occasion he had been returning with a friend from a shooting trip in Mysore, and had disregarded warnings about a dangerous rogue elephant. Halfway along the forest trail into Ooty, the animal had attacked them and forced them to dismount and take refuge for the night in a narrow culvert. In the morning, the two exhausted men continued into Ooty on foot, only to be attacked again – by the yapping lap dogs of a finely dressed woman out for a stroll. Brittle-tempered after a night without sleep, Meinertzhagen warned her that if she did not call them off he would wring their necks. When this had no effect he chased after one of them, caught it in his butterfly net, and threw it into the tangled undergrowth at the side of the road. The woman, absolutely furious at his behaviour, proceeded to chase them up the road, striking at them with her umbrella.[8]

So often this note of humour, almost farce, that sounded in his early life stressed the vein of eccentricity in his character, and diverted attention from the larger and more continuous development of his abilities. In India he seemed unable to shake off the rôle of clown, and if not clown, then rebel. His main problem was his quick tongue, and an even quicker temper. He found it difficult to suffer fools gladly, particularly if he was meant to treat them as his betters. At mess, once, angered by an adjutant's remarks, he had risen from the table dragging the tablecloth and all the crockery into the officer's lap. On manoeuvres he captured the depot commander, Major Mainwaring – 'a grumpy, old fuss-box, hopelessly

stupid'[9] – and refused to let him go, which roused the old man to a fit of impotent rage. But to Meinertzhagen this was water off a duck's back. There was no such thing as automatic respect for his superiors; the man had to deserve it. If he was serious and keen and his approach to military matters was an effort to anticipate the future, Meinertzhagen was happy to obey. But time-serving fossils like Mainwaring, who simply wished to preserve practices and traditions, because he had not the originality to think of anything different, were just an encumbrance, and he gave them short shrift.

In Burma, two months later, Major Bird ran up against this same flint-like quality in his lieutenant. Having asked Meinertzhagen to arrange a snipe shoot for him one Sunday, he had reprimanded him the following day for not seeking permission to be absent from church parade, and threatened him with arrest. This seemed too much like arbitrary justice to Meinertzhagen. He wrote the major a strong letter of complaint asking for his name to be put forward for service overseas, preferably in Africa. Bird tried to retrieve the situation with a partial apology, but Meinertzhagen was unmoved. Within eight weeks he was informed of an appointment to the King's African Rifles, and set sail for East Africa in April 1902.

As Meinertzhagen came into port at Mombasa a month later, he had been in the army for about three and a half years, almost three of those in the Indian subcontinent. In many ways it had been a fulfilling time. The stamps and addresses from around the world which he had once collected, and which had stirred his imagination during his time as a reluctant clerk at Tokenhouse Yard, had been translated into real-life experiences. His travels had been extensive: in the last 15 months he had covered 25,000 km. In the forests of Burma and India he had made his first bird collections, netted butterflies, shot his first leopards and tigers; on the plains of Rajputana he had ridden out after boar or gazelle. Yet all this had only ever been a prelude. It was Africa that had always exercised the most powerful hold on his imagination. Much of the discovery and exploration of the vast continent had occurred within his lifetime; famous events, like the Matabele War, the Jameson raid, Omdurman, he had followed in *The Times*; he knew or had met a number of the pioneers – Henry Stanley, Cecil Rhodes, Harry Johnston, Frederick Jackson. Even as he set down on the land for the first time, he sensed its curious energy. 'I am full of hopes for the future in this new country,' he wrote. 'I am already in touch with the romance of Africa . . . the Dark Continent has me firmly in her grip.'[10]

Britain's conquest of the East African Protectorate had come about only

very recently and in a rather roundabout fashion, which was ultimately linked with her possessions in the Orient. Ever since the opening of the Suez Canal in 1869, the British felt it of paramount importance to have influence over and, if possible, control of the new short route to India. In their eyes, whoever dominated the 160-kilometre stretch of water would have a stranglehold on the British Empire, and when Egypt came under British control in 1882 it seemed that imperial communications had been guaranteed. However, Egypt's new masters quickly realised that the possession of new territory was a mixed blessing, bringing in its train new vulnerabilities. For the national security of a country that was known as 'the gift of the Nile', it was felt essential to control the Nile; otherwise someone further upstream might attempt to dam it or divert it, even to flood it. Since Uganda and the Sudan contained much of the source and headwaters of the great river, the British, compelled by the illogical demands of imperial security, found it necessary to annex these countries as outer bulwarks for their defence system. It then only remained to guard the land route to their possessions in the African interior, by welding the East African Protectorate to the new fortifications.

Initially the British government had hoped to maintain their interests in this region at little real expense to themselves, through the offices of a commercial group, the Imperial East Africa Company. However, the directors of the company, an odd mixture of philanthropists and business men, were unable to attract investment into the region or to secure sufficient profits from their trade. Faced with the company's financial collapse, the British government was more or less forced to intervene and in July 1895 formally declared the establishment of the East African Protectorate. Most of the old company's staff agreed to continue under the new regime, and helped to build up the rudimentary infrastructure that the government had inherited. After the suppression of an Arab rebellion in the strategic coastal region of Mombasa, the first Commissioner of the Protectorate, Sir Arthur Hardinge, oversaw the construction of a railway line that linked Uganda with the coast. This development, almost completed by the turn of the century, coupled with the advances made in native administration, had changed the Protectorate from an unwanted backwater, important only as a marginal staging post on the route to Britain's oriental empire, into an area of rich, hitherto untouched, farmland ripe for European settlement.

None the less, at the time of Meinertzhagen's arrival, its economic value was latent rather than actual. The life was still very much that of a frontier

territory – raw, arduous, and full of dangers. Disease and wild animals were a constant threat, while a variety of indigenous tribes watched British penetration of their lands with alarm. Lording over the vast areas of open savannah between the coast and Nairobi were the Masai – a tall, proud people famous for their prowess as warriors – who wandered the plains in search of fresh pasture for their cattle. Further inland, confined by their enmity with the Masai to the more temperate highlands, and based respectively to the north and south of Nairobi, were the Bantu tribes – the Kikuyu and Kamba. Beyond these, to the north-west, in the region south of Mount Elgon, were the Nandi, a highly unified, agricultural people. Relations with all of them, particularly the last three, were frequently turbulent and involved a number of violent clashes, in which the British, in spite of their vastly superior weaponry, had not always been successful. The safety of lone missionaries and independent settlers and traders could not always be guaranteed, and only the string of British outposts and their immediate vicinity offered anything like settled conditions.

As a consequence of the railway development in East Africa, the fulcrum of national administration had moved westwards from the coast to the interior. Although Mombasa continued as the nominal administrative headquarters, Nairobi, originally a jerry-built shanty town that had served as a supply depot during the construction of the railway, had come to assume an increasing importance. And it was to Nairobi that Meinertzhagen travelled when he wished to report at the headquarters of the newly formed King's African Rifles.

He was not particularly impressed with the place – the only shop was a small tin hut, the only hotel on the only street a 'wood and tin shanty'. There was no clear-cut division between civilisation and wilderness: at night hyaenas and jackals filled the air with an unearthly chorus; occasionally a lion would attempt to enter the cattle kraal. The area immediately surrounding the town was full of game. Races organised by the town's inhabitants had recently been halted by an angry rhino, while a zebra had dropped her foal on the army's parade ground. For Meinertzhagen there was no longer any need to go out in search of excitement, there were dangers all around. Within weeks of his first posting to Fort Hall – a government outpost in Kikuyu country, about 100 km north of Nairobi – he had his first taste of action.

Early one morning in July an African boy rushed into the station with the news that a mail party had been attacked. When Meinertzhagen arrived with twenty men the three murdered porters had begun to decompose,

while the wounded were a mass of flies and maggots. The two most seriously injured were women, one with a spear thrust under her right arm and protruding from her left, the other with viscera dribbling, maggot-ridden, from a stomach wound. Meinertzhagen dealt swiftly and efficiently in the crisis, dressing and stitching up wounds that the district officer, Hemsted, who had arrived the day before, had been unable to face. To keep off the flies he had shelters constructed and ordered the wounded to be fanned, while a stiff thorn zariba was erected to deter further attacks.

In spite of these precautions they were assaulted again, not by Kikuyu but by a man-eating lion that had been terrorising the district for some months. In the night, the animal had leapt the thorn barricade and grabbed a porter by his buttocks, but startled by the man's screams, had immediately seized another victim by the throat and made off. Meinertzhagen, roused by the terrified shouts and thinking it was another Kikuyu raid, leapt up with his revolver and rushed towards the commotion. In the failing light of the camp fires he was just able to make out the ghostly form of the man-eater jumping back over the zariba with the prey in his jaws. As soon as it was light he tracked the blood spoor until he came upon a human skull and a scattering of shattered bones, at which point the hunt was abandoned.[11] Meinertzhagen had been in the country for less than two months.

After pressing on to Nairobi he soon returned to Fort Hall, where the atmosphere remained tense in the wake of a number of threatening gestures by the Kikuyu. In spite of this, he could not help seeing the funny side to his situation. There he was, in the heart of Africa amid half a million well-armed 'savages', over a 100 km from the nearest reinforcements with only two other white men and seventy black policemen and soldiers, administering an area the size of Yorkshire. Strangely, these apparently hopeless odds seemed to buoy his confidence. Should they attack, he boasted to his apprehensive colleague, not only would he repulse them, but in twenty-four hours he would have burnt down every village within eight km of the station. In the event, he could almost certainly have done it. Africa had awakened in him the capacity to act with an absolute confidence and an unnerving singleness of purpose. Responsibility, either for the security of others, or for taking the lives of others, he shouldered with an almost unnatural ease. He imposed upon himself and upon his troops a rigorous discipline. While his brother officers played cards, or drank, or enjoyed a steady stream of native girls, Meinertzhagen held aloof. He was

supremely fit and constantly active, either on duty, or on self-initiated geographical surveys.

When news arrived at Fort Hall that a local tribe had murdered a policeman and was then dancing round his mutilated body in an orgiastic prelude to an attack on the station, Meinertzhagen counselled summary justice, otherwise an unpunished crime would imply British weakness and give rise to further atrocities. His views prevailed. The village was surrounded that night and when the war party tried to break through the cordon of soldiers, a fight ensued. Many of the natives were shot, while their huts were burned down and their livestock confiscated. In the morning a deputation of village elders brought peace offerings of honey and milk, together with several of the original murderers, who were later imprisoned. The harsh tactics seemed to have paid off.

Two weeks later, during a reconnaissance of the Aberdare mountains, Meinertzhagen was caught up in punitive measures taken against the Kihimbuini, a branch of the Kikuyu that had earlier attacked the mail party. The officer in charge informed him that the tribe had only recently seized a white man while he was attempting to buy sheep, dragged him to their village and pegged him to the ground. The whole village had then urinated into his open mouth until he had drowned. Again, Meinertzhagen felt the need for instant justice, or, rather, revenge. Attempting to achieve the same element of surprise as he had a fortnight earlier, he made a night march to the edge of the village, and against a background of beating war drums and flickering village fires, gave the order to take no prisoners except children. In the event, not a soul survived the assault, although, fortunately, many of the young women and children had been evacuated the previous day. The political officer, Maclean, who had been with Meinertzhagen at the time, refused to consent to the action, but promised not to interfere if he wished to proceed. The decision, therefore, to slaughter the entire village – both men and women – had been taken almost entirely by a twenty-four-year-old lieutenant.[12]

Even when allowances are made for the inevitability of conflict in a soldier's life, portions of Meinertzhagen's diary in East Africa – *Kenya Diary* – can read like an improbable and distasteful celebration of violence. His zeal for action was more than a simple desire to see his duty well done. At times he appeared positively to relish the thrill and danger of arm-to-arm combat. In his descriptions of violent encounters with native Africans he spoke in terms of 'fun' or 'excitement',[13] almost as if it were little more than a challenging form of blood sport. On one occasion, in his account of a

long day's fighting against the Embo tribe, he concluded: 'It was a grand day.' He mused on how easily a bayonet slid through the body of a man. One only had trouble if it went right up to the hilt and then it was a desperate effort to tug the thing out.[14]

The amount of bloodshed met with considerable comment when the book was first released in 1957; a criticism that intensified when it was reissued in 1983. 'Richard Meinertzhagen was a killer. He killed abundantly and he killed for pleasure,' were the opening lines of a new preface that seemed to be the moral point of departure for a modern audience.[15] Their author, Elspeth Huxley, looked to his painful, occasionally tortured relationship with his mother for the origins of Meinertzhagen's African bloodlust. It is undoubted that the systematic brutality he encountered at Fonthill, coupled with Georgina's rejection, go some way to explain this element in his personality. However, to see those childhood experiences as entirely responsible for his later behaviour is surely to overburden them. It is equally important to consider the larger historical and military context of his actions in the Protectorate, if not to excuse, then to explain them.

The colonial scramble for Africa in the last quarter of the nineteenth century was not noted for the scrupulous correctness of its methods. The European nations may well have convened diplomatic conferences at Heligoland or Berlin to decide amongst themselves, in gentlemanly fashion, who should have which portions of African territory, but how each nation then disposed of their booty was not generally an issue of importance. The brutality involved in King Leopold's systematic exploitation of the Belgian Congo was probably the most notorious example of colonial rapacity, but it was by no means an isolated case. In German East Africa the savage repression of the Maji-Maji uprising in 1905 depopulated large areas of black-African territory, and probably accounted for the deaths of more than 250,000 tribal people. The French, the Portuguese, and the British had all suppressed native resistance to their African conquests with methods that, if not quite as harsh, were similarly inhumane.

Bolstered by a whole gamut of anthropological and evolutionary theories, which placed indigenous Africans on a level only marginally above the animal kingdom, the European conquistadors marched with the conviction that the moral principles governing their behaviour in Europe were inapplicable in Africa. High-born British or German men, reared in a scrupulously Christian environment, experienced a curious kind of moral atavism as soon as they lost sight of the European coastline. Meinertzhagen

acknowledged this process, but tended to project responsibility for his own brutal behaviour onto Africa itself.

> It is hard to resist the savagery of Africa when one falls under its spell. One soon reverts to ones ancestral characters, both mind and temperament becoming brutalised. I have seen so much of it out here and I have myself felt the magnetic power of the African climate drawing me lower and lower to the level of a savage.[16]

In his more temperate seventies, Meinertzhagen acknowledged that he had extinguished the lives of fellow human beings with all too few qualms. Yet he clung to a severe logic that had fortified him at the time of his slaying: action, immediate action, carried through without pause or mercy, was in Africa often the most lenient way to conduct a punitive expedition. There was possibly some justification for this cruel-to-be-kind attitude. Since the 1890s the British had embarked on no fewer than five expeditions against the Nandi in an attempt to end their persistent belligerence. On each occasion the inconclusiveness of the British assault gave rise to a fresh cycle of murders by the Nandi that would then precipitate yet another campaign. Only when they had been resolutely beaten in an extensive and bloody struggle did they relinquish the notion that they could defeat the British.

If Africa, paring away surface levels of civilisation, had revealed in Meinertzhagen a naked desire for blood – something to which he later confessed[17] – he was significantly free of the other vices acquired by his fellow whites. Many of the other officers in the King's African Rifles were the rejects of other regiments, heavily in debt and addicted to gambling or drink. African women they seemed to acquire on a sale or return basis. Freed from the stifling sexual mores of their own culture, few, it seemed, could resist the temptation. An English missionary operating near Fort Hall had persuaded his young female converts that true Christianity was best conferred by intercourse with a Christian and was doing a thriving business. Meinertzhagen found out through the local chief and had the 'missionary' thrown out of the country. Three Italian White Fathers were practising a similarly liberal version of Christianity with the young boys and girls of the tribe, and once again, he saw to their removal.

For all his severity during periods of conflict with natives, it is interesting to note that Meinertzhagen was part of a small minority which upheld the interests of blacks. This was not only with regard to small-scale incidents of corruption among missionaries or government officials, but on the larger question of white settlement. True, he believed – with all the chauvinism of

his age and race – that white conquest and rule were ultimately a great benefit to the 'savage' indigenous population; but Africa should be preserved for Africans, and not parcelled out into farmsteads for prospective European settlers – a view that brought him into conflict with a number of his superiors.

When Sir Charles Eliot, the second Commissioner for the Protectorate, heard that Meinertzhagen was the nephew of Beatrice Webb – a woman whom he greatly admired – he was invited to dinner. Since European colonisation was the burning issue of the day, it was inevitable that conversation should turn to a subject on which host and guest held diametrically opposed views. Eliot, a brilliant scholar, philosopher, and expert on sea-slugs, nurtured visions of a large white population dominating the whole of the western highlands, from the borders of German East Africa to Mount Elgon, on the border of Uganda. The fiery young Potter disagreed. He thought that it was wrong to evict Africans from their land, and any policy of subjugation would ultimately lead to violent clashes between black and white in which the former would eventually triumph. With Lord Delamere, the great champion of white settlers in East Africa, he had the same disagreement. Meinertzhagen's predictions of conflict between Africans and Europeans, and his belief that the Kikuyu would spearhead opposition to white rule showed a remarkable prescience for a young man.[18]

It was equally remarkable that the staunch Conservative, who had denounced the politics of his famous aunt as 'a foul, infectious disease', should have found himself championing the cause of blacks against the great empire builders of the Protectorate. Possibly, it was connected with the old Potter response to the difficulties faced by minorities or underdogs. Yet in India he had come into contact with a nation similarly dispossessed by outsiders, but felt no corresponding sympathy for their position. More likely, his support for the Africans stemmed from a genuine affection for black people, particularly the Kikuyu, and a real concern for their wellbeing. His own deep love of the outdoors, and his strong, elemental personality, were in harmony with the character and lifestyle of tribal natives. While African nakedness was a source of embarrassment and offence to the academic Eliot, Meinertzhagen suffered no such complications. He admired the tribes-people for their natural intelligence, their martial prowess, resourcefulness, and courage – qualities he had found absent in Indians. When the time came for Meinertzhagen to leave Fort Hall, to which station he had been attached for almost two years, he was

deeply moved to leave so many Kikuyu friends. And after more than six months on leave in Europe, he registered a preference for 'Africa and the savage to England and the over-civilised society which lives there'.[19]

His visit to his family for the winter and Christmas of 1904 had not been particularly enjoyable. It pained him that on his arrival at Victoria Station, in spite of a cable to inform them of the precise time of his train, nobody came to meet him. Meinertzhagen saw that as an unforgiveable piece of neglect which set the tone for the rest of his leave. Brockwood, the spacious country house and estate in Hampshire that Daniel Meinertzhagen had bought after their departure from Mottisfont, was a disappointment. Everything that he had enjoyed about his old home was missing at the new; he had seldom seen such an unattractive place. He argued with his mother and sisters, and found them cold and indifferent to his presence. None of them took any interest in his work or his travels, while all of them were pro-Boer, anti-British in their attitude towards the South African war. Most galling of all, they ran down the army to his face.

Autumn was taken up in a busy round of social calls, Richard shuttling between his parents' two houses and those of his relatives, like Hadspen House in Somerset, the home of the Hobhouses, and Longfords, Aunt Mary Playne's country house in Gloucestershire. In October he had a ride in his first motorcar. In November and December he took further military examinations, emerging from both with high hopes of passing. Christmas itself was a mixed occasion. Except for his brother Fritz, who was in South Africa, all his family were in Hampshire for the festivities, and it was pleasant to be a family of ten once again. But how much pleasanter if someone had thought to buy him a present. Three days later he had to go into hospital for a minor operation, in which dilated veins were removed from his abdominal wall. During his period of convalescence he learnt that his post-examination confidence had been fully justified: he was now Captain Meinertzhagen.

In early February, en route to East Africa, Richard went with his mother and his sisters, Lorna, Bobo, and Betty, and their old faithful maid, Sarah Peacock, on a short holiday to France and Italy. But once again, the experience was overshadowed by unhappiness. A man on board ship called Pike, with whom Meinertzhagen had become friendly, had committed suicide in Nice, while at Portofino in northern Italy the news reached them that Uncle Clou, the last remaining son of Frederick Huth, had died. The double blow had a curious effect.

Throughout his period in England Richard had felt himself buffeted and rejected by his family, particularly his mother and sisters. In middle age, Georgina, increasingly estranged from her husband, had found support and companionship among her six daughters. To their sensitive, and – certainly with the opposite sex – slightly tongue-tied brother, they must have appeared a difficult tribe to get to know. With their mother's quick wits and her faintly radical politics they were a unified chorus of opposition to their conservative, imperialist soldier-brother. Perhaps if he had been around longer and had seen more of them in the last five years he could have picked them off in a quiet moment one by one and established real intimacy. As it was, they were used to not having him there, and their obvious camaraderie and self-containment must have seemed to Richard a conspiracy of coldness. In fits of bitter depression caused by these feelings of isolation, he had toyed with the idea of taking his own life. Pike's suicide, however, rather than inspiring his own, jolted him back to life, while Venice, with its melancholy beauty and out-of-season tranquillity, restored some peace of mind.

On the last day of February he set sail once again for Mombasa. During his eight-month absence from East Africa there had been a number of important changes in the colony. Sir Charles Eliot, embittered by a protracted disagreement with the Foreign Office, had resigned as Commissioner and been replaced by Sir Donald Stewart. The latter, a soldier by profession, having served in Afghanistan, the Transvaal, and Sudan, before becoming the Resident in the Gold Coast, was a man of very different temperament to his predecessor. Indolent, hard-drinking, and inclined to neglect the nuts and bolts of civil administration, he none the less stamped his mark on East Africa by a series of military expeditions against African tribes. While these were ostensibly to punish those who had rebelled against British control, they served the double purpose of clearing natives from areas highly prized as *lebensraum* for the growing influx of white settlers. The implementation of this new aggressive policy coincided with Meinertzhagen's return to East Africa and soon involved him in the largest and most important of these punitive missions, which was against the Nandi.

His arrival in Nandi Fort, now as a company commander, was not an auspicious one. The only two other whites there were Cary – the officer Meinertzhagen had been asked to replace – and Walter Mayes, neither of whom inspired his confidence. Judging from the very low standards of the troops, he thought Cary must be an extremely poor soldier; while Mayes

and Meinertzhagen had crossed swords a year ago, over the death of an American missionary, which the latter attributed to Mayes' negligence. At the time of the incident Meinertzhagen had registered his immediate dislike of the man, and things had changed little with the passage of time.[20]

Mayes, the District Collector in the Nandi territory, had led an adventurer's life in the islands of the Indian Ocean before drifting into government employment ten years previously. On account of his excellent service during the Uganda Mutiny he had been rewarded with a permanent post in East Africa. He was largely an uneducated man not above defrauding the administration, but in the early days, hard-pressed for good employees, they were prepared to tolerate his rough-and-ready methods. There is little doubt that, through long years of residence among them, Mayes had evolved an effective authority over the Nandi, and had helped pacify a troublesome people during a critical period for the colonial government. But once the railway was complete and the administration consolidated, and as the Protectorate started to attract a higher calibre of employee, Mayes' deficiencies became increasingly apparent.

Meinertzhagen soon discovered that Mayes had elaborated a number of schemes to supplement his income, at the expense both of the administration and the Nandi themselves. Livestock, lifted in the form of a fine for the latter's misbehaviour, was merged with his own herds without records being kept of the transaction. Often these animals were then sold, once again without records or receipts, and the profits kept by Mayes. He also put in inflated claims to the administration for the wages of his natives, and then used the difference to employ workers to build his own house.[21] Meinertzhagen challenged him over these abuses, warning him that any further irregularities would be reported; but the malpractice continued unabated.

Two months later matters came to a head when a number of Boer settlers in the district claimed that since they were paying rent to the administration – in spite of Mayes' previous assertions to the contrary – they were entitled to protection from the Nandi. It was clear to Meinertzhagen that Mayes was operating his usual double practices, and this, on top of a stream of other complaints from the Nandi themselves, prompted him to report the whole affair to the sub-commissioner.[22] Mayes' subsequent demotion from Collector to Assistant Collector and his transfer to another station after a court of inquiry had found him guilty of the charges brought by Meinertzhagen, initiated a vendetta that would ultimately have serious consequences for both men. For now, however, their personal quarrel was

overtaken by the larger conflict between the Nandi and the British Government.

Ever since white penetration of East Africa, the Nandi had exercised a forceful hegemony over the other tribes of the Rift Valley, and were reluctant to abdicate from this pre-eminent position. Previous expeditions to subdue them had proved ineffective and only swelled their self-confidence, while failure to punish them for their latest outrages against white settlers and traders had convinced them of growing British weakness. The time was fast approaching for a decisive showdown. With the lapse of an ultimatum demanding a fine of 300 cattle, an expedition against the tribe was eventually viewed as the only solution. Meinertzhagen concurred with this decision, but felt that the majority of the Nandi were 'a peaceful and loveable lot', and regretted the inevitable damage done to their 'gorgeous country'.[23]

It is interesting to note, in view of the charges of bloodthirstiness brought against Meinertzhagen, that he showed a sympathetic attitude towards the Nandi and until the eve of the expedition favoured a diplomatic solution to the quarrel. Equally, the action above all others that would earn him a reputation as a trigger-happy hothead, and which would precipitate his dismissal from East Africa, did much to reduce the casualty figures on both sides. The events leading up to this climax had hinged on an almost personal contest between Meinertzhagen and the Nandi medicine man, or Laibon, Koitalel. The latter, standing at the peak of a chain of command between tribal elders and young warriors, wielded immense influence over his people and was pivotal in any conflict. He claimed to have devised medicine that would reduce the white-man's bullets to water, while Sir Donald Stewart's untimely death from pneumonia in October 1905 was held up before his followers as an example of his powerful magic.

Meinertzhagen had maintained an up-to-date knowledge of the Laibon's intentions and movements through an elaborate spy-network of Masai and Nandi faithfuls, and believing that the latter's influence over his tribe was an important factor in the forthcoming conflict, he was prompted to devise a plan for Koitalel's capture. He outlined his intentions to Colonel Harrison, the expedition's commanding officer, and to the chief staff officer, Major Pope Hennessy, and asked for permission to proceed. Anxious not to implicate themselves should anything go wrong with the plan, his superiors issued a telegram that authorised the attempt, but shifted responsibility from their shoulders to the young captain himself.

However, Meinertzhagen was never one to shy away from action on that account.

The Laibon had already attempted to kill him once, when he sent a young Nandi maid, supposedly as a peace offering, with instructions to poison him. With advance warning of the plan, Meinertzhagen had found the poison and returned it to its original sender with a recommendation that he should take the stuff himself.[24] Koitalel's next move was to arrange a peace meeting at which he again planned to murder his opponent as they went to shake hands. Rising to the challenge, Meinertzhagen agreed to enter the Laibon's trap certain either that he could outfox him if treachery were practised, or, that he could capture him the following evening if the meeting passed without incident.[25]

On the morning of 19 October, two days before the official launch of the expedition, both men went out to meet at a place called Kaidparak Hill, twenty kilometres from Nandi Fort. It had been previously agreed that each should have only five accompanying men at the appointed rendezvous, and that the exact spot should be in full view of Meinertzhagen's reserve column. However, Koitalel had approached with twenty-two armed warriors, while hundreds were concealed in the surrounding bushes, and Koitalel himself had vanished from view into a small hollow. It was clear to Meinertzhagen that some kind of treachery was intended, and he moved his column to take account of Koitalel's change of meeting place, then went down to meet him.

The events of the following few minutes, which became the subject of three separate courts of enquiry drawing the attention of the Commissioner and the Colonial Secretary in England, Lord Elgin, passed ultimately into the Nandi's mythology as an example of unparalleled British treachery that was still talked about over fifty years later.[26] Immediately after the fight, however, and much to his surprise, Meinertzhagen was given a hero's welcome with congratulations coming in from all quarters, together with several recommendations for the Victoria Cross. When the Nandi Expedition proceeded a few days later it was clear that Koitalel's death, along with twenty-two of his warriors, had left the tribe without its most experienced leader and had undermined their morale. Opposition to the British was half-hearted and confused, and within two weeks the first phase had been successfully concluded. The Nandi had lost over 500 warriors, while almost 30,000 of their cattle, sheep, and goats were in British hands.[27] It had been agreed that once they had been punished, the tribe should be moved out of the vicinity of the railway line in

order to avoid a repetition of past crimes, while their territory would be opened up for European settlement. Meinertzhagen disapproved strongly of this policy of eviction, but owing to his knowledge of the region, it was he, ironically, who was chosen to survey the future reserve.

In the heat of the conflict his fellow soldiers had been happy to pat their comrade on the back for the timely outcome of his meeting at Kaidparak Hill, but as the expedition came to a halt it was evident that some had taken a less positive view of the affair. Foremost amongst these was Mayes, now anxious for revenge for his demotion. He had stirred up a rumour that the treachery at the fatal meeting, far from being on the part of the Nandi, was all Meinertzhagen's. And there were some, even in the highest places, willing to believe it.

Meinertzhagen heard about the rumours from various sources and took immediate steps to answer the charges. On 1 December a court of enquiry was convened at which any imputation of misconduct was strongly repudiated. However, the rumours refused to die and three days after Christmas he asked for another hearing, which once again returned a verdict in his favour. But Mayes, with an almost Iago-like determination to bring his rival down, persisted in his accusations until a third and final court of enquiry met on 9 January to investigate the circumstances of Koitalel's death. With the two leading protagonists present the trial became a personal battle, Meinertzhagen relentlessly cross-examining Mayes, until the latter broke down and refused to take further part in the proceedings.[28]

There is little doubt that Meinertzhagen's version of the events at Kaidparak Hill was largely correct. The Laibon had undoubtedly sought to kill him. He had clearly violated the conditions which were to have governed their meeting: he had altered the exact spot of the rendezvous, he was surrounded by a very large number of warriors, while his personal escort exceeded the agreed figure by seventeen. It is equally unquestionable that the unexpected death of the Laibon knocked the Nandi off balance and allowed for a rapid conclusion of hostilities. Meinertzhagen's actions, therefore, had been an extremely valuable and brave contribution to the expedition. Why then did the rumours persist, and why, if he vindicated his position in three separate trials, was he eventually recalled from East Africa?

His account of what had happened on 19 October, which he submitted in his original report to Colonel Harrison, was maintained consistently in the three courts and in his published work on East Africa, *Kenya Diary*. He had gone down to talk to Koitalel, Koitalel had refused to shake hands and had

almost immediately given the signal to fire. The government interpreter, one of the Laibon's spies throughout the whole build-up to the meeting, had turned as if to kill Meinertzhagen and was shot by the latter's native corporal. Meinertzhagen had then grabbed Koitalel to shield himself from spears and arrows, the Laibon had struggled free and Meinertzhagen opened fire and killed him and a number of his retinue. The five government soldiers had then retreated to their reserve column.

However, this account is clearly at odds with the one in Meinertzhagen's private diary, written down immediately after the shoot-out, and although it was later published in the *Kenya Diary*, a crucial passage was omitted:

> Before going down to meet the Laibon I had warned Butler to open fire at once if he saw us being overwhelmed. He mounted the machine gun and covered the place of meeting. An arrow knocked off my helmet and Butler, thinking I was down and seeing the hand-to-hand fighting going on opened fire. The bullets flew thick among us and I don't know how we escaped. One bullet just grazed my shin, which has done no more than give me a stiff leg and one of my men Jumia Wad Malhi was hit in the fleshy part of the neck.[29]

Although these details do not alter in any way the initial sequence of events, they shed a completely different light on the way the struggle developed. Moreover, the fact that they were left out from his report and later testimony reveals two important points. Firstly, Meinertzhagen had wished to suggest throughout that the twenty-three fatalities were the result of the panicked shooting of the five men on the spot, and not, as was surely the case, largely the work of a well-positioned machine gun some way off. Secondly, he had quickly decided that the high state of readiness in which he had left his reserve column might easily be construed, not as the last line of defence, but as a fairly carefully organised plan of attack. In the event, in spite of his precautions to avoid this interpretation, this was precisely the view that some took.

His omission of the important part played by the machine gun – possibly in an effort to shield Lieutenant Butler – meant that there was a discrepancy between his version of events and the events themselves. These gaps in his testimony clearly provided fuel for Mayes and the others who had challenged Meinertzhagen, while the judges themselves, for all their avowed general support for the latter, may well have questioned the verity of some of his details. The high number of casualties inflicted also tended to work against him. If Meinertzhagen's trump card was Nandi treachery,

then the Nandi and their advocates could ask in reply, where were the victims of that treachery. In a sense he had outflanked the Laibon too successfully. Ironically, had it been the English captain who had been left as a corpse at Kaidparak Hill, he would have emerged from the affair entirely guiltless. Rather unfairly, his survival tended to confirm his own sharp practice. When the Commissioner's report on the affair was sent to the Colonial Office, several officials seized on this aspect.

> There was never such an unsuccessful ambuscade in the history of warfare. The men who are taken in the ambuscade escape without a scratch, while the 50 or more ambuscaders lose 23 killed. These facts appear to testify stronger than any evidence that treachery was not intended by the Laibon.[30]

After Meinertzhagen had forced Mayes to withdraw from the third enquiry the military personnel presiding again upheld the verdict of the previous two. He now felt his position had been vindicated. Mayes was subsequently moved to a small station on the coast, while of the two officers who had made accusations against him – Captain Cuffe and Lieutenant Wilson – the first had resigned and the second had made a written apology. However, there were still forces operating behind the scenes which tended to work against him and culminated in his own dismissal.

The rivalry between the civil and military authorities that often seemed to dog colonial administrations, while it guaranteed Meinertzhagen the support of his brother officers, had the opposition effect on the civilians. Hayes Sadler, the man who had replaced Sir Donald Stewart as Commissioner, felt that there had been a strong bias against Mayes in the enquiries – a view upheld in the Colonial Office.[31] Mayes had received excellent reports for his work as a political officer during the Nandi Expeditions,[32] and although, in view of past misdemeanours, the civil authorities did not wish to retain his services, they had no intention of punishing him for bringing accusations against Meinertzhagen. When he was actually moved it was not, as the latter thought, for his part in the trials, but because of larger considerations about the type of personnel the Protectorate wished to employ.[33] Similarly, Cuffe, who, according to Meinertzhagen, had been dismissed for his part in the affair, had actually insisted on resignation himself, and Manning, the Inspector General of the King's African Rifles, had accepted it only with great reluctance.[34] Meinertzhagen gained the impression that Manning, like all his other superiors, had seen his side of the events. But the Inspector General privately recorded a less favourable

verdict. In his report to the Colonial Office he wrote that 'the reputation for fair dealing and honesty of the British government had been called into question'.[35]

Bogged down in a myriad of other duties, the higher-ranking officials, like Hayes Sadler and Manning, rather than analysing the minutiae of the case, took an Olympian view of things. Surely three courts martial would not have been convened if the charges had been groundless? No smoke without fire seems to have been the premise for their verdict, while the Colonial Office simply followed the opinions of the men on the ground. It was unfortunate for the Laibon's executioner that as the incident was being aired in public there was a movement afoot in the Colonial Office to censure the high number of casualties and captured livestock involved in the last three punitive expeditions. Altogether some 2,426 natives had been killed, while confiscated livestock amounted to a staggering 93,546.[36] Furthermore, not only had the Nandi been soundly beaten, but they had been evicted from their traditional homeland and confined to a reserve in order to make way for white settlers. To soothe any remaining feelings of resentment and to re-establish the British reputation for fair play, it was a relatively simple and cheap gesture to remove the man who had killed their spiritual leader.

So, on 28 May 1906, after almost four years in East Africa, Meinertzhagen set sail for England, determined to put the incident at Kaidparak Hill firmly behind him.

1906–14
A Prelude to War

Before he left East Africa, Meinertzhagen had sought to discover the reason for his dismissal and an opportunity to answer any undisclosed accusations by the civil administration. Hayes Sadler, known in the colony as 'Flannelfoot' for his evasive and indecisive manner, reluctantly agreed to an interview, but true to his reputation gave little away. Rather than deflecting any curiosity, his silence simply provoked Meinertzhagen's greater determination to get to the bottom of the affair. Remarkably, it was only after fifty-four years, when his interest was still unabated, that he was allowed to see the Colonial Office documents relating to the incident;[1] but at the time, in an effort to secure more immediate satisfaction, he was keen to press his side of the story as widely as possible.

In England Daniel Meinertzhagen received letters from Colonel Harrison and the battalion commander, Gorges, defending his son's reputation and praising his abilities. At the War Office Richard asked for a chance to state his case before the Army Council, and was eventually granted an interview with the Secretary of State, Haldane. The latter, a friend of Meinertzhagen's uncle, Sidney Webb, was sympathetic to the young soldier. He explained that the War Office, like the officers in East Africa, had fully accepted his testimony, but owing to the strong views and actions of the Colonial Office, they could not openly support him without forcing a breach between the departments. However, a letter written to him by the secretary to the Army Council had toned down to a minimum the idea of his culpability, talking of 'nothing more than an error of judgement'. In private, Haldane praised Meinertzhagen's initiative, and told him that a note had been made in his record of service stating that as far as the War Office was concerned the whole business was at an end.[2]

Even before his dismissal Meinertzhagen had registered an intention to leave East Africa; the longer he stayed there, he realised, the more difficult it would be to slot back into his British regiment. Equally, the climate and solitude were beginning to get him down, but it was disappointing to finish on a bad note. More so, in view of the fact that the time spent in the Protectorate – curiously, always referred to by himself as being for five

years, although he was actually only there for a little over four – had been of immense importance. Seven years later he was to claim that it had been the basis of his career.

The ardour and bumptiousness of a young clown who had charged his company on elephantback, or had captured his commanding officer in manoeuvres and then refused to let him go, had largely disappeared. Owing to the raw state of the administration in East Africa Meinertzhagen had been pushed into positions of responsibility that he would never have enjoyed in England, or even in India. There had also been scope to experiment: he had tested different manoeuvres, different tactics. The Kaidparak Hill incident itself was in many ways the culmination of this experimentation – a trial of nerves under dangerous conditions – on which count the affair had been successful. He had also learnt the importance of good morale amongst his troops, the need for regular training and strict discipline. Above all, the real-life dangers that his time in Africa had constantly thrown up had answered the subaltern's prayer for action. Strangely, the effect was not as he had calculated: the aura of glamour which had previously surrounded his vision of warfare had worn away in the sweat and gore of actual fighting. On the eve of the First World War he would never share the attitude of so many of his colleagues, that ahead lay the most romantic adventure of their lives.

Africa had left Meinertzhagen a realist. He had no time for foolish displays of heroics, while chivalry and gentlemanly conduct were, in his eyes, often only an impediment to the real business of fighting. His experiences between 1914 and 1918 would stretch and develop his military talents to their fullest extent, but there would be no corresponding deepening or hardening of his attitude. From the outset he displayed the necessary resolve, total commitment, and cold professionalism that were the ingredients of victory, and which were qualities the British as a nation only seemed to acquire in the latter part of the war. To a large extent, this sense of preparedness was attributable to his time in East Africa. It had given him the necessary practical experiences; in the coming years he would reflect upon their significance.

In early January 1907, after six months' leave, he set sail for South Africa, his mother, his two brothers – Fritz and Louis – and his sister Mary, or Polly as she was always known, coming to see him off. It was the first time that his mother had ever accompanied him to his ship and he felt sad to leave her. Not that this period at home had differed very much from previous occasions. He still disliked Brockwood, while his imagined sense

of being unwanted by his family had resurfaced after a few weeks' contact. When his name was mentioned in dispatches in the *London Gazette* only his father had bothered to congratulate him; that the others had omitted to make a fuss of him was a source of great disappointment. Similarly, when he had been slightly injured during the second phase of the Nandi Expedition and his name had appeared in *The Times*, letters of concern came in from many of his relatives, except the one person he had most wished to hear from – his mother. This continued to rankle on his return, as did her criticism that at the wedding of his sister, Margie, to George Booth, Richard had looked 'dowdy'. At Christmas he was drawn into domestic squabbles, they argued about the Boer War, and when Georgina blamed him for snow on the carpet he threatened that in future he would not come home at all.[3]

Louis, nine years his junior, was now the family hope. He had studied at Oxford and then departed for an extended tour of Europe, Africa, and the Middle East, before joining his father's banking firm. In the past Richard had always played second fiddle to his elder brother, but any jealousy that he might have felt for Dan was tempered by the intimacy and respect between them. Louis, however, he had hardly seen for the last seven years, and his harsh judgement – that his brother was full of superficial knowledge – reflected this lack of contact. As his ship pulled away from the quay on its way to South Africa, and Richard waved farewell to Louis and the other members of his family, his feelings were confused: he was sad at parting from them once again, but relieved to be free of the painful emotions that entangled his family relationships.

After the constant activity of his time in the Protectorate, the three years in South Africa would be a relatively peaceful period of consolidation. In East Africa he had already decided to try for a place at the Staff College in Camberley, Surrey, and intended to pack into the intervening time as much experience of regimental soldiering as possible. In the event, it would be seven years before he finally gained entry, while his studies would be carried out, not in rural Surrey, but among the mountains of Baluchistan at Quetta.

Although Meinertzhagen had always laid down as a condition of his happiness a complete lack of ambition, he was not above planning his career, nor did he eschew promotion. What he objected to was the careerist's scramble for unmerited preferment achieved often through the machinations of highly placed contacts, or by currying favour with superiors. He was convinced that his seriousness, his commitment, and the steady glow of his talent would eventually win him recognition. His early

efforts to read and study in India had fortunately not been stinted by the vilification of his peers. On the contrary, they had intensified, particularly after the Boer War when the British high command, shaken by the realisation of army incompetence, had recognised the need for change. The Elgin Commission of 1903, established to investigate the preparation and conduct of the South African war, exposed the shortcomings of military training. However, it was a smaller committee of three, formed the following year and headed by Viscount Esher, that had swept in a succession of radical reforms. It was hardly difficult for Meinertzhagen to accommodate this new professionalism; in many ways it was the army that had changed to accommodate his outlook, rather than the other way around. In the fresh atmosphere he simply shone more brightly. His service reports were a succession of glowing tributes:

> I think this officer the best in his rank. He takes a great interest in all branches of his profession, reads much and with judgement and at the same time is very practical. His self-reliance is unusual and I think justified.

> An excellent officer. Great capacity for command and leadership and power of instructing. Exceptionally self-reliant. Tact, temper and judgement all good.

> Quite a first-class company commander.

> One of the best officers I have ever served with.[4]

Meinertzhagen took advantage of his posting to South Africa to tour and analyse the battlefields of the Boer War. At Colenso, where in 1899 the British had incurred heavy losses of both men and *matériel* while trying to lift a Boer blockade on the garrison at Ladysmith, Richard was shocked by British blunders. He felt that faulty reconnaissance and incomplete information had left the British commander, General Redvers Buller, ignorant of the enemy's exact positions. Even if he had known these data his plan was abominable, amounting to a frontal assault on a previously prepared and well-defended position. Meinertzhagen's conclusions on the engagement were as economical as the battle had been costly: 'Colenso was not merely a defeat. It was a dishonourable and shameful disaster'.[5] The principle lesson he drew from examining so many British mistakes was the need to come to a decision, even if it was not the best one, and to pursue it with commitment, rather than hesitating and drifting into confusion.

Almost a year into his period in South Africa he took examinations to

enable him to attain the rank of major, and passed comfortably; his mark –
1078 out of 1600. Even these tests came under his scrutiny: how could a
written paper be a measure of efficiency when it took no account of capacity
to command a company, let alone a battalion? Nor was there any way of
assessing the interior economy or discipline of a company. Meinertz-
hagen's own grasp of these elements of soldiering was extremely sure. He
had developed a reputation as something of a salvage expert, taking charge
of the weakest companies and knocking them back into shape. His
discipline was hard, his methods not always conventional. When two men
deserted with their rifles and ammunition he sought permission to sur-
round them with their own company and walked out himself to ask for their
surrender. In spite of threats to shoot him, Meinertzhagen continued until
they laid down their arms. His pleas to avoid an immediate court martial
and imprisonment were successful, and after administering a stern warning
he made one his groom, the other his personal horse-holder. Another
ring-leader of malcontents was given much the same treatment, Meinertz-
hagen softening him up with a private reprimand, and then making the
man his personal servant. In both cases, the challenge of responsibility in
his brand of tough leniency brought the best out of these trouble-makers.

His adaptation to life as an orthodox regimental officer was the measure
of Meinertzhagen's increasing maturity. He had shown himself capable of
working within a large, disciplined machine and functioning effectively;
but it had not simply been a temporary and strained effort to submit to a
discipline he could not otherwise bear. On the contrary, in his fluent
accommodation of the military framework he had excelled most of his
peers. Yet this alone was not the key to his ability. It was the interplay of his
own creative individualism and a willing submission to the discipline
inherent in effective teamwork that accounted for his successes. Occa-
sionally he could pull too far in one direction and individualism became
recklessness. The shooting of the Laibon – a one-man show devised and
executed with daring, but lacking the full sanction of higher authority –
was an earlier case in point. Normally, however, the two qualities were in a
steady equilibrium.

On his return to England in November 1909, Meinertzhagen became
involved in an exercise that would invite a fresh departure from his
regimental life, although at the time, in spite of its success and his obvious
flair for the work, he refused to take up the offer. During his leave, he had
decided to visit Waterloo and the Crimea with the intention of fleshing out
his readings of the great campaigns. Keen, while he was there, to take on

any small task that might be helpful to the War Office, he agreed to become involved in some spying work.

This was not an entirely new field to him: during the Nandi campaign there had been his network of native agents to keep tracks on the Laibon. Later still he had also been detailed to perform survey work along the road from British to German East Africa. On his return from the latter, having made a detailed reconnaissance of German military positions, and gleaned a mass of other data that would be valuable in the event of war, he had intercepted a native German soldier disguised as a porter. A letter that the soldier was carrying, from the German commanding officer who had earlier been Meinertzhagen's host, was secretly opened and then resealed without its courier knowing of the deception. The message was addressed to a German, Count Coudenove, who was posing as a prospective settler in British East Africa, but who was actually involved in intelligence-gathering like Meinertzhagen himself. Coudenove was urged to attempt to make contact with the latter and then if possible to steal the English officer's maps and papers. Forewarned of the plan, Meinertzhagen turned the tables on his opposite number and was able to get hold of the Count's documents, while burning down his entire camp, which he disguised as an accident.[6]

His mission to the Crimea was significantly more dangerous and complex than the work in East Africa, involving a survey of a recently completed harbour fortress in Sevastapol and taking soundings of the harbour itself. In addition, he was asked to contact a British agent in Odessa and to bring back the latter's intelligence reports. Before his departure Meinertzhagen made extensive preparations: in order to familiarise himself with naval ordnance, and to practise pacing out distances and then translating the information into accurate sketches, he visited naval installations at Dover and Portsmouth. At Dungeness he simulated the penetration of a guarded fortress by illegal night-time entry of coastal defences. It was difficult to commit all the necessary data to memory and he disguised measurements on picture postcards or on maps already crammed with innocent-looking details. On 12 February 1910 he set off on the Orient Express for Constantinople and arrived in Sevastapol ten days later.

The presence of a British officer in the Black Sea port, ostensibly to study Crimean battlefields, soon drew the attention of the Russian authorities. During his nightly visits to the fort, Meinertzhagen's room and luggage were searched for suspicious evidence, and on one occasion he was confronted by an armed agent when his pockets were full of highly

incriminating notes. As he had done with Count Coudenove, Meinertzhagen managed to remain a step ahead of his opponents. He uncovered the visits to his room by attaching fine thread to his cases that would snap when the latter were tampered with. The agent he bluffed into revealing his real identity and then to avoid possible detection he dropped the papers he was carrying into bushes as they walked along. All the important information he had gathered on the fort and harbour – some of it with the unwitting assistance of a Russian engineer at the fort, whom he had charmed with his talk of birds and flowers – he deposited with the British Consul in Sevastapol. The secret reports of the agent in Odessa were left with the British Embassy in Constantinople.

On his return to England, having achieved success, Meinertzhagen was commended for the high quality of his work and asked if he wished to make a similar visit to Heligoland where the Germans had important naval installations. But the offer was declined. Spying had proved an exhausting business; it demanded the coolest nerves and the quickest brain. He had enjoyed the excitement and test of cunning involved in a solo mission, but the need to deceive, even those who had extended the hand of genuine friendship like the Russian engineer, had enforced a degrading loss of standards. It was too shameful an occupation for him to wish to get involved. Besides, at that time he had other things on his mind.

In Odessa Richard had celebrated his thirty-second birthday. He was now the eldest son of the senior English branch of the family, yet of the five eldest Meinertzhagen children he was the only one still unmarried. Even during his period in East Africa his mother had expressed her desire to see him settled down in England with a family of his own. Not that she had particularly strong grounds for optimism: hitherto, his contact with the opposite sex had been fairly limited. His inability to establish easy relations with either his mother or his sisters had to a large extent shaped the pattern of his social development; while the change from all-male schools to a profession so overtly masculine had also tended to emphasise a natural leaning towards the company of his own sex. There had been occasional romance, but this was seldom and usually short-lived.

His close friendship with his cousin Rosie, the daughter of his mother's sister, Blanche, and Willie Cripps, a London surgeon, had edged towards romance during his months of leave in 1904. However, both had agreed that the closeness of their blood relations made it unwise for them to proceed further and they broke off. On his return journey to Africa the following spring he befriended an American family, the Joneses, and devel-

oped a close attachment to the daughter, Joyce. They became inseparable
for the duration of the voyage, the young girl – she was twelve – accom-
panying him on bird-collecting forays whenever they had a chance to put
ashore. In spite of her obvious youth, Meinertzhagen treated with some
seriousness her childish infatuation and avowal to marry him when she
grew up. He promised that if in six years' time she should still wish to do so,
he would stick by the bargain. They continued to correspond for a couple
of years, but with the passage of time her interest dwindled and at
Christmas 1906 he received a letter from New York saying that she thought
their earlier promise had been rather silly and that henceforth they should
just be friends. Meinertzhagen registered some disappointment at this
breach of contract and indicated that he had had every intention of keeping
to it. However, it seems more likely that this last assertion, given his
pervasive fear of being unloved and unwanted, was a momentary and
sentimental over-reaction to the feeling of being jilted.[7]

Even when taking into account the rigorous taboos surrounding sexu-
ality at the turn of the century, Meinertzhagen appears to have been
signally lacking in experience on the subject. Unlike so many of his peers he
had never taken advantage of his out-posting in either India or Africa to
satisfy his curiosity. On the contrary, his behaviour, it seems, had been
scrupulously correct, in spite of obvious temptations. Once, after shooting
a tiger in the Nilgiri Hills, he was plied with milk and honey by the local
people, the Todas, out of gratitude for slaying an animal that had been
killing their cattle. The Todas, a polygamous and, by Edwardian stan-
dards, a highly promiscuous tribe, had given instructions to the attractive
young girl bearing the gifts that she was to remain with the white man for
the evening and attend to him. After 'a short, sharp fight with animal
instinct', Meinertzhagen declined the offer,[8] as he did years later in Africa,
when confronted with similar gestures of hospitality. Not that he was
prudish; African nakedness, like tribal dancing, was to him a healthy
celebration of physicality. Similarly, in South Africa he had been fascin-
ated by the cave paintings of bushmen and had taken tracings of a large
number. When a woman from Cape Town working on a monograph of the
bushmen had suggested that explicit illustrations depicting scenes of coitus
should be obliterated, Meinertzhagen was outraged. 'Such a thing as
indecency is impossible among a people who continually go naked. And yet
the silly woman comes along and has the impertinence to wish to destroy
those interesting drawings because her mind reads indecency into them.'[9]

Possibly the closest he had come to real intimacy with a woman, prior to

his marriage, had occurred during a shooting trip to Nyasaland in 1908. By coincidence, Mary Bridson, the niece of the Governor, Sir Alfred Sharpe, had been on safari for kudu at the same time as Meinertzhagen. Meeting on the shores of Lake Nyasa, the two solitary hunters had decided to join camps for the evening and improvised an exotic and not unromantic dinner of champagne, curried prawns, and kudus' kidneys. Serendipity coupled with an obvious mutual attraction enticed the young people to draw out their encounter for longer than they had originally intended. When Mary fell ill and Richard was forced to administer to her in bed, he became acutely aware of what he felt was the impropriety of their situation, and the inevitable outcome should they remain together for much longer. A return to Government House in the capital, Zomba, and the restraining effects of civilisation helped to regularise their relationship, though the attraction persisted for some time after their parting.

In his subsequent evaluation of the affair, Meinertzhagen expressed shock that their initial courteous friendship had been replaced, in his words, 'by something much more serious'. 'It has taught me a great lesson. Young men and young women cannot remain friends if thrown together by themselves. I was a fool to think such a condition possible.'[10] That Meinertzhagen, at thirty years old, should have made such fundamental discoveries about the opposite sex and about his own sexuality reveals how remarkably innocent he had remained. In the next two years he struggled to overcome this and to evaluate, as marriage became an increasingly important and likely proposition, precisely what he sought from it and from a female partner. It was his particular misfortune that such a development should lag just behind actual events themselves. Only after he was unable to set things right did he realise the obvious incompatibility of himself and the woman he had finally chosen.

His wife-to-be, Armorel, was the daughter of a Hampshire neighbour, Hermann Le Roy Lewis, who was also a major in Meinertzhagen's old regiment, the Hampshire Yeomanry. Richard had clearly known the Major's daughter for some time before their engagement, but had never mentioned her in his diaries and probably had only a sketchy insight into her personality. None the less, two weeks after his return from Sevastapol on 27 March he asked her to marry him.

In Mary Bridson Meinertzhagen had recognised the qualities of a woman who would have probably better suited him as a partner.

She is unselfish and the first woman I have met who really understands men and does not act to them. She treats me as though she were one

herself and expects the same treatment, nothing more or less. She is
independent, will do things for herself and knows how to take her share
in work . . . Unlike most women she despises flattery, hates being
waited on or having her goods and chattels carried for her. She says what
she thinks and expectes men to do likewise. I think she is the best type of
woman I have ever met.[11]

Unfortunately, Armorel was very different to this type. In fact, all the
stereotyped feminine qualities that he felt Mary Bridson had eschewed,
Armorel seems to have revelled in. Not that she lacked character: the
picture created by Meinertzhagen's admittedly scanty diary references is of
a vital and strong-minded non-conformist, no respecter of authority or
convention, with a very modern attitude towards sexual morality compared
with her husband-to-be. Her background was similarly unconventional.
Meinertzhagen claimed that her grandmother – 'A queer old woman with a
strong American accent in her native French'[12] – had been a Parisian
prostitute kept by a Jew called Lewis. They had supposedly had two
illegitimate sons – Armorel's father and his brother, who, according to
Meinertzhagen, had later become a racing tout in Paris.

When he had departed for a twelve month period in Mauritius between
1910 and 1911, Meinertzhagen had expressed grave doubts about the
wisdom of his marriage to Armorel, an uncertainty which culminated in a
letter breaking off their engagement. He argued that they were temper-
amentally unsuited and that Armorel would be unable to adjust to the life of
a soldier's wife. Furthermore, he felt that their 'views on morals were so
divergent as to lead to a certain breach sooner or later'. The next few years
would prove the accuracy of these forebodings, and yet the man who had
only a few years previously stressed the importance of coming to a decision
and then sticking by it, allowed himself to be badgered into a withdrawal of
the letter. In the lead-up to his first marriage Meinertzhagen's actions and
decisions lost all their customary resolution – a state of emotional uncer-
tainty that seemed to arise out of an earlier family conflict.

While he had been in Mauritius he had received a barrage of criticism
from his brothers and sisters for having left England just as his father was
critically ill. Daniel's health had been failing rapidly during Meinertz-
hagen's leave and he had slipped into a coma about ten days before his son
was due to depart in May 1910. Richard had asked the doctors to give him
some indication of his father's condition so that he could gauge whether he
might remain with his family through the crisis and, if necessary, await the
funeral. Their uncertainty on this point, his mother's intolerance of

interference at Daniel's bedside, coupled with the fact that his father was unconscious, and therefore indifferent to the presence of his family, all prompted Richard to go. In the event, Daniel passed away less than three weeks later and Meinertzhagen received a stream of letters complaining bitterly that he should not have left at so critical a time. In spite of Richard's obvious resentment at these accusations, the family censure seems to have found its mark, and the diary entry, in which he attempted to justify his original decision to leave, is filled, not so much with righteous indignation, as a strenuous effort to repress feelings of guilt.[13]

When he later took steps to break with Armorel and then received another 'storm of telegrams and letters' all protesting at yet further injustice, he seems to have felt compelled to capitulate. Georgina, Louis, Bardie, and Margie, who were all closer in lifestyle, and probably outlook, to Armorel than Richard was, claimed that his fiancée displayed the qualities of a loving and devoted wife. However, this judgement took no account of the differences between Richard and themselves, nor of the corresponding difference in their respective expectations of a marriage partner. In many ways then, Armorel was his family's choice of a sister- and daughter-in-law, not Richard's idea of a wife; a situation which augured badly for the future.

With an almost Hardyesque sense of irony, Meinertzhagen claimed that the initial estrangement between him and his wife occurred on the evening of their wedding day. After a service on 28 September 1911 in West Meon, Hampshire, they had travelled to a hotel in Oxford. Here Armorel confessed that her husband's earlier doubts about their suitability had been well founded: she had no intentions of carrying out the promises she had made that morning; he had to be prepared for modern conditions when married to a modern woman. Furthermore, she claimed his ideas on morality were absurd and he could not expect too strict a code from her.[14] If Armorel's revelation had been intended to set the tone for a loose, free-loving liaison between the couple, she had hopelessly miscalculated her partner. Richard was completely stunned: from his point of view it was clear that the marriage was doomed from the start. After what seems to have been a bitterly unhappy honeymoon, they moved into a house in Chelsea, but their togetherness was largely a dumb-show rigged up for the benefit of the public. These formalities continued for the next six months until in March 1912, exactly two years after their engagement, they left for India where Richard rejoined his regiment.

It seems incredible that his diary, usually a safety valve and a repository

for his inner life, sheds very little light on the development of their relationship – an omission possibly calculated to block the experience from his mind. What few references there are only confirm the impression of grinding misery. After the honeymoon he had vowed that their marriage had not and could not be consummated, and that in the absence of true love such a thing would be immoral. It is difficult to know whether he subsequently relented and made an effort to sink their differences. Certainly, a reconciliation became impossible when, after only nine months in India, he received letters from acquaintances that provided evidence of Armorel's unfaithfulness. According to Meinertzhagen, she openly confessed to the crime and asked for other, earlier offences to be taken into account. Up until this time, Richard had hardly ever referred to Armorel by name, always talking of 'my wife'; after this date he never mentioned her again. He had promised not to divorce her unless she had expressly wished for it, but in effect the marriage was finished and Armorel returned to England some time – completely undocumented in the diary – in 1914.

Although Meinertzhagen appeared unable to ventilate his feelings on the failure of their marriage, he gave expression to a bitter resentment of women in general in his opposition to female suffrage. The possibility of votes for women had been raised in 1912 by Asquith's Liberal government, when they had appended clauses to a government bill offering them a limited franchise. At the last minute the clause was jettisoned in January 1913 as a result of technical parliamentary difficulties, but the wide interest engendered in the subject made it a high-profile issue. Masculine resistance was not an atypical response in the first quarter of the twentieth century: Winston Churchill, for example, a member of the Liberal Cabinet responsible for the bill, was himself unsympathetic to the idea. Even had Meinertzhagen's relationship with his wife been happy, his inherent conservatism would probably have determined his position. However, it must certainly have been the case that his deep, personal resentment of Armorel gave his pronouncements their peculiar colour. His arguments were framed in terms of 'fundamental differences between the sexes', or 'laws of nature' and 'fundamental laws of humanity', all of which female suffrage would shatter.[15] With the final evidence of her adultery his opposition took on a fresh intensity. When the Royal Geographical Society permitted female membership for the first time, he was horrified. His bizarre vision of suffragettes disrupting meetings with their 'hideous skrieks and hysterical interruptions' forced him to consider immediate resignation.[16]

As a further antidote to personal grief he threw himself wholly into his

army work. Even during his last period in England he had been studying for entry into Staff College, and although he ultimately failed to secure a position at Sandhurst he had gained first place in Quetta, and moved there in February 1913. This apparent second-best belied the real achievement involved in his result, since just before the examination he had been hit by a pellet in a shooting accident and was almost blinded in his right eye. Extremely painful treatment by a specialist at Amritsar had saved his sight, but it was now permanently impaired and strong sunlight or glare brought on intense headaches. The loss of his previously excellent vision had brought an end to his career as a big-game hunter, particularly for dangerous game, since he could no longer rely on accurate shooting. He now had to wear spectacles, and on occasion was forced to give up his work and retire to the soothing gloom of his private quarters.

None the less, Meinertzhagen's natural physical resilience, coupled with a determination to wring from his years at Quetta every drop of knowledge and experience, ensured that he maintained his usual heavy schedule. With Armorel's departure his life had slotted back into its customary, solitary routine. After the first year at college, satisfied that he had given his best, he strained after the idea of an intelligence-gathering mission to Mesopotamia. At first the military authorities refused to sanction a visit to a country that they claimed was in 'a state of war'. However, Meinertzhagen made a personal appeal to the Director of Military Operations, General Hamilton Gordon, and during the Christmas vacation of 1913 the decision was reversed.

1914 got off to a bad start. On New Year's Day, Meinertzhagen felt that the terrific storm that confined him to his quarters on the banks of the Tigris was a bad omen for the future. Their trip in Mesopotamia was bedevilled by bad weather, and in Baghdad heavy floodwaters caused the raft, which they had sailed down the great river, to smash in two. Earlier in the trip they had argued with the two Arabs hired as crew – a fracas that escalated into a violent clash with a riverside village, whose inhabitants had bombarded their raft with stones. Wherever they went trouble seemed to follow: at Abadan about 2,000 Persian coolies had rioted at one of the oil refineries; in the Persian Gulf violent storms had swept a crew member overboard; at Muscat the Arab who fired the signal gun was transfixed by the ramrod and blown out to sea. This run of bad luck Meinertzhagen attributed to his irreverent behaviour during a visit to the tomb of Jonah in Nineveh, where he had been overcome by a fit of giggles. Even after they had returned to Quetta things continued to go wrong. An attempt with a

friend to visit Afghanistan – only 100 km away from the Staff College –
ended in disaster when they lost one of their baggage camels carrying
valuable equipment. Since the trip was completely illegal and, if disco-
vered, would have resulted in the immediate loss of their commissions, the
two officers hid while hired Pathan tribesmen searched for the missing
animal. When this failed they were forced to return to British India and on
the way were attacked by Afghan horsemen in the dark.[17]

For all these dark portents, the events of the following summer took
Meinertzhagen – as they would the rest of the world – largely by surprise.
The Staff College had closed down for the summer vacation in June, and he
had retired to a hill resort called Ziarat, 75 km from Quetta, for a spot of
ornithology. It was some time before news filtered through to his retreat
that in Bosnia, a small province somewhere in the Austro-Hungarian
Empire, the Archduke Franz-Ferdinand and his wife, the Duchess of
Hohenburg, had been assassinated as they toured the streets of the region's
capital, Sarajevo. To a tired officer enjoying his favourite pastime after a
summer of hard study, it was difficult to grasp the full relevance of an
incident that took place more than 10,000 km away. From his camp, at an
altitude of 3,000 metres, he could look out to the east and see way below in
the distance the sweltering haze of the Indus Valley, and beyond that the
Thar Desert of Rajputana, and the dry plains where his military career had
first started. The remoteness was confusing. It was like a man, who should
happen to glance down at his morning paper and read, as he travelled along
Oxford Street to his office in Holborn, of some minor disturbances in a
village in the Nepalese Himalayas, and then have to force himself to believe
that these details of unimaginable remoteness would bring to a sudden
close the grey domesticity of his clerk's life, and replace it with the blood
and thunder of the battlefield.

Meinertzhagen, however, had been trained to sift political situations for
their military significance; as news percolated through of each fresh
development his mind gradually brought into focus the enormity of its
implications. His judgements oscillated wildly: at times he wanted 'to tell
Germany straight out that in the event of any big European conflagration
we shall be against them hammer and tongs, tooth and nail, to the last man,
to the last penny'; and at others, he was overcome by a sense of despair. At
such a distance it was not easy to comprehend each claim and counter-claim
that shuttled between the chancelleries of Europe; in the end he cut
through the tangle of remote complexities with a single, simple, and
accurate intuition. This was 'THE WAR'.[18]

1914–16
The East African Campaign

To those officers sitting in the mess at Quetta Staff College it was clear that in the coming conflict the major theatre of action would be in Europe against the Germans; and most of them, Meinertzhagen included, hoped to be in the thick of things. However, if a boat journey to France was the thirty-six-year-old officer's immediate intentions, it was certainly not his destiny: almost four years would elapse before he ultimately saw the Western Front. It is interesting that it was his experiences in the East African Protectorate of almost a decade ago that determined his first wartime posting. A small contingent of the Indian Army had been assigned to combat enemy forces in German East Africa and Meinertzhagen, owing to his knowledge of the country, had been attached to it as intelligence officer.

African conditions demanded more than just a knowledge of the military textbook. Its landscape of arid, thorn bush country and seasonal swamps rendered the use of heavy artillery or supply systems based on motorised vehicles almost impossible; while the severity of the climate made any campaign involving white-skinned combatants a doubly taxing affair. Equally, natural dangers such as disease and wild animals were a more subtle and pervasive opponent, and did more to swell the casualty lists than any single human enemy. In these conditions it was the modern, unorthodox, and relatively unexplored aspects of warfare – guerrilla tactics and bush-craft – that were at a premium; and it was Meinertzhagen's gift for innovation that permitted him to shine.

Although his career, in later years, came to be most closely identified with Allenby's campaign against the Turks, and his military abilities given their widest audience in the deserts of the Holy Land, it was in East Africa where he did most of his fighting. It was also there that his successful intelligence techniques were first employed and perfected. In Palestine Meinertzhagen was only one of a host of stars in orbit around their sun and source of light – Edmund Allenby. For the first eighteen months of the East African campaign, however, he was a lone beacon amongst the British staff officers. Anyone wishing to understand the failure of Allied tactics during

that period would do well to examine Meinertzhagen's personal account of events, later published in his *Army Diary*. Here, the sharp, peculiarly metallic quality of his mind sheared through to the bones of British incompetence and mediocrity.

In Bombay on 16 October 1914, as he set off for Mombasa with Expeditionary Force B, to which he had been attached, Meinertzhagen cast an initial critical eye over the troops, and was singularly unimpressed.

> They constitute the worst in India and I tremble to think what may happen if we meet with serious opposition. I have seen many of the men and they do not impress me at all . . . Two battalions have no machine guns and the senior officers are nearer to fossils than to active, energetic leaders of men.[1]

B Force, a collection of British and Indian regiments, scraped together after the best had been shipped off to Europe, betrayed the home government's perception that in the coming struggle the East African theatre would be only a side show. Of the ten battalions, three Indian units were made up of non-martial races, while two had not seen active service for more than a generation. Only three regiments – the 2nd Loyal Lancs, the 101st Bombay Grenadiers, and the 2nd Kashmir Rifles – could be relied upon in the event of serious fighting. The commanding officer, Major-General Arthur Aitken, a bluff, over-confident veteran of the India Army, predicted that he would mop up German East Africa before Christmas: a boast that betrayed an ignorance of African conditions, and which brushed aside Meinertzhagen's warning that in the German native askaris the British would encounter a formidable opponent.

Owing to the haste with which the men had been assembled, and the consequent absence of familiarity between the officers and troops, Force B lacked the necessary *ésprit de corps* for a fighting army. And what little morale it had enjoyed in India was shaken by the cramped conditions on board the transports, and the tedium of a crossing the pace of which was dictated by the speed of the slowest boat – about nine knots per hour. By the time of their arrival off East Africa, two weeks later, the men were nervous and seasick. However, Aitken, disregarding their weariness, decided to press ahead immediately with an invasion of German territory. After a conference in Mombasa on 31 October, it was agreed that their target should be Tanga, a port about 150 km north of Dar-es-Salaam. With its natural deep-water harbours, Tanga was the second most important coastal city: a vital centre of communications with the country's northern

interior, and a major trading port. Aitken hoped that once he had captured it, he could push up the Usambara railway line that linked the port to the highland territory surrounding Kilimanjaro. Once this vital border area had fallen under his control, the safety of British East Africa would be guaranteed.

On paper, this seemed to be a simple exercise: the British forces were vastly superior in numbers, while the planned assault would have all the benefits of a surprise attack. The Governor of German East Africa, Dr Heinrich Schnee, a gifted and, by the standards of his day, enlightened administrator, hoped to avoid his colony being dragged into the European conflict. To this end he attempted to invoke a series of neutrality clauses of the 1885 Congo Act, which stated that, in the event of war, the Europeans in Africa would refrain from hostile acts. Furthermore, he had made an unofficial pact with the British naval authorities in East Africa that had guaranteed the safety of Dar-es-Salaam and Tanga from bombardment, so long as neither port was used for military or naval purposes. In conformity with it, at the time of Aitken's planned assault, the latter port was policed by only a token German guard.

It seemed to most people in Force B, therefore, that the problems involved in occupying Tanga would be minor and largely logistical rather than of a military nature. Yet, within a week of their arrival off the German coast, Force B had sailed away from Tanga for Mombasa, and had disembarked at the British port. A tenth of the entire army, 800 men, had been left behind in the mangrove swamps and thorn bush country that encircled the German harbour, as prisoners-of-war or as unburied corpses. The British government, hitherto largely uninterested in the African campaign, now suppressed news of the débâcle for several months, not wishing to impose on an already depressed public further bad news. But it was difficult to disguise the facts of Tanga, which according to one historian was 'one of the most notable failures in British military history'.[2] How had so simple a landing exercise – as it should have been – gone so completely wrong?

Initial complications had arisen out of the unofficial truce between the Civil Governor, Schnee, and the British navy. Captain Caulfield, the commander of HMS *Fox*, the cruiser accompanying the strike force, insisted that prior to the landing he would have to warn the Germans of British intentions. Aitken and Meinertzhagen disagreed. Since the Admiralty had neither been informed of, nor sanctioned, the truce, both men wished to repudiate it and thereby capitalise on the element of surprise.

Meinertzhagen further warned that if the Germans had advance knowledge of the assault they could quickly reinforce the port from a garrison at Moshi, only 300 km away along the Usambara railway. However, at the decisive moment Aitken seems to have allowed his judgement to be swayed by a naval officer far his junior in rank. And on the morning of 2 November, while the transports grouped 23 km off the German coastline, sufficiently distant to be invisible from land, Caulfield steamed into Tanga to ask for its surrender.

Caulfield, whom Meinertzhagen had earlier rubbished as 'nervous, yet pompous, shifty-eyed and not at all inclined to help',[3] now showed as little resolution as the army commander had done earlier. His ultimatum to Tanga's District Commissioner, that he would bombard the port at 9.30 a.m. if it was not handed over, had by midday wilted into inaction and finally a retreat to Aitken's ship for further instructions. The threat of naval action had done little other than warn the Germans of an impending attack and give them sufficient time to dispatch telegrams to Moshi for help, much as Meinertzhagen had predicted. However, if Caulfield had returned to the transports in the hope of finding steadier nerves than his own, he was sorely disappointed: Aitken now dithered hopelessly. Instead of sailing straight into the harbour and sweeping aside what little opposition there might have been, he decided on a night-time landing in the mangroves 2 km from the town itself, advancing as his reasons Caulfield's dubious claim that the harbour would be unsafe until swept for mines.

The disembarkation of troops, completely unrehearsed and involving only a fraction of the entire force, proceeded with fresh incompetence. What little determination there might have been in Aitken's orders to capture Tanga that evening fizzled into nothing amongst the blank confusion that reigned on the beachhead. There had been no prior reconnaissance or advance guard, and it was as much as the troops could achieve in one evening to fight their way through the tangle of mangroves and collapse onto dry land. Between them, Aitken and Caulfield had by now given the Germans twenty-four hours to prepare their defence, and had compromised their chances of success.

Not that they anticipated failure: even at this stage, although the element of surprise had been squandered, the British position was still very strong. On paper, they enjoyed massive superiority of both artillery and men; and if the Germans had interior lines of supply, the British had overwhelming naval support. A considered plan of action pushed ahead with resolution should have been sufficient to carry any opposition before them and sweep

the British into Tanga in a matter of hours. Unfortunately, both planning and resolution were absent. Owing to his underestimation of black troops, a refusal to credit Meinertzhagen's intelligence reports, and tragically inadequate reconnaissance, Aitken believed for much of the battle that he had a relatively simple task on his hands with more than adequate resources to achieve it. It was characteristic of this miscalculation that throughout, his proposed measures lagged just behind the Germans' preparations to meet them.

On the morning of 3 November, instead of ordering a general disembarkation and a full-scale attack, he pushed ahead with only those men who had gone ashore the night before – two battalions of exhausted Indians with no previous experience of Africa, or of an efficient well-armed enemy. The resulting fight bore out many of Meinertzhagen's earlier misgivings. In the face of a defending force, numbering only 220 men (which the British commanding officer, Brigadier-General Tighe, later inflated to 2,500) and four machine guns, the Indian advance halted and collapsed. Tried by the events of the last three weeks and bewildered by a sleepless night in entirely alien surroundings, both battalions – the 13th Rajputs and the 61st Pioneers – disintegrated into a retreating rabble. Officers anxious to stem the withdrawal rushed into the enemy firing line, an act of futile heroism whose only significant effect was to extinguish their own lives. Towards evening, his forces having sustained more than 300 casualties, a good proportion of them amongst the higher ranks, Tighe gave the signal to retreat. Aitken himself now came ashore and took over personal command, planning his major offensive for the following day. As usual, however, his measures were too little too late.

The collapse of morale amongst the Rajputs and Pioneers after their day's fighting spread rapidly to the other Indian troops who had landed. Even before many had reached the shore, stray shots from German scouts had been sufficient to cow them. During the evening the rattle of a kettle or the unintentional discharge of a rifle by one of their own men was enough to send whole companies bolting for the shore in panic. By the following morning and the day of the big battle they were in no condition to face the ferocious machine-gun fire of the defending Germans and their retreat was instantaneous. Many threw away their rifles or fired deliberately into the backs of their own troops, while the chaotic withdrawal of the front line often simply bowled over the reserves and carried them along backwards in the confusion. Their loss of will to fight sent Meinertzhagen into paroxysms of rage. Those unfortunate enough to have their retreat blocked

by his towering presence were cursed and kicked back into the fight; those who showed resistance to his orders were brutally shot where they lay. To him their cowardice was inexcusable, although he claimed his anger was directed less towards the men than towards Simla 'for enlisting such scum and placing them in the King's uniform'.[4] Presumably, he had never stopped to consider that these Indians, many of them from isolated villages in the Himalayas or quasi-independent princely states, were a subject race without any stake in the fighting, for whom the First World War – a remote squabble between European colonial powers, largely antipathetic to their own political and cultural aspirations – could hardly have been less relevant than if it had been fought by rival armies of ants. Although the Indians had lacked grit at the decisive moment, they could hardly be blamed entirely for the defeat at Tanga. Ultimately, it was Aitken and his staff who had failed.

They had been so dismally slow in mounting a major assault that the skilful German commander, Colonel von Lettow Vorbeck, had had sufficient time to rush cracks units of askaris down the railway line from Moshi. By the time of his big push on 4 November, Aitken faced a fresh, confident force of over 1,000 men. Although he had numerical superiority, he had still not brought ashore valuable artillery and explosives, while the fire of the field guns he did use was not properly co-ordinated with the advance of the infantry, and had minimal impact.[5] The huge guns of HMS *Fox*, which could have been employed with devastating effect at point-blank range, were similarly neglected until too late. His failure to reconnoitre the territory through which the men had to advance, and the immediate withdrawal of a sector of his troops, drew his battle line sharply to the British right, leaving his left flank insufficiently extended. In the heat of the battle, it was not his own force that outflanked and enveloped the enemy line, as indeed his numerical superiority should have allowed him to do, but the reverse. The British left became badly exposed to a German counter-attack, which mowed down almost an entire battalion of the 101st Grenadiers.

Shaken by the constant stream of panicky troops rushing out of the firing line, Aitken himself moved towards the front in an effort to stiffen British morale. However, in doing so he lost touch with the overall course of the battle and was unable to influence matters at a critical moment. The sight of so many wounded or dead British troops had the added effect of weakening his own resolve. Towards evening, when the fighting had largely fizzled out, the German bugles suddenly sounded, and fire halted. Amongst the

jumpy British staff a rumour flashed round that the Germans had ordered the charge. To Meinertzhagen, however, who knew the enemy bugle calls from his months living in Bremen, it was clear that they had actually called the retreat. He attempted to tell Aitken this, but the General ignored him. With almost comical irony, he ordered his troops to regroup at their position of the previous evening on the beach, just as the Germans themselves, owing to a bugler's error, had abandoned Tanga and left it wide open to the British army. Meinertzhagen slipped forward to discover what had happened and on finding the town deserted claimed to have begged Aitken to seize his opportunity. But the latter was finished.[6]

The official history of the campaign, published twenty-six years after the events at Tanga, suggested that Aitken was 'the victim not so much of positive error as of a combination of adverse circumstances and conditions, originated outside his control, which it had been beyond his power to bend to a successful conclusion'.[7] At the time, however, Meinertzhagen took a less dispassionate view of affairs. In 1942 he disclosed that he, Major-General Sheppard, and Dobbs – the Quartermaster General, believing Aitken no longer fit to command, had pressed him to go sick and allow Tighe to take over. When the General refused to entertain the idea, the rebellious trio decided on the flick of a coin who should assassinate him if he attempted to surrender.[8] The plot, if it did actually take place – and there seems little reason to doubt Meinertzhagen's testimony (although his portrait of Sheppard as a murderous rebel does not fully square with the contemporary diary entry of the following day, when the latter was clearly behind Aitken's order to abandon all equipment and re-embark) – indicates the depth of dissatisfaction with his leadership. Fortunately for Aitken, and also for Meinertzhagen, the Germans never pushed the advantage they had achieved on 4 November, and never tested the British chief's resolve to continue the fight. The mistaken German bugle call to retreat had initiated a general withdrawal to some distance west of the town, and it was only at dawn the following day that Lettow Vorbeck had fully grasped the situation and ordered his men back into their lines.

By this time Aitken had already initiated a general re-embarkation – a decision that Meinertzhagen seems to have been completely unaware of until much later in the day. After a breakfast of warm water and rum drunk out of a bucket, he had been sent into Tanga under a white flag with medical supplies for the British casualties. There, he was courteously entertained by a German staff officer, who treated him to a hearty breakfast where the two supposed enemies discussed the previous day's fighting 'as

though it had been a football match'. To Meinertzhagen it seemed almost dreamlike that he should be eating, talking and laughing as friends with men he had attempted to kill the previous day. It was only as he returned to British lines and a sniper's bullet pierced his helmet that the grimmer reality of warfare reasserted itself in his mind. Meinertzhagen charged the native askari with his flag of truce, rammed the stake into his stomach and, wrenching the man's own rifle out of his hands, killed him with the bayonet. 'I was furious with him and any pacifism which I had gained in the German hospital was at once transformed into deadly hatred for the Germans.'[9]

On his return he was staggered to hear news of the withdrawal, although even he recognised that the thoroughly demoralised rabble scrambling into the transports could hardly have withstood another German attack, let alone mounted a second assault on Tanga. What he could never counten- ance was Aitken's order to abandon all equipment – a decision which left an already hard-pressed German army in possession of more than half a million rounds of ammunition, a stack of machine guns,[10] and other valuable stores. That no attempt was made even to destroy these was to Meinertzhagen highly negligent, and he took it upon himself not to circulate an order forbidding regiments to make efforts to save their machine guns. When he went ashore to hand over some of the British equipment to a German officer – 'a revolting business' – he was equally disgusted to find a large number of British troops bathing in the shallows. Even Dobbs, the QMG, was calmly wandering amongst the abandoned stores taking an inventory.

When the whole force finally set sail for Mombasa on 6 November he registered a sense of shame at the whole Tanga fiasco: 'Here we are now . . . a beaten and broken force. My confidence in the leadership and personnel of the force is badly shaken, and I am now suffering bad headaches from being blown into a palm tree by HMS Fox.'[11]

Meinertzhagen was not the only one to experience a loss of faith in British fighting abilities, nor was Indian Expeditionary Force B the only one to suffer a setback. A detachment of IEF C, some 1,500 men, had assaulted a force of only 600 Germans just north-west of Kilimanjaro at a spot called Longido. Here an equal lack of luck or success, just short of outright defeat, attended the enterprise. Timed for 3 November, the attack was too late to prevent Lettow Vorbeck's first major dispatch of troops from Moshi to stiffen his defences at Tanga; on the other hand, it was too early to take advantage of the general German withdrawal, which left the

area around Kilimanjaro virtually unmanned. Although Longido was not strictly a defeat, and although it was overshadowed by the reverse in Tanga, the fact that British forces had not met with success on any front established an atmosphere of pessimism which it took more than a year to dispel.

The next few weeks after Tanga were absorbed by reorganisation. Towards the end of November overall control for the campaign passed from the India Office to the War Office, a change that delighted Meinertzhagen. Aitken's departure also brought a sigh of relief, although in his obituary notice for his ex-chief's career he was more generous than he had previously been. 'We are all sorry for the old man who has done his best,' he wrote. 'Simla is really to blame for giving him all the riff-raff of the Indian Army.'[12] Before he left, Aitken himself complained to India about the quality of his troops, and, in an attempt to justify his own failure, inflated the size of the German army to 9,000 askaris and 5,000 armed and trained Europeans. On the basis of his own intelligence, Meinertzhagen divided the first by three, and the second by ten; none the less, there was general agreement about their high quality, and the fact that the British were in no position to mount a second offensive. Both Indian Expeditionary Forces were now amalgamated and redistributed on defensive lines under two commands, one based on Nairobi, the other on Mombasa.

The new commander, Brigadier-General Wapshare, or Wappy, as he was known throughout Kenya, was, according to Meinertzhagen, 'a kindly old gentleman, nervous, physically unfit and devoid of military knowledge',[13] who inspired him with hardly more confidence than his predecessor had done. He was certainly no match for Colonel von Lettow Vorbeck: the very mention of the latter's name was apparently sufficient to send him into 'shivering fits of apprehension'. It was as much as this rather Blimp-like character could achieve to keep his own military administration from squabbling with that of Sir Henry Belfield, the colony's civilian governor. Throughout the difficult period of 1915 the two organisations were on extremely poor terms. Belfield resented the war as a disruption of East African affairs and said so publicly; equally, many civilians took offence at the army's arrogant intrusion on the social life of the colony. On the other hand, the high command considered the civil administration apathetic towards the war effort. They were disgusted, for example, that one of Belfield's secretariat was allowed to write with impunity a poem lampooning the military failure at Tanga.

Even amongst the higher-ranking British officers themselves there was

very little general accord. For Meinertzhagen, his diary acted as a mental punch bag on which he worked off frustration engendered by British indecisiveness. He felt that Wapshare lacked the necessary drive and military experience to establish effective authority over his subordinates. Each brigade commander felt that his particular district was the most vulnerable to German attack and refused to yield any men for the formation of a general reserve and mobile strike force. In consequence, the troops evenly distributed throughout a border area more than 800 km long were broken up into 'numerous weak detachments' that could 'be beaten in detail wherever the Hun liked to attack'. At Jasin, south of Mombasa, in January 1915, Lettow Vorbeck took up such an opportunity, launching an assault on a recently captured British outpost. The Indian troops fought bravely for several days, but were eventually overcome and forced to surrender. Ironically, the strongly worded criticisms from Lord Kitchener forbidding Wapshare to embark on further offensive actions and accusing him of being 'too venturesome' were received by the timid commander with apparent pride. Meinertzhagen, however, recognised their underlying significance: within two months Wapshare had received another telegram ordering him to transfer to Mesopotamia in April 1915.

His replacement, Major-General Michael Tighe, a leathery old tough nut with a reputation as a 'thruster', was felt to be a definite improvement. Meinertzhagen had earlier claimed that if Tighe had led at Tanga the outcome might have been very different. Now he hoped that his appointment as the new commander would raise the morale and efficiency of the East African forces. The border patrols, made up of the same Indian troops who had performed so badly at Tanga, were particularly vulnerable. After long months of inaction and isolation, discipline had virtually disintegrated, and on a number of occasions detachments had been caught entirely by surprise and overrun. In order to prevent the Germans disrupting the Uganda railway line each bridge now enjoyed a guard, but these were hardly a source of confidence. As Meinertzhagen travelled around the border territory in the course of his intelligence work he observed their lack of precautions and sloppy behaviour with contempt.

> The Germans would have no difficulty in blowing up any bridge they wished to. I have pointed this out . . . but all that happens is to strengthen the posts with men, a useless step only giving the Germans more rifles and ammunition for themselves. They can take the men with my blessing for they are mere rubbish.[14]

One post claiming to have been assaulted by a superior German force had actually been stampeded by a female rhinoceros and her calf; and of 200 rounds of ammunition expended on the animals, not one had hit them.[15] Another bridge guard had been rushed and caught unarmed in broad daylight. The Germans had removed their weapons, blown up the bridge, and retired without even bothering to take any prisoners. It was later revealed that barbed wire with which the guard had been issued had been dumped in long grass without being uncoiled, while the 'undergrowth was still standing within spitting distance of the bridge'.[16]

The intelligence officer gave such 'rotten soldiering and gutless soldiers' short shrift. He advocated that Tighe court-martial their officer and make an example of him; but the latter demurred, arguing that on that basis he would have to arraign half the officers of the Indian Army. Meinertz-hagen's effort to maintain what he believed were high standards of professionalism was often a lonely business. Even amongst the staff officers he found few natural allies. Just as Aitken had ignored his intelligence reports at Tanga, so the other commanders refused to credit his data during the defensive operations of 1915.

Yet his intelligence corps was possibly the most effective branch of the British force. With the help of the Liwali, a Muslim leader in Mombasa, he recruited hundreds of Swahili agents, whose dark skin and greater immun-ity to the region's malaria permitted them to move freely on both sides of the border. In the interior he used a small number of white hunters, largely Boers, to penetrate the bush country around Kilimanjaro. The information these first-class agents brought back to British territory was deposited with European agents, who acted as a postal service relaying the data to headquarters in Nairobi. The precise details of the whole system – dubbed DPM by its architect – remained a closely guarded secret; even forty-five years later Meinertzhagen refused to disclose any information, except the fact that he had continued to employ it for the rest of his career in intelligence, which lasted until he was well into his seventies. Charles Miller, in *The Battle for the Bundu*, suggested that DPM stood for 'dirty paper method'[17] – a reference to the British practice of searching military latrines in German East Africa. In the absence of a suitable alternatives, many officers used official papers and private letters for more pressing needs, and Meinertzhagen found these a constant source of 'filthy though accurate information'. However, it is clear from what little the latter revealed on the subject that Miller's definition is far too narrow, and that latrine-searching was only an element in a much larger organisation.

Whatever its precise workings, DPM gave Meinertzhagen an up-to-date picture of the enemy's military intentions, and conditions inside the German colony. Within six months of its employment he claimed to have acquired the signature and occupation of almost every enemy official – data that enabled British officers to identify the author of any paper that fell into their hands.[18] He also swept British territory of German agents, who had previously moved unmolested even in Nairobi and Mombasa. One ruse to eliminate a particularly efficient Arab was to send him a letter thanking him for the supply of data (actually gathered from other sources), and rewarding him with 1,500 rupees. The letter, delivered through an incompetent agent, fell intentionally into German hands, and the Arab, damned by the false evidence, was tried, convicted, and executed. Meinertzhagen was momentarily troubled about the morality of his ploy: 'If means justify the end then I am right. If one is justified in doing anything, fair or unfair, to save lives and property and help win the war, then I am right again. But what about the moral aspect? Is everything fair in love and war?'[19]

Other tactics he used were equally effective. He flooded the German African economy with thousands of counterfeit twenty-rupee notes in order to discredit the colony's currency. On another occasion, a strategic waterhole close to the Uganda Railway was regularly strewn with the freshly shot carcasses of birds and animals, while a sign was placed over it announcing that the pool was poisoned. This simple ruse, which kept a 130-km stretch of the line secure from attack, met with angry German complaints concerning British usage of poison, but Meinertzhagen ignored them. Everything was reduced to a simple and severe logic. Did it aid the war effort? Did it hinder it? Meinertzhagen preferred to sacrifice sentiment rather than efficiency. He favoured harsh, military discipline for those officers who failed to ensure the security of British outposts, just as he censured loose talk in mess. The editor of the *Leader*, a Nairobi newspaper that published an article suggesting he was a German agent, could have expected little mercy.

> I sent for Davis . . . and asked him to explain. He was fat, pale-faced and quivering as he stood on the mat in front of my desk. I railed at him and asked him why he was not fighting. Physically unfit? Too much to drink? . . . I had Tighe's authority to place the wretch under arrest which was carried into effect in my office and he goes before a court martial tomorrow for bringing His Majesty's Forces into contempt and his rag is indefinitely suspended.[20]

In his private war with incompetence Meinertzhagen's biggest battles were with men far higher in rank than himself. Admiral King Hall, the commander of the HMS *Hyacinth*, had omitted to inform the high command in Nairobi that he had sunk a supply ship bound for German East Africa with much fuel and *matériel* on board. And it was only weeks later that Meinertzhagen came to discover through his agents that millions of rounds of ammunition, six field guns, and eight machine guns had been salvaged from the supposedly wrecked vessel. Furious at naval failure to ensure the ship was definitely destroyed, he requested permission to go to Mombasa to discuss the issue with the naval commander. It was an explosive meeting. King Hall, 'a small peppery individual full of importance was clearly on his dignity and bubbling with indignation over something'[21] – largely the forceful tone and insinuations of negligence in Meinertzhagen's report. They argued bitterly about the lack of co-operation between the army and the navy, the amount of equipment salvaged from the storeship, whether the Germans had mines in East Africa, and the need and rôle of secrecy in their respective intelligence departments. King Hall was flustered by his encounter with the arrogant young intelligence officer, 'and no doubt wished to God [he] were one of his own officers whom he could place under immediate arrest'. But Meinertzhagen seems to have cared little about his insubordination, and 'stripped of his smart uniform [he] could see a quite mediocre, stupid, vain little brain devoid of humour and lacking intelligence and initiative'.[22]

He had a marvellous line in insults; of one officer he wrote: 'Jollie is a decrepit old woman without the courage of a hedgehog or the energy of a guineapig, and in saying that I am libelling two charming little creatures.'[23] But his favourite insults were reserved for the *bête noire* of his East African campaign – Brigadier-General Wilfrid Malleson, whose dark, dapper, moustachioed appearance gave a faintly onomatopoeic ring to his name. The Inspector General of Communications, an ordnance officer from India with little experience of commanding troops or fighting, fell out with Meinertzhagen only three weeks after Tanga and their relationship deteriorated from then onwards. For Meinertzhagen, Malleson personified all that was incompetent in the British East African high command: 'A bad man, as clever as a monkey . . . by far the cleverest man out here . . . from a class which would wreck the Empire to advance himself.'[24]

Although Tighe's elevation to overall commander was a matter for some celebration, Meinertzhagen was despondent that the reshuffle had given Malleson control in the Mombasa region. A prediction shortly after this

that within six months the Brigadier-General would have proved himself a dismal failure, and that within a year he would be sent home, proved accurate on both counts. An attack under Malleson's direction on a German border garrison was repulsed with the loss of 170 men; while, only a few weeks later, a crucial outpost under his command at Kasigao guarding a section of the Uganda Railway was overrun by the enemy. According to Meinertzhagen, he was loathed by his subordinate officers as an overbearing and ill-mannered bully: in the Mombasa mess they openly discussed ways in which they could shoot him. As the intensity of the conflict between the two wore on, Meinertzhagen searched lower and lower down the evolutionary scale for names most appropriate to his favourite enemy. He wished him captured by the Germans, or eaten by lions; he was a 'jackal', a 'cur', a 'snake', a man 'more poisonous and treacherous than a viper'.

Partially owing to the loss of Kasigao, British fortunes in East Africa had, by September 1915, reached their nadir. The stores salvaged from the vessel Admiral King Hall had failed to destroy, coupled with *matériel* brought in by another blockade-runner, served to equip native troops freshly raised in a recruitment campaign. It was estimated that the forces in German East Africa numbered 20,000, a figure well in excess of the healthy and reliable troops under British command. Moreover, the loss of Kasigao in August 1915 had left the Germans in a position to threaten and eventually establish themselves on the Uganda Railway, thereby severing the principal communications in British East Africa. And if the Germans never actually carried this into effect, their raids against the line became increasingly more daring and destructive.

All this created an atmosphere of despondency at the Nairobi head-quarters. Even after a successful British strike on Bukoba, a German installation on the western shore of Lake Victoria, no effort was made to follow it up. And Tighe, unable to withstand the strains of his position, had taken refuge in drink, which, together with his worsening gout, left him an increasingly ludicrous and isolated figure. During a boat journey on Lake Victoria, supposedly for the sake of his health, not even the combined remonstrances of Meinertzhagen, the ship's captain, and its chief engineer could convince him that the boat was not going backwards. Nor could they reassure him that what he took to be a ship's fire was only the kitchen odours as the crew's supper was being prepared. 'Poor Tighe, a most delightful man, great charm, a good soldier, as straight as a die and drinking himself to death in the middle of the greatest war in history.

Sad.'[25] For Meinertzhagen, his commander's incipient delirium tremens could have only one outcome – his imminent replacement.

Fortunately, as local conditions deteriorated the home government's capacity to respond to the needs of East Africa improved. Under General Botha, South African forces had recently conquered the German protectorate of South West Africa, freeing almost 20,000 troops for deployment in more pressing theatres. It was eventually decided that many of these should be diverted to East Africa in order to check German advances, and to launch a major fresh offensive. The man elected to command the new army was General Sir Horace Smith-Dorrien, who had earlier led the Second British Army at Ypres. His plan, an enlargement of the disastrous IEF strategy, involved a pincer movement, one arm driving down through the Kilimanjaro region, and another making a surprise landing at Dar-es-Salaam. Lord Kitchener had strongly opposed this, arguing that it was a serious drain of resources from the more critical conflict in Europe; but he was overruled, and Smith-Dorrien set sail for Africa on Christmas Eve 1915. However, during the course of his journey the British general fell ill with pneumonia, and was forced to resign his appointment in Cape Town.

A few days later, a Boer, a man who had previously fought against the British during the South African war, was nominated as a surprise replacement. Jan Christian Smuts, in 1916 the Defence Minister for the Union government, was, as Herbert Asquith confided to Meinertzhagen several years later, a political appointment, a man to rally South African opinion behind the British cause.[26] Although he was not strictly a soldier he was of exceptional military ability, combining tremendous physical courage and energy with a gift for subtle and innovative strategy. His presence in East Africa, and the strengthening of British forces to more than 27,000 men, 71 field guns, and 123 machine guns had an immediate impact on the colony's morale. The Boers, fresh from victory in South-West Africa, and with an ingrained contempt of 'kaffir' troops, anticipated a speedy resolution to the coming campaign – an inflated optimism that Smuts shared, and which Meinertzhagen was anxious to prick.

> Smuts is as keen as mustard, but underrates the fighting qualities of the German native soldiers. I warned him that in bush he would find them as good as his South Africans. I told him bluntly that before he leaves this country he will have a great respect for what he now terms 'damned Kaffirs'.[27]

The intelligence chief's own appreciation of their worth dated from the time of his visit to German African territory in 1906, and this had only deepened during the eighteen months of the campaign. For Lettow Vorbeck, their commander, he felt nothing but admiration.

It is perhaps curious that Meinertzhagen, so entirely committed to his nation's cause, should have felt such sympathy for the German commander. Yet there was something in the latter's professionalism and single-minded dedication that was attractive, and which possibly left Meinertzhagen with the feeling that he had more in common with Lettow Vorbeck than with any of the previous British generals. Apparently, the German commander fully reciprocated Meinertzhagen's respect, and claimed that the only person he truly feared on the other side was the British head of intelligence.[28] Their 'first social contact', as he put it wryly in his autobiography, had been at Tanga on the main day of battle on 4 November, when the two men had shot at each other on the outskirts of the town. It was fortunate that neither should have found his target on that occasion, since they became close friends in later years. In fact, shortly after the Second World War, Meinertzhagen had kept his old adversary supplied with food parcels at a time when Lettow Vorbeck's fortunes were at their lowest.

This closeness of outlook and methods between them seems to have allowed Meinertzhagen a sharper insight into his opponent's intentions than most others in British East Africa. On 13 November 1914, only a week after Tanga, he felt that they should show 'a determination to regard this colony as a detachment from the main theatre of war – Europe – and not ask for a gun beyond what is vital for the defence of the colony . . . Von Lettow is not going to fight it out. He will flit from pillar to post and occupy as many troops as he can.'[29] Remarkably, this was more or less the core of Lettow Vorbeck's strategy. Sealed off from Europe and reinforcements by a British naval blockade, the German commander, realising that victory was impossible, made his principal objective to present as large a threat as he could to the British in East Africa, and so draw their resources away from the more pressing conflict in France. In March 1916 the enormous build-up of British troops in the highlands around Kilimanjaro presented him with a nice conundrum; for while it was confirmation of the efficacy of his policy, at the same time it was evidence of imminent invasion.

Given Meinertzhagen's hypercritical response to his superiors, it was hardly surprising that he was quick to identify problems in his new chief's tactics. The Boer commander was wary of the political repercussions of

high casualty figures – 'he could not afford to go back to South Africa with the nickname "Butcher Smuts"' – and sought to manoeuvre the Germans out of their position, rather than to beat them in a stand-up fight. His strategy, which omitted the seaborne invasion involved in Smith-Dorrien's plan, centred on a southward thrust through the central highlands, where he hoped to capture Lettow Vorbeck in a sweeping encirclement. One division of his forces would pin the main German force down on the eastern slopes of Kilimanjaro, while another, cutting around the western side, would catch the enemy in the rear at Moshi and severe their line of retreat. Meinertzhagen felt that: 'A decisive action in the . . . region might finish the campaign, but a series of manoeuvres will only drag the operations on for years. Von Lettow is concentrated here and ready for a fight, but of course he is not going to risk a decisive action against vastly superior numbers.'[30]

In the event, this judgement proved largely correct. Yet for all his percipience, he had no more convincing alternative to put in the place of Smuts' plan. In December 1916, on the eve of his departure for Europe, he stated that had Smith-Dorrien taken over command, as had been intended, the British general would have concluded the campaign in its first phase at or near Kilimanjaro, by forcing the Germans into a major battle.[31] But in saying this, he seems to have failed to take account not only of Lettow Vorbeck's success in avoiding such a showdown, but also of the important points on which he himself had lectured so many others. The German native troops' greater familiarity and adaptation to the terrain, their resistance to the climate, the difficulty of effecting swift flanking movements through dense bush, and the country's greater suitability to defensive rather than offensive operations, would almost certainly have confounded Smith-Dorrien as it did Smuts.

The Boer commander's big push, launched on 5 March, rumbled southwards to recapture Taveta in less than a week, but ensnared little but abandoned buildings. The flanking movement under Brigadier-General Stewart had been so completely snagged in the 110 km of bush through which it had to move that it arrived four days later than intended. Strictly speaking, since success had hinged on Stewart's rapid concentration in the German rear, and since Lettow Vorbeck's army had slipped away in good order with only minor losses, Smuts' plan had failed to secure its objective. Yet it had not been without achievement. The Boer commander's invincible zeal played a major part in restoring British morale. The novelist, Francis Brett Young, a combatant in the East African campaign, claimed

that his 'personality, remote, unsympathetic, cold, well-nigh inhuman as it seemed . . . impressed itself upon the whole force as an incarnation of the will to conquer'.[32] Moreover, the real fears Meinertzhagen had voiced only six months earlier concerning the Germans' capacity to threaten British territory, now seemed a remote bad dream; while the invasion and conquest of German East Africa appeared an inexorable certainty.

Smuts had thrust the Germans back from two strongholds in the hills, and had then immediately pushed forward again, this time throwing out a South African mounted brigade under General van Deventer as a flanking force to block the enemy's retreat. It was almost as if having failed with this ploy the first time, he intended to use it again and again until he met with success to demonstrate that his judgement had been correct all along. But at Kahe, as at Moshi, it proved not to be so. Smuts had inched deeper into German East Africa and now held the Usambara Railway, but he had conquered nothing but territory. For Meinertzhagen, however, it had forced some welcome decisions. Intent on weeding duds from his staff, Smuts sacked Stewart for the lamentable slowness of his advance on Moshi, while Malleson, who, in the eyes of the intelligence officer, had plumbed fresh depths of cowardice by retiring from the battle line with 'suspected' dysentery, was summarily dismissed by his chief. Tighe too, inebriate and worn out, had to go, but a KCMG ensured that the old warrior was not tarred with the same brush as the other rejects.

As if to demonstrate the standards he required, Smuts pushed on, ahead even of his own scouts, to survey the territory for his next strike. Meinertzhagen pointed out to his chief the 'danger of meeting an enemy patrol and the ignominy of having our C. in C. captured or scuppered'; but the general simply brushed it aside. The advance into German East Africa now halted at Kahe to regroup. Theoretically, it should have remained there for the rainy season, but Smuts' determination to finish the campaign that year drove him to greater and greater efforts. His strategy was an enlargement of his old encirclement manoeuvre: the second division under van Deventer, almost 10,000 men, would force its way south-west to a town called Kondoa Irangi, from where it could take the Central Railway, the colony's principal artery of communication. In tandem with this, Smuts would crash down onto the Central Railway at a point 250 km west of the capital, Dar-es-Salaam. Between the two British divisions, Smuts hoped to trap Lettow Vorbeck at the midway town of Morogoro. However, his strategy, as always, was based on the erroneous assumption that the German commander's intentions were the defence of German territory.

A fortnight later, at phenomenal cost in both transport animals and men (of the 10,000 troops that set off on the 160 km march only 3,000 arrived on their own two feet), van Deventer arrived at Kondoa Irangi, where Meinertzhagen joined him soon after. As Smuts' restlessness intensified, his demands on his staff became exorbitant. Meinertzhagen stayed sufficiently long to participate in the defence of the town, at which Lettow Vorbeck suffered one of his most significant defeats of the year, before returning to British headquarters in Moshi. In spite of Smuts' reluctance to credit his information, Meinertzhagen told his chief that the Germans were no longer in force just south of his position at Kahe, but had withdrawn towards the Central Railway. Two days later Smuts launched his hammer blow.

Ironically, as the British forces became increasingly exhausted and depleted by sickness, the pace of conquest seemed to quicken. In ten days they had driven southwards for 160 km. New towns fell daily to the British army. By the third week of June they were halfway to Dar-es-Salaam. By 7 July Tanga was at last in British hands. The rapidity with which the battle now moved, and the extended front on which it was fought, involved Meinertzhagen's spy network in an enormous task. In order to keep all units fully informed of the latest development he had expanded his intelligence corps to 2,500 scouts, seven British officers, and hundreds of agents.[33] DPM was now at full stretch, although Meinertzhagen claimed that the proximity of the enemy lines meant that he was often in receipt of enemy orders before the German officers themselves. To maintain control of the whole operation, Meinertzhagen worked from early morning until sunset, and often late into the night. When GHQ transferred to Tanga, he also assumed responsibility for policing the town, and then shortly after that, when the capital itself fell, he was given control of Dar-es-Salaam. This excess of work now threatened to overwhelm him, and by October 1916 he was exhausted. 'Sleep left me and my liking for food disappeared. I found my mind wandering and brooding over plans of a lunatic. I consulted Freddy Guest[34] and the doctors. They . . . wired off to Smuts saying that if I did not have immediate rest I should break up altogether.'[35]

In a state of complete agitation he raved at the South African forces in German East Africa. They were frightened of casualties and unreliable fighters. Smuts too came under the same warped scrutiny. He lacked the grit of any ordinary British general to finish the campaign; he got mixed up in the local situation too readily. As for van Deventer and the other South African generals, they were incompetent gasbags, their official reports

were mere flatulence.[36] As if to confirm that these were the rantings of a mind unbalanced by exhaustion, his medical examination found him seriously unfit for further duties, and on 10 November he received orders to return home. Yet even in his madness Meinertzhagen seems to have grasped the essentials of the situation in East Africa. Lettow Vorbeck was still the leader of an undefeated force, which would not succumb to starvation or disease; nor would the capture of the entire German colony secure his surrender. Smuts' tactics of manoeuvre were not the solution: for every soldier he saved on the battlefield, he lost another in the hospital to the climate or to sickness. The real war was not against the Germans, but against Africa.[37] Examination of a map might have revealed vast areas of conquered territory, but Lettow Vorbeck, if not the victor, had achieved most of what he had set out to. Before the conclusion of the campaign, several days after the Armistice in Europe, more than 150,000 troops and millions of pounds of equipment had been drawn into the East African sideshow.

Thirteen years later, almost to the day of Meinertzhagen's departure for England, he and Lettow Vorbeck walked together in London to lay a wreath at the foot of a cenotaph, in memory of their heroic campaign and the thousands killed in it. Later the same day, at a reunion of veterans, the German general thanked Meinertzhagen for the medals and papers that the latter had captured during his last weeks in East Africa and kept until that evening, when he had returned them to their rightful owner.

> To me it is an act of chivalry and generosity, which I cannot sufficiently acknowledge. It is acts like these that make one think that my people should have killed a million of your people and that your people should have killed a million of my people between 1914–18 all seems so purposeless, so stupid, and so cruel.[38]

In 1916, for both men, the period of purposeless, stupid cruelty had two years to run.

1917
The Palestine Campaign

The year 1917 began badly for Meinertzhagen. The cold winter that had swept Asquith's Liberal government from office and replaced it with a Conservative-Liberal coalition under the Welsh premier, David Lloyd George, found Meinertzhagen at the War Office – an experience he loathed. It was 'most bewildering and not unlike a rabbit warren. Its inmates are a most depressing lot and it is rare to see anything approaching a smile . . . I can already see it is no place for me.'[1]

Georgina, his mother, had been dead for over two years now. The news had been relayed to him on the eve of the assault on Tanga, in October 1914, but Africa and the war had allowed him to stave off any real adjustment to the fact. However, on his return to England in December 1916 he encountered the full, cold significance of her absence. She had been the emotional centre around which the Meinertzhagen children had revolved, and her death had robbed them of that unity. Without a home of his own, Meinertzhagen lodged temporarily at Cheyne Walk in London with his father's brother, Uncle Ernie and the latter's wife, Gwavas. He saw little of his brothers and sisters, and whenever they did meet it could hardly have run less smoothly. During an April trip to Lulworth in Dorsetshire, they bickered endlessly.

> The whole time . . . my sisters have given me a constant flow of arguments and discussions, and ideas which have literally staggered me. I find myself not only completely out of touch and sympathy with them, but bitterly opposed to them in vital principles, and revolted at their ideas. It makes me feel more than ever adrift from my family.[2]

His homecoming had also reawakened the pain of his failed relationship with Armorel, for which, it seems, his family gave him little support. Although he had not seen her for three years, they were still married, and he provided her with an allowance of £500, about a third of his salary.[3] The four conditions that Meinertzhagen had defined seventeen years earlier as the basis for happiness – free exercise in the open air, an object of unceasing pursuit, a complete lack of ambition, and the love of a good woman – had in

his present life crumbled to two. And to cap it all, for the first time he had started to feel his thirty-nine years: 'I have at last turned the corner, passing from youth to middle age, for I succumbed to a hot water bottle last night owing to the severity of the weather. It was so pleasant that it is doubtful whether I am able to give it up in future.'[4] News of a foreign appointment as GSO2 Intelligence in the Egyptian Expeditionary Force brought some recompense, but since France was his ultimate objective even this was mildly disappointing.

In the past his departure from England had so often been an occasion for deep emotional conflict; May 1917 proved no exception. In fact, his sense of grief and the corresponding feeling of relief were more intense than he had ever known previously. For over two years the concerns of fighting a war had blocked family problems from his mind; more, the camaraderie he enjoyed with his fellow officers had become a kind of family substitute. It was profoundly disillusioning to realise that relations with his own flesh and blood had hardly changed since he had last seen them over five years before, and even earlier, since childhood. The unpleasant truth was that he actually felt happier without them than with them, and this seems to have precipitated a profound reaction – in Meinertzhagen's own words, 'a revolution'.

> On Sunday last the climax of my mental subservience to outside opinion and my family's feelings, to conventionalities, to unhappiness, and disappointment was reached and I raised the standard of revolt against them all. Henceforth my mind is free . . . One after another ever since I can recollect failure and disappointment have wrecked happiness. The more energetically I have sought it the more violently have I been disillusioned, till my hunger for Love, for Freedom and even for Friendship has become stale . . . For the future I shall go my own way, disregarding conventionalities, with hardened morals, ignoring failure and thwarting disappointment, following my own inclinations, regarding the world as one huge play thing made for my amusement, doing good to others when and where I am able but refusing outside effort to make me happy, encouraging companionship but avoiding friendship and ignoring the advice and, if necessary, the existence of my family.[5]

The journey to Egypt gave Meinertzhagen little opportunity for melancholic reflection. On 3 May he embarked at Marseilles on the transport *Transylvania*, along with 3,400 troops all bound for the Middle East. The following day, the boat was torpedoed and sunk by a German submarine

close to the Italian coast. As the ship foundered Meinertzhagen refused to enter an overcrowded lifeboat; instead, he put on a life-jacket, helped himself to two bottles of brandy and walked off the sloping deck into the water, where he was picked up by Japanese sailors four and a half hours later. More than 200 men lost their lives that day, and Meinertzhagen, who was kicked heavily in the stomach by one of the fifty horses floundering off the wreck, put his own survival down to the litre of alcohol he had consumed. In his diary, he presented the whole incident in a mock-dramatic, almost humorous, fashion.[6] But, clearly, it had been a close shave; over forty years later he considered the event sufficiently important to include it in the auto-obituary he wrote for *The Times*.[7]

Shortly after his arrival in Cairo, Meinertzhagen heard that the man he had come to serve, Sir Archibald Murray, was to be replaced by the commander of the Third Army in France – General Edmund Allenby. The campaign in the Sinai, like that in East Africa, had hitherto been considered only a sideshow to the war in Europe. And if the allied tactics had not been marked by the same inefficiency that Meinertzhagen had met with in Africa, they were decidedly without lustre. Theoretically, the Turkish army should have been little match for any of the principal European combatants in the war; yet, for almost two years the British had fought a defensive campaign on the borders of their own territory, on the Suez Canal. Finally, however, in 1916 the balance had tipped in their favour: they had soundly defeated the Turks at Romani and pushed them back across the Sinai desert to a defensive line based on the coastal town of Gaza and an oasis called Beersheba. Here, the battle had once again ground to a standstill.

General Murray had proved himself a thorough, methodical, but unenterprising leader in Egypt. His major contribution had been to consolidate the British position in the waterless territory they had newly acquired, by the construction of roads, railways, and supply lines between his base in Egypt and the battlefront. Allenby himself acknowledged that it was his predecessor's foresight and imagination to bring 'the waters of the Nile to the borders of Palestine that formed the cornerstone of [his own] successes'.[8] Yet in battle Murray had not shown the necessary drive to finish the campaign. Twice in the winter and spring of 1917 he had attempted to penetrate the Turks' defensive position at Gaza, and on both occasions he had been repulsed. On the first attempt the operation was, in Lloyd George's words, 'badly fumbled',[9] and the troops withdrawn at the very moment when victory had seemed within their grasp. It was clear to

the War Cabinet in London that in order to unlock the situation a more vigorous commander was needed.

The Prime Minister's man was Smuts, who had freshly returned from East Africa having exhausted one army in the cat and mouse game with Lettow Vorbeck. Much to Meinertzhagen's relief, Smuts declined to wear the crusader's colours, and the second choice was Allenby. At first, the latter had felt the appointment a step downwards from his position in France. In the early years of the war he had disapproved of diversionary measures in the east – as at Gallipoli, Mesopotamia, and in Palestine.[10] But the Welsh premier, who had insisted on an interview with his new commander, attempted to instil in him the sense of importance that he attached to the eastern campaign.

Lloyd George, sickened by the stale tactics and carnage on the Western Front, was the strongest advocate of 'knocking away the props' – a policy of striking the Central Powers where they were weakest – in the Balkans and in Turkey. Having eliminated Germany's principal supporters, he believed the Allies could tighten their grip in Europe and so squeeze the major enemy into submission. It was an imaginative strategy that had already met with considerable success. The appointment of General Stanley Maude in Mesopotamia, and the transfer of overall control of the campaign from the India Office to the War Office, had given Baghdad to the British in March 1917. In June of the previous year the Sherif of Mecca, after protracted negotiations, had initiated a general Arab uprising against his Turkish overlords in the Hejaz region of Arabia. Under the guidance of a young British intelligence officer called T. E. Lawrence, the Arabs had secured first Wejh and then Aqaba, strategic ports on Arabia's western coastline. These conquests were of double significance, eliminating for good the possible threat of German submarines in the Red Sea, and also protecting the right flank of the Egyptian Expeditionary Force from counter-attack. The Arabs then launched an effective guerrilla campaign against the Hejaz Railway – the lifeline for the Turkish garrison now pinned down in Medina. This additional offensive forced the Turks to defend the ailing Ottoman Empire on three fronts, an exhausting affair that drained off their slim military resources.

Allenby's rôle in this eastern plan was crucial. Of the four principal cities of Islam – Mecca, Medina, Jerusalem, and Baghdad – half were in Allied hands. Lloyd George now wished to offer a third as a Christmas present to the British public – Jerusalem. At their meeting before Allenby's departure, the Prime Minister indicated that the commander would have con-

siderable freedom in the conduct of the campaign. Moreover, every effort would be made to supply him with the men and resources he required to finish the job.

In 1917 General Sir Edmund Allenby was a tall, powerfully-built fifty-five year old, with a strong jutting chin and a reputation for drive and high casualty figures. For many years he had enjoyed the nickname 'The Bull'. With subordinates he was brusque, even rude; he was a stickler for protocol and had a sharp eye for detail. The absence of creases in a uniform, or a split infinitive in a military report, were grounds for aggressive reprimand. Whenever the commander went out on personal inspection of his forces in Palestine a simple two-letter message – 'B.L.' – was passed out to all units: 'Bull Loose'.[11] On his first day in command he made it clear that he was not going to be another desk general: a pile of routine papers brought into his office were thrown to the floor and left for the attention of a junior staff officer. Although he lent heavily on subordinates he seldom interfered in their work, except to ensure that it was completed. From France he had brought a number of trusted men, like Major-General Louis Bols, his Chief of Staff, and Lord Dalmeny, his personal secretary and later his ADC.

Meinertzhagen's first impressions of his new chief filled him with confidence:

> My word he is a different man to Murray . . . Allenby has made huge demands on the War Office for divisions, guns and aeroplanes and hopes to be in Jerusalem by Xmas. He looks the sort of man whose hopes rapidly crystalise into a determination which is bound to carry all before it. What is most satisfactory is that he means to become active at once and bring new life back into this inert Army. The Egyptian Expeditionary Force is already awakening from its lethargic sleep under Murray.[12]

Within a week of arrival Allenby had made a personal visit to the front line. He discontinued Murray's policy of maintaining GHQ in Cairo and pushed it up to within 30 km of Gaza, where the increased contact and shared hardships of field life bonded the troops to their commander. Only a week after his initial inspection he had devised his assault on the Turkish position and had reported back to Whitehall with an outline of his proposals and his fresh requirements – substantial supplies of artillery and two new divisions – requests that the home government tried their hardest to meet.

Allenby's plan for the coming campaign was based largely on an

appreciation drawn up just prior to his arrival by two of his subordinates – General Sir Philip Chetwode, a pre-war friend and colleague, and the latter's Chief of Staff, Brigadier-General Guy Dawnay. In many ways a third direct assault on the Turkish position at Gaza was considered the most logical course to follow. It was the enemy's strongest position, and involved the shortest line of attack, while any British advance would enjoy continuous naval co-operation. Equally, British supply lines were most effectively established in the coastal area before Gaza itself. However, in balance with these advantages was the fact that the Turkish garrison at Gaza was now strongly entrenched, having developed an elaborate, inter-connecting trench system encircled by numerous screens of barbed wire. Penetration of a position as carefully prepared as anything on the Western Front would be extremely slow work and achieved at high cost. To dislodge the Turks from one defensive line and then to find them repositioned perhaps only 20 km further north would have achieved very little, except to lengthen and so complicate British supply lines, and to shorten those of their opponent. Success depended, therefore, on rolling the Palestine front back, at least as far as Jerusalem, in one continuous lightning manoeuvre.

The new commander's intentions were to push the Turks off-balance at the outset and allow them no opportunity for recovery. Rather than making Gaza his first objective he would assault Beersheba, the Turk's vulnerable left flank – an arid, waterless area where they would least expect a strike – and then trap the principal Turkish force, at Gaza, by an encircling movement, or, at minimum, manouevre it out of position. This plan too, however, was not without complications, for in the area west and south of Beersheba the British had no substantial communications network, and all supplies they needed would have to be taken with them. This demanded immense preparation and taking a considerable risk. It was crucial to the enterprise, for instance, that the Beersheba wells were captured intact, otherwise, in the absence of water, a further thrust at the Turks would be impossible. Perhaps more than anybody else, Meinertzhagen was responsible for ensuring that when Allenby delivered his double punch, at Beersheba and then Gaza, the Turks were entirely wrong-footed.

Throughout the summer of 1917 the head of field intelligence had worked hard to establish an effective spy network, based once again on his DPM system. Some thirty agents, largely Jews and Arabs, had been recruited to penetrate the Turkish lines, while a wireless receiving station had been established on the Great Pyramid in Egypt to intercept enemy messages. The ruse he had used in East Africa to eliminate a successful

Arab agent was employed again to foil a spy operating from Beersheba. Meinertzhagen sent his opponent a letter of thanks for information and a substantial payment in Turkish currency – a communication that fell intentionally into enemy hands, and which led to the Arab's execution.[13] In order to tighten security in the British sector, he turned to his advantage a persistent rumour that circulated among the forward troops concerning a supposedly mythical German agent called Franks, who passed through the British line disguised as an Australian. By circulating a false description of Franks and false information about his activities, Meinertzhagen succeeded in raising standards of vigilance – in fact, so much so that on one occasion he himself was arrested.

Yet the Franks episode did not have the denouement that Meinertzhagen had expected: in fact, it appears to have involved him in a struggle that dragged on for seven years and which, on occasion, threatened his life. During a visit to a prisoner-of-war camp in Alexandria he was approached by a supposed Greek deserter, who told him that Franks was not only a real figure, but that he, the prisoner, had previously worked with him. Convinced by his story and offer of assistance, Meinertzhagen agreed to let the Greek go in order for him to set up a meeting at which Franks might be arrested. At this rendezvous, in a dry wadi just south of Gaza, it seems the Greek and an accomplice attempted to kill Meinertzhagen while his back was turned. Entirely surprised by this treachery, the latter was, none the less, able to fire on the two as they sped off on horseback, and succeeded in hitting the Greek's companion. To his complete amazement, on inspecting the body he found that he had shot a woman. Months later when the British had captured Jaffa, Meinertzhagen made a search of Franks' house and discovered photographs which revealed that the Greek prisoner was himself the legendary agent, and worse, that the woman he had shot had been Franks' wife.[14]

The unintentional but tragic consequences of their meeting seem to have sparked off in Franks a desire for revenge that resurfaced two years later. In Meinertzhagen's diary there is a note, inserted when he was chief political officer in Palestine, dated 14 September 1919.[15]

In 1919 when in Paris I received a letter from Franks written from Munich. He was abusive and reminded me I had shot his wife, a woman whom he still loved. He also threatened to shoot me should he ever get the opportunity. To this outburst I paid little attention and of course did not reply.

On September 12, 1919 I recognised Franks in Aleppo in broad daylight and recollecting his letter I took precautions. On returning to the station that evening in order to sleep in my railway carriage, I saw a figure near the carriage (the station was otherwise deserted at that late hour) and recognising Franks figure drew my pistol, shouted to him to hold up his hands in German, and as he bolted I fired. His left arm was slouching from the shoulder so I presumed I hit him.

I at once returned to report the matter to Bell[16] but so far he has been unable to trace the man.[17]

Within the context of Meinertzhagen's life dramatic incidents of this nature almost cease to be exceptional. Over and above the routine dangers of warfare, he had often been involved in events where his life had been imperilled, such as in the conflict with the Laibon, escaping the *Transylvania*, even his spying in Sevastapol. What seems most notable about them is not that they happened, but that he could approach them with such insouciance. It was almost undoubtedly this sense of ordinariness he maintained in the tightest of corners that allowed him always to walk away from them. In October 1917, for example, during the course of one of his regular reconnaissance missions over the Turkish lines, he and his young pilot, Sandy Mackintosh, were pursued and shot upon by a German plane. This succeeded in hitting and wounding the British pilot, sending the plane into an uncontrollable nosedive. Had Meinertzhagen, with only a minimum of flying experience, not possessed a remarkable sang-froid the incident would certainly have been fatal.

Our fantastic aerobatics must have convinced the Hun that we were finished, for he swerved off and I soon got the plane straight and under control and then made off for home, where I dropped a message over the aerodrome, 'Sandy hit, how do I land?' There was at once tremendous activity below, people rushing about, fire engines running about and with me flying in circles at about 500 feet. Eventually they spelled out in strips of calico, 'Touch down here at 80'. I had never landed before but knew what I ought to do. I made a shockingly bumpy landing throwing me almost out of the plane and running right off the aerodrome into rough ground, at last fetching up against a small palm tree. We were at once surrounded by fire engines and ambulances. Sandy was taken out unconscious with a bad wound in the stomach. He was at once evacuated to Cairo by air and I was given a huge and very strong drink.[18]

Only four days after this he was back in the hot seat to put into effect the most celebrated piece of wartime trickery that his fertile imagination could conjure up. In the two-month period before Allenby's offensive he compiled a set of staff officer's papers, which he intended should be found by the Turks, and which would lead them to believe that the main British assault would be at Gaza with only a feint against Beersheba. Although two previous attempts had been made to plant the information, by a British and an Australian officer, neither effort had met with success: on the first they failed to locate the deliberately dropped haversack, and on the second the Turkish patrol refused to give chase. On 10 October Meinertzhagen rode out himself through the arid country to the north-west of Beersheba until he was spotted by a Turkish guard and pursued. After about a mile, when the enemy had almost given up, he dismounted and fired on them. Once they had resumed the chase Meinertzhagen loosened the haversack, his field glasses and waterbottle, and dropped a rifle previously smeared with horse's blood to give the impression that he had been wounded. When the Turks had approached closely enough he dropped his equipment, and having seen them stop to pick it up, made off at top speed for the British line.

The false documents had been meticulously assembled to give the impression of authenticity. A mock agenda for a conference and instructions from GHQ both confirmed that British intentions were to launch a major offensive at Gaza; while a false telegram authorised a reconnaissance by a chief staff officer in the area where the haversack was dropped. Another from the intelligence department suggested the impracticability of an assault on Beersheba. Two private letters were included – one from an imaginary staff officer criticising the Gaza offensive and suggesting that an attack on Beersheba would be a wiser course of action; another, purporting to come from the officer's wife, gave details of the birth of a son, Richard. Meinertzhagen's thoroughness with all these papers was remarkable. In order to ensure that in the last letter both the handwriting and the sentiments were authentically feminine, he had it composed and written by a woman – his sister Mary. Its deeply intimate nature, coupled with £20 in cash, were both calculated to deflect any suspicion that the bag had been lost intentionally. A page of notes on a cypher enabled the Turks to decode a number of dummy messages sent out regularly between 24 September and 31 October, all of which reaffirmed the colossal deception.[19]

On the British side, the whole affair was surrounded by the utmost secrecy – besides Allenby, only Dalmeny, Dawnay, and Bols knew the

truth. When Meinertzhagen reported the loss of the haversack to the Desert Mounted Corps he met with vigorous rebuke; a report was sent to Allenby complaining that the general should not employ 'such inexperienced young officers on reconnaissance'.[20] Allenby himself issued an order warning against any repetition of Meinertzhagen's carelessness, a copy of which was also lost to the Turks, wrapped around some sandwiches.[21] The initial Turkish response to all this absent-mindedness was much the same as that of their enemy: they too circulated a message to all units pointing out the folly of carrying important documents.[22] However, the NCO in charge of the patrol that had pursued the careless British staff officer was rewarded for the capture of valuable information. According to Meinertzhagen, when the haversack and its contents were relayed to the high command, the Turkish general staff were suspicious, while the German officer commanding on the Palestine front, General Kress von Kressenstein, inclined to accept their authenticity. This error proved decisive. Work on trenches on the Turkish left flank quickly decreased as that at Gaza intensified. An order later captured by the British read:

> I am instructed to inform you that the information contained in these documents is of such great value to us that we have been able to ascertain the date of the enemy's offensive and it will enable us to forestall him in that all our reinforcements will now be near Gaza in time for us to crush the arrogant English.[23]

Meinertzhagen's eight months in Palestine constituted an important turning point for him, proving to be both the climax and, in many ways, the end of his career as a regimental soldier. His official military life would continue for another seven years, but from 1918 onwards he was drawn increasingly away from the front line and seconded to administrative or political posts, largely involved with intelligence. It was in 1917 in the Middle East that he earned the reputation as 'one of the best and most colourful intelligence officers the British army has ever had'.[24] And it was the haversack incident, more than any other, that established such a reputation.

Not unexpectedly, this has been written about over and over again, often inaccurately, often in an exaggerated manner, but always with a high regard for its cleverness, and its simplicity.[25] Yet in the ruse he had done very little that was actually new: it was, after all, simply a modern variation on a strategy as old as the Trojan War. Moreover, he had used much the same technique to eliminate the spy in Beersheba, and earlier in East

Africa. Behind his sign announcing 'Poison' at the edge of a waterhole in the parched Kenyan bush, one can identify a similar intention – a desire to fool and misinform. Meinertzhagen's great originality lay in his ability to turn the conventional intelligence officer's task on its head. Instead of being a desk-bound recipient and collator of information about the other side – an aspect of intelligence at which he was also adept – Meinertzhagen deliberately went out in search of his opponents to provide them with data, albeit carefully doctored falsehoods. In his hands, intelligence became almost a weapon of attack, as crucial to the campaign as a superiority in artillery or cavalry.

Allenby himself was in no doubt about the importance of his chief of military intelligence: 'This officer has been largely responsible for my success in Palestine',[26] was his comment on Meinertzhagen's military report. Lloyd George too, in his *War Memoirs*, claimed that 'Meinertzhagen's device won the battle'.[27] To invest the ruse with sole responsibility for success is almost certainly to claim too much for it, and overlooks a number of important factors that gave victory to the British. Had the Turks not lost air superiority, for example, at the time of Allenby's arrival in Palestine, they would have been able to make full aerial reconnaissance of the British positions, identify a build-up of troops and equipment, and then ascertain their intentions. As it was, the greater fire power of the Air Force's Bristol fighters forced the Turks and Germans to fly so high that they did not fully appreciate the large movement of British forces towards Beersheba. Equally crucial was the massive superiority that Allenby enjoyed in almost every arm of his force, with twice as many infantry, eight times more cavalry, and three guns for every two on the Turkish side.[28] Furthermore, by the time of the offensive the Turkish troops were in poor shape. Living off meagre rations, many of them were racked by ill health and desertion was common. Their high command, meanwhile, was riven by disagreement. The German generals, intolerant of the apparent disorganisation of oriental military procedures, imposed on the Turkish forces a general staff composed almost entirely of Europeans – a situation that was hardly likely to engender smooth relations.[29] Like many conquerors, Allenby was also blessed with good fortune. A large body of Turkish reinforcements, the newly formed Seventh Army, had only just left Jerusalem at the time of the attack. Had it reached its destination on the Palestinian front only a few weeks earlier, the battle might well have had a very different outcome.

It would be equally wrong, however, to underestimate the significance of

Meinertzhagen's deception. The Turks and their German commanders had woven it so entirely into their forecasts for the coming campaign that their tactics were fatally flawed from the start. If Beersheba had been the hinge on which the Palestinian campaign had turned, then Meinertzhagen had ensured that when the gates guarding the Plain of Philistia were pushed in, they flew wide open all the way to Jerusalem. Beersheba fell on 1 November, less than twenty-four hours after the attack was launched, the Turks being completely surprised by the magnitude and direction of the British assault. Shortly after, having put into operation the undamaged wells in the oasis, the British resumed their drive at the Turkish left flank, co-ordinating it with a concerted attack on Gaza. For this stage of the campaign Meinertzhagen had retained one final ace.

Several weeks prior to the battle he had initiated daily flying missions over the Turkish lines to drop propaganda inserted in small packets of cigarettes. The Turks, short of all supplies, particularly tobacco, were only too happy to take advantage of their enemy's unexpected generosity. At this crucial stage in the battle Meinertzhagen distributed his largesse in the customary manner, having first laced each cigarette with grains of opium. Meinertzhagen claimed that enemy troops at both Gaza and Tel esh Sheria, an important stronghold at the centre of the Turkish front, were 'drowsy and fuddled' from the effects of the drug. Apparently, the whole operation had been dreamed up and executed by the chief of military intelligence without authority from Allenby, who had considered the plan, but deemed the insertion of opium too much like the use of poison. But Meinertzhagen went ahead regardless, convinced that 'anything which saved casualties to our men was justified'.[30]

After a week of fighting, the weight of the British offensive threatened to overwhelm the Turks and, fearful that they would be cut off on the coast around Gaza, they withdrew. By 7 November both Gaza and Tel esh Sheria had fallen. Pressed hard by Allenby's increasingly weary troops, the Turkish withdrawal became a general retreat, and despite counter-offensive measures, Jerusalem fell on 9 December, only forty days after the launch of the campaign.

News of Jerusalem's capture drew world-wide attention. At home every newspaper gave the story front-page coverage, while in London the bells of Westminster Cathedral were heard for the first time in three years. In Rome every church bell in the city rang out in passionate celebrations. General French, the previous commander of the British army in Europe, heralded Allenby's victory as the 'finest feat in the war',[31] and the British

Cabinet, in their telegram of congratulations, called it an 'event of historic and worldwide significance'.[32] In Palestine Allenby was received with almost religious fervour. An ancient legend foretold the liberation of the Holy City by a great seer, and by strange coincidence Allenby's name resembled the Arabic word for prophet – El Neby. T. E. Lawrence, the increasingly celebrated leader of the Arab revolt on the British right flank, had travelled up from Aqaba to enter the city at Allenby's side. He felt this to be the 'supreme moment of the war'.[33] Yet for Meinertzhagen the year closed as it had opened – in disappointment.

His experiences in the Holy Land had brought the Bible to life for him and had ensured that in the future he could read it with real understanding, but Jerusalem was an anticlimax. 'There was so much lack of reality and of what is genuine about the city.'[34] In Bethlehem too he found fault. It was 'a very unattractive place with little of real beauty except the children'.[35] Worse still, they had promoted him. In spite of protestations, he had been appointed GSO1 at the War Office and was ordered home. 'Out here my brother officers, my work and surroundings have together formed one of the brightest chapters in my life, perhaps the brightest since Mottisfont days. I have certainly been happier here than in most places and I am very sorry indeed to leave.'[36] But after dawdling for several days in Cairo's Zoological Gardens with ornithologist friends, Meinertzhagen set sail for Europe in January, and the chapter closed.

1918–19
With Lawrence in Paris

On Saturday morning, 25 January 1919, the men and women who had been selected to represent Britain at the Peace Conference in Paris, and who, after three weeks in residence at the Hotel Majestic, now relaxed in its leisured atmosphere, would have been forgiven had they failed to recognise that the figure newly entered in colonel's uniform was one of the brightest hopes of the British army. For, when Richard Meinertzhagen arrived at the sumptuous British quarters, he hobbled into the foyer on crutches, a stooping convalescent – hardly the entry expected of a freshly victorious soldier.

Almost three months earlier he had received a blow on his stomach from a piece of shrapnel, aggravating an earlier wound inflicted by a horse's hoof as he scrambled off the ill-fated *Transylvania*. In December 1918, although neither injury had caused any external damage, surgeons at an Allied hospital near Dieppe fearing peritonitis and a punctured intestine had decided to operate. 'It will all be over one way or another in a few hours,' Meinertzhagen wrote shortly before the anaesthetic, 'and it is not such a bad period of one's life just to retire quietly into peace. I certainly should not very much regret it for I have nought to live for and I certainly do not fear death.'[1] The tone of resignation was highly uncharacteristic for Meinertzhagen, even as a patient; equally, from the point of view of his career prospects, the lines were completely untrue. In the six months before the Paris Peace Conference his star was firmly in the ascendant. At the end of September 1918 he had finally left the War Office as a lieutenant-colonel for a post at general headquarters in France in charge of security. Many years later he discovered that during the two months before the end of the war he was being groomed to replace Brigadier-General Stanley Clive as the head of British military intelligence.[2] On 11 November, he had accompanied Marshall Foch to witness the German signing of the Armistice, and the following day, in spite of his car being hit by a German shell, delivered a copy of the agreement to his chief, Douglas Haig. Soon after, he was informed by Clive that a request had been placed with the War Office to send him to Cologne as the British Commissioner with

the rank of major-general.[3] This plan, which did not entirely square with Meinertzhagen's own wishes, and which was forestalled by his injury and subsequent operation, was finally replaced by his appointment as a military adviser to the Peace Conference.

For Meinertzhagen this work was far from congenial. An almost obsessive predilection for action and a concomitant distrust of paper solutions to political problems left him suspicious of the whole conference apparatus. He believed greedy and self-seeking politicians – 'like a lot of vultures round a carcase'[4] – might easily squander the victory so dearly bought by military valour. In diary entries excised from the later published volumes he launched on violent tirades against many of the leading British representatives. Balfour was in his second childhood, the Raja of Bikanir was a mere ornament with a nebulus of court parasites. He lamented the absence of a really 'big man', and feared the worst for the eventual outcome.[5]

His lifelong disapproval of the French and inherited sympathy for the Germans had also tended to confuse his perception of Britain's allies and her enemies. Only four months earlier, near Amiens, he had pursued a German officer with a knobkerrie, an African native war club, and felt 'furious' when a British Hotchkiss, raking the fugitive with bullets, had cheated him of his prey.[6] In Lille, after the Armistice, he wrote:

> My heavens, what these people have suffered at the hands of the Bosch. It is almost incredible that such cruelty could have been practised by any human race. No sex, no age was too sacred for their lust and vice. No cruelty was too studied for their pleasure, no vice too ghastly for their indulgence.[7]

Yet, within a month, Meinertzhagen had concluded that:

> The Latin races never have been a source of attraction to me. Their inherent jealousy, their small mindedness, their excitability and their purely surface veneer of civilisation and chivalry, are to me distasteful. As Allies they are a source of constant trouble and suspicion. I frankly much prefer the more northern races of Europe, with their open temperament and their closer affinities to ourselves. Even the German, once he is cured of his overbearing behaviour, his idea of ruling by force, his lust for plunder and world power and his accompanying disregard for human suffering is preferable to the Frenchman, Italian or Spaniard.[8]

In Paris he was quickly out of tune with proceedings. He fulminated against the conference's democratic slowness. Delay would only increase

the likelihood of the Central Powers – Germany, Austria, and Bulgaria – refusing to sign the final treaty. Worse still, Bolshevism was seeping into Eastern Europe and the absence of a quick settlement in Paris simply exacerbated post-war instability, and raised the possibility of revolution. The Middle East was also a source of anxiety: Meinertzhagen, who had recently come under the spell of the Zionist leader, Chaim Weizmann, sensed an unhealthy shallowness in the British government's commitment to the Balfour Declaration, and in Syria he feared the consequences of French ambition.

In spite of his recent operation, the next six months were a period of intense activity. He fired off memoranda on subjects as diverse as the use of black African troops in Mesopotamia and the establishment of an international bird sanctuary on the German island of Heligoland. On the growing uncertainty over allied policy in the dismembered Turkish Empire he was particularly voluble. Ten lengthy papers, that drew the attention of Balfour, Curzon, and Lloyd George, hammered home the consequences of delay and equivocation. His clear-headed work on the allocation of mandates for the captured German African territory had also attracted the notice of the Colonial Secretary, Lord Milner, and he was entrusted with any further negotiations concerning these African colonial questions.[9]

Curiously, consideration of Meinertzhagen's time at the Peace Conference has come to be dominated, not by any aspect of his work, but by his friendship with another of the British delegates, whose room at the Hotel Continental was directly above his own. Colonel T. E. Lawrence had come to Paris as adviser and interpreter to Prince Feisal, the leader of the Arab delegation. The proximity of Meinertzhagen's and Lawrence's respective quarters and their mutual concern for Middle Eastern issues seem to have been the catalysts to a temporarily close and, apparently, confessional relationship. Almost forty years later, Meinertzhagen revealed something of this when he published his *Middle East Diary* in 1959. His portrait of Lawrence at the time of the Conference, as a guilt-ridden figure, provoked considerable speculation amongst the latter's later biographers, which deserves detailed consideration. Not only does it shed light on this highly complex personality, but it invites important questions about Meinertzhagen himself, particularly the methods he used to compile both his diaries and books, the principal sources of information about his life.

Lawrence had used Britain's wartime promises of Arab independence during the Hejaz campaign as a constant thong to stir his Muslim allies into

action against the Turks. In Paris, however, France's opposition to the idea of Arab autonomy along the lines that Britain had agreed with Feisal's father, King Hussein, threatened to force the British government into a situation where, rather than break with their most important European ally, they would have to go back on their word to Hussein. For Lawrence, this development would have serious repercussions, exposing him as the principal agent in Britain's breach of promise. Moreover, the Lawrence of Arabia legend that was gathering momentum in 1919, partially as a consequence of Lawrence's personal efforts, far from being the merited glory of achievement, would then be an ironic reminder of his own and Britain's treachery. His acute sensitivity to this dilemma and his deeply ambivalent response to his increasing renown now weighed heavily upon him. In such an atmosphere of self doubt, he felt that the written account of his exploits on which he had recently embarked, and which would finally evolve into *The Seven Pillars of Wisdom*, was exaggerated. And in an effort to escape his increasing sense of guilt he seems to have turned to Meinertzhagen, treating him as his confessor.

On the surface, a close relationship between these two very different men might have appeared unlikely. Although Lawrence had withstood two years of gruelling desert austerity, he was a physically short, almost delicate figure, a deeply cerebral and polished Oxford graduate, who was highly sensitive to art, literature, and music. In public he was a gifted and persuasive speaker, his quiet, slow delivery soon to command wide attention amongst the world leaders in the French capital. Meinertzhagen, on the other hand, was tall and powerfully built. He was the archetypal action man – a soldier and big-game hunter. Science, not art, was his life's interest. His formal education had ended at eighteen, and although his mind was sharp and responsive, his views on politics and world affairs had been defined hitherto in narrowly conservative terms – the product of gut reaction, *The Times*, and military training. In company he was often taciturn, and when inspired to speak his manner could be coarse-grained and direct, which might appear like bluntness.

Their first encounter, in Palestine in 1917, shortly after the British capture of Jerusalem, was a roughly humorous contest of ego and machismo. Meinertzhagen belonged to the class of humanity most frequently disparaged by the uncrowned Prince of Mecca – the regular officer – and since neither was initially willing to yield ground, both had started off on the offensive. Lawrence impressed on his companion the importance of the Arab revolt, the high quality of his Muslim forces, their invincibility in

desert conditions, and his own achievements as a guerrilla leader. Meinertzhagen, however, entirely nonplussed, chaffed Lawrence that the Arab operations were simply a side show of negligible importance to Allenby's campaign in Palestine. He dismissed the Arab troops as mere looters and murderers so fearful of casualties that even the Turks would not enlist them in combatant units. In spite of this ostensible antagonism, a curious gruff affection seems to have developed between the two.

In *Backing Into the Limelight* Michael Yardley identified in the barbed playfulness of this first encounter a suppressed current of homoerotic attraction, and cited the following passage from Meinertzhagen's diary as evidence.[10]

> As I was working in my tent last night – about 10 p.m. – in walked an Arab boy dressed in spotless white, white headdress with gold circlet; for the moment I thought the boy was somebody's pleasure-boy but it soon dawned on me that he must be Lawrence whom I knew to be in camp. I just stared in silence at the very beautiful apparition which I suppose was what was intended. He then said in a soft voice 'I am Lawrence, Dalmeny sent me over to see you'. I said 'Boy or girl?' He smiled and blushed, saying 'Boy'.[11]

However, Yardley's interpretation would seem to place too strong a valency on the nature of their attraction. Although there is evidence to confirm that Lawrence's sexual orientation was occasionally confused and ambivalent, there is nothing in Meinertzhagen's thousands of pages of diary to support the idea that he was ever attracted to his own sex.[12]

There may possibly have been something in Meinertzhagen's brusque dismissiveness and directness that deflated Lawrence's mounting hubris, and which he found perversely soothing. A conversation recorded by Meinertzhagen after a subsequent meeting in Rafa would appear to bear out this suggestion.

> I think he knows I see through it all and am not impressed for he suddenly said, 'I believe you are unique'. When I enquired in what way he said 'In thinking I am a humbug'. 'No', I said, 'I don't think you a humbug but you are making too much of your desert war and you are trading on your charm to make people believe you are this war's hero.'[13]

The attraction of opposites certainly seems to have been an important element in their relationship. Lawrence possibly found Meinertzhagen's

down-to-earth manner and apparent emotional simplicity a welcome relief
from his own super-subtle and self-torturing lucubrations.

There were also shared characteristics that may have offered the basis for
intimacy. Both, for example, were noted for their daring, and any compari-
son of war scars or military exploits would have left little room to choose
between them. It is also interesting to note that each attempted to identify
in the other a distasteful relish for bloodshed that he himself did not have.[14]
Lawrence's customary criticisms of staff officers – their strict adherence to
regulation, their inflexibility, and lack of imagination – could hardly be
levelled at Meinertzhagen. He, like Lawrence, shone because of his
originality. Equally, in August 1914 they had both been relatively obscure
figures – men of definite but hidden talent who had risen to prominence in
the exigent conditions of the war. In 1919 Meinertzhagen noted, with only
partial satisfaction, that his work had brought him into contact with
prominent men at whom he had gazed from afar in the past.[15] During his
period at the War Office in the last months of fighting he made good friends
with Sir Henry Wilson, the Chief of Imperial General Staff. He dined
regularly with eminent men of affairs: Lord Crewe, Asquith, Hugh
Trenchard, Balfour, and Smuts. At the Conference he established close
contact with Eyre Crowe, the permanent Under-Secretary at the Foreign
Office, and the latter's colleague, Robert Vansittart. Lawrence, too, on his
return to Europe enjoyed a prominence amongst international figures and
an access to them that his rank as a colonel – the same as Meinertzhagen's –
hardly seemed to warrant. Both of them, then, were *new men*, the Great
War's parvenus.

Although their political allegiances in the Middle East would eventually
follow radically different lines, in Paris in 1919 their views ran more or less
parallel. Both were vehemently Francophobe and were anxious to see Syria
established as an autonomous Arab kingdom, with Feisal as its leader.
And, in spite of different motives, they were jointly committed to a British
mandate in Palestine and the creation of a Jewish homeland. At the time,
the idea of Jewish and Arab co-operation in the Middle East seemed a
possibility to both of them, and according to Meinertzhagen they were
instrumental in drafting a letter from Feisal to the head of the American
Zionists, Felix Frankfurter. In this document the bonds of race and
common nationalist goals in the Middle East were offered as grounds for a
grand Semitic alliance.[16]

According to Meinertzhagen, the two spent an increasing amount of
time in each other's company as the conference wore on. If Lawrence

wished to communicate with his friend he simply banged on the floor of his room, while Meinertzhagen would tap on his ceiling. In April Lawrence confided that he had started on his written account of the Arab revolt and was increasingly troubled about the extent of his exaggeration – 'dull little incidents embroidered into hair-breadth escapes'.[17] An entry in Meinertzhagen's diary more than three months later clearly indicated that the task of literary creation was on the point of overwhelming Lawrence, and in a highly vulnerable state of mind the latter made a number of interesting revelations to his friend. This passage, dated 20 July, and an earlier one dated 8 April, have become the focus of considerable controversy and deserve extensive quotation here.

8.IV. 1919. Peace Conference, Paris

I have been seeing a good deal of Lawrence and have got to know him well. He is a complex character, his moral barometer jumping about from extreme depression to hilarious practical jokes.

We lunched together and later took a walk in the Bois. The poor little man is intensely depressed. He is writing a book on his Arabian exploits and admitted to me that though it purports to be the truth, a great deal of it is fancy, what might have happened, what should have happened and dull little incidents embroidered into hair-breadth escapes. He confesses that he has overdone it and is now terrified lest he is found out and deflated. He told me that ever since childhood he had wanted to be a hero, that he was always fighting between rushing into the limelight and hiding in utter darkness but the limelight has always won . . . He says it has all gone too far and that others are pushing him into the limelight. He also excuses himself by saying that none of his exaggerations can be checked or verified – that seems rather ingenuous. He blames Hogarth, Lowell Thomas, Storrs and many others and complains that people in high places are already beginning to regard him as a little War Hero and that any going back now would be misunderstood.

20.VII. 1919. Peace Conference, Paris

Last night, as I was working in pyjamas, T.E.L. sent me a string message reading 'My mind is afire with all kinds of forebodings; may I come in?' I answered 'Come along'. I have never seen him in such a state, intensely worried. But before he started on himself I told him I had been considering what he said about me in his book and begged him to expunge it as the first part was not true and put me in a false light. Then he started. He surprised me by saying that little of his book was strict

truth, though most of it was based on fact; he had intended giving me a copy of his book; I begged him not to as I loathe fakes; he then told me that was precisely his trouble; he also hated fakes but had been involved in a huge lie – 'imprisoned in a lie' was his expression – and that his friends and admirers intended to keep him there. He was now fighting between limelight and utter darkness. It was slowly corroding his soul. And there were other troubles which might be laid bare. His father and mother were never married, which filled him with shame. I told him that in these enlightened times such things mattered little and that he was in good company for Jesus was born out of wedlock. He then went on to describe the indecency and degradation he suffered at the hands of the homosexual Turks.

He did not intend to publish the true account of this incident as it was too degrading, 'had penetrated his innermost nature' and he lived in constant fear that the true facts would be known. He had been seized, stripped and bound; then sodomized by the Governor of Deraa, followed by similar treatment by the Governor's servants. After this revolting behaviour he had been flogged.

He took the blame for the legend which had sprung up about him, whilst admitting encouragement and exaggerations by his admirers. In his own words (1918) 'He craved to be famous and had a horror of being known to like being known . . . I wondered if all established reputations were founded like mine, on fraud.' What was he to do? Go ahead and risk being exposed or hide himself in the wilderness of darkness and obscurity? I suggested that he should start with a clean slate, write a straight forward and true account of his Arab exploits, ignoring his friends' embroideries. He promised to think it over, but I fear he has gone too far, poor little man. His nature shrinks from obscurity unless it would bring mystery and applause.[18]

John Mack,[19] Desmond Stewart,[20] and Michael Yardley[21] have all suggested that these entries were not an authentic and contemporary account, but that Meinertzhagen 'drew upon memories of later periods, and from various readings in reconstructing his diary',[22] pointing to evidence in these two passages. Mack, the first to publish of these three, and from whom the other two may have taken their cue, suggested that the entries bear a resemblance in tone and content to Richard Aldington's book, *Lawrence of Arabia – A Biographical Enquiry*, which was not published until 1955, but which Meinertzhagen did indeed read. He went on to

suggest that the entry dated 8 April was curious for a number of reasons. Only the day before, 7 April, Lawrence had received a telegram informing him of his father's serious illness. Lawrence, according to Feisal, flew home to Oxford, arriving two hours too late to see his father alive. He had then flown immediately back to Paris, apparently in time, if Meinertzhagen's diary was accurate, to lunch with his friend. Mack contended that if the dating of the entry was correct it was strange that Meinertzhagen had not mentioned either the death of Lawrence senior or his son's recent visit to Oxford.

There are two possible explanations for this: firstly, that Lawrence did not tell Meinertzhagen of his bereavement; secondly, that Meinertzhagen was out on his date. The first, however unlikely, is possible, since Feisal, with whom Lawrence had worked closely in Paris, only learnt of the death a week after it had occurred and was shocked by Lawrence's silence and discretion over the matter. Lawrence's brother, Arnold, also stressed the former's extreme self-control in moments of emotional stress.[23] However, in an unpublished portion of the same diary entry, Meinertzhagen described how he and Lawrence showered an important meeting of delegates, including Lloyd George, Balfour, and Lord Hardinge, with toilet paper[24] – hardly the behaviour of a son in mourning. Meinertzhagen frequently caught up on the happenings of the previous few days, even weeks, in one bout of writing, and it is therefore most likely that the passage dated April 8 referred to events before 7 April. Presumably, subsequent editing for publication, which deleted the toilet-paper joke, also inadvertently suggested that their meal together had been on 8 April.

Mack then challenged the entry dated 20 July on the basis of the following sentence: 'In his own words (1918) "He craved to be famous and had a horror of being known to like being known . . . I wondered if all established reputations were founded like mine on fraud?"' He correctly showed that the quotation Meinertzhagen had dated 1918 was from *The Seven Pillars of Wisdom*,[25] which Lawrence had not started until 1919 and was not widely available until 1935. Stewart, too, demonstrated that an entry in the *Middle East Diary* dated 13 November 1951[26] mentioned Nasser six months before even the military coup in Egypt, and sixteen months before Nasser himself rose to prominence and replaced General Neguib as head of the government.[27] Yardley pointed out that in the April entry Meinertzhagen mentioned Lowell Thomas – 'He blames Hogarth, Lowell Thomas, Storrs and many others' – four months before Thomas had started to publicise Lawrence.

What, then, should be made of Meinertzhagen's diaries? Clearly, these discrepancies indicate that when he claimed to have written something on a particular date, he could not possibly have done so. Did he, as Mack suggested, doctor and recompose his diaries to take account of subsequent reflections and readings, even as much as thirty years after the original entry? Obviously, this is a serious charge, since proven examples of retrospective editing will have a domino effect, throwing into doubt the validity of the whole work, and even the other published diaries – a position a number of people have adopted vis-à-vis Meinertzhagen's writings.[28]

There are four possible ways of explaining the diaries' anomalies: firstly, that they were simply errors; secondly, that Meinertzhagen largely concocted the entire seventy-six-volume diary in a grand deception, as has been suggested to the present author; thirdly, that the published version was simply a misleadingly edited copy of the original; and finally, that there was an interval, sometimes involving many weeks, between the time of the events themselves and the time Meinertzhagen actually wrote up the diary account that describes them.

The first approach – that many of the problems arise out of simple errors – is surprisingly fruitful. There is no doubt that Meinertzhagen was capable of mistakes. For example, he repeatedly claimed that his original spell in East Africa lasted for five years, when in fact it was only four, and excluding leave, under three and a half years. Similarly, his *Middle East Diary* indicates that his first encounter with the Zionist leader, Chaim Weizmann, occurred on 10 July 1918, when in fact it was five months earlier, on 10 February.[29] Most interesting of all is his description of when he and Lawrence threw toilet paper on Lloyd George and Balfour in the Astoria that appeared in the *Middle East Diary* dated 8 December 1937. Here, he spoke of 'a huge roll . . . which he [Lawrence] let unfurl down the well till it was festooned in graceful paper cascades all over the balconies and with a neat little heap at the bottom'.[30] In Meinertzhagen's original and unpublished 1919 version, however, Lawrence produced 'two packets of Bromo lavatory paper and shook them out over the well. There was a dense snowstorm of white paper flakes floating down on the top levels.'[31] What is interesting in this example is not so much the discrepancies, which when one considers that the two versions were written eighteen years apart, are small, but rather the high degree of detail in the 1937 version – detail that was almost certainly inaccurate. Clearly, Meinertzhagen could recreate events years later, but the carefully wrought realism could be, as here, largely the product of his imagination. It is almost certainly this mixture of

invention and forgetfulness that accounts for the number of discrepancies in his various descriptions of the events at Fonthill.

The second option – that the diary was an immense piece of forgery – is an extraordinary theory that has been suggested, and is raised here only so that it might be eliminated. It is almost inconceivable that a man could have largely invented over 15,000 pages of diary for the sake of posterity, particularly one so largely uninterested in public recognition. Moreover, it is hardly likely that anyone could compose such a fake and escape detection, even one so skilled at counterfeiting as Meinertzhagen. Besides, there is a mass of corroborative evidence to substantiate much of his life story. There is a small number of interesting examples where this is not the case, but they are irrelevant to his relationship with Lawrence and are dealt with elsewhere.

It is the final two approaches, or at least a combination of them, that offer by far the most reasonable solution to any problems with Meinertzhagen's diary. Firstly, it is important to be clear about the physical nature of the original volumes. These are not hand-written, as might have been expected, but typed throughout, largely on Meinertzhagen's highly characteristic italic typewriter. He claims to have bought this in 1906, and the earliest evidence for its use, outside of the diaries, is a letter written in 1914 to Colonel Dunnington-Jefferson, now held in the Imperial War Museum. The typed pages of diary were then inserted in a loose-leaf, leather-bound folder; generally a volume for each year. This system of compilation does allow for the possibility of retrospective editing. However, it could not have been achieved without considerable difficulty. The gradual decrease in the strength of each ribbon as it was used up would have demanded that the ink colour on any insertion would have to have been carefully matched with the surrounding pages to avoid immediate detection. Equally, Meinertzhagen's habit of numbering the pages makes it easy to identify any attempt to add or take away from the diary.

It seems likely that he did not compose and then directly type the original entries, but firstly hand-wrote an initial draft, which was then copied. This suggestion is supported by an entry in the *Army Diary* on 2 November 1914 at Tanga, that reads: 'As I write, a few rifle shots ring out and I can see the flashes of enemy rifle fire.'[32] The interval between the preparation of the hand-written draft and the final typed version would obviously have varied according to the extent of his other commitments. In periods of intense activity, as at Tanga, it is extremely unlikely that he would have typed up

on the spot. It is much more probable that this would have happened days or weeks after the events, at which time Meinertzhagen may well have altered the contemporaneous impressions, guesses, and predictions to accord with subsequent known developments.

It is possibly this species of alteration that Yardley identified when he pointed out Meinertzhagen's insertion of the name Lowell Thomas in the April 1919 entry, four months before Thomas had opened his show on the Middle East campaign at Covent Garden. It need not necessarily follow, however, that in order for Meinertzhagen to have referred to Thomas's activities, the typing up was done more than four months after it was originally written. There is a possibility that he had heard of Thomas even in April 1919. The American journalist had already run a series of shows in New York featuring Lawrence as early as March, and it is feasible that Meinertzhagen heard of this publicity from American delegates at the Peace Conference. Similarly, Thomas had spent time with Lawrence in the Middle East during the spring of 1918 collecting material for his shows. Although Meinertzhagen had left Palestine by then he could easily have known about this contact through a variety of official and unofficial sources.

What then of Stewart's observation that in November 1951 in the *Middle East Diary*, Meinertzhagen referred to Nasser sixteen months before his rise to prominence? This would indicate that portions of the diary had been written many months, and even years, after the events he was purporting to describe contemporaneously. However, a comparison of the original with the published version suggests that there was no such lapse of time. In the former draft Meinertzhagen had written:

> Elath told me that if we abandoned the Canal, Israel would most certainly stabilise the situation by marching across Sinai and occupying the Canal Zone; he thought and I agree that the United Nations would of course protest but would welcome such a move if forced by a fait accompli.[33]

In the *Middle East Diary* he replaced this with the following:

> Elath and his wife dined this evening and we had a long talk about how Egypt's attitude over the Suez Canal might affect Israel. Elath told me that with Egypt's new aggressive military regime Israel's security might be seriously undermined were Nasser to start making use of the situation to increase hostile activities in the Gaza Strip.

Clearly, in 1959 it would have been highly imprudent to have offered the original piece to the public, since it implied that Israel was prepared to pursue an aggressive policy in defiance of the United Nations. In order not to embarrass his friend, Eliahu Elath, who, at the date of publication, was still serving as Israel's Ambassador in London, Meinertzhagen must have substituted the later, erroneous piece – falsely suggesting that Egypt, not Israel, was the aggressor – and then not realised his mistake.

How should one understand or judge changes to the diary of this kind? To deliberately and almost unnecessarily invert the facts, as Meinertzhagen did in this instance, is of questionable morality. However, to shield a friend from possible criticism seems eminently sensible, and at worst, venial. Harold Nicolson, a fellow diarist and delegate, sheds some light on the issue of retrospective editing in his account of the Paris Conference, *Peacemaking, 1919*:

> To those who specialise in new vices I recommend the fierce temptation of publishing a diary which one has written 14 years before. The desire to suppress a word here and there, to alter a word here and there, to add a word here and there, is more potent and insidious than any of the odd temptations which I have encountered and to which generally I have lavishly succumbed.[34]

It is remarkable, in view of the harshness of some of Meinertzhagen's opinions, and the extent of bloodshed in the diaries, all of which he must have recognised might be received unsympathetically, just how few alterations he actually did make. Careful comparison of the text of the original volumes with the published works – *Kenya Diary*, *Middle East Diary*, and the *Army Diary* – has revealed only a handful of significant changes.

A comparison of the original Lawrence passages with those in the published work shows that they are identical word for word, except for two changes, both of which relate to the 20 July entry. It is perhaps the largest irony of the whole issue that the individual pieces of evidence cited by Lawrence's biographers can all be explained, if not to Meinertzhagen's credit, then at least to a position where one can understand his motives, and yet the substance of their charge – that the diaries were tampered with – remains valid.

In the original the whole of the following paragraph is absent:

> He did not intend to publish the true account of this incident as it was too degrading, 'had penetrated his innermost nature' and he lived in con-

stant fear that the true facts would be known. He had been seized, stripped and bound; then sodomized by the Governor of Deraa, followed by similar treatment by the Governor's servants. After this revolting behaviour he had been flogged.

However, in the original the last sentence of the preceding paragraph ends with a line subsequently deleted from the *Middle East Diary*: 'having preferred submission to a flogging which he would not have survived'.[35]

Does this revelation suggest, after all, that Meinertzhagen's testimony on Lawrence is actually invalid? Not necessarily. Although it demonstrates that an important paragraph had no place in his original text, it does not disqualify the remainder: since this last omitted sentence contains much of the information of the added, unauthentic paragraph – namely, that Lawrence was homosexually assaulted by the Turks. True, Meinertzhagen *had* changed the diary, but he had elaborated on an idea present in the original text, rather than introduced a completely fake one. It is also difficult to detect any particularly devious motive behind the insertion. What purpose could it have served to invent a story about Lawrence having been sexually assaulted, if Meinertzhagen himself did not believe it, which is what he stated quite clearly in December 1937?[36] Irrespective of his capacity to do so, it seems that Meinertzhagen was attempting to recall in greater detail Lawrence's revelations of that night in July, and to illuminate, for the benefit of an audience hooked on Lawrence gossip, an incident that his original diary had only hinted at.

It is interesting to compare the omitted line – 'having preferred submission to a flogging which he would not have survived' – with a passage from Lawrence's self-revelatory letter to Charlotte Shaw of 1924.

> About that night. I shouldn't tell you, because decent men don't talk about such things. I wanted to put it plain in the book, & wrestled for days with my self-respect . . . which wouldn't, hasn't let me. For fear of being hurt, or rather, to earn five minutes' respite from a pain which drove me mad, I gave away the only possession we are born into the world with – our bodily integrity.[37]

The fact that both these express the idea that Lawrence's submission was an attempt to spare himself from excruciating pain is either a most remarkable coincidence or a telling congruence. Surely Meinertzhagen could not have written such a detail, no matter how much he had subsequently read (the Shaw letter was not revealed until 1969 – two years

after Meinertzhagen had died) unless Lawrence himself had been the source?

Finally, there remains only Mack's observation that Meinertzhagen quoted from *The Seven Pillars of Wisdom* and dated it 1918. It is difficult to imagine that Meinertzhagen, who knew the history of the book extremely well, would have extracted a quotation from it when it was published in 1926 or 1935, gone back to his 1919 diary and inserted the passage, and then dated it 1918. What seems far more probable is that the quotation, which, significantly, is very different to the version that appeared in the published edition of *The Seven Pillars of Wisdom*, is from the original 1919 draft that was eventually lost at Reading Station. And the date, 1918, refers not to the date of authorship, but to the period of Lawrence's life in which the quotation is situated. The passage is from a very late chapter in the book dealing with Lawrence's thoughts and actions of August 1918, towards the close of the Arab campaign, when indeed Lawrence's reputation was beginning to spread.

In conclusion, then, what can be said of Meinertzhagen's relationship with Lawrence in 1919, and of his statements about him? Firstly, it is barely credible that he knew him as well as any living man, as he later claimed.[38] His statements over the seventeen years of their acquaintance are protean – confused, contradictory, and repetitive. (Indeed, what better evidence could there be than this to confirm that his pronouncements on Lawrence were largely the unpremeditated jottings of the moment?) The true lineaments of Lawrence's personality were as unclear to Meinertzhagen as they were to more subtle psychologists, like Ronald Storrs or Harold Nicolson. None the less, the facts – that they developed a briefly close relationship in Paris, that Lawrence confided in him about his illegitimacy and about his brutal treatment at the hands of the Turks – seem incontestable. Moreover, in spite of the proven addition to the diary entry of 20 July, his testimony on the Deraa incident remains a valuable piece of evidence. His own words, and their close relationship to the letter to Charlotte Shaw, confirm that Lawrence suffered some traumatic experience at the hands of the Turks, which had a profound impact on the course of his life after the war. Equally, the portrait of Lawrence in Paris as a man troubled by his own reputation, and about the relationship between personal experience and the language and fictions we create to describe that experience, remains essentially valid.

1919–20
The Best Lack All Conviction

On Thursday 11 September 1919 T. E. Lawrence wrote to *The Times* to identify for the benefit of a confused British public the various documents that the government had issued during the war binding it to its two principal allies in the Middle East – the French and the Arabs. In peacetime the two most important of these documents, the Hussein–McMahon Correspondence and the Sykes–Picot Agreement, should have provided the framework within which the captured Ottoman Empire could have been dissolved and redistributed to the victors. Lawrence claimed at the end of a laconic analysis of these treaties that he could see no inconsistencies or incompatibilities amongst them, and implied that a settlement between the three powers should have been straightforward. Unfortunately, the events of the previous nine months at the Peace Conference had not borne out the simplicity of his conclusions: agreement amongst the erstwhile allies proved almost more difficult to obtain than the peace between the latter and their wartime opponents, the Turks. Furthermore, Lawrence's assertion that he knew of nobody who found the various documents in any way overlapping seemed remarkably myopic.

Exactly a month earlier a memorandum by Britain's Foreign Secretary, Arthur Balfour, had identified with precision the problems attending a Middle Eastern agreement.[2] The Hussein–McMahon Correspondence of 1915 and the Sykes–Picot Agreement of 1916 had been drawn up separately by Britain with each of its allies, the Arabs and the French respectively. In neither case were all three powers fully party to the same agreement. Since in each of these pacts it seemed that the same territory had been offered to a different nation, there was inevitable conflict. Moreover, on 2 November 1917 Balfour himself had issued a letter to Baron Rothschild known as the Balfour Declaration, which expressed Britain's intention, in the event of complete victory over the Turks, to enable a Jewish return to the Holy Land. The document, a classic piece of diplomatic ambiguity, had in sixty-nine words earmarked the lands of 600,000 Palestinian Muslims and Christians as an area of resettlement for an alien people, without any prior consultation of that resident population.

To complicate affairs even further, the Sykes–Picot Agreement, a cynical piece of imperialist *realpolitik* that cut the Fertile Crescent in two, half each for Britain and France, leaving only a few ancient cities – Damascus, Hama, Homs, and Aleppo – with a desert hinterland for the Arabs, had been overtaken by the events of 1916–18. By the time of the Peace Conference, the British, especially, had lost all enthusiasm for the document. They felt that, irrespective of the final contribution made by the Sherifian revolt, the Arabs had been their brothers in arms for almost two and a half years; they had fought gallantly and endured numerous sacrifices. After the war it seemed only right, particularly to those in Allenby's victorious army, and also to many in Lloyd George's peacetime government, that their Muslim allies should gain a place in the sun alongside the other victors. Moreover, the Covenant of the League of Nations, which was intended to provide the legal and moral framework for the whole workings of the Paris Conference, upheld the rights of new nations to self determination, and embodied a fresh and democratic spirit from the New World, a spirit directly opposed to the imperialist self-interest contained in the Franco-British pact. Independence for new nations like the Arabs, therefore, seemed to be the order of the day.

Meinertzhagen, like Lawrence, was keen to see Britain honour her obligations to the Arabs, particularly with territory that under the terms of the Sykes–Picot Agreement had been assigned to the French. Yet he was not motivated solely by Francophobia. From his memoranda, written at the Peace Conference, it appears that he felt a genuine desire to rid Arabic-speaking peoples of Turkish control and then to see them achieve the political goals they had struggled for in the war.[3] However, in the final analysis his views on the redivision of the Middle East revolved around his commitment to a Zionist policy in the Holy Land. Arab autonomy in Syria might have been a desirable objective in itself, but more importantly, it was a convenient compensation for political and territorial losses that Muslims would almost certainly incur as a consequence of extensive Jewish resettlement in Palestine.

His allegiance to Zionism was remarkable for a number of reasons. Not least of these was the fact that in the military administration, for which he worked after leaving Paris in August 1919, he was almost alone as a proponent of Jewish interests. Zionism isolated him from his old army colleagues, and led eventually to his dismissal from the post as chief political officer in Cairo. These were the immediate repercussions; in the long term his new-found faith seems to have shaken his old commitment to

the army in general – an institution that for more than twenty years had been his material and spiritual guardian. The conflict of interest was all the more exceptional in view of the fact that in 1919 his Zionist faith was in shallow soil: only two years before he had hardly even heard of the subject.

From the *Middle East Diary* it appears that Meinertzhagen was capable of the most curious inconsistency on Jewish issues, which a number of commentators have seized upon. Christopher Sykes, for example, pointed out that in 1940 Meinertzhagen posited the need to curb Jewish political and social ascendancy in Britain as had happened in Nazi Germany.[4] It was undoubtedly the case that his enthusiasm for Zionism fluctuated, but his inconstancy was less marked or significant than his published diary – his major public statement on the issue – might suggest. His private journals had always served him as a political sounding board; particularly in the early years of his contact with Jews, he worked through the implications of Zionist ideas, measuring these against earlier beliefs. When these internal debates were all drawn together in a single volume, they gave an impression of a mind struggling for unanimity on a complex subject. As Meinertzhagen stated clearly in the preface, he had made no attempt to eliminate opinions with which he had come subsequently to disagree.[5] The *Middle East Diary*, then, should be read as a series of extemporised jottings, not as a carefully digested treatise.

Like many Britons, he felt his initial attitude to Jewish issues coloured by a pervasive anti-Semitism; but unlike most, he acknowledged its existence, and in large measure succeeded in extirpating prejudice, or overlaying it with a counteracting sympathy. When opposition did resurface it was often half-hearted, and largely in response to established and assimilated Jewish dynasties: the 'worshippers of the Golden Calf', as he called them – the Rothschilds, Montefiores, Swaythlings and Montagues – a number of whom were his personal friends. The most frequent source of divided loyalty was undoubtedly the increasing hostility in the 1930s between the Nazis and the Jews. In the post-war years Meinertzhagen's familial sympathies for Germany and Germans recovered, and throughout this period he showed some susceptibility to the Jewish-conspiracy theory of the Nazis. He was also an enthusiast for Adolf Hitler, a man he met on several occasions, largely to discuss issues concerning Jews. Meinertzhagen was willing to acknowledge that he did not always find Jews the easiest people to work with, particularly those fired by a vision of Eretz Israel. Their singlemindedness, zeal, and intelligence often alienated inadvertently those who were attempting to help them.

Although these issues had some temporary counter-effect on his Zionist commitment, their primary significance was to highlight, by sharp contrast, the overwhelming uniformity of his statements. Meinertzhagen's lobbying was motivated by a passionate desire to see a Jewish state in Palestine. In fact, the strength of this pro-Jewish and anti-Muslim ardour has also drawn criticism. Bernard Wasserstein, for instance, has called him an *'enfant terrible* . . . a violent and prejudiced partisan . . . a lone operator . . . almost unique among senior officers in Palestine'.[6] There is no doubt that his statements about Arabs and his comparisons of them with Jews could be intemperate and thoughtless. As soldiers (military prowess was always an important measure of national characteristics for Meinertzhagen) he dismissed them as 'just murderers and looters', a 'throat-cutting and castrating' rabble.[7]

> I suppose the Arabs are one of the most inefficient races of a semicivilised nature. Their shortcomings include laziness, conceit, greed, dishonesty and treachery . . . The Arab has the mentality of a pariah dog, only attacking in pack, afraid of casualties, a terrific bark with a non-existent bite, more usually a hurried snap when nobody is looking and a disinclination to face up to danger.[8]

And again in 1919, in a memorandum to Lloyd George, he wrote:

> This Peace Conference has laid two eggs – Jewish Nationalism and Arab Nationalism; these are going to grow up into two troublesome chickens; the Jew virile, brave, determined and intelligent. The Arab decadent, stupid, dishonest and producing little beyond eccentrics . . .[9]

This dramatic over-simplified splitting of the Semitic peoples into two halves – one progressive, one regressive – would seem to spring from an almost neurotically narrow perspective. Yet this was not the case. It is interesting that the equation he constantly imposed on Middle Eastern affairs – Jewish society as a highly organised and deeply cultured community in opposition to Arabic disorder and antisocial barbarism – was a dichotomy Meinertzhagen's complex personality seemed to embody.

The rebellious and antisocial aspects of his character approximated closely to the qualities he identified in Arab culture. Although military life satisfied an apparent need for strict personal discipline, which, indeed, he maintained for over eighty years, with regard to social constraints or conventions he was largely indifferent. His paternal family had adhered to a strictly Calvinist moral tradition, and he had inherited in full measure the

non-conformist's deep dislike of social ritual or artifice, which seemed to intensify as he grew older. Many of the nuances of social etiquette – formal dress, polite conversation, and overly mannered behaviour – often bored him; particular hates were sherry parties, make-up, and nail varnish. His own dress was frequently unconventional: a loose pullover and a silk cravat threaded through a small ivory ring instead of a shirt and tie were often cause for comment amongst his acquaintances.[10] He once entered Johannesburg's Carlton Hotel dressed in a windcheater and a pair of corduroy trousers, a costume deemed so inappropriate by the management that they refused to serve him with dinner.[11]

Meinertzhagen as rebel and outsider had enjoyed clearest expression during his first four-year spell in Kenya, and culminated in a proclaimed preference for 'Africa and the savage to England and the over-civilised society which lives there'. Although this was in part a youthful quest for adventure, largely exorcised by the primitive excitement of his time in the Protectorate, he never entirely lost his urge for a life of brutal simplicity. In 1914 in Quetta, at the age of thirty-six, he addressed the issue more fully:

> I loved the naked, raw life, bereft of all trappings and tom-foolery of civilisation. I loved the state where Man himself is the last resource, where strength, endurance and personal courage come into their own and constitute the ultimate test of survival. Wide horizons in thought and vision, freedom and always more freedom, fresh air and exercise and a contempt of Death – that is what I love.[12]

It is interesting to compare Meinertzhagen's words with T. E. Lawrence's description of the bedouin response to their desert environment:

> . . . [He] had embraced with all his soul this nakedness too harsh for volunteers, for the reason, felt but inarticulate, that there he found himself indubitably free. He lost material ties, comforts, all superfluities and other complications to achieve a personal liberty which haunted starvation and death.[13]

The apparent similarity between Meinertzhagen's quest for physical and psychic austerity and the lifestyle of desert nomads is striking, and can be carried further. For example, he was an inveterate wanderer himself: by the time he was forty he had travelled in more than thirty countries in Africa, Asia, Europe, and the Middle East. Invariably, his favoured form of transport was on foot, or with pack-animal, rather than in a motorised

vehicle.[14] Deserts, particularly, exercised a compelling attraction for him. Some of his most lyrical prose, in *Nicoll's Birds of Egypt*, was in praise of deserts and desert life. His journeys in the Middle East inevitably brought him into contact with Arabs, and on a personal level he seemed to encounter no bar to friendship. Indeed, both Feisal and his principal military adviser, Nuri es-Said, later the Prime Minister of Iraq, were close acquaintances if not friends. During a visit to Mesopotamia in 1914, he had recorded his encounter with a local sheikh who had offered him hospitality: 'They pleaded, "Let us alone in our desert", a plea with which I thoroughly sympathise. They dreaded the hurry and bustle of civilisation and all the laws and regulations which ruin freedom but which always follow in the wake of the white man.'[15]

Why, then, given this apparent sympathy for Arab lifestyle, did Meinertzhagen always weigh in so heavily on the side of the Jews? And why, when political questions exercised his mind, did his almost anarchic passion for personal liberty fall away with such deciduous ease? Quite simply, one often looks in vain for consistency with regard to Meinertzhagen's personality or his views. He was too experimental a thinker and too ready to write down the views of the moment ever to be limited to one avenue of thought. For example, if one examines his characteral assessments of Churchill, Lloyd George, and Herbert Samuel, although these are often penetrating, they are as full of contradictions as is his analysis of Lawrence. Similarly, those qualities in him which approximated to his vision of Arabs, and which should have been a source of sympathy for them, lived in a state of easy contradiction with political views wholly antagonistic to Arabs and Muslims in general.

His idea of Zionist society, based on a perception of Jews as dynamic and orderly people, offered the possibility of highly coherent forms of government, and of rapid, active solutions to political problems, both of which he had always favoured. If Arabic, especially bedouin, lifestyles appealed to his sense of romance, as he himself confessed,[16] then Zionism tapped the deepest motivating forces in his character. His maternal family's instinctive sympathy for the underdog, coupled with his own childhood experiences as the family's black sheep, nourished his support for a nation of outsiders. The idea that Jews had been badly treated throughout the ages, and that they deserved full compensation, was one of Meinertzhagen's most frequent justifications for Israel. That the Holy Land belonged to the Jews, irrespective of 1,300 years of Arab occupation, was a curiously irrational notion to appeal to a scientist. Yet he, like Balfour and Lloyd

George, frequently cited the fulfilment of biblical prophesy as a strong motivation for his Zionist allegiance.

As a military strategist of considerable vision he also saw eminently practical reasons why the Jews should be established in Palestine. In March 1919, following conversations with Lloyd George and his secretary, Philip Kerr, Meinertzhagen outlined in a widely quoted memorandum what he saw as the most compelling rationale for a Jewish state.

> The British position in the Middle East today is paramount; the force of nationalism will challenge our position. We cannot befriend both Jew and Arab. My proposal is based on befriending the people who are most likely to be loyal friends – the Jews; they owe us a great deal and gratitude is a marked characteristic of that race. Though we have done much for the Arabs, they would not know the meaning of gratitude; moreover they would be a liability; the Jew would be an asset.
>
> Palestine is the cornerstone of the Middle East; bounded on two sides by the desert and on one side by the sea, it possesses the best natural harbour in the Eastern Mediterranean; the Jews have moreover proved their fighting qualities since the Roman Occupation of Jerusalem. The Arab is a poor fighter though an adept at looting, sabotage and murder.
>
> With Jewish and Arab nationalism developing into sovereignty and with the loss of the Canal in 1966 (only 47 years hence) we should stand a good chance of losing our position in the Middle East. My suggestion to you yesterday is a proposal to make our position in the Middle East more secure.[17]

Not only was Palestine the corner-stone of the Middle East, the Middle East was the fulcrum on which the British Empire balanced. It had to be guarded at all costs. Britain's sovereign control of Sinai, and therefore the Suez Canal's east bank, coupled with her mandate over Palestine, would most effectively buttress her imperial communications. Moreover, Meinertzhagen envisaged that Jewish gratitude for their opportunity to return to the Holy Land would offer Britain the possibility of a world-wide secret service network, operating under the auspices of international Jewry.[18]

At the Peace Conference Meinertzhagen's attention was focused increasingly on Palestinian issues. He and his new friend, Chaim Weizmann, the President of the British Zionist Federation and a leading member of the Jewish delegation in Paris, sought to ensure that there was no back-sliding in Britain's commitment to the Balfour Declaration.

Although Meinertzhagen had been predisposed towards the Jewish case prior to their acquaintance, it was the personal warmth and magnetism of Weizmann, more than any other individual, that had converted this latent intellectual sympathy into active support. Weizmann had sent Meinertzhagen a parcel of books on Zionist issues in February 1918, no doubt recognising, with all the missionary's instinct, a possible convert.[19] In Paris, however, the newly recruited disciple proved more impatient of the Jews' return to Zion than his tutor. Throughout March, Meinertzhagen conducted a behind-the-scenes campaign to drum up international support for immediate Jewish sovereignty in Palestine, a scheme that ran ahead of Weizmann's own cautious diplomacy; and he was perhaps not too disappointed when his friend's efforts ran up against the lumbering slowness of the Conference machinery.

For all his impatience, Meinertzhagen's activities had not gone unnoticed. His memorandum to the Prime Minister of 25 March had prompted Lloyd George to approach the US leader, President Wilson, concerning the possibility of a British sovereign base in Sinai. The Foreign Secretary had also got wind of this young military officer's fluent understanding of Middle Eastern issues and of his full-blooded support for Jewish rights. Balfour was increasingly concerned that there were wide differences of opinion between the personnel of the military administration in Palestine and the government staff in both Paris and Whitehall about how best to secure British interests in the Middle East. Allenby's chief political officer in Cairo, General Gilbert Clayton, had written in May 1919 expressing his belief that:

> The Palestinians desire their country for themselves and will resist any general immigration of Jews, however gradual, by every means in their power including active hostilities . . . If a clear and unbiassed expression of wishes is required and if a mandate for Great Britain is desired by His Majesty's Government it will be necessary to make an authoritative announcement that the Zionist programme will not be enforced in opposition to the wishes of the majority.[20]

Balfour rejected outright the chief political officer's suggested proclamation, and dangled before him the idea

> . . . that it might be advisable to send out to Palestine a further adviser on Zionist matters to assist General Clayton and preferably some representative who has been in Paris during the last few months and

understands the different currents of opinion here. Major-General Thwaites proposed in this connection Colonel Meinertzhagen, DSO, as the most suitable person.[21]

The Foreign Secretary's veiled statement of no confidence in Clayton, which was, in effect, a proposal to send out a Foreign Office watchdog, was followed shortly after by the latter's resignation, presenting the government with an opportunity to appoint a man more fully aligned with official policy. Weizmann, anxious to exert his influence over the choice of candidate, wrote to Balfour to suggest one who would enjoy Jewish support.

I understand that the Foreign Office has already suggested as successor to General Clayton the name of an officer who, I know, possesses a thorough understanding of the problems with which he would have to deal and who would, I am sure, be rigidly just to all sections of the population as well as to all the others who are concerned in the welfare of the country. He would have, I can assure you, the full confidence of the Zionist Organisation and of the Jews of Palestine and I know of no reason why he should not also obtain the full confidence of all the other elements in the population.[22]

The man the Foreign Office and Weizmann had in mind was Meinertzhagen.

Balfour lunched with the new chief political officer before his departure and offered him full governmental backing, expressing a complete confidence in his ability to establish Zionism in Palestine. Meinertzhagen, however, was far less sanguine about his prospects. On arrival in Cairo in September he wrote:

I am Allenby's Political Officer for all occupied enemy territory including Syria, Palestine, and Transjordan. I am responsible that the Foreign Office is kept informed of what is going on, I advise Allenby on all political matters and am responsible to the Foreign Office that the policy is carried out. The dual responsibility and dual loyalty, the one to Allenby the soldier and the other to the Foreign Office, is not going to be easy and must end in friction.[23]

His predecessor's mistake had been to express opinions contrary to those held in Paris; Meinertzhagen, on the other hand, had left Europe in full agreement with his Foreign Office superiors. Clearly, he anticipated difficulties from another direction.

In Palestine contact with the local situation softened his initial hope of outright Jewish sovereignty to a more moderate policy of patient development. For all his pro-Jewish, anti-Arab lobbying, the new chief political officer never envisaged either the dispossession or the resettlement of the resident non-Jewish population; nor, indeed, did he advocate repressive measures of any kind. Shortly after arrival in the country he outlined his programme for a successful implementation of Zionist policy to Lord Curzon, the acting Foreign Secretary. Existing opposition to Jews was local and artificial, fuelled by Syrian-Arab and French propaganda, and the pro-Arab activities of some of the members of the military administration. Uncertainty about the precise nature of British policy, and the fear of wholesale immigration swamping the country with Eastern European Jews similarly exacerbated the situation. Once the firmness of Britain's commitment to the Balfour Declaration was recognised, and once Jewish enterprise had uplifted the material well-being of the whole Palestinian population, Zionism would take root. It was necessary to make slow, methodical progress, striking an acceptable balance that allayed the apprehensions of the Palestinians, but which gave sufficient impetus to the development of a healthy Jewish community.[24]

Although in Paris Meinertzhagen had given ear to the rumours of strong pro-Arab bias amongst the military personnel, he was forced on arrival in the Middle East to recant: 'on the whole our administration has exhibited laudable tolerance towards a subject they dislike and towards a community which is often unreasonable, and, by nature, exacting'.[25] Even Ronald Storrs, the Governor of Jerusalem, whom he previously believed to have been instrumental in fomenting trouble, he now felt had been 'much maligned'.[26] Unfortunately, this admiration of his fellow administrators' 'laudable tolerance' was not particularly long-lived. In Cairo he disagreed with the Acting High Commissioner, General Congreve, when the latter refused to give Weizmann permission to enter Egypt. The Jewish leader had followed Meinertzhagen out to Palestine only a few weeks after his friend's departure. Congreve, unaware of Weizmann's status or the purpose of his visit, had been advised to prevent him landing at Alexandria, in spite of Meinertzhagen's remonstrances that the Jewish leader was travelling at the invitation of the British government. When Congreve proved obdurate, the chief political officer took the risky step of going over his superior's head, sending telegrams directly to the Foreign Office and War Office to have Congreve's veto rescinded.[27]

The intelligence network Meinertzhagen established shortly after arrival

also began to provide him with evidence that the rumours of anti-Semitism he had heard at the Peace Conference were actually correct. The foremost target of his suspicions was Colonel Waters-Taylor, the chief of staff to the military administrator in Palestine. The latter, according to Meinertzhagen, 'had a curious nature, fortunately rare among soldiers.'

> He is a man who works purely for himself and is deliberately inaccurate in his statements as he is unscrupulous in his acts. When he took up his appointment . . . he set himself the task of gaining complete control of Bols' [the military administrator] intellect, and he succeeded to the downfall of both. Waters-Taylor has a strong will which is ruined by bombast and ambition; he has a clear and able brain which is ruined by the taint of intrigue and deceit. His manifestations of loyalty to Bols ill-concealed his thirst for power and a childish jealousy and intolerance for any other force which stood in the way of his aspiring ambition. His reputation for double-dealing was best described by a friend of his whom I asked for an opinion about Waters-Taylor. He replied 'To which Waters-Taylor do you refer?'[28]

Mrs Waters-Taylor also drew Meinertzhagen's attention:

> Madame is a most astounding woman, who says whatever enters her head, regardless of propriety or sanity. Her early morning attire is her husband's jodhpur breeches and his pyjama tops. She then rides down to Haifa beach where she bathes in her husband's shirt and shorts. Her day dress is some oriental kit, and in the evening she surpasses herself in some native drapery wrapt round her and enormous silver anklets on her legs.[29]

On one occasion as Meinertzhagen drove along the coast road towards Haifa, he sighted what he believed to be a monk seal, a rare Mediterranean species. Stalking along the coastline to within shooting distance, he was on the point of taking aim when he recognised that his intended quarry was not a seal but Mrs Waters-Taylor, who was 'bathing without bathing costume', while her husband, previously out of sight, sat in a car smoking a huge cigar.[30]

The development of Meinertzhagen's relationship with the chief of staff bore some resemblance to earlier conflicts he had had with other fellow officials. For example, his efforts to discredit Waters-Taylor played some portion in his own dismissal from Allenby's military administration, a

situation that paralleled closely the outcome of his feud with Walter Mayes in East Africa in 1905–6. It is also interesting that the accusations he made against Bols' chief of staff – unscrupulous ambition, self-interest, and a capacity to corrupt an honourable but weak and lazy superior – mirrored exactly the charges he made against General Malleson during the East African campaign in 1915. It was almost as if Meinertzhagen, finding himself out of sympathy with the methods or character of the regime he was serving, needed to embody its faults, as he saw them, in a single person and then make that individual the object of his discontent.

None the less, it is significant that in all three cases the substance, if not the detail, of Meinertzhagen's criticisms was borne out by events. There was little doubt, for instance, that Waters-Taylor was conniving with Muslim parties to forestall both the separation of the various Arab territories – Palestine, Mesopotamia, and Syria – and the implementation of Zionist policy in Palestine. A telegram written by him approving of violent anti-Jewish demonstrations had been intercepted, albeit illegally, by a Jewish postal worker, and passed to a Zionist in London, Dennis Cohen, who had brought it to the attention of the Foreign Office.[31] Meinertzhagen further claimed that, through a courier, Waters-Taylor was in constant communication with Feisal in Damascus, while his wife, disguised as an Arab, secretly visited Haj Amin al Husseini, a leading member of the Palestinian community. Checking the correspondence of his own department, Meinertzhagen came across letters that referred to the chief of staff's encouragement of Prince Feisal to hold out against Britain's pro-Zionist policy.[32]

Armed with this evidence, he took steps to block Waters-Taylor's intrigues, pointing out to Allenby the 'dangerous results of such actions'.[33] The commander in chief, however, although shocked by these revelations about his subordinates, took them as a slight on his administration and refused to act – a decision that seems only to have excited his chief political officer's sense of urgency.

In April 1920 matters in Palestine came to a head. After eighteen months of indecision over which European power would be mandatory for the region, the population had been strained to snapping point. The military governorate, on the other hand, designed only as a temporary holding operation until the Peace Conference could conclude its negotiations, offered no real solutions to either Arab fears or Jewish impatience. It was felt by some, notably by Meinertzhagen, that the festival of Nebi Musa, the most important in the Muslim calendar, and roughly coinciding in date

with the Jewish Passover and Easter, would become a focal point of Arab discontent.

Before the war, although the government in Palestine had been that of an alien power, the Turks were united with the vast majority of the populace by common Islamic faith, and had fully participated in its festivals, providing a band, ordnance, and ammunition for dawn and dusk cannon salutes. As Jerusalem's Governor in 1920, Ronald Storrs, pointed out, British handling of Nebi Musa demanded great sensitivity, since 'it marked too sharply, unless the Administration was prepared for a little give and take, the passing of thirteen hundred years' Islamic theocracy'.[34] The Turkish authorities' professed deference to the religious susceptibilities of their subjects, which had expressed itself in lining the route of the procession with 4,000 troops, was a strategic piety that guarded against the possibility of political agitation. In 1920, however, in spite of warnings from both Meinertzhagen and Weizmann, who had recently returned to Palestine, and in spite of a build-up of anti-Jewish propaganda and tension between the two communities, Bols and Storrs had garrisoned the city with only thirty-three poorly trained police.[35]

By late morning on 4 April, the day of the celebration, it was abundantly clear that all those responsible, from Allenby downwards, had seriously misjudged the atmosphere. The Muslim crowds, roused to violence outside the Mosque of Omar by the inflammatory speeches of Haj Amin al Husseini and other Arab leaders, had marched through the streets attacking Jews and Jewish property. A group of militant Zionists, under the leadership of a Russian, Vladimir Jabotinsky, took immediate retaliatory action, until the British army smothered the disturbances and imposed a curfew. At the end of the violence 5 Jews had been killed and 211 wounded, 18 of them seriously. Arab casualties amounted to 4 killed and 21 others wounded.[36]

Jewish reaction to the disturbances was immediate and impassioned. Even Weizmann, noted for his patience and tact, was deeply shocked by the events; years later he wrote:

It is almost impossible to convey to the outside world the sense of horror and bewilderment which it aroused in our people, both in Palestine and outside. Pogroms in Russia had excited horror and pity, but little surprise; they were seasonal disturbances more or less to be expected round about the Easter and Passover festivals. That such a thing could happen in Palestine two years after the Balfour Declaration, under

British rule . . . was incomprehensible to the Jews, and dreadful beyond belief.[37]

Meinertzhagen's reaction was a mixture of anger and gloomy satisfaction – for the riots had fully vindicated his earlier calls for greater security. They also provided him with the ammunition for a final, devastating salvo at the anti-Semitism of the military government. Four days before the riots he had written to Weizmann, informing his friend of his imminent resignation and his motives: '(a) The solid block of anti-Zionist feeling against [?] our administration which I could no longer endure (b) Serving 2 masters & the prevention of my freely voicing my views to the F.O.'[38] On 14 April, indifferent to the consequences of his insubordination, Meinertzhagen wrote bluntly of administrative negligence in handling the Nebi Musa festival, and of the government's invidious 'Hebraphobia'. The document, which Allenby had read but not sanctioned, was significant for the crisis of loyalty it initiated in the Foreign Office and War Office, and for its (subconsciously) autobiographical imagery.

Zionism is being brought into the world as a discontented child, accustomed only to troubles and disappointment unused to even the care of a foster mother. No policy, still less that of Zionism, can expect healthy growth under such conditions and such treatment becomes all the more harmful when it is entirely opposed to the attitude towards Zionism which pertains to my knowledge in the War Office and the Foreign Office.[39]

The following day Allenby called for his chief political officer to ask for his resignation, and wrote to the War Office more or less forcing them to acquiesce.

From the date in June 1917 of my appointment to the Egyptian Commissionership, I have had on my staff a Chief Political Officer who corresponded directly with the Foreign Office. Hitherto this officer's reports have always been approved by me.

Now it appears that my military administration is to be subjected to uncontrolled criticism by a subordinate member of my staff.

If this is the case I must infer that I have lost the confidence which the War Office has until now reposed in me. Without this confidence it is impossible for me to continue in the execution of my duties as Commander-in-Chief.[40]

Under the threat of the High Commissioner's own resignation, the War Office capitulated. The Foreign Office staff, however, were loath to abandon an officer who had been scrupulously loyal to them, even at the risk of his own career. Although Meinertzhagen himself acknowledged that his letter had made his position untenable: 'a Colonel runs but poor chance against a Field-Marshal of Allenby's calibre, my exit was inevitable from the outset'.[41] Eventually, the latter's towering prestige carried the issue, but not before the Foreign Office had patched together a convenient fudge. A commission of inquiry had been established to investigate the administration's rôle in the Nebi Musa riots, and the extent of its negligence, if any, in failing to anticipate them. The chief political officer would remain in Palestine to attend the hearings and would then be called home for consultation.

After sitting for fifty days and sifting through the testimony of 152 witnesses in eight languages, the commission issued a final report that was never publicly released, in which they were severely critical of the chief political officer.

> Colonel Meinertzhagen's view of his own countrymen's attitudes towards Zionists is so damnatory that it had best be quoted in full. He says, 'I believe that most Englishmen have inherited a dislike for the Jew. I do not think any normal body of British officers could hold the scales equally between Jew and Moslem. I do not think any civil administration could do so unless it had a certain sympathy with the Jewish case' . . . A sweeping statement of this character is extremely difficult to meet. Indeed, it is fairly clear from Colonel Meinertzhagen's own statement that what he demands is not this equal holding of the scales but a definite bias in favour of the Zionists. He is wholly unable to appreciate the justice of the native case which he dismisses contemptuously as superficially justifiable because in his view the Arab is a very inferior person.[42]

It was almost inevitable that a panel largely composed of military personnel, having weighed the endless complaints of two foreign peoples against an administration caught momentarily off guard in the performance of its arduous and thankless duties, would come down on the side of neither Jew nor Arab, but for their fellow Britons and fellow soldiers. In largely whitewashing the governorate's part in the Nebi Musa riots, the panel was considering the general situation, not the specific incident. Moreover, their attack on Meinertzhagen and the post of chief political officer, as one that

offered an opportunity for political interference from outside, a point implicitly aimed at the Foreign Office, represented the defence of men on the spot against the intrigues of Whitehall.

Even before its report was compiled Meinertzhagen had found the commission without real interest or understanding of the issues, and their questions loaded with pro-administration bias.[43] He himself was convinced that there had been a determined effort to sabotage Zionist policy and was violent in his denunciations. As one commentator has pointed out, however, it was 'ironic that such an energetic intruder into policy', as Meinertzhagen himself had been in Paris, 'should later have been so bitter about other officials' disregard for settled policy'.[44] He accused Waters-Taylor of deliberately absenting himself in Jericho on the day of the riots, and claimed to have damning verbatim reports of his conversations with Haj Amin al Husseini only two days after them, in which the chief of staff told the Arab leader that 'I gave you a fine opportunity; for five hours Jerusalem was without military protection; I had hoped you would avail yourself of the opportunity but you have failed.'[45] Storrs too, according to Meinertzhagen, had also indicated his Arab sympathies prior to the riots.[46] In his letter to Lord Curzon of 14 April Meinertzhagen had expressly disavowed the accusation that the Palestine administration as a body had connived at the disturbances, confining his complaints to specific individuals. He later admitted, however, that he had suspected complicity from Allenby downwards.[47]

It was certainly true that many officers, even those sympathetic to the Jewish case, were unenthusiatic about Jewish immigration to Palestine. Meinertzhagen's predecessor, General Gilbert Clayton, whose wide tolerance and 'simple integrity' had been warmly praised by committed Zionists like Weizmann and Norman Bentwich (the Attorney General for Palestine in 1920 and a Jew himself), had written critically of political Zionism. Allenby, who had clearly endorsed Clayton's misgivings of May 1919 about the government's policy, had himself written as late as March 1920, when the Anglo-French division of the Middle East was almost settled and Zionism a *chose jugée*, arguing that the European powers should 'acknowledge the sovereignty of Feisal over an Arab nation or a confederation embracing Syria, Palestine, and Mesopotamia'.[48] Similarly, at the time of the Nebi Musa riots General Bols had criticised the Jewish representative body, the Zionist Commission, for its high-handed interference in the country's administration, and had advocated its dissolution. Anti-Zionist recommendations of this kind, which were often the reasoned (and pre-

scient) objections of intelligent men to a policy that they believed was impracticable, were simply received as clear evidence of the military's anti-Semitism.

After the Nebi Musa riots, however, the precise nature of the administration's attitude to Zionist policy was of little consequence. It mattered only that the Prime Minister, Balfour, and the Foreign Office believed it to be opposed. Meinertzhagen's blunt criticisms in his letter of 14 April, and Allenby's subsequent threat of resignation, which tended to confirm rather than dispel the verity of the former's charges, had created an atmosphere of friction between Whitehall and the Egyptian High Commissioner. In such conditions it was easy to believe the worst of the Palestine administration. Although the inquiry into the Nebi Musa riots had largely vindicated the position of the military, and although Allenby had forced his chief political officer's resignation, Meinertzhagen had ultimately emerged victorious. If his fellow soldiers had closed ranks to exclude him, he had fallen Samson-like, the whole edifice crumbling around him, while distant politicals applauded the strength of his actions.

In June, Meinertzhagen wrote:

> I fought Allenby and his administration on the Zionist question, exposed the lamentable state of affairs to the Foreign Office, succeeded in removing the heads of the Administration and transferring responsibility from the War Office to the Foreign Office, thereby bringing into Palestine a civil Government under Herbert Samuel. My work automatically ceased and my appointment became impossible. Allenby clamoured for my removal and I go, but meanwhile I have done what I set out to do, namely I have set Zionism up in Palestine against a solid block of local opposition.[49]

In a mood of exultant isolation he had arrogated to himself too much of the credit for Zionism's immediate success. Throughout his period in Palestine he had the strong backing of two of Whitehall's most powerful departments. Moreover, his views were aligned not only with those of the Prime Minister, but also other highly influential members of the cabinet like Balfour and Lord Milner. It was likely that settled government policy would have prevailed irrespective of local opposition. However, Meinertzhagen had seen his plans mature and succeed against considerable odds. Months of isolation had made it seem to him at least that Zionism had few allies. Furthermore, his indictment of the administration following Nebi Musa showed considerable political acumen. The riots had almost certainly

been timed to catch the European heads of government in conference at San Remo, where they were drawing up the treaty with Turkey. The news of the disturbances would have been received as an emphatic statement of Zionism's unpopularity. Meinertzhagen's letter, however, diverted attention from the meaning of the protests to the possibility of administrative connivance. Although Lloyd George might not have acted on Meinertzhagen's letter within twenty-four hours, as the latter had later claimed, it had ensured that the transfer of power from a military to a civil government was both inevitable and rapid.

Fortunately, Allenby harboured little resentment against the officer to whom he had owed his success in the Third Battle of Gaza. With patrician condescension he had first asked for Meinertzhagen's resignation then invited him to stay to lunch. When the latter pointed out to his ex-chief that he had given him less notice than he would a housemaid, 'The Bull' roared with laughter. Meinertzhagen, too, lost none of his respect for the Field Marshal: in later life he claimed that after his resignation from the army, Allenby was the only soldier he continued to call 'Sir'.

Yet the mental strain of months of hard work and constant opposition had exhausted Meinertzhagen. The following day he wrote to Allenby:

> I have had literally no leave or rest (except two periods of 10 days) since March 1912, a period of over 8 years, during which time I have had 2½ years in India, 2½ years in East Africa, 1½ years in Egypt and Palestine, 8 months in France and 10 months at the War Office.
>
> I now wish to have 6 months' leave so that I can travel to Cyprus, Crete and Palestine in search of birds.[50]

With characteristic indifference to official sanction for his actions, Meinertzhagen sailed for Crete on 6 June 1920.

1920–24
'The Most Inhuman Machine in the World'

Throughout the period of Meinertzhagen's dispute with Lord Allenby, the Foreign Office had refused to countenance the idea that the chief political officer's behaviour had been in any way irregular. Hubert Young, a wartime colleague of T. E. Lawrence and in 1920 a secretary in the FO's Eastern Department, had written shortly after the rupture that: 'As regards to Colonel Meinertzhagen I am loath to agree to his recall or to any slight being put upon him. He has served the Foreign Office well and loyally and has been perfectly correct in his attitude towards Lord Allenby.'[1]

The permanent Under-Secretary of State for Foreign Affairs, Lord Hardinge, also felt that there was no case to answer.

> He [Allenby] must realise that we cannot take action reflecting upon Colonel Meinertzhagen whom we consider to have acted loyally towards us and correctly towards Lord Allenby. What the latter dislikes is that the military administration should have been criticised by a military officer, but as far as one can judge and from what one hears the criticism is justified.[2]

However, when the High Commissioner's own threat of resignation over-bore all objections and Whitehall was forced to abandon its man on the spot, as a suitable compensation Young proposed a post for Meinertzhagen in the Foreign Office dealing with Palestinian questions. Yet, two months after Lord Hardinge had approached the Foreign Secretary on this issue, the candidate himself remained entirely oblivious of the department's machinations.

On 6 June 1920 Meinertzhagen, satisfying an ambition of more than twenty years, landed at the small port of Candia on the Greek island of Crete.[3] With only his taxidermist, H. L. Powell, a man who had worked for him, on and off, for the previous three years, he set out with a hired team of mules for the island's central mountain range and its 2,500 m summit. After the stress of his post in Palestine his intention was a month of freedom and ornithology wandering the forests and thyme-scented slopes

of Mount Ida. He turned a deaf ear to police strictures about the possibility of robbers, and soon came across their leader, George Nikolokakis, a huge, roughly-bearded Pan-like figure, to whom he took an immediate liking. While Meinertzhagen spent his days in the hospitality of this bandit prince, shooting and skinning the island's montane birds, and the mild summer nights sleeping without tent beneath the open sky, in England, Weizmann and the Foreign Office were working to interrupt his Greek idyll.

If the Zionist leader could not retain Meinertzhagen's services in Herbert Samuel's new civil administration, as he had hoped to do, he was anxious that his friend should be brought home to give substance to the charges he had outlined in his April letter to Curzon. Moreover, the War Office had written to General Bols demanding to know who had sanctioned the ex-chief political officer's six months' leave, and whether he was being paid for it.[4] Shortly afterwards, a telegram was relayed to Meinertzhagen's mountain retreat demanding his immediate return. He bitterly regretted the intrusion, and was further angered to discover on his arrival in Egypt that the military officers there had omitted to inform him earlier that London not Cairo had been the source of the instructions. Retracing his steps to Port Said, two weeks later he set sail for England on the SS *Wahehe* and arrived in Southampton on 6 August 1920.

On his return to London, having sifted through the Eastern Department's files of the last few months, Meinertzhagen was comforted to discover that his Whitehall colleagues had been studiously loyal to him. However, their offer of employment, coming at a time when he had renewed his request for leave, was far from welcome.

> They are a moribund and ineffective department, and I should hate working under such stagnant conditions. Moreover, I wish to cut adrift at any rate for the moment from Zionism. If I do not do so now, I may find it difficult later on. All these reasons I have explained fully to the Foreign Office, in explanation of my refusal to work with them. Their reply is that I am missing a great chance of 'gaining a footing' in an important Government office. My reply to that is that I have a horror of gaining a footing in any Government office.[5]

Under a threat of strike action, the Foreign Office finally consented to his demands for leave, enabling him after almost nine years of travel and continuous bird-collecting to tackle the large number of skins he had accumulated.[6] Early autumn was spent at Tring in the enormous museum of his friend, Lord Walter Rothschild, arranging and cataloguing his

collections of African and Middle Eastern birds. In October he travelled northwards to Scotland and the west-coast home of his old Aysgarth master, George Brooksbank. For the following month he retired to the Outer Hebrides, which were swept for weeks by ferocious Atlantic gales. On some days winds of more than 150 km an hour battered the islands, and migrant blackbirds were bowled along the ground like balls. At 3.00 a.m. on the night of the 15th, he woke to 'a crash and a thump in my bedroom . . . and found a large cabbage had been uprooted from the garden and had come hurtling through my window'.[7] In late November he returned to Brooksbank's large dour house at Taynish, and finally headed south to London leaving the old teacher in his living room 'looking for his clothes with his waders on walking around in deep water'.[8]

At the close of his sabbatical, Meinertzhagen was forced to consider his future. As the war and its aftermath receded from view, he was less and less inclined to return to regimental soldiering.[9] He had been mooted for the post of military attaché in Tokyo, and the idea of Japan and its birds was particularly appealing. However, his ignorance of the language was proving to be a 'fatal disqualification' with the Far Eastern Department, in spite of high recommendations from the Secretary of State for War, Winston Churchill. A Foreign Office minute appended to Meinertzhagen's candidacy for the Japanese post offers an interesting insight into the rumours that attached to his name after his successful demolition activities in Palestine.

> The traditions of the War Office do not preclude the supposition that officers are at times chosen for these outside appointments not on account of any special qualification but in order to get rid of them, either for the time being or definitely. Colonel Meinertzhagen is not, I believe, persona grattissima at the War Office. Possibly the proposals to send him to Japan merely reflect a desire to have him out of the way. I think we ought to renew our objections.[10]

Apart from his lack of Japanese there were other forces also urging him to reconsider the idea of further overseas employment. In August 1920, while he was arranging a selection of wader skins at Tring Museum, the curator, Ernst Hartert, asked if he could show them to an ornithologist acquaintance, Anne Constance Jackson. Meinertzhagen agreed and then proposed that she might keep them. There followed a brief correspondence during his visit to Scotland and in November, at the suggestion of Harry Witherby,[11] another ornithologist and mutual friend, the two arranged

to meet when Miss Jackson visited London.[12] Several months later Meinertzhagen indicated that the occasion had a profound impact on both of them:

> The moment we met it was obvious that the meeting was no ordinary meeting. I fell in love with her in less than five minutes and she apparently did the same with me. My first impulse was to tell her so, and if I had she would have accepted me as her future husband. But I thought that even for me it would be rather soon.[13]

However, a more contemporaneous diary entry, while indicating the direction of his hopes, was far less unequivocal:

> I am torn between two desires, to get abroad and see new country and new birds and plants, and I have also a great desire to have a house full of children of my own, a noisy nursery, a noisy dining room and the chatter and babble of children all over the house; that would entail settling down; it would also mean a wife and at the moment I dare not risk another wife; I feel I should make an admirable father but a rotten husband.[14]

Almost two years earlier, his marriage to Armorel had been legally dissolved in the same atmosphere of bitterness and disillusionment as it had begun. Although just prior to their separation in 1914 Meinertzhagen had been fully informed of her unfaithfulness, five years later he was unwilling to rake up these pre-war affairs as grounds for divorce. Instead, he submitted to Armorel's proposal that he himself provide the evidence necessary for an annulment. In February 1919, after several weeks at the Paris Peace Conference, he crossed to England, took a room in London's Charing Cross Hotel, and arranged that he should be seen in his room with a prostitute. Having armed his wife's solicitor with this contrived evidence of infidelity, Meinertzhagen, with bitter humour, asked that the solicitor's clerk and the obligatory witness – a chambermaid – should meet him with the formal papers at the monkey house in Regent's Park Zoo.

> So at 4 p.m. today amid the jabberings of the simian world, the pair of them arrived, the one to serve me with some papers and demand a receipt, the other to recognise me and I solemnly signed the receipt to which representatives of the Monkies [*sic*] of the World bore witness.[15]

In spite of the unmitigated failure of his previous marriage, in February 1921 Meinertzhagen approached the possibility of a second with something

less than caution. After renewed correspondence on the issue of some golden plover skins, Anne Jackson made a second visit to London. Following an evening at the theatre to see *The Betrothal* – 'which did not improve matters' – the couple visited Tring together, ostensibly for ornithological purposes. Two days later, in the same zoo where Meinertzhagen had finally severed ties with Armorel, he explained to Anne the entire history of his previous marriage, with the professed intention of discouraging her. However, his confessions clearly had the contrary effect, and before parting she agreed to meet again to give her answer to his proposal. On 8 February, beneath the statue of energy in Kensington Gardens, she consented. Meinertzhagen was elated, and after a second night at the theatre – *The Great Lover* – he wrote: 'I am intensely happy and feel that at last I have got the full portion of eternal happiness.'[16]

The following morning they made arrangements for their wedding with the same breathtaking, almost comical haste that had characterised their courtship. They initially agreed to marry on 28 April, ten weeks hence. However, by lunchtime this had been altered to 16 April. At tea that date was still considered to entail too long an engagement and they brought it forward to 3 April. 'But even this proved to be too far ahead and after dinner it was definitely decided that there was no reason for us to wait beyond my birthday, March 3rd.'[17]

In February 1921 Anne Constance Jackson was a dark-haired and gentle-featured woman in her thirty-second year. Her father, Randle Jackson, had been a major in the Fife Light Horse Volunteers and had owned estates at Swordale in northern Scotland and at Upwell, near Wisbech, in Norfolk. He died when Anne and her only sister Dorothy were still young, and their mother, Emily, had allowed the daughters to follow their own unconventional interests, both of them studying zoology at Imperial College, London. In 1915 Anne had been elected an honorary female member of the British Ornithologists' Union, and at the time of her marriage to Meinertzhagen she was a noted authority on ducks and waders, having contributed to books and journals on the subject.

Not surprisingly, their wedding celebrations were an affair dominated by birds. In the spring issue of *The Ibis* (the journal of the BOU) a small notice announced the union of 'two well-known ornithologists and members of the British Ornithologists' Union . . . an event unique in our history'. On the eve of the wedding, at a Claridge's dinner party, all the guests apart from Meinertzhagen's sister Mary were ornithologists, and according to the former 'all talked birds' the whole evening. Even the

menus were decorated with illustrations of sea eagle and black kite. The following day, after a simple ceremony at a South Kensington registry office, they were joined for an 'old-fashioned wedding breakfast' by one of Meinertzhagen's colleagues from his period in the Middle East – Lord Willy Percy[18] (another noted ornithologist) – and Freddie Guest, who was to become the Air Minister for the government the following month. That evening, also Meinertzhagen's forty-third birthday, he wrote: 'Not till today have I realised real happiness, not till today have I realised what the love of a good woman means.' The couple had known each other for only a fraction more than three months.

On the same morning as the wedding, Freddie Guest's cousin, Winston Churchill, and his wife had embarked on the French steamship *Sphinx* for Alexandria in Egypt. Churchill had recently taken over the seals of the Colonial Office from Lord Milner on 13 February 1921 and had quickly convened a meeting of the principal British administrators in the Middle East, including the High Commissioner in Baghdad, Sir Percy Cox, Gertrude Bell, his oriental secretary, General Haldane – the British commander in Mesopotamia, the Chief of Air Staff, Sir Hugh Trenchard, as well as Sir Herbert Samuel, General Congreve, Hubert Young and T. E. Lawrence. The Cairo Conference, as it was called, was a final attempt by the government to give substance to its wartime promises to the Arabs, and to come to terms with the enormous changes that had taken place since the close of the war eighteen months earlier. Churchill, a restless, dynamic forty-seven year old, one of the youngest men in Lloyd George's cabinet, with fifteen years of government appointments behind him and an uncanny instinct for trouble, intended to push through a series of radical solutions to the region's mounting problems.

Since Meinertzhagen's departure from Palestine in the spring of 1920, events in the surrounding region, particularly Syria, Mesopotamia, and Turkey had moved at an alarming pace. In spite of British efforts to establish cordial relations between Prince Feisal – the chosen spokesman of the Syrian Arabs – and the French, the two powers had polarised into bitter conflict. Unable to curb the demands of the quasi-representative Arab body, the Syrian Congress, Feisal was swept along on a tide of nationalist, anti-French feeling, which resulted in the declaration of an independent Syrian state incorporating both Palestine and the Lebanon. In July 1920, the French commander in chief issued an immediate ultimatum for Arab acceptance of the French mandate for Syria, the punishment of those hostile to the French, the reduction of Arab forces, and the French

occupation of Aleppo and other key areas in Arab territory. Although these high-handed demands were finally conceded by the Syrian monarch, the French refused even to accept his peaceful submission, and invaded. Abandoned by the British, defeated and deposed by the French, and then finally rejected by his own people as a weak and vacillating puppet, Feisal faced complete humiliation. On his journey into exile he was received at Ludd in Palestine with embarrassed courtesy by Herbert Samuel, who mounted a guard of honour a hundred strong. The Egyptian Sultanate, however, refused '"to recognise" him, and at Quantara station he awaited his train sitting on his luggage'.[19]

Feisal's dismissal from Syria had coincided with further reverses to government policy in Mesopotamia, Turkey, and Palestine. In the former, the Muslim population, exasperated by Britain's three years of procrastination in establishing an Arab administration, expressed its discontent in widespread armed revolt. Only after considerable casualties and at enormous expense did the forces under Haldane succeed in containing the violence. And no sooner had a precarious ceasefire been imposed than Britain experienced serious difficulties in Turkey. For almost two years the government had supported the Greeks in their efforts to wrest a large portion of western Turkey from the Ottomans, a policy that was forcefully pressed by Lloyd George himself against increasing cabinet opposition. In the eyes of many, an openly hostile stance towards Turkey ran counter to Britain's interests as a major Islamic power, and risked the possibility of armed Muslim rebellion in India and elsewhere in the empire. At the War Office, Churchill and his Chief of Imperial General Staff, Henry Wilson, also condemned a pro-Greek policy on the ground that it forced the Turks into the arms of the Russian Bolshevics, a development that might threaten all of Britain's wartime gains in the Middle East.[20]

In November 1920, on top of these setbacks, a crisis situation developed in eastern Palestine. Abdullah, Feisal's elder brother, outraged by the Feisal's deposition, set out from the Hejaz with an army of bedouin and the professed intention of conquering Syria and re-establishing an independent Arab government. As he moved northwards towards Syria and into the eastern portion of Britain's Palestinian territory, known as Transjordan, the army commander, Congreve, wrote to London expressing fears that the British forces were insufficient to resist the Sharifian army. As a solution, he argued that the whole of Transjordan should be severed from the area assigned for Jewish immigration in coastal Palestine and given up to an Arab administration.[21]

In an attempt to unravel this array of Middle Eastern problems and to enforce drastic economies on a region that in the previous year had cost the British taxpayer in excess of £37,000,000, Churchill demanded and won sweeping powers for his new office. The responsibilities that had been previously split between the Foreign Office, War Office, and India Office were to be placed with a specially created Middle East Department under Churchill himself. Here, he gathered around him a team of experts that has been described as having 'more "man on the spot" knowledge of those territories and probably less experience of the techniques of civil administration than had ever been assembled in a department of the Colonial Office'.[22] John Shuckburgh, a cautious, competent, India Office man, who, according to Curzon, was 'the best drafter of an official telegram' he had ever known,[23] was to head the department, with Hubert Young as his assistant. Churchill had also tempted the reclusive Lawrence out of his bolt-hole in Oxford, where he had received a fellowship at All Souls College, to join him as expert on Arab affairs. To these he then wished to add a military adviser.

On 8 January 1921, while he was still Secretary of State for War, Churchill wrote to Curzon at the Foreign Office, informing him that he wanted 'Meinertzhagen for the Middle East department; so I will leave the WO to suggest to you another attaché for Japan'.[24] The same day he, Freddie Guest, and his intended military adviser met for lunch at the Embassy Club on Bond Street to discuss the political problems in Mesopotamia and the possibility of a future appointment for Meinertzhagen. Initially, the latter had baulked at the idea of another post dealing with Middle Eastern issues and pressed his case for the job in Tokyo. But the War Minister insisted that Meinertzhagen would be of greater value dealing with a region he knew well, and informed him that he had already cancelled his Japanese appointment. A month later an appeal to Meinertzhagen from the Director of Military Operations, General Radcliffe, saying that '. . . it would mean much to the C.I.G.S. and all of the General Staff to have a man they know . . . in that position', otherwise 'we shall always be nervous as to what the new Department may be at',[25] eventually flattered him into submission.

So to-day I . . . had an interview with Winston Churchill. He told me that it was wicked of me to think of going to Japan and cut adrift from the Near East after all I had learned of that region . . . He therefore wanted me to come into the New Middle East Department as Military Adviser

and Inspector-General of local troops in Palestine, Aden and Mesopo-
tamia. Meanwhile he wished me to go to Cairo with him for the coming
conference. I explained to him that I had arranged to get married on the
very day he sails, and I offered to start the next day, but he at once said
that I had better remain in England . . .'[26]

When Meinertzhagen started his new post over two months later, on 9 May
1921, he was dismayed by the situation that greeted him. In a matter of
days the Cairo Conference had redrawn the political boundaries of the
Middle East (along lines that have more or less endured until the present)
and swept through a series of radical and innovative changes in military
policy. In order to diffuse the continuing tension in Mesopotamia, Prince
Feisal had been foisted onto the country as its monarch and the head of a
new Arab government. A rigged plebiscite had given the decision a vague
air of legitimacy, although the abduction of the only viable opponent and
the massive ninety-seven per cent pro-Feisal vote were equally unconvinc-
ing. In Transjordan, the Conference had accepted Abdullah's presence as a
fait accompli, and built a policy around him, largely along the lines of
Congreve's recommendations. Jewish immigration was disallowed, and an
entirely Arab administration, subject only to British political advisers and
military assistance, was established in the region. As Churchill's
biographer, Martin Gilbert, concluded, 'In three days, two new Arab states
had been created, their sovereigns chosen, and a part of the Zionist cause
lost by default.'[27]

Meinertzhagen's response verged on violence:

I told Shuckburgh I wished to see Churchill on the question; he told me
it was no good as the matter was settled; so I rang up Eddy Marsh
[Churchill's personal secretary] and told him I must see the S. of S. at
once and down I went foaming at the mouth with anger and indignation.
Churchill heard me out; I told him it was grossly unfair to the Jews, that
it was yet another promise broken and that it was a most dishonest act,
that the Balfour Declaration was being torn up by degrees and that the
official policy of H.M.G. to establish a Home for the Jews in Biblical
Palestine was being sabotaged . . .[28]

Churchill 'saw the force' of his argument and promised to consider his
proposal that Abdullah's tenure of Transjordan was limited to only seven
years, but Meinertzhagen left 'thoroughly disgusted'.

He was equally alarmed to discover that Sir Herbert Samuel had

appointed Haj Amin al Husseini as the Mufti of Jerusalem. After the riots of Easter 1920, when his inflammatory speeches had incited the crowds to violence, the Husseini had been sentenced *in absentia* to ten years' imprisonment. However, on taking up his post as the High Commissioner, Samuel had reprieved Husseini, and in the hope of making a responsible moderate out of a dangerous extremist offered him the religious office of Mufti, also a position of great political influence amongst Palestine's Muslim population. Before he had left Palestine in 1920, Meinertzhagen had written a memorandum informing the new head of government of the dangers involved in such an appointment. He now warned Churchill 'without mincing words of the harm we must expect from such a scoundrel', a prediction that was entirely borne out by events.[29]

On another occasion Meinertzhagen clashed with his equally volatile superior on the issue of white settlement in East Africa. He upbraided Churchill for encouraging white immigration, pointing out that this was in contradiction of what Churchill himself had written in *My African Journey* in 1908. 'By changing his mind,' Meinertzhagen argued, 'he was laying the seeds of trouble, that Africa belonged to the Africans and that in another 50 years when the African is educated, there is bound to be serious trouble.'

> Winston was rather astonished that I should attack him in his own office; he said he had a perfect right to change his mind as often as he wished and what did I know about Kenya; so I told him; he became angry so I left the room after telling him that I knew I was right and that by encouraging the white settlers he was sentencing them to death. He banged his fist on the table and said, 'Rubbish'. I nearly slammed the door to show my displeasure.[30]

On top of these disagreements life for Meinertzhagen in the new office was far from easy. 'Working like a Trojan himself and expecting equally hard work from his staff,'[31] Churchill was a tough master to serve. He had promised Lloyd George huge reductions in military expenditure in the Middle East and was fastidious in rooting out waste. Typical of his restless, probing mind was a minute written on 26 July to Meinertzhagen and Vernon, the financial adviser, asking them to explain 'why it is that you consider it a natural and legitimate thing that 3 British Infantry battalions and a cavalry regiment . . . should require 2,000 other British corps and departments at a cost of £735,000 a year? And why 5 Indian infantry battalions require 5,400 other Indian ranks and corps to look after them?' He demanded to see sketch establishments showing how the 7,400 non-

combatants were made up, setting out the actual staff 'in exact detail . . . down to the lowest clerk'.[32]

Problems like these prompted Meinertzhagen to consider briefly a number of offers of alternative employment. He had earlier been considered for the post of secret intelligence chief in Ireland, but had refused it on the grounds that it involved separation from Anne. The possibility of work in the Special Section of the Metropolitan Police, and even a seat in parliament – that of Oscar Guest[33] – had both flattered him, but were declined as uncongenial. Retirement on army half-pay was no real solution since it offered little scope for furthering the causes – principally Zionism – that he espoused. He therefore resolved to continue in government service, where his efforts could be most effective.[34]

As in Palestine the previous year, Meinertzhagen saw his rôle as opposing those he believed to be 'hebraphobe', which included anybody who, unlike himself, had difficulty in solving the political equation in Palestine. In the Middle East Department he found the cautious Shuckburgh 'the worst offender', although Hubert Young and Lawrence were both suspect, since they strongly supported Whitehall's official pro-Arab policy and 'frowned on the equally official policy based on the Balfour Declaration'. With an unabashed disregard for consistency, Meinertzhagen concluded that 'the latter is the only policy I recognise'.[35] According to his military adviser, even Churchill himself did 'not care or know much about it'; while Herbert Samuel, the man whom only twelve months before he had recommended to govern Palestine, was dismissed as weak.[36] Riots involving Jews and Arabs had broken out near Jaffa in May 1921 and these had been the signal for widespread racial fighting. Samuel, convinced by this unrest of the need to allay Arab fears, temporarily suspended Jewish immigration to Palestine and made moves to establish some form of representative government. It was obvious that uncertainty about Britain's Zionist intentions was still a major cause of Arab discontent, and Samuel hoped that by securing an authoritative restatement of policy, its moderation would be recognised and would diffuse the tensions. Meinertzhagen, however, interpreted these developments as the Palestine administration being intimidated into concessions, and recommended with characteristic force that the Arabs receive 'a good sound punishment for breaking the peace and killing Jews'.[37]

Unfortunately, Meinertzhagen's strongly pro-Zionist allegiances made him an immediate suspect when it was discovered that Weizmann was gaining access to secret telegrams and dispatches coming in and out of the

Middle East Department. On 14 June 1922 Meinertzhagen recorded in his diary that:

> Churchill sent for me . . . He was most concerned about the leakage and I gathered that I was under suspicion. I told him that if he was not satisfied I would resign my position as Military Adviser. It is all very unpleasant. He said he did not wish me to go but again begged me to be most careful in my conversations with Weizmann. Churchill is clearly much upset about it and I feel I am under suspicion; I told him so and repeated my offer to resign which he refused to accept.[38]

Meinertzhagen's rebuttal of the accusations and his later statement, which appeared in the *Middle East Diary*,[39] that he suspected a junior member of the department, a Jew, whom he had seen leaving Weizmann's house, might seem rather disingenuous in the light of the fact that the following year he definitely did leak information to the Zionists. In an interview with Leonard Stein,[40] Meinertzhagen revealed full, secret details of a meeting of a cabinet sub-committee – a disclosure so disquieting to the Zionists that Weizmann was urged to return from a visit to Europe immediately. Since Meinertzhagen was prepared to divulge confidential information to a man with whom he had only official contact, and then only seldom, it seems most likely, in fact almost certain, that the flow of information between the military adviser and his close friend, Weizmann, was far greater. Indeed, on the latter's return to England, only a fortnight after Stein's summons, he launched into a round of talks with Meinertzhagen.

In October 1922 Meinertzhagen left the Colonial Office for a lengthy tour of the Middle East, principally for the purpose of inspecting the local levies organised to replace the British forces which Churchill's cuts had brought home. On his return to England six months later, in April 1923, he found the situation at the Middle East Department much changed. A general election, precipitated by the refusal of many Tories to co-operate in Lloyd George's coalition government, had forced Churchill out of the Colonial Office and replaced him with the Conservative Duke of Devonshire. The military adviser found his new chief 'supremely ignorant'.

> I could not help noting the difference between dealing with him and Winston, the latter knowing the geographies of the countries well and understanding the problems. The Duke appeared sleepy but pleasant. I should say that his main assets are integrity and solid common sense with little originality or drive. At the Colonial Office he is certainly a rest after

Winston, but I think I prefer the fulminations of the latter to the ducal yawns.[41]

Wary of Devonshire's apathy and of the strongly pro-Arab lobby amongst many Conservative MPs, led notably by Sir William Joynson-Hicks, one of the Treasury secretaries, Meinertzhagen persisted in his belief that the government's Zionist policy was threatened – a siege mentality that did not seem to take account of the current of events since his period as chief political officer. Despite the Arab riots in April 1920 and again in May 1921, and Samuel's temporary suspension of Jewish immigration, an influx of Eastern Europeans had continued to arrive in Palestine's ports throughout the first years of the Mandate. Moreover, a government White Paper in June 1922 had upheld Britain's commitment to a Jewish National Home (although in a form mildly diluted from that expressed in the Balfour Declaration), and a month later the League of Nations ratified Britain's Mandate for Palestine, giving legal status and international recognition to Zionism. The various Arab delegations that had visited Britain in the hope of reversing the government's commitment to the Jews had all returned empty-handed. Even Samuel's efforts to implement restricted forms of representative government, albeit as a palliative for the Balfour Declaration, had foundered in the face of Arab non-participation, and had left the Muslim community at a serious disadvantage in the business of political lobbying.

In spite of this slow but steady hardening of Britain's position vis à vis the National Home, Meinertzhagen remained on his guard. He was stridently critical of those who opposed Zionism. Joynson-Hicks, for example, was 'a dangerous little man when he meddles with Imperial Strategy, and my short acquaintance with him has led me to both mistrust and despise him'.[42] When discussing Zionism, Meinertzhagen's tone and language oscillated between the grimly apocalyptic and the unrealistically sanguine. On the one hand, he frequently saw the future as bleak, the Zionist ideal being 'strangled at birth', 'torn up by degrees', 'wrecked on the rocks'. On the other hand, he swept aside Arab opposition to the Jewish National Home as meaningless and irrelevant – an artificial vapour that would evaporate once the sweet sunlight of Jewish reason had come to work upon the Holy Land. Where others predicted a beleaguered British administration presiding fruitlessly over ungrateful and mutually hostile Semitic communities, Meinertzhagen envisaged a contented commonwealth regenerated by Jewish enterprise, and a new and exemplary population, grateful for, and adding to, British imperial might.

Yet so positive a vision of the Zionist experiment took no account either of the groundswell of doubts and reservations which British officials in the Middle East had voiced since the capture of Palestine, nor did it fully comprehend or recognise the deeply felt opposition of the indigenous Muslim and Christian Palestinians. Taking an unequivocally one-sided view of the country's political future, Meinertzhagen bracketed all opposition, from the fair-minded and democratic probings of Herbert Samuel and his saintly Chief Secretary, Wyndham Deedes, to the fanatical ravings of Haj Amin al Husseini, as crude hebraphobia. Instead of the infinitely complex grisaille, the style of representation most appropriate to the Palestinian situation, Meinertzhagen chose to render it as a simple line drawing, with clear cut moral and political choices.

This mixture of hope and anguish was clearly demonstrated during a number of discussions by the cabinet sub-committee held on the return of Sir Herbert Samuel to England in June 1923. Under the chairmanship of the Colonial Secretary, these meetings were intended to consider ways of softening Arab opposition to government policy. Curzon, the Foreign Secretary, put forward proposals for an Arab Agency along the lines of the existing Jewish equivalent, the Zionist Commission, whose status was guaranteed by the ratified Mandate. Meinertzhagen, who was present at all the meetings, was dismayed by these developments and expressed his doubts to Samuel in a letter on 18 July.

I have always held the view opposition to Zionism is largely artificial, and that it is by artificial intrigue and to satisfy personal aims that the Arab bogey has been kept alive. I think your experience in Palestine is that if left alone the Jew can live at peace with the Arab, their aims and ideals being identical . . . I frankly cannot understand the necessity for an Arab body to counteract the alleged preferential treatment given to the Zionist Commission in Palestine. The Mandate with purpose gave the Jews a moral preferential status in Palestine and this is expressed in practical shape by the Zionist Commission . . . An Arab body, appointed by H.M.G. and presumably on equal terms with the Zionist Commission is another attempt to make Zionism a failure whilst still in its infancy. It deprives the Zionists of their trump card and demonstrates to the world that no matter what was said in the Mandate, Great Britain intends it to be inoperative . . . Finally, I trust that no decision will be reached without giving an opportunity to those whom it most concerns to state their case. Is it fair that the Zionists should have their whole

future, policy, ideals wrecked on the rocks of prejudice, ignorance and anti-semitism . . .[43]

During his period at the Colonial Office, in spite of his clear allegiance, perhaps as a consequence of it, Meinertzhagen made a smaller contribution to the Jewish cause than he might otherwise have done. Since 1919 he had risen rapidly as an expert on Middle Eastern affairs. He was a hard-working, clear-minded adviser, and there is little doubt that he enjoyed wide respect from the Prime Minister downwards.[44] And yet his passionate advocacy of Zion, and the question of his reliability that this gave rise to in the Colonial Office, possibly tended to neutralise his influence.

In March 1924 Meinertzhagen's post at the Middle East Department came to a close, and he left the office with mixed feelings:

> I shall always look back on my time in the Colonial Office with pleasure. I have learned a lot and have had a unique experience. Much as I have been absorbed in the work, I never again wish to serve in a Government Office in London. The machinery of an ancient hide-bound concern like the CO is too slow for description and exercises a harmful influence if one is ever going to work abroad again. The moral tone . . . is most depressing and more than once I have rebelled against it . . . I fancy it is the most inhuman machine in the world. Heavens knows why we have not lost all our colonies long ago.[45]

Without a definite appointment to go to, he had been requested to travel to India the following winter to join the first battalion of his new regiment, the Duke of Cornwall's Light Infantry; meanwhile, he was told to contact the second battalion on service in Cologne. For Meinertzhagen the news was 'disturbing'.[46]

1924–30
The Killing Age

In 1924 Meinertzhagen's career had reached an important watershed: he was not enthusiastic about returning to a purely military lifestyle; on the other hand, he had no wish to continue in administrative rôles like the one he had recently left. In four years he had declined as many high-ranking posts: as the chief of the Irish intelligence service, Assistant Commissioner of the Metropolitan Police, the Inspector-General of British West African Forces, and as the Governor of the Falklands, the latter with the promise of a larger colony shortly after.[1]

Following a brief period in Germany – where he experienced homesickness 'for the first time in my life' – and a short ornithological visit to Madeira and the Desertas Islands, he was called by the War Office to set sail for India in December. Prior to the journey he had written: 'I dislike the prospect of leaving Annie . . . but unless I were to resign I do not see how it can be avoided.'[2] Midway across the Arabian Sea this option, mooted only eight weeks before, had become his chosen course of action, and with characteristic thoroughness Meinertzhagen listed his reasons in numerical order in his diary.

Regimental soldiering was no longer adequate compensation for his loss of homelife, particularly since his interest in the army had declined in inverse proportion to the revival of his 'old love – natural history'. Most of his old army colleagues had been killed during the war, and he felt unable to establish new friendships of equal depth; while the change of regiment had also been a 'wrench and strain'. Although he would have been enthusiastic to command a battalion of the Royal Fusiliers, the Duke of Cornwall's Light Infantry meant nothing to him. Moreover, the army was not what it used to be: it was harder work with less freedom, and his relations with the War Office had steadily deteriorated over the years. Even the post of chief political officer had not been 'entirely congenial', and had it not been for Sir Henry Wilson, the CIGS, he would have declined his work at the Colonial Office. Point nine was of particular interest and signified an important development for Meinertzhagen: 'I have a growing tendency to dislike the idea of devoting one's whole life to training men to

kill their fellow creatures. Before the war death meant little to me. It now revolts my feelings. The cruelty of it all disgusts me and I try not to think about it.'[3]

In 1925 he was forty-seven. Considering his age, his health was exceptional, although since Tanga, eleven years earlier, his eyes had been susceptible to the heat and glare of tropical climates, which brought on severe headaches. If retirement was left much later he would be too old to fulfil the personal ambitions he still held. Above everything else were considerations of his wife. Her wishes had been the decisive factor in refusing all the appointments, from the military attaché's post in Tokyo to the Governorship of the Falklands. However, he claimed not to regret these missed opportunities; he was not an ambitious man, and 'her happiness counts for more than any worldly advancement'. His 'intense desire' now 'was to travel in search of ornithological knowledge in company with Annie' – a lifestyle their financial position would easily accommodate. After twenty-five years' service his army pension would be £420, barely less than half the income he would receive as a fully serving colonel, and only £100 less than the pension received after five further years' service. These army payments and his earnings from investments combined with those of his wife, which accounted for more than half of the total, amounted to a gross income of £4,560[4] – a figure with a purchasing power greater than a present-day income of £80,000. On his arrival in Lucknow on 26 January 1925 Meinertzhagen delivered his resignation.

Thus closed the twenty-five years of his official career – the best known and the best documented period of his life. Although subsequent appraisal of him has focused on this time, and although he himself gave a fuller picture in his published diaries of this quarter century than any other portion, it would be false to see it as a climax from which he made a slow and relatively uneventful descent into old age. One could possibly argue with greater justification that the career that made his name was a long interlude in a lifetime of privately funded scientific study. From 1925 onwards he pursued ornithology with the same energy and vigour as he had previously brought to bear on soldiering. On several occasions Meinertzhagen stated publicly that his primary interest in life had been natural history.

Although the conventional approach to his two interests, military and ornithological, would be to place them at opposite ends of a spectrum – one serious, the other perhaps rather frivolous, one devoted to taking life, the other to appreciating and in some way enhancing it – it would be inaccurate

to impose on him any kind of schizophrenic double nature. The rôles of soldier and natural scientist were more tightly fused together in Meinertzhagen's life than in anyone else with a dual interest of this nature. In two prominent twentieth-century soldiers who were also keen ornithologists – Field Marshal Edmund Allenby and Viscount Alanbrooke – their interest in the subject can be seen, almost certainly correctly, as a restful diversion from the main business of soldiering. To Meinertzhagen, however, the two were of equal importance.

This combination of interests was almost certainly less unusual than it might appear. There is a perhaps surprising historical association between an interest in nature and the personnel of the armed services, particularly those who occupied the higher ranks. In the nineteenth and early twentieth centuries, for the social classes from which these officers were generally drawn, nature formed an important focus of recreation and social life. The rent of a large Scottish house and estate for the grouse shooting and fishing in early autumn was an important social ritual for Meinertzhagen, as indeed it was for Allenby, Air Marshal Trenchard, and Major-General Percy Cox – all of whom were Meinerzhagen's friends. Similarly, the weekend at the country house, the plus-fours and gaiters, the beaters and copses stocked with hand-reared pheasants, were as important to British social and commercial life as afternoon tea or the business lunch. Certainly, Daniel Meinertzhagen, like his second son, was a regular guest and host of such events. It was perhaps natural that those who enjoyed outdoor life and who regularly indulged in the ritual slaughter of Britain's wildlife should have taken interest in the quarry species themselves.

For the personnel of the armed services there were other important points of contact between their profession and hobby. The use of firearms was clearly central to both. The facility to travel widely throughout the world, particularly to areas where the fauna was more diverse, more abundant, and almost unknown compared with Britain's, was also of importance. But perhaps the closest the two activities came to one another was in big-game hunting. Whether the objective was to bag a white rhinoceros or to quell a party of Nandi warriors, the requirements for success were essentially the same: a considerable degree of skill and discipline with a rifle, cool nerves under stress, stealth, physical fitness, courage, and a full understanding of the quarry. The nature of the experience itself was also remarkably similar – a mixture of dangerous excitement and fear, with the constant threat of injury and possibly death. Hunting, the conventional testing ground of manhood (and less frequently, womanhood), proved to

be a magnet for Meinertzhagen, and there is little doubt that for ten years, 1899–1909, he was a passionate and skilful hunter.

His diary account of this decade, nine-tenths of which was spent abroad, is a continuous chronicle of hunting adventures. He kept a meticulous tally of his bag and often gave a detailed description of individual hunts, illustrating them with maps and diagrams. This attentiveness to slaughter, fully represented in the *Kenya Diary*, has earned Meinertzhagen a reputation as a killer of unspeakable cruelty. The reviews following the reissue of the *Kenya Diary* in 1983, for example, spoke of 'chilling heartlessness',[5] 'gleeful slaughter',[6] 'a professional killer',[7] an 'old brute'[8] and 'a shrewd swine'.[9] There is no doubt that most of this moral condemnation was aimed at his ruthless tactics during the punitive expeditions against tribal Africans. None the less, considerable opprobrium was heaped on his activities as a hunter. Elspeth Huxley, in the preface, wrote: 'The tally of slaughtered animals, then present in such astonishing abundance, seems nauseating . . . He had only to see an animal, provided he was reasonably sure it was a male, to shoot it.' Meinertzhagen's responses to wildlife and hunting are worth examining in some detail: not only do they illustrate the recurrent contradictions in his nature, but they also reveal that he often fell far short of the received images of savagery which are frequently applied to him.

Firstly, it is wrong to see the four years of his East African service as a period of exorcism, in which the furies that had lurked beneath the surface of his genteel Victorian childhood had poured forth in a few years of concentrated slaughter; an interpretation that has possibly been encouraged by Meinertzhagen's retrospective assessment of the *Kenya Diary*: 'When I arrived in the country I was obsessed by an unashamed blood-lust. Hunting is man's primitive instinct, and I indulged it and enjoyed it to the full.'[10] However, the real antecedents of his interest in hunting lay not in a lifetime's repression in Hampshire, but in several years of big-game hunting in southern India and Burma, where he had already shot tiger, leopard, gaur, sambhar, and chital. Similarly, after leaving East Africa he continued to hunt, although perhaps not with the same intensity, for a further four years. Owing to the undeveloped conditions of East Africa and the greater abundance of game on its plains, this country provided the greatest opportunity for hunting; but the period should be seen as the apex of a ten-year curve, not an unprecedented or unbridled release of demons.

The statistics of Meinertzhagen's East African bag also deserve greater scrutiny. The *Kenya Diary* was almost certainly not, as one reviewer

suggested, a carefully and dishonestly designed autobiography packaged as diary,[11] but rather an authentic blow by blow account. Apart from a few deletions to avoid possible libel actions and the correction of English at the manuscript stage, the book is almost identical to the original diaries in Rhodes House Library. At the start of the first volume of the Rhodes House version Meinertzhagen wrote: 'During 1907 I typed out my 1899–1906 manuscript diaries and placed them in loose-leaf books. Nothing material was altered although I often corrected my bad English and spelling.' If one accepts that this surviving version is identical to the contemporaneous hand-written version, then one has a fairly full picture of Meinertzhagen's hunting activities in East Africa. Yet the full list of mammals and reptiles shot is only 216 of approximately 45 species – a total that averages out at little more than 5.5 animals each month.[12] This is not a particularly damning tally, since, as Meinertzhagen himself said, three-quarters of them provided meat for large numbers of porters, retainers, and levies.[13]

This becomes an almost insignificant bag when one compares it with the slaughter carried out by a truly professional hunter like W. Buckley, who in a single morning's work could bring down eight bull elephants. The ivory from these four brace alone he sold 'off-hand' for £500. In his remarkably dull account of a twenty-year career, during which time he killed many thousands of large mammals, Buckley could summon only a single regret. 'I have an uncomfortable feeling,' he wrote wistfully, 'that if elephants had not been so ruthlessly and persistently hunted . . . [they] would have been turned into useful domestic animals.'[14] During a shooting trip in East Africa in 1907 Winston Churchill and his entourage killed twenty-three species – half of Meinertzhagen's species count – in only ten days. Basing a total figure on the highly unlikely assumption that they shot only a single of each species, one still ends up with a tally greater than a tenth of Meinertzhagen's entire kill; and most probably it was closer to a half.[15] In Sudan in the 1930s, Wilfred Thesiger, a judicious and discriminating big-game hunter, shot an average of more than a lion a month for five years – a grand total of seventy.[16] Such comparisons do not excuse Meinertzhagen's relish for blood, but they help to give it context. For 200 years, 1740–1940, the majority of Europeans travelling in Africa saw big-game hunting as no more immoral or cruel than the steak dinner to which the reader of this book might look forward on finishing the chapter.

It is perhaps more puzzling that hunters and explorers of an international reputation – like Jim Corbett, Richard Meinertzhagen, Wilfred Thesiger,

and Laurens van der Post – could combine a passion for hunting with an equally strong concern for game protection. In Meinertzhagen this conflict of apparently opposing emotional responses to wildlife is particularly acute. And it is these striking contrasts in his relationship with the natural world that make him particularly interesting.

In early manhood he showed remarkable foresight with regard to the issue of conservation; in East Africa, for example, in 1904, he had pressed for the establishment of game reserves under the control of independent trustees based in London.[17] In 1909, en route to England from South Africa, he visited a whaling station in the South Atlantic, where he wrote about the consequences of this particular form of hunting with considerable vision:

> From the North Atlantic they have been sadly thinned out and experience shows that once these, the largest creature the world has ever seen, have been reduced to a certain level they are beyond the power of recovery. They are harmless creatures and ever a source of joy and wonderment to travellers on the sea. We of this generation shall have a sad tale of slaughter and extermination to bequeath to our children. We may well be dubbed 'The killing age'.[18]

And yet this modernity went hand in hand with lively Victorian prejudices. In 1901, for instance, in southern India, he wrote: 'On the way in from the Kundahs today I passed many hundreds of snakes all in pairs and "in copula". They were all of the same species – Zamenis diadema. I killed a large number. I always kill snakes on principle.'[19] Crocodiles too came in for the same rough treatment.[20] Even in 1955 he still refused to accept ornithological records based solely on observation, and was only prepared to consider them if he could handle the prepared corpse of the individual birds in question.[21]

So often, as in these instances, the basis of his approach could be found in his nineteenth-century upbringing. By the time of his childhood in the eighties and nineties, the golden age of natural-historical discovery was drawing to a close. The principal ground rules and theories had already been laid down and the primary dramatis personae – Darwin, Wallace, Huxley, Newton, Gould, Hume, Hodgson – were either dead or old men. It is significant that in Meinertzhagen's three-quarters of a million kilometres of ornithological travel he himself discovered only a single new species of bird and perhaps fifty new subspecies, depending on one's

taxonomic point of view.[22] These figures are a clear indication of the extent to which the world, in ornithological terms, had already been staked out by the time Meinertzhagen was an adult. It is also interesting to note that the scientific fraternity that contributed to this immense mapping project showed many of the responses to the natural world of the nineteenth-century industrialists, seeing it as one huge resource at their disposal. Often the only difference between the ornithologist and the entrepreneur was that the currency of the former was knowledge and scientific acclaim, rather than sterling. There was very little sense that the creatures inhabiting the earth alongside *Homo sapiens* had any independent value or rights to existence. Human perception alone conferred significance. The animals themselves were simply useful, intriguing, ornamental or profitable extensions of our world. Only when this axiomatic response to nature is understood is it possible to comprehend the apparently glaring paradox of nature study – that one of its primary objectives was often to kill and secure the object of interest.

The other principal co-ordinate of Meinertzhagen's ornithological approach was his deeply nineteenth-century and strongly familial passion for collecting. The Meinertzhagens often devoted considerable portions of their banking wealth to one particular whim or another. Richard's great uncle Louis – 'Clou' – was an extravagant collector of china, furniture, and paintings. The former's own father more than dabbled in early English mezzotints, his collection, when sold at Christie's after his death, going for £14,016 13s. 6d.[23] Richard's younger brother, Louis, also continued the tradition, amassing a significant stamp collection. (An interest in unusual pets, possibly an extension of this family characteristic, was strongly represented in Meinertzhagen's elder brother Daniel, who kept a panther while at Oxford, and was the prime mover in establishing the aviaries at Mottisfont. These contained a large variety of raptors and other unusual species such as sandgrouse. Even Meinertzhagen's younger son, Ran, was keen to own a cheetah as a teenager.) However, of all the family, Richard Meinertzhagen himself probably had the most varied, the most persistent, and also the most eccentric collecting instincts, which were ultimately of the greatest value to his fellow enthusiasts. His will to acquire was on a prodigious scale. Birds, birds' eggs, duck down, mammals, reptiles, invertebrates, particularly snails, plants, plant seeds, bulbs, ferns, rocks, soil, the grit from animals' stomachs, including anything from domestic fowl to crocodiles, and also stamps featuring birds – these were all taken, identified and neatly labelled. Even Meinertzhagen's seventy-five years of

diary writing suggests a desire to garner daily experiences as material, collectable items.

It was the impulse to have which became one of the central motivating forces in his travels, and which partially grew out of and ultimately superseded his interest in hunting purely as an exciting pastime. In 1910 a large number of Meinertzhagen's specimens were exhibited at an international sports exhibition in Vienna, including the skull of his giant forest pig. *Hylochoerus meinertzhageni*, a large coarse-haired hog, standing as much as a metre at the shoulder, and weighing up to 275 kg, was one of the few large game animals to be discovered this century. Rumours of its existence had circulated amongst British administrators in East Africa for many years, but it was not until Meinertzhagen obtained a large piece of skin in 1904 and a skull of a young adult male in May 1905 that the creature was conclusively identified.[24] The exhibition of his trophies was an obvious source of pride to him, but after this event his enthusiasm dwindled, largely as a consequence of the deterioration in his eyesight after the shooting accident in India, but also because increasing military duties allowed him fewer opportunities. He had also evolved by this date a fairly strict code of conduct when hunting. For example, he disapproved of taking females, apart from as necessary meat; shooting indiscriminately into herds, or without an opportunity to recover, or at such a distance that the bullet might only wound and therefore inflict unnecessary suffering, were all equally frowned upon. Those who fell short of his standards often felt the keen edge of his wrath, as demonstrated during a boat journey in South Africa in 1907.

> A fellow traveller disgusted me . . . Producing a shotgun on the launch he fired at a sea eagle which he could not possibly have recovered if he had hit it. He broke one of its legs and the fine bird flew off to die a miserable death. I was very rude to him. Later on he fired a shot at some game more than 150 yards off 'just in case a chance bullet might knock one over', as he explained. I told him he should be locked up for a lunatic or given in charge as a rogue![25]

From a young age Meinertzhagen was also strongly opposed to zoos and circuses. As early as 1907 he wrote of the latter: 'I wish there was some legislation to stop wild animals being used in this way. It is downright cruel and man has no right to be cruel to any animal.'[26] Cruelty for him was often synonymous with some degree of unnaturalness. Shooting animals in the bush, in their own habitat, then skinning them and eating their carcasses

had a kind of primaeval logic and justice to it. But the separation of animals from their natural environment, or training them to perform bizarre tricks, or in some way interfering in what he perceived to be a natural situation, as in the affair concerning jackals in Quetta in 1913, drew strong reactions from him. An incident in 1902, during his voyage from Burma to Mombasa, was typical of this response. The German crew of the ship had a pet monkey on which they practised all sorts of brutal jokes, such as burning its buttocks with cigarette ends. On another occasion

> They made the poor creature comatose with drink and to cure him they decided to tie a line round his waist and let him dangle in the sea for a bit. I protested but was politely told to mind my own business . . . I could stand it no longer and taking out a knife, I cut the line. I trust that he quickly drowned he was so drunk that he cannot have lived long in the water. The Germans all jabbered with rage, gesticulated and were, I thought, at one time about to lay hands on me. But they decided not to. I told them they were a lot of cowardly savages and left them livid with rage on deck. I should dearly love to throw them all after the monkey and I told them so. In consequence I am by no means popular on board.[27]

One senses in these situations that the prospect of being a solitary and unpopular crusader was not always unwelcome.

Although there was much about Meinertzhagen that could be attributed to his nineteenth-century background, and although towards the close of his active life some of his methods and ideas were being superseded, none the less there was a good deal about his approach that remained fresh, even strikingly modern; a claim that might seem out of joint with the conventional portrait of him as a trigger-happy philistine. This picture, however, is derived largely from the *Kenya Diary*, in particular a handful of incidents, such as the occasion when Meinertzhagen used thirty soldiers to annihilate a troupe of baboons that had ripped his dog to shreds the previous day.[28] While anecdotes like this one stand out in stark relief, the overwhelming picture is of a humane naturalist increasingly concerned with the welfare of the natural world.

His profound sense of sympathy for animals deepened as he reached middle age, almost, it would seem, as his faith in his own species declined. In 1924 he wrote: 'The human race is divided into those who like human beings better than animals and those who like animals better than human beings. I belong to the latter category.'

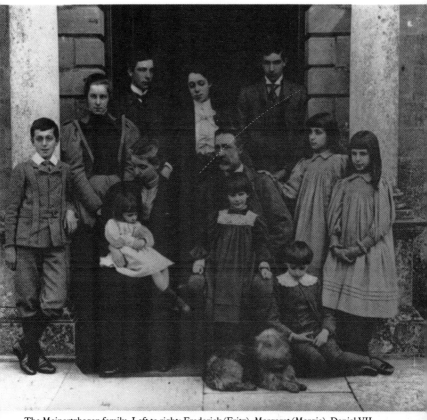

The Meinertzhagen family. Left to right: Frederick (Fritz), Margaret (Margie), Daniel VII,
Georgina (seated) with Elizabeth (Betty), Barbara (Bardie), Daniel VI (seated) with Mary
(Polly), Richard, Louis (seated), Lawrencina (Lorna), Beatrice (Bobo). Although Meinertz-
hagen dated the photograph 1897 in his *Diary of a Black Sheep*, it was probably taken in 1893

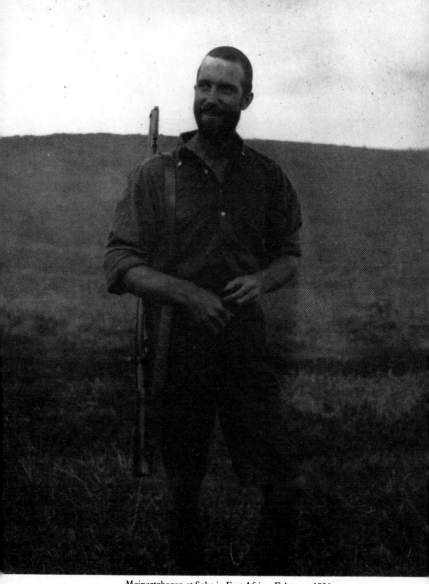

Meinertzhagen at Soba in East Africa, February 1906

Meinertzhagen in Mesopotamia, 1914

'Me and my lioness', Meinertzhagen in East Africa, 1915

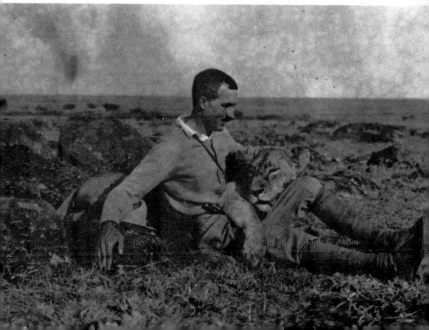

I had last month in connection with the murder of the
and his family.

1917. Lenin was smuggled into Russia from Germany in Ap
The Tsar and his children were arrested in Mar
1917 and remained in confinement at Tsarko
until August 1917 when they were taken to Tobo
In November 1917 they were removed from Tobols
Ekaterinburg where they remained until their m
on July 16 1918. Even now I feel it a bit dan
to disclose detail. Whilst at the War Office
to visit the King at buckingham Palace once a
to tell him about the campsigns in Iraq and Ge
East. On one occasion I found my friend Hugh
Trenchard there. Part of my work in the War Of
was organising an intelligence service devoted
happenings in Russia. King George opened the
conversation by saying he was devoted to the T
(his cousin) and could anything be done about
rescuing them by air as he feared the whole fa
would be murdered. Hugh was very doubtful as
family must be closely guarded and there was n
information regarding landing facilities for
aircraft. I said I thought I could find out a
that and perhaps arrange for a rescue party to
bundle atleast some of the royal prisoners int
aircraft. But it was taking a great risk as fa
would entail the murder of the whole family.
and I talked it over and after a few days I wa
able to try and get some of the children out b
the Tsar and his wife were too closely guarded

/July On ~~August~~/1st everything was ready and the pla
took off. Success was not complete and I find
too dangerous to give details. One child was
literally thrown into the plane at Ekaterinbu
much bruised and brought to Britain where she
is. But I am sure that if her identity were k
she would be tracked down and murdered as the
to the Russian throne.

What bestial swine the Russians are, murderi
little girls because they are the daughters of
the Tsar. Aunt Bo and sidney Webb thoroughly
approve of this type of murder in their desire
kill off the upper educted class and bring the
loer uneducated class to the top. And I fear
Bardie also approves having absorbed the poiso
of Aunt Bo and Sidnet Webb.

ican slackness. The Americans are being as slow as they ca
binging an efficient army into Europe. This
partly due to inefficiency but mainly their
desire to get Britain as exhausted as possibl
our/ that they can take/place in world leadership.
That greedy and jealous desire, at the expens
suffering humanity is typical of the U.S.A wh
can be trans lated into Unusual Silly Asses
American supremacy is successful, God help as

Entry from Meinertzhagen's diary dated 18 August 1918, referring to the attempt to free the
Russian Royal Family

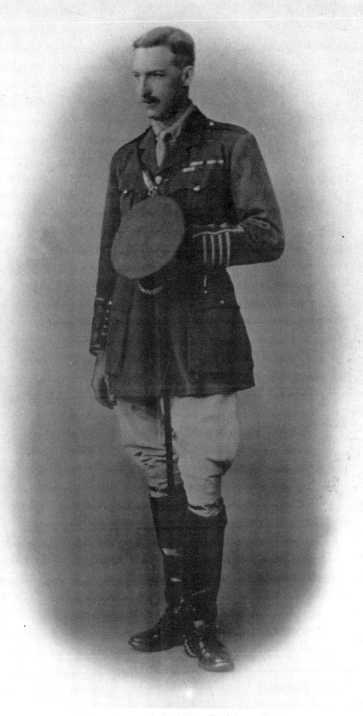

Meinertzhagen at the Paris Peace Conference, 1919

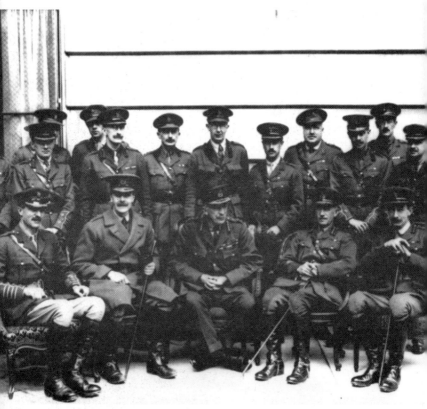

The British Military Section at the Paris Peace Conference. Seated left to right: Meinertz-hagen, General Radcliffe, Field Marshall Sir Henry Wilson, General Thwaites, unknown

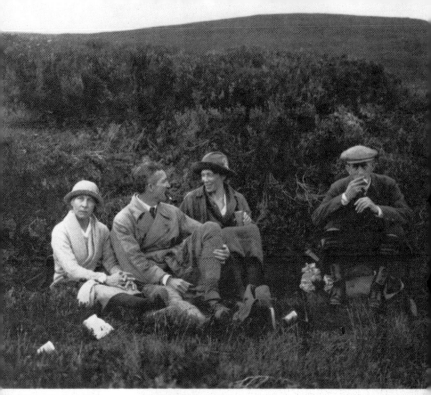

...ting party at Swordale,
...ember 1922. Left to right:
...ie Nicoll, Richard Meinertzhagen,
...e Meinertzhagen, George
...ksbank

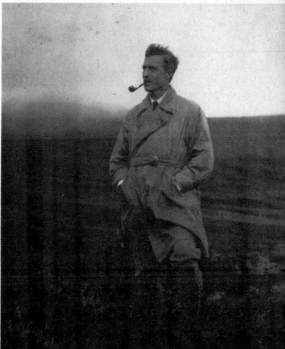

...nertzhagen at Swordale, September
...22, just before his seven-month tour
of the Middle East as the Colonial
Office's military adviser

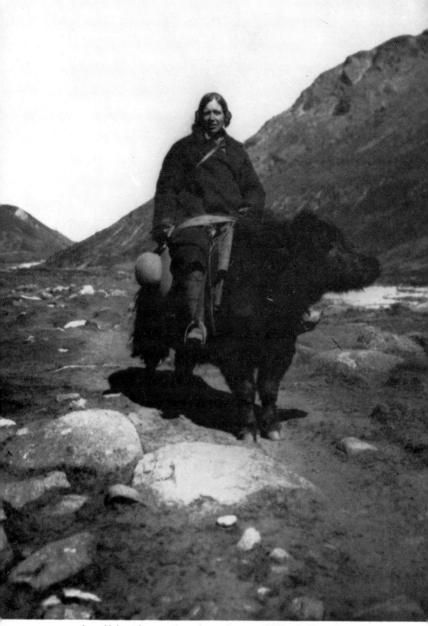

Anne Meinertzhagen on her yak near Gyagong, Sikkim, in November 1925

COlOnel Meinitzhagen.

So nOw we know. You swine, we shall.
get ypu. We know now that ypu did the killing
in Ronda and murdered poor Michael Doronetz
and many other of pou best friends. But ypu
shall pay for it and it will not now be long
before we get ypu. And we know all yŝur
movements and that you h ave been stayinh at
Rogozan in Jersey and all your activities are
closely watched. It will give us all so much
pleasure when you are cold and still lying
in a pool of your own blood, stiff and in
Hell, curse you. It will avail you nothing t
that you can shoot straighter than any other
man we know. We know you are brave and
relentless, but the word has gone out that you
must die, so be prepared. You of all men have
done more to harm the greatest blessing which
we are endeavouring to give the world, namely
freedom from the oppression of your bloody
class.

I am no Russian and you will never discover
the writer of this letter unless in dying you
recognise the hand which strikes you. You
dirty cruel swine, in striking you down, I
shall experience the greatest pleasure of my l
life. Nothing you can do will avert your
much deserved fate.

One who knows you well and whom you
may recognise.

The threatening letter received by Meinertzhagen after the Ronda incident in 1930. The
hand-written entry reads, 'Received 13.V.1930 by hand post. Postmark Paddington'.

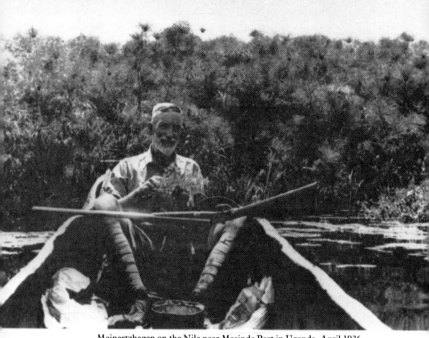

Meinertzhagen on the Nile near Masinde Port in Uganda, April 1936

Meinertzhagen and Peter Scott. The two ornithologists had met by chance during a goose-shooting trip to Hungary in November 1936

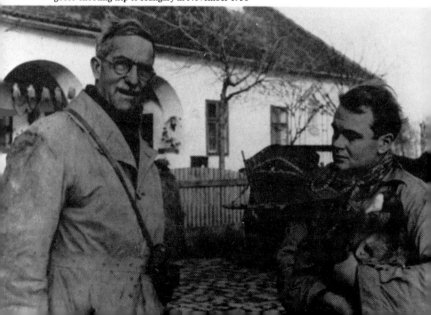

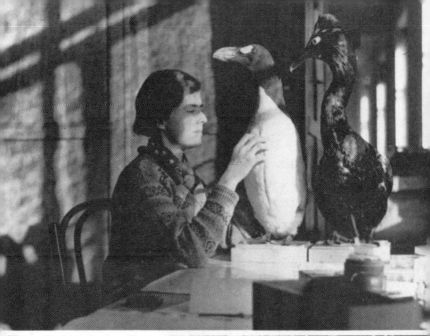

s [Theresa Clay] dedudinating a Great
at Leningrad with the extinct
norant (perspicillatus) looking on',
uary 1938

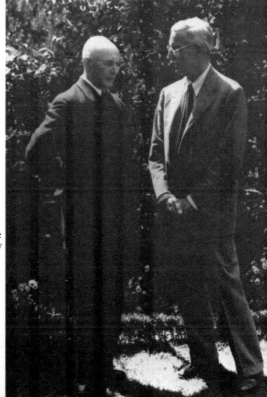

the First World War, Meinertzhagen
he head of the German forces in East
a, General von Lettow Vorbeck, became
friends. This photograph was taken only
weeks before the start of the Second
d War

Meinertzhagen collecting migrating birds
in Sweden, September 1946

Meinertzhagen aged 86

Cruelty is not in the killing but in the method of killing, though to take life for no other purpose than pleasure must be wrong. To shoot for food or kill for food can easily be justified by good argument. To take life in the interests of science can be justified but is often abused. Modern methods of sports shooting purely for pleasure is to my mind technically unjustifiable though I find it difficult to curb my hunting instinct. But as I get older I dislike it more and more . . . Personally I should like to see an end made of all those sports which end the day with the killing of a bird or a beast for amusement. I would give my vote tomorrow in favour of the cessation of bullfighting, rabbit coursing, fox hunting and pigeon shooting, for we inflict pain on dumb animals for our amusement.[29]

Representative of this change in attitude was Meinertzhagen's decision to cease egg collecting, which in the 1920s was still considered an important facet of ornithology and was popularly pursued. However, the latter saw oology, its spurious scientific cover, for what it often was – an indiscriminate desire to build up vast collections of birds' eggs, with no more truly scientific basis than philately. In 1924 Meinertzhagen gave his collection to a fellow ornithologist, Stuart Baker, a gift that led to an angry exchange between donor and recipient. He claimed that he had offered them on the understanding that Stuart Baker kept only what he needed, and any duplicates, and eventually those retained, should all go to the national collection in the British Museum. Stuart Baker, disregarding this, had a catalogue made of all Meinertzhagen's eggs and sold them off for £150 – a figure equivalent to a present-day sum of £3,000.[30] This story, if true, indicates not only the very great demand for eggs and the popularity of collecting, but also that Meinertzhagen's assessment of oology as a science of little scientific value was ultimately just, particularly when one considers that the villain in the piece was an ornithologist of otherwise high reputation.

Another battle which Meinertzhagen waged more vehemently and for much longer was against the 'gamekeeper mentality' as he called it, and the destruction of birds and animals, particularly raptors like eagles, buzzards, and falcons, in the interests of gamebird populations. It seems Daniel Meinertzhagen had managed the estate at Mottisfont on an extremely enlightened basis, refusing to allow his keepers to kill any vermin but mice and rats. His second son, on his marriage to Anne Constance Jackson, managed his estate at Swordale, in conjunction with two neighbouring landowners, in a similarly liberal manner, and if Meinertzhagen's figures

are accepted, with considerable success.[31] In order to protect wildlife he would sometimes go to considerable lengths to achieve his objective. On one occasion in 1957 when he was informed of the whereabouts of a breeding pair of honey buzzards, a rare occurrence in this country, the seventy-nine-year-old colonel took steps which were quintessentially Meinertzhagen. Notices were posted around the woodland warning of unexploded bombs – a measure that brought him into conflict with the Ministry of Defence.[32]

His first full-blooded expression of a conservation ethic, excepting his tentative moves in East Africa to establish game parks in Masai territory, occurred in 1919, in the heat and confusion of the Paris Peace Conference. A proposal, forwarded to the Acting Foreign Secretary, Lord Curzon, by Mr and Mrs Frank Lemon, the vice-president and honorary secretary of a small ornithological/conservation group called the National Society for the Protection of Birds,[33] wished to bring to Curzon's attention 'the desire of the Council . . . that Heligoland should be made an international bird sanctuary'.[34] Heligoland, a small island in the North Sea off the mouth of the River Elbe, had been ceded by the British to Germany in 1890, after which the new owners had converted the island, barely a single square kilometre in area, into a naval fortress – a move that gave recognition to its strategic position between Denmark and Scandinavia, and the north European mainland. However, its naval significance was matched by its importance as a focal point of avian migration between the two land masses, an importance that had been widely publicised in a book by a German ornithologist, Gäetke. The Lemons' proposal, destined for the waste-paper bin as the crackpot idea of a group of bird lovers, was suddenly lifted by Meinertzhagen's championship into a scheme that almost gained acceptance amongst the world's leaders gathered in Paris.

He immediately wrote to Lord Grey of Fallodon, the previous wartime Foreign Secretary and a well-known ornithologist, and secured his ready support. A memorandum was then circulated to all of the important departments, including the Prime Minister and Balfour, with whom the idea appeared popular. The language of the paper was full of Meinertzhagen's usual vigour:

> An Englishman's love of nature and his hatred of injustice and cruelty to wild animals fits him more for such a post than do the qualifications of either Teuton or Latin peoples . . . To many such a proposal may not be considered seriously or may be classed as the outcome of some dreaming

idealist. To such persons, the only reply is that they do not love nature and all that is beautiful, but that their eyes have been blinded by more material and perhaps more profitable products of our civilisation.

The island lies at a junction of many routes of migration and has from the earliest ages . . . served as a resthouse for migratory birds from Asia. At present the most wonderful phenomenon is made the excuse for wholesale slaughter by every means. Every man, woman and child during strong waves of migration turns out to partake in the horrible slaughter. Guns, nets, and every conceivable instrument of destruction are used, including sticks with which to kill the wretched birds . . .[35]

The proposal had been introduced into the Conference long after the agenda had been drawn up, and the Council of Four – Clemenceau, Lloyd George, President Wilson, and the Italian premier, Orlando – found themselves unable to consider it. However, the measure continued to enjoy wide British support and Meinertzhagen pressed again. 'In view of Foreign Office and Legal opinion favouring a proposal which no other department has objected to on naval, military, or political grounds and which receives the moral assent of the Heads of the Foreign Office and Naval sections,' he argued, 'cannot this again, in the interests of the world, be put forward?' Unfortunately, the project ran aground on administrative technicalities rather than any lack of popularity. Although there is little doubt that some of those attending a conference intended to reshape the future of the world's human population found it difficult to take seriously a project concerning the birds on a wind-swept island in the North Sea that was smaller than Hyde Park.

Meinertzhagen's efforts to have Heligoland established as an international bird sanctuary are significant for a number of reasons: they demonstrate the extent to which ornithological issues were a constant in his life, irrespective of time, place, and other commitments (it is important to remember that at the time of the Paris Conference Meinertzhagen had just suffered the emotional strain of a divorce, he was working furiously to establish a Jewish National Home, while simultaneously keeping up with a host of other military issues, particularly concerning African and Middle Eastern colonies). Also, they show how a man, who was in so many ways staunchly conservative, could be so responsive to the novel and unprecedented. This imaginativeness is one of the most attractive facets of Meinertzhagen's work as a naturalist, and it is possibly as nature's inquisitor that he is seen at his most brilliant.

Owing to the contemporaneity of his outlook, or possibly as a conse-
quence of his particular date of birth, he ducked entirely the controversy
that raged amongst the senior ornithologists of his youth concerning
trinomials. Hitherto, scientific nomenclature had been based on a binomial
system, established by the pioneering Swedish naturalist, Linnaeus, in the
mid eighteenth century. Each different species had a standardised scien-
tific name consisting of two parts – the first denoting its genus, the group of
species to which it was closely related, and the second to indicate its
independent status. House sparrow, for example, became *Passer domesti-
cus*. However, this system had been extended in recognition of wide
variation within the populations of a particular species. Thus, the mark-
edly different, chocolate-crowned race of house sparrow occurring in the
Italian peninsula became *Passer domesticus italiae*. These subspecies, or
races, were recognised as important, since they demonstrated the evol-
utionary process of speciation at work. A race like *italiae*, for instance,
might in time, possibly involving thousands or tens of thousands of years,
become a wholly distinct species. Meinertzhagen took to this theory (which
has itself been partially modified)[36] without qualms, and, indeed, in his
heyday as a traveller/naturalist – 1917–47 – contributed significantly to the
identification of many distinct races. *Ammomanes deserti payni*, *A. d. janeti*,
A. d. annae, *Oenanthe moesta brooksbanki*, and *Sylvia nana theresae* are just a
few of those Meinertzhagen found and named after friends, and which are
still treated as valid.

In his efforts to discover something about bird migration, Meinertz-
hagen showed considerable ingenuity, and often went to enormous lengths
to pursue his inquiries. One way of lightening his load during his time as a
soldier was to enlist the support of off-duty subordinate officers.[37] At Rafa,
for example, Allenby's forward base prior to the Third Battle of Gaza, in
his work on bird flight Meinertzhagen used theodolites established at two
anti-aircraft gun stations and their interconnecting telephone systems to
calculate a bird's speed and altitude between the two fixed points. Sim-
ilarly, at Montreuil in northern France, where he was lecturing in the
closing months of the war, he used the same techniques and sent up small
balloons to the altitude of the bird's flight in order to ascertain wind
velocity.[38] Using these results, and observations solicited from aircraft
pilots via the pages of *The Times*, he provided probably the most accurate
figures on the subject up to that date. In contradiction of Gäetke's claims
that birds migrated at elevations greater than 6,000 m, and at speeds of up
to 400 km an hour, Meinertzhagen demonstrated that most observed

migration involved figures approximately six times smaller. To continue his inquiries into the subject, he also gained the support of the Egyptian civil authorities during his period as chief political officer. Lighthouse keepers on the Mediterranean and Red Sea coasts were requested to collect bird corpses in the vicinity of their lighthouses, which were often struck by disorientated flocks in difficult weather conditions. Although the exercise yielded fewer results than Meinertzhagen hoped, it is representative of the wide support he would enlist to pursue his inquiries.

Further work on migration, initiated during the First World War, which he eventually hoped to bring to fruition in a comprehensive monograph on the subject, involved the collation of biometric data on migrating species of bird. This entailed the meticulous assembly of weights, wing lengths, wing shape, and wing areas, much of which he recorded on sheets of paper bearing careful tracings of the spread wings – an entirely novel approach to this issue. He continued on this self-initiated project for many years, eventually amassing many thousands of pages of wing drawings of 440 species. Unfortunately, however, although he published three papers on the subject, the initial concept was never fully realised.[39]

This was not so much as a consequence of Meinertzhagen's inability to carry his ideas through to completion but rather of his abundant creativity. His failing, if one could identify it as such, was the sheer range of his inquisitiveness, and his instinct for scientific problems and for the means to explore them, since these often exceeded the man-hours available in his individual life to follow them all to a satisfactory resolution. And yet he was a relentless worker. He seemed to have an almost obsessive need to be occupied. On encountering certain aspects of his life's work, particularly his later, prodigious efforts for Zionism and Israel, and in his ornithological study, one is often left wondering where he derived the motivation to go to the lengths that he so often did. What prompted the head of field intelligence during his spare moments in the days before the Third Battle of Gaza to appropriate anti-aircraft gun stations to study bird flight? Or, for example, the eighty year old to pull out his ladders, carry them to local woodland and mount them at the spot where he had seen a woodpecker drumming, to examine whether the sound created was vocal or percussive?[40] And in all these enterprises, it is important to bear in mind that he was, in the fullest sense of the term, an amateur. He had no obvious incentive but his own inner resources. It is this directness and drive which distinguish him from many other amateur enthusiasts. Others shared his inquisitiveness, his instinct for the correct question, and generated poten-

tially fruitful ideas with the same abundance; but Meinertzhagen had the capacity to follow them up.

The other striking factor about him as an ornithologist was his unconventionality. Here, perhaps, one can detect a relationship between, on the one hand, his early isolation within his family and the increasingly private world that this forced him to inhabit, and on the other, his fresh, often off-centre approach to things. His detachment, occasionally indifference, to external authority and reference often meant that he never sought precedents or guidelines for his methods – a set of circumstances that could make him self-righteous and even arrogant. And yet also it could make him a person of startling authenticity. As a soldier and as a natural scientist these qualities were probably the source of his success and, at times, the cause of his undoing; they gave his thoughts and actions an acutely fresh angle, and occasionally left him out on a limb. The following are typical of his imaginative yet often very simple responses to problems.

In Ladakh, at an altitude of 4,500 m, Meinertzhagen found a colony of breeding great-crested grebes on a lake. Wishing to examine their instinct to locate their own particular nests, he waded into the freezing water and moved twelve nests, swapping the location of one for another. Within an hour, after much squabbling, each nest was occupied by a sitting parent.[41] In Arabia, intrigued by the relationship between desert birds and the distribution of plants, Meinertzhagen would try and cultivate the seeds he found in the stomachs of seed-eating birds to see if these would germinate. On one notable occasion in Iraq he extracted the intact crop of a chukar, a species of partridge, from the stomach of an imperial eagle, to which the chukar had obviously fallen prey. From the seeds he was able to germinate several botanical species previously unknown in the locality where he had obtained the eagle. With the mud taken from the feet and beaks of waders and wildfowl he conducted the same experiment, and whenever he was able to obtain 'sufficient to cover a half-crown,' he was invariably successful in growing plants. To examine the potential fertility of the desert, Meinertzhagen took random handfuls of dust from ground entirely devoid of vegetation and managed to germinate thirty-six individual seedlings.[42] Evaluating erosion in the same country, he collected dust from a square yard of the deck of a ship after it had passed through a sand storm off Bahrein, and weighing it, computed the scale at which Arabia's terra firma was lost in this manner to the Arabian Gulf.[43]

The subject of cryptic colouration in desert fauna, where many species of animal resemble the general tone of the soil and rock on which they live,

intrigued Meinertzhagen for more than thirty years. He eventually published his controversial conclusions in the introduction to his ornithological *magnum opus* – *Birds of Arabia*. On one occasion, to test the cryptic properties of desert larks' plumage, he placed dead individuals on rocks with a similar colouring beneath the flight path of migrating harriers. He found that only when he moved the birds to an entirely different-coloured substrate were the harriers able to locate the potential prey.[44]

Meinertzhagen soon began to put his findings onto paper, publishing them in natural historical journals, principally *The Ibis*. His earliest efforts as a scientific author came in 1912, when he gave a short account of the birds of Mauritius, an island where he had lived for twelve months. Two years later followed another equally brief paper, on the birds of Mesopotamia. After the war, however, from the period of the Paris Peace Conference until his retirement, Meinertzhagen published a stream of papers, largely on the birds of the Middle East, which he had covered extensively in his job, but also several speculative pieces on migration. In his writings, from the outset, he adopted an anecdotal, conversational style of address, wandering freely onto a range of entirely unrelated subjects. In a paper on Cretan birds, for example, he sang the praises of Mount Ida's shepherds, particularly of George Nikolokakis and his bandit lifestyle.[45] In a paper which described the birds encountered on a journey across the Syrian desert, from Jerusalem to Baghdad, completed during his period as the Colonial Office military adviser, Meinertzhagen was even more liberal in his interpretation of what would hold the attention of fellow ornithologists.

> Around our camp ground grew a profusion of white flowering desert-bushes delightfully soft and heavily perfumed. By gathering armfuls of these bushes I prepared for myself as comfortable a bed as could be wished. The clear star-lit night, the crisp desert-air, the delicate aroma of the crushed desert shrubs . . . made me at peace with the world. But my peace was not to last throughout the night. No sooner had I dozed off than I was awakened by a rifle-shot and the whistle of a bullet awoke the camp. We at once stood to arms, when yet another shot whizzed over our heads. As our unwelcome visitor was obviously not far, and as, in fact, we could just distinguish by the moonlight the horse he was riding, we shouted out to him and asked him his business and the reason of his rudeness. This was answered by another shot, on which I ordered one of our Lewis gunners to open fire. We were left in peace for the rest of the night.[46]

In spite of his penchant for digression, by the late 1920s Meinertzhagen had established himself as a first-rate naturalist. His personal collection of bird skins was growing in reputation, and in 1927 he was elected a council member for both the Royal Geographical Society and the British Ornithologists' Union. His work in the Middle East was establishing him as something of an expert on the region, an association that was cemented by his first full-scale published work, *Nicoll's Birds of Egypt*.

As its title suggests, the book was the brain-child of another man, Michael Nicoll, a close friend of Meinertzhagen's since the Palestine campaign. Nicoll, born in 1880, had worked as a librarian for the Zoological Society of London, and had then travelled on the yacht of Lord Crawford, a journey of more than 122,000 km that Nicoll described in his book *Three Voyages of a Naturalist* in 1908. Shortly after these adventures he settled in Egypt as the assistant director of the Zoological Gardens at Giza, where he published a handlist of Egyptian birds in 1919. This was to be followed by a comprehensive book on the subject, but an early death cut short the project.[47]

Meinertzhagen and Nicoll had first met in 1917, while the former was attempting to work out the growing numbers of bird skins that he had acquired during the war. This acquaintanceship had been cemented during Meinertzhagen's time as chief political officer, and afterwards at Swordale. Later, in 1923, the two friends, with their respective ornithologist wives, Norrie and Anne, made an expedition to the deserts between Cairo and Suez. Even then Nicoll seems to have suffered from poor health, their desert trip being delayed because of his illness. During the excursion Meinertzhagen wrote of the Nicolls' laziness, citing as evidence the fact that Michael, in spite of twenty years' residence in the country, had never explored Egypt's eastern deserts, nor wandered from the beaten track. Even on a voyage of only five days' duration, the couple had five tons of kit and eight servants. None the less, Meinertzhagen concluded, 'they are dear friends and have many endearing qualities, not the least being their love for each other, their hospitality and their complete ignorance of the outside world'.[48]

Only two years after this trip, Nicoll, then only forty-five, underwent a massive operation for gall stones and after a second five months later, died on 31 October 1925. Pressed by Norrie Nicoll, Meinertzhagen agreed to continue with Michael's project, and in January 1928 set out on a three-month expedition to the lesser-visited areas of Egypt, combining ornithology with intelligence work for the British government. Meinertzhagen

travelled to Egypt's border with Italian Cyrenaica, then southwards to the important oases of Dakhla and El Kharga, to Wadi Halfa, and then to the mountain areas of the Sinai Peninsula.

There is little doubt that the greater portion of the workload for the book published in 1930 had been borne by the deceased contributor. His large collection of Egyptian birds and his personal notes provided the bulk of data for the final text. Even so, Meinertzhagen's own input was not insubstantial. With typical thoroughness he visited areas that Nicoll himself had not covered, and prepared the entire text and oversaw its publication, which had been financially assisted by the Egyptian government.

The finished product – a huge, thirty-shilling, 698-page, double-volume tome – was received as 'a lasting memorial to his old friend and companion Michael Nicoll',[49] and 'a very excellent and important piece of work'.[50] It was *Nicoll's Birds of Egypt*, but it was a book stamped with all Meinertzhagen's well-established trademarks. In one of the four introductory chapters he struck out at the thoughtless collection of bird skins simply for its own sake: it was 'a quite useless pursuit ranking no higher than the zeal of the philatelist'. (Yet, by contrast, he refused to accept a claim of a British race of wagtail because it was based only on observation, rather than an examinable skin. And this was one of Nicoll's own records.) The well-known custom in the Mediterranean countries of taking small, passerine birds for the pot was also damned. It could not 'be justified under any circumstances. Even if the cruelty entailed in their capture were not sufficient to stop the scandalous and illegal practice there can be no excuse for slaughtering the small birds to serve as appetisers for bar hoofers, lounge lizards and froth blowers.'[51]

In an extended metaphor, Meinertzhagen waxed lyrical on the austere beauty of the Egyptian landscape. 'The attractions of the desert are that of woman for man. It is when she is silent that she is most attractive, most elusive, most seductive. It is when she is boisterous that one hates her most. Life with her is one continual dream of romance, for she has the power of making the traveller feel he is her sole admirer, her lonely visitor.'[52] Meinertzhagen's representation of the desert as a feminine force was hardly the conventional portrait. More typically, this landscape's intense aridity and unremitting harshness are framed in terms that are at least masculine if not demonic. But then Meinertzhagen was seldom true to others' conventions. He remained for most of his life, particularly in the twenty-one years that separated the two world wars, a passionate seeker for his own version of the desert's elusive power.

1918–39
Silence, Solitude and Space – A Traveller Between the Wars

> The main reward of travel is not discovery of new forms of life, of Hittite inscriptions, of new lakes, mountains, or waterfalls; it is the discovery of oneself. I doubt whether any person has discovered himself without travel – real travel, not hotel hopping and lounging on luxury liners. To derive the greatest benefit from travel, one must leave the beaten track and branch off into the country, meet the country people, get to grips with local religions, husbandry, customs, and folklore, travel on horseback from village to village, or to see areas uninhabited by man. To travel from town to town by rail or auto is much the same the world over.[1]

Published in 1963, these were the words of an old man, then in his eighty-sixth year and bed-ridden after two crippling accidents. However, one senses in Meinertzhagen, even in this debilitated condition, that a Ulyssean appetite and spiritual, if not physical, capacity for further travel was still alive. His last journey had been only two years before – to Trinidad and British Guiana; his first, sixty-four years before, in another century. And in his prime he had been a rugged, relentless, and gifted traveller, perhaps one of the most interesting and unsung of his age.

The statistics of his wanderings are remarkable. From 1899, when he was twenty-one, until 1961, there had been only nine years when he had not ventured beyond the British shores. Six of these years had come between 1940 and 1945 when, apart from repeated visits to the beaches of Dunkirk during the night of the 30/31 May 1940, Meinertzhagen's movements had been of necessity circumscribed. The other three years had come during the time of his greatest happiness and then deepest despair – in the 1920s, the period of his marriage to Annie, and the year after her tragic death. In the other fifty-three years, excluding Mauritius, Madeira, and a host of other offshore islands that he had visited, he journeyed extensively through sixty of the world's modern nation states. His total time overseas amounted to twenty-eight years, almost a third of his life. The quarter century of his military career accounted for nineteen of these. However, foreign service

was not some kind of unwished-for exile: he delighted in it and when opportunity presented itself it proved to be the springboard for further travel. While stationed in South Africa, for example, he made private journeys to Portuguese East Africa (Mozambique), Nyasaland (Malawi), and Rhodesia (Zimbabwe). From Quetta Staff College, he organised an expedition down the Tigris in Mesopotamia (Iraq).

As with so many of his activities, people have been generally divided on the principal locus of his interests. Some, notably Salim Ali, the renowned Indian ornithologist, saw Meinertzhagen as an expert on Africa.[2] Others, possibly with greater justification, have defined him as an orientalist, largely concerned with the Middle East – a perception confirmed by his two major ornithological works, *Nicoll's Birds of Egypt* and *Birds of Arabia*. Strictly speaking, however, neither interpretation is correct. Although it is difficult to decide whether his ornithological interests followed his politico-military concerns, or vice versa, they both focused on the same region. This bordered the shortest maritime route to Britain's imperial territories in Asia and Africa, and is simultaneously an important channel of avian migration between Africa and Eurasia, having its centre on the Arabian peninsula. Politically, scientifically, and spiritually the region was Meinertzhagen's homeland, which, if one attempted to delimit it, would constitute a roughly isoceles triangle with its apex on Leh in Ladakh, while its base would be the axis between Dar-es-Salaam, in Tanzania, and Athens. Meinertzhagen spent seventeen years, roughly a fifth of his life, in this area, the place of his most meaningful travel. Unlike his trips to Europe, or his visit to North America in 1939, these journeys were for long periods; apart from occasional motorised transport they were without modern conveniences, and to inhospitable, even dangerous, regions. Scientifically, they were also the most fruitful. Even then, such a definition of his chosen area excludes several significant journeys in the interwar years: to Sikkim and Darjeeling in 1925–6, to the Ahaggar Plateau in southern Algeria in 1931, and to Morocco in 1938. None the less, in the twenty-one years between 1918 and 1939 Meinertzhagen made seven extensive visits to this triangular region, amounting to a total of more than four years.

The bulk of his journeys in this period, apart from between 1918 and 1924, were self-financed, and with only a single exception – his trip to Egypt in 1928 – were without a stated official purpose. It is, of course, possible that hidden behind all his ornithological paraphernalia, Meinertzhagen was simultaneously collecting military and political intelligence. The truth of this is unclear. However, even if he were travelling on

government business, it does not alter the fact that he had no need to work: in the final analysis, he travelled because he enjoyed it; his motives were personal rather than exigent. He himself suggested that his wanderlust was a characteristic inherited from a gypsy-like ancestor, Mary Seddon, who was his mother's grandmother, the wife of the first Richard Potter. A genetic explanation of his own behaviour was typical of Meinertzhagen, but it hardly does justice either to the manifold scientific (and possibly political) purposes of his journeys, or to the underlying spiritual quest, which was at the heart of his constant travelling.

It was perhaps ironic that from 1922 onwards, until his death, the family home was a three-storey house in Notting Hill, at 17 Kensington Park Gardens – KPG, as it was known affectionately – which Richard and Annie had bought for £3,750 in 1922.[3] Ironic, because in many ways travel was the simplest escape route for Meinertzhagen from the encroachment of the twentieth century. London might have been the most convenient place to live – a base camp from which to plan the next expedition, an easy port of call for an international fraternity of ornithologists, close to many of his friends and family, his clubs, and to the South Kensington museums; but half a century of city residence is no place to start for an assessment of his character. 'London is as dull and unpleasant as ever. Pavements hard as Pharaoh's heart and noisy as Niagara . . .', was his verdict in 1910,[4] and for the whole of his days he remained in opposition to much that was conventional in city life. Modern dancing, café society, and large parties, for example, were anathema to him. Introduced to the Charleston in 1926, he thought it 'a simple imitation of sexual intercourse adapted to the ballroom'. Sherry parties came in for heavier criticism.

> I attended a cocktail party yesterday evening – the second of its sort I have been induced to accept. I loathe these American rot-gut functions and everything attending them. In the first place one is badgered to drink and eat inferior food and drink, conversations are interrupted every minute by, 'Won't you have some sherry?', 'Oh, do have some sherry', 'Are you quite sure you won't have a sherry?'; and the next minute someone comes round with a nasty little sausage at the end of a match and the same interruption ensues.[5]

Inevitably, he carried this distaste for popular culture abroad. The French Riviera, for example, was not his favourite holiday location. 'The artificial surroundings, the incessant desire for amusement and pleasure, the complete disregard for nature and all that is beautiful, the overdressed females

and the dissolute type of man who haunts the restaurants are all to me disgusting.'[6] It was equally unsurprising that his staunchly protestant sensibilities would find St Peter's in Rome 'tawdry and vulgar . . . The stale pungent smell inside the building may have been dead Popes or only the stagnant air of ages, or perhaps both, but it was most unpleasant.'[7] In Jerusalem he wished to tear down the Mosque of Omar and replace it with a 'small but beautiful edifice emblematic of all religions who worship God'.[8] This apparent philistinism often rested on a vision of ancient suffering. When confronted with the colossal Buddha statues at Bamian in Afghanistan, Meinertzhagen could only think about 'the waste of energy, time and labour employed to make them, all in the name of religion. I wonder if it has been worth it,' he added, 'the millions of money and millions of human lives sacrificed for religion. I often wonder if all the money lavished on cathedrals and churches, their upkeep and decoration, has been worth it.'[9]

Curiously, the Sphinx in Egypt was the one notable exception. On his many journeys to the east Meinertzhagen seldom tired of revisiting it. 'Surely no imaginative mind could be disappointed at this ancient Egyptian divinity?' he opined in 1917.[10] More than a decade later he wrote with feeling (and typical inconsistency) for his favourite monument:

> After my guests had gone I paid my respects to the Sphinx by moonlight – watched his (for the Sphinx is a man, having once had a beard but never breasts) serious countenance under the most attractive conditions. I always think that the only way to really understand that stone image is either by the flood of moonlight or with the rising dawn creeping up her body and enlightening her face. One then catches looks of mystery, power, sadness, strength, kindness, serenity, knowledge but never mockery, cruelty or sarcasm.[11]

Looking at it, he felt that he could 'almost grasp the meaning of eternity'.

One would have perhaps expected a man who had so strongly rejected the surface trappings of his own culture to have embraced in his travels the elemental lifestyles of less sophisticated peoples. This was not the case, however. Meinertzhagen was no Wilfred Thesiger, nurtured by noble savages and imprinted with their culture. Although the two men covered much the same geographical territory, their individual approaches to travel, particularly to the people through whose lands they passed, were very different. Where Thesiger has felt deep empathy for African tribals and Muslim nomads. Meinertzhagen brought to bear on his dissection of foreign cultures a trenchant patriotism and razor-sharp wit. To be fair to

him, he could be deeply sympathetic towards foreign people, as diverse as Jews, Germans, Druze, and African tribals, such as the Kikuyu. In general, it was the closer a people came in culture to that of his own race that drew his criticism.

His professed disdain for the French was inexhaustible. 'The Frenchman is always an object of amusement,' he proclaimed in his twenties. 'When he is not ridiculous he is idiotic.'[12] The Spanish and the Greeks fared little better. During a visit to Spain in 1930 he wrote: 'They are a decadent race. They have greasy bodies, greasy minds, greasy clothes, oily manners and must have greasy guts.' Sensing that he had perhaps been less than fair, he added, 'half the fun of being in a foreign country is laughing at the inhabitants. It is a noxious and impertinent English prerogative.'[13] To the infusion of Spanish blood in the veins of the Meinertzhagens (through Frederick Huth's marriage to a Spanish woman), he attributed the decline of his own family. His attitude towards the Greeks seemed to be determined by their national beverage. 'I have never cared much for the Greeks,' he wrote in 1910, on his way back from his spying mission in Sevastopol, 'but to see them putting butter in their coffee and drinking it down in greasy gulps, surely places them very low in the scale of civilisation.'[14] His taste in Europeans was, on the whole, Anglo-Saxon. Scandinavians, Dutch, and Germans were the nations he praised most frequently and with whom he expressed the deepest affinity. This led him to devise a genealogy that went back beyond his known fourteenth-century Germanic origins, to a Scandinavian, even Viking ancestry. However, it seems that the basis for such a claim was largely Meinertzhagen's own wishful imagination.[15]

His response to Asian and African peoples who had come under British imperial domination was far more complex. Given the fact that Meinertzhagen was one of the small band of colonial administrators and soldiers that enforced British control, and given his particular temperament, he emerges from an analysis in a generally positive light. Notwithstanding his capacity to kill black Africans in the course of so-called 'punitive operations' in 1902–6, Meinertzhagen was largely sympathetic to their cause. That he had defended their right to ownership of the East African Protectorate and had foreseen the increasing political and cultural development of some of the African tribes, especially the Kikuyu, almost fifty years before the advent of Mau Mau, have prompted some to suggest that the diaries covering this period were retrospectively composed. However, Meinertzhagen restated his support for Africans and the inevitability of conflict between white settlers and the indigenous population in 1916,

1922, and repeatedly in the 1940s and 1950s. In 1953, for example, he wrote, 'I think the Kikuyu are being treated abominably, it is their country, they have legitimate grievances and we are slaughtering them as though they are vermin; never again can we claim to be supreme in colonial administration.'[16] This consistent sympathy, coupled with the repeated evidence for it, suggests that Meinertzhagen's 1904 statements were almost certainly authentic.

Emphasising his rather atypical support for Africans is not to suggest that he was some kind of anti-racist ahead of his time. Meinertzhagen was a committed imperialist; the decline of the British Empire was to him 'a first-class tragedy'. In 1958 when Fenner Brockway, a Labour MP, got hold of a memorandum he [Meinertzhagen] had written on the Kenyan situation and published it in the journal of 'The Movement for Colonial Freedom', Meinertzhagen sought to have Brockway sued.[17] Clearly, he did not wish either himself or his views to be associated with such an organisation, even though there might have been broad agreement between them. Meinertzhagen was also troubled by the idea of a multi-racial society – in his view black and white were 'biologically different and hybridisation has proved to be a failure'. In his early years, when confronted in South Africa with the possibility of racial equality – the presence of a native African in a first-class train compartment – his instinctive response was some form of apartheid.

> At Mafeking a nigger got into the train, holding a first class ticket. There were five Europeans on the train and four compartments each holding four. So while we were divided into two compartments he had one to himself. Niggers should not be allowed to travel first class. If they do there should be special carriages for them. They stink the carriage out, their habits and customs make it impossible for Europeans to use a carriage, once occupied by them and it places them on an equal footing with Europeans, which is highly improper. No matter who the nigger is he should be kept in his place.[18]

This overt and distasteful brand of Afrikaner racism, which was by no means uncommon at the turn of the century, is exceptional in Meinertzhagen's diaries. Whether he was affected here by the spirit of place, or later influenced by the formidable qualities of African troops in the British and, more importantly, in the German army during the First World War, it is difficult to assess, but by 1916 he had performed a complete somersault on the issue. In that year, just prior to his return to England from the East

African campaign, he had argued with Boer settlers over the status of the indigenous population. Here, Meinertzhagen insisted 'that the African, especially the Kikuyu, is particularly intelligent and with three generations of education he is quite capable of running the country . . .' – views for which he was branded 'a dangerous man'.[19] From then onwards his views hardly wavered. In 1960 he wrote: 'apartheid is dynamite and can only be imposed by an increasing use of force and bloodshed'.[20]

Although the 'Mafeking' passage might have been out of tune with most of his views on African racial problems, none the less the sense it conveys – that a black man in a first-class carriage subverted the natural order of things – *was* a response highly typical of him. In Meinertzhagen, the political analyst with a flair for looking ahead often struggled against the gut-reactions of the entrenched conservative. Socially, he often adhered to the Victorian world his consciousness awakened to in adolescence. It should not be surprising, for example, that one finds Meinertzhagen on the losing side over the issue of female suffrage, or in opposition to the growing strength of trade unions or the Labour Party, or to the national self-assertion of the Indians under Gandhi, or Egyptians under Nasser.

Yet, it would be inaccurate to derive from any of his fulminations against foreigners – be they Latins, Africans, or Arabs – an image of undiluted xenophobia. Meinertzhagen had an international circle of friends, and in later life felt that his contribution to ornithology was more appreciated abroad than at home. Salim Ali, one of the foremost ornithologists of the century, was both an Indian (nominally also a Muslim) and 'a rank seditionist' – a supporter of Gandhi's swaraj movement – neither quality calculated to endear him to the English imperialist. Yet Meinertzhagen's close friendship with him extended over thirty years, and was one of the many and glaring disparities between the political and the private man. In his autobiography, Ali wrote of his friend: 'Richard Meinertzhagen was one of the most colourful, original and, in many ways, likeable characters that ornithology introduced me to.'[21]

From his mother, this 'likeable character' had inherited a biting wit; from both of his parents, difficulty in expressing emotion, especially potentially difficult emotions such as affection or tenderness. And Victorian public-school life had hammered this awkwardness into a remarkably tough exterior. Open affection from any quarter was seldom welcome. On one occasion, when close friends, with whom Meinertzhagen had gone to stay, stopped him on the landing on their way to bed to say how much they loved and admired him, he was left 'curled up tight in my shell and

almost determined never to see them again'.[22] Even with his own children he found intimacy extremely difficult. Abroad, the brusqueness of his manner and his fierce patriotism were often a bluff that few dared call. Yet those who, like Ali, were brave enough, or often simply human enough, to do so, found a quite different man beneath. Those who ignited his rather short fuse found his typical English coolness an impenetrable shield.

Boarding a train in Egypt once, he was unable to find a seat and entering a carriage occupied by an American couple, asked if they might move some of their luggage so he could sit down. The man refused claiming he had reserved the whole compartment, at which point Meinertzhagen demanded to see six tickets and threatened to make room for himself amongst their belongings if they would not co-operate. The American then jumped up excitedly 'and said "You Britishers seem to think you have bought the Universe"'. With complete composure and characteristic chauvinism, Meinertzhagen demurred that while it was true his country-men had not bought the universe, 'we did in fact own the best part of it. That brought forth the rejoinder that we did not own the United States of America. "No", I said, "I was referring to the BEST part of it".'[23]

Liberated from any compromising sense of indebtedness or endearment, abroad Meinertzhagen was also free to give rein to his particular brand of sardonic humour. His writings on foreign people and their customs could be as cutting and as amusing as anything by perhaps the finest travel writer between the wars, Robert Byron, and, like Byron's deserving of a far wider audience. American effusiveness for a genuine English gentleman ensured that his visit to the United States in 1939 was a rich source of amusing anecdotes. At one dinner party in California, Meinertzhagen's enthusiasm for his female hosts visibly wilted as their interest in him gathered pace.

> Within five minutes a stout, over-dressed female patted me on the shoulder and exclaimed, 'Say Folks, I'm just crazy about that guy.' I felt rather like disappearing into the earth. What a lunch. Four silly women all talking at the same time, displaying their knowledge of England, how they met the Prince of Wales, what he said and what they said and all their feelings. Apparently they had played on the same golf course as the Prince and on one occasion he had picked up one of their balls. That ball is now mounted in a glass case with a silver inscription.[24]

Arabs or Muslims were also an inevitable target. Occasionally the humour was unintentional, arising out of a Victorian priggishness which was curious in one so tough. On a vessel bound for Bombay, Meinertzhagen

encountered the Saleh bin Sultan Ghalib, a pretender to the Sultanate of Mukalla in the Hadhramaut, a man with a 'cruel sensual face'. His behaviour on board ship caused a considerable stir, and the fact that many passengers, particularly women, drooled over his expensive and ostentatious jewellery was enough to invite Meinertzhagen's disapproval. The climax came when the Sultan, with supreme audacity, changed his socks in the saloon – 'impossible behaviour', fumed the colonel, that was 'too much for the English passengers'.[25]

Islamic hospitality and Arab cuisine – often an overwhelming combination – were the catalyst for some of his most indignant prose. In spite of his family's reputation for an inexhaustible appetite, Meinertzhagen was a fastidious eater, claiming in later life a preference for vegetarian dishes. When passing through rural Mesopotamia as the Colonial Office Inspector General, and besieged on all sides by offers of sheikh entertainment, Meinertzhagen felt less like an honoured guest than chief victim. Of one encounter he wrote:

> Our meals consisted of boiled rice, a boiled sheep and coffee flavoured with cinammon. It was the same for lunch, breakfast, tea or dinner. The boiled sheep was always an ordeal, as the eye was always extracted by our host and handed to me as the great delicacy. It was with some difficulty that in each case I managed to slip it into my pocket without being seen. There are few things so unappetising as the eye of a boiled sheep.[26]

Having found the expedient of pocketing the eyeballs more tolerable than actually eating them, he carried the stratagem to ridiculous extremes. A feast two months later resulted in this passage:

> We started with greasy soup, which was half tepid, then bony boiled fish which tasted of mud and smelt of kerosene, having been cooked in an old kerosene tin, then roast chicken, tough and stringy, then goat cutlets and potatoes, then potato rissoles, then curried chicken, then more fried fish and finally a stodgy pudding made of half-cooked dough and inferior jam. I eat practically none of it, though the sheikh insisted on my sampling every dish. The result was that by the end of dinner my pockets were full and overflowing of garbage of every description which I later buried in my hut.[27]

In 1931, during his visit to the Ahaggar Plateau, Meinertzhagen was press-ganged into a feast with the commandant of a French garrison. After an evening of Gothic entertainment, he let fly in his diary with volleys of suppressed disapproval.

The dinner was gross. We started with a dish called kus-kus, sodden pulp of boiled wheat, unappetising and tasteless. It was followed by chicken torn into unrecognisable joints and saturated in garlic. The course was accompanied by vegetable or sauce, merely plain tough boiled fids of an old rooster. The table was then cleared and two servants entered bearing an object which I at first took to be a crocodile, but on closer inspection it proved to be a whole roast sheep. A rough log of wood was thrust into the mouth and protruded through its rump and this was carried and dumped on to the centre of the table in fact onto the table cloth, for no plate would hold it. A native then pulled the log out and the hideous carcase with eyes and ears still there lay grinning at us, spluttering grease and gravy and leaking badly elsewhere. It was a most revolting sight.

Jean [the host] and his masculine aquiline angular tortoise-necked wife then proceeded to tear the sheep into bits with forks, fingers, knives and any weapon which came handy. Great gobbets were handed round. A native unable to resist the joy of tearing the toothsome carcase, barged in . . . and commenced to assist in the operation.[28]

It is so characteristic of Meinertzhagen that in foreign conventions of hospitality he did not see the host's unquestioning generosity, and if he did he preferred to measure it against a deeply English sense of decorum, in whose light its openness might seem excessive. But then Meinertzhagen was not like other travellers. He did not seek out these experiences to adorn an after-dinner tale or to convert them into saleable books of exotic travel: ultimately, he sought to escape people rather than to find them. His response in 1926 to a lounge full of old English ladies in a hotel in Darjeeling is typical.

One of them, as fat as a Gloucester spot and as flabby as a flounder, with a dewlap as preposterous as that of a bull eland and a neck as corrugated and wrinkled as that of a giant tortoise, bore down on me from the other end of the lounge, flopped into an easy chair, introduced herself and commenced to bombard me with questions. Was I married? Was I religious? What was I doing and where was I going? Why did I collect birds and what did I stuff them with? How many had I got? She finally asked me to feed at her table and told me she had a comfortable sitting room. That did it. I had to tell the dear old soul that I liked travelling by myself and that to me solitude was a luxury.[29]

His companions on his travels were few – two or three close friends, who

were often themselves distinguished naturalists, like Salim Ali, Con Benson, Willoughby Lowe, William Payn, and Lord William Percy. It was not surprising that these men, living in such close contact, over fairly long periods and often in extremely trying conditions, came in for some fairly stiff, if humorous, criticism. On their trip to Afghanistan in 1937 Meinertzhagen wrote that he was 'disappointed in Salim. He is quite useless at anything but collecting. He cannot skin a bird, nor cook, nor do anything connected with camp life, packing up or chopping wood. He writes interminable notes about something – perhaps me. And he requires waiting on.'[30]

In spite of a world war and a lifetime of self-imposed privation, Meinertzhagen remained a light sleeper, and any one of a myriad of nocturnal sounds could keep him awake. In Mesopotamia once he wrote that 'the night was made hideous by constant crowing of cocks near my hut; the persistent howling of dogs, one in particular with a shrill yelp causing me to frequently burst into a torrent of abuse on the whole canine breed, and a chorus of amorous cats who must have been unrivalled elsewhere in Asia'.[31] Snoring, however, by one of his companions could be the ruin of an entire expedition. In southern Algeria, discovering that one of the party, Willoughby Lowe, was afflicted, Meinertzhagen, during his long sleepless nights, devised an array of expedients to tackle the menace.

> Old Willoughby snored like a grampus, very persistent and loud. I thought he looked like a snorer and asked him about it, but he was most indignant and protested that he was a quiet sleeper. It is curious how a snorer will never own to his crime. But they are a curse. I have suffered badly from them on board ship and in camp. Snorers should be branded so that the world knows. And if when a couple gets married, one finds out that the other snores, divorces should be made easy for it is cruelty to have to sleep for the rest of ones life with a guttural sound that sometimes shakes the bed and prevents all sleep.

It was not only the snoring that kept him awake: 'in addition to the weather the Tuaregs . . . kept up an incessant chatter and our four sheep, tethered together near my tent, chorused their bleats to coincide with the more restful moments of Willoughby's vocal efforts.'[32]

Lord Percy, a member of a famous aristocratic family and one of Meinertzhagen's lifelong friends, was an irascible, argumentative and lovable old bulldog, who shared Meinertzhagen's passion for debate, but seldom his particular point of view. On a trip to Arabia they would contest, until the lights went out at night, such burning issues as the colour of the

soles to a song thrush's feet or camel dung, and then recommence as soon as they rose in the morning. On the same trip a discussion on whether it was possible to see the full moon in the middle of the Southern Cross ended in a £25 bet (a present-day sum of about £250) and a letter to the Royal Observatory.

If the peculiar habits of his co-travellers could irritate him, Meinertz-hagen's patience with those whose only apparent purpose was to thwart his movement between different countries was infinitely less. When en-countering a particularly uncooperative official Meinertzhagen would produce from his wallet and hand to the man a slip of paper on which he had pre-written:

> Love of power and dislike of responsibility are the main functions of the government servant. A civil servant who says NO to a project satisfies atonce [sic] his pleasure in exercising authority and his disinclination for work or responsibility. But the civil servant is a public servant; he serves the public. I am the public and I pay him. He therefore serves me and should help me not obstruct.[33]

For more difficult obstacles Meinertzhagen could draw, even in retire-ment, on a range of official and family connections to smooth his path. Beatrice and Sydney Webb, his socialist aunt and uncle, were unwitting accomplices to their nephew's efforts to get to the Soviet Union in the 1930s. In her diary account of a dinner party, at which the Russian Ambassador and his wife, M. and Mme Maisky, were the guests of honour, Beatrice Webb describes how the 'tall, handsome, elderly colonel . . . made love to Madame as he desperately wants to get a visa for a remoter part of USSR in search of birds'.[34] Sometimes he had resort to the highest in the land to triumph over the especially intransigent. In Egypt in 1928 he was not allowed to take his guns into the country, although he had applied for an import licence three months earlier and had been given reassurances that it would be waiting for him on arrival at Port Said. When officialdom refused to yield, to obtain satisfaction he went first to the Minister of the Interior, the Prime Minister, and finally, the King, who at that time served, like Meinertzhagen, as a council member of the Royal Geograph-ical Society.[35]

In addition to contacts, his particular style of travel demanded enormous organisational ability – a quality, incidentally, that he claimed to lack – and considerable amounts of money. For Meinertzhagen was no Gertrude Bell, Rosita Forbes, or T. E. Lawrence: he did not attempt to merge with the

background, disguised in native costume, travelling light and living off the land. His trips were well drilled and precisely executed, for which his military training stood him in good stead. Even from his earliest days in Africa he made extensive use of local labour. On his solo shooting venture to Nyasaland, for example, in 1908, he had the services of thirty porters, three trackers, a cook, a kitchen boy, and a personal servant. He also oversaw the provision and transportation of food for all these men, in inhospitable country for several weeks. The total expenditure for this trip alone was about £117 – the equivalent of the price of a small car today.[36]

In Ladakh, in 1925, his organisation of the supplies, porterage and route was personally carried out down to the finest detail. It had to be: Ladakh was, and indeed still is, a lunar landscape of high-altitude passes, boulder fields, barren glacier-scoured valleys, and of high wind-sculptured peaks and rock faces. It is a place of great extremes, claiming the coldest spot in Asia. Even in summer the night temperatures are often below freezing; yet by day the sun beats down with Saharan intensity. The Ladakhis, a resilient Buddhist people more closely allied to Tibetans than Indians, scratch a meagre existence from a poor barley crop, a few vegetables, and wherever conditions are suitable, apricot orchards. In winter, when the region can be cut off from the rest of the world for up to seven months, they retire into their badly lit mud houses with their milled barley, their livestock, and their fleas, and emerge again only in spring.

For a six-month journey Meinertzhagen made up twenty-four cases of supplies weighing 16 kg each, which was enough food for a week for two people – himself and his bird skinner. In addition to these were six other cases of food, each designed to last a whole month. One case alone contained '1lb biscuits, 30lb potatoes, 2lb cooking salt, 6lb cooking fat, 3lb rice, 4lb dried vegetables, 3lb cooking sugar, 10lb onions, 1lb cornflour, 4 large bottles olive oil, 28lb flour'. These monthly packs weighed more than 45 kg each, an extremely heavy load for a single porter. And in addition there were tents, axes, water bottles, entrenching tools, plus a myriad of packing boxes for all the bird skins, as well as botanical, photographic, and lepidoptera cases. On top of the taxidermist, two shikarees, a cook and his mate it was obviously essential to have a veritable caravan of porters.[37]

This entourage of followers was no indication that Meinertzhagen was some kind of pseudo-adventurer, addicted to home comforts and unable to abandon them. He was incredibly tough and inured to danger. He could approach life-and-death situations with chilling insouciance. On one occasion in South Africa he came across a group of people, three of whose

number were flat out on the ground. These had been bitten by a poisonous snake, a mamba, and had died after twenty minutes of writhing agony. Meinertzhagen loaded his shotgun and approached the bush in which the reptile had taken refuge, until he was within ten paces of the spot, when a huge black snake rushed out at him, its head and foreparts raised to the height of his shoulder. Discharging both barrels he shot it dead. However, afterwards he confessed that he had not realised that a snake 'could strike so high', and admitted that it gave him 'a fright'.[38]

Salim Ali, in his autobiographical *The Fall of a Sparrow* gave a grisly portrait of Meinertzhagen's indifference to pain.

> While we were collecting in a reedy marsh near Kabul, he [Meinertzhagen], wearing khaki shorts with legs uncovered, accidentally stepped on a barb-pointed reed which broke off, leaving about three-quarters of an inch of its length within his flesh. Regardless of this, he continued splodging through the marsh while his blood flowed freely. Finally, after some persuasion, he agreed to return. As he was limping back to the car to get back and have the barb removed by the embassy doctor, he noticed a Bearded Vulture – a wanted species – some 300 yards away in a different direction. Ignoring the projecting reed and the flowing blood he limped up to the bird and shot it before getting back to the car.[39]

On his Ladakh expedition, in the Changchenmo valley, east of the regional capital, Leh, he came across two snow leopards – an exquisitely beautiful feline now hunted to the verge of extinction in the Himalayas – and shot them. The female fell in the Shyok, a tributary of the Indus, and floated downstream. At an altitude of approximately 4,000 m physical exertion is extremely difficult. Moreover, the glacial melt water from which Ladakh's rivers are derived is only marginally above freezing. Exposure to it, even for a few seconds, is excruciatingly painful. Yet Meinertzhagen, rather than lose his precious skin, waded up to his waist, grabbed it by the tail, lost his footing, and swam with the creature back to the shore.[40]

In 1925, the year of this journey, he was forty-seven and still supremely fit. In the course of the six-month trek he marched 1,905 km, and he calculated an additional 1,660 km when the party had not moved camp – an average of 20 km a day. They had crossed a total of fifteen passes, the lowest, the Zoji La, at 3,500 m, the highest, the Marsimik La, 5,550 m. At these heights his usual pulse rate of 76 raced to 98. The altitudinal limit above which he experienced discomfort was 4,330 m, although he had been up to 6,416 m. However, he found that his strong Burma cheroots, of

which by 1935 he estimated to have smoked ten kilometres,[41] helped his respiration and calmed his heart.

Meinertzhagen's health was remarkably resilient, but like most physically courageous people he had his share of accidents and near misses. In 1912, near Quetta Staff College, he had slipped while walking in the mountains down a shale slope and crashed headlong into the stump of a juniper tree. Had he not, a 100-metre precipice and certain death would have awaited him. In Egypt, in 1928, he was involved in potentially fatal accidents three times in as many months. Returning from Sollum in convoy, he decided to switch cars just before the first vehicle somersaulted off the road and seriously injured the driver. At Luxor, scaffolding on the Karnak Temple collapsed only inches from him, while during a quail shoot his Egyptian gun bearer discharged both barrels as he handed Meinertzhagen a loaded gun, one barrel over his left shoulder, the other over the right.[42] In Afghanistan, almost a decade later, the expedition's lorry careered off a greasy mountain road and fell on its side in one and a half metres of water. Meinertzhagen fell on top of Salim Ali and the driver, with Ali's loaded rifle jammed up into the pit of his stomach. His Indian companion then started 'to fumble with the bolt and trigger with trembling hands', until Meinertzhagen screamed at him to leave it until he had wriggled free of the weapon.[43]

Illness, occasionally of a serious nature, and minor physical injury were both commonplace on his journeys. Less than a year after his initial departure for India in 1899 he went down with acute fever and a temperature of 101°F, keeping him in hospital for more than a month. Little more than a year later and he had crashed off a foot bridge chasing butterflies with a net and broken several ribs. In Africa and the Middle East dysentery or malaria were barely more than occupational hazards, and in Ladakh he was struck by a severe attack of cholera that almost killed him, and meant that he had to be carried on horseback for a week.

Yet physical danger and the risks to his health were more a spur than a check to travel. Even in his seventies and eighties, Meinertzhagen was relentless. Travel was not so much a pleasure as a compulsion. Even when in Britain, he was barely at home for long. Midway through 1931 he revealed in a letter to his friend, F. M. Bailey, that he had been in London for only three weeks that year.[44] Although February and March had been spent in Africa, the other three months had been absorbed by a restless tour between Scotland, Yorkshire, and the West Country. Meinertzhagen needed constantly to be out of doors and, at least for some of the time, by

himself. This habit had developed at a young age, according to the *Diary of a Black Sheep*, from the time of his childhood in Hampshire. At Mottisfont he had enjoyed the loneliness of the surrounding Test marshes. In India and Africa during his twenties he had been happy to go on solitary safari. In 1908, hunting for kudu on the edge of Lake Nyasa in modern Malawi, he found it 'a real treat to be alone'.[45]

It is significant that with the exception of portions of equatorial Africa falling within the defined triangular region of his travels, this area is almost entirely one of desert. Desert landscapes remained his favourite destination. Indeed, with the exception of the Gobi, he had visited all the true deserts of the Old World, from the high-altitude Tibetan Plateau to the curious architectural columns of the Ahaggar region in the central Sahara. His preference for a level, arid landscape was articulated for the first time in 1923, during the visit with his wife and the Nicolls to the desert region between Suez and Cairo in Egypt.

> Dense forests are full of life but depressing, for one never sees much, marshes have a peculiar interest for me as does all water, sea cliffs and the sea shore are invigorating, full of life and always attractive to the naturalist, the vast prairies of east and south Africa appeal to me on account of their very vastness and the unending skyline, but the desert appeals to me more than all these. The dignified solitude of the desert, the loneliness of desert life, the peculiar desert fauna and flora, seem so removed from civilisation and so near the heart of nature and the Presence of God. I simply love the desert and am never so happy as when I am in it. And all deserts, whether the Karoo, Bikanir, Sind, Arabia, or the Libyan Desert, are alike for me; they all attract, mystify and call to my inner soul.[46]

Allied to this peculiar passion for emptiness, possibly its central motivation, was his preoccupation with eternity. From childhood onwards he was absorbed intermittently by contemplation of the limitlessness of space and time. Steeped from youth in Darwinian theories of evolution and non-theological explanations of life, he was none the less concerned to find a God in the machinery. This effort to knit together science and religion was a peculiarly Victorian dilemma, and it is characteristic that Meinertzhagen should have disapproved of *Evolutionary Theory and Christian Belief*, the work of a younger scientist, David Lack, because 'it destroyed what little religion is left'. These periods of spiritual doubt were often triggered by his perception of natural phenomena – 'a full moon and a spangled mass

of planets and suns'. His mind would then revolve, sometimes for days and nights, in orbits of doubt around these central mysteries – a sense fully conveyed by a passage written in 1962.

> . . . I find them most frightening. Was there ever a beginning and will there ever be an end? Is there no end in space? Is there life on other planets and if so it must have developed on different lines to our evolution life. Shall we ever know? Does our conception of God apply to life on other planets? Did it all start a hundred million years ago and will it continue for another hundred million years? Are we the only planet where speech and civilisation has developed? Shall we ever know? I find it most frightening. Is there no end to time and space and was there ever a beginning?[47]

On another occasion, in his eightieth year, a bout of 'worry and contemplation about eternity' was awakened by thoughts of Halley's Comet. After sleepless nights he eventually applied to the Astronomer Royal to lay to rest his intimations of mortality. It is indicative of his pantheistic fusion of the material and the spiritual that he should address what was essentially a religious inquiry to a scientist. Although Meinertzhagen's original letter is absent, it is possible to infer its content from the reply. 'It approaches the sun within 55 million miles at one end of the ellipse and goes out to 3,300 million miles at its furthest point,' explained the rationalist with great patience. However, the latter was at a loss to understand 'the word "infinity" which you introduce into your letter as this seems to me to have no connection at all with Halley's Comet'.[48]

In Meinertzhagen's spiritual restlessness, his compulsive desire to be in transit, and in his passion for the open landscape of the desert – for its emptiness, austerity, and its peculiarly savage beauty – one is reminded not so much of a naturalist-traveller like Peter Scott, even less of an urbane traveller-raconteur like Robert Byron, but rather of a handful of explorers, such as T. E. Lawrence or Wilfred Thesiger. These men, whose souls having been touched and made whole by the purifying spirit of the desert, look curiously ill-at-home in the domestic greyness which we all inhabit, and to which all travellers must eventually return. Lawrence, unwilling or unable to adapt, found solace in a celebrated anonymity, in motorbikes and speedboats. Thesiger, rejecting conventionality, adopted the nomad's garb and the nomad's lifestyle. Meinertzhagen, with his passion and will to encompass all, fell somewhere between the two, moving restlessly back and forth between the super-civilised life of his well-appointed Victorian house and the silence, solitude and space of the wasteland.

1928–45
My Other Work

One of the most intriguing, least known and, in many ways, most confusing aspects of Meinertzhagen's extraordinary life concerns his involvement in military intelligence and the secret service. Almost inevitably, it was the one activity on which his diaries reveal least, although they do in fact give away something, which itself raises a number of interesting questions. For Meinertzhagen, intensely reserved emotionally, found it easy to keep even from those who were closest to him the most fundamental information about himself. In 1951, for example, to take just a single year, he refused to disclose to his family either the fact that he had suffered from what he believed to have been a heart attack, or that he had received the offer of a knighthood.[1] Given this capacity to hide himself away, why should he have revealed anything about his secret intelligence work?

As in so many other areas of his life, it seems possible to detect curiously opposing impulses behind his actions. On the one hand, his was the perfect character for espionage: discreet, fiercely patriotic, courageous, resilient, devious, and capable, if necessary, of complete ruthlessness. And yet simultaneously, for all his reserve, he seems to have enjoyed the fact that his intelligence work was an open secret, almost wishing, by disclosing just so much, to surround himself in an aura of mystery. Many of his friends and, indeed, those who knew him only distantly, were aware of his 'other work', as he liked to call it, and the fact that his ornithological journeys were a smokescreen for a very different kind of research. Moreover, while his diaries are a patchy source of information on this subject, they do provide startling evidence concerning two remarkable incidents. It seems that the need for absolute discretion was at times too much for Meinertzhagen, and his over-excited mind spilt out the facts in his diaries, perhaps as a form of exorcism.

The more remarkable in many ways of these two incidents occurred in February and March 1930, at the time of his fifty-second birthday. Anybody reading his diaries in sequence comes upon volume thirty without any hint of what follows. Suddenly, one is thrown into a Buchanesque world of British secret agents, of special foreign assignments,

nocturnal rendezvous, fast getaway cars, and finally of a life-and-death struggle with Bolshevik agents in the Andalusian hills of republican Spain.

However, anyone wishing to appreciate the full significance of this melodrama has to go back more than eighteen months, to the Meinertz- hagens' vacation in the summer of 1928 at Swordale. A few months earlier Annie, then in her fortieth year, had given birth to a second son, Randle, during her husband's three-month expedition to Egypt. After his return and the christening of the new baby, the family of five, including the three children – known monosyllabically as Anne, Dan, and Ran – travelled to Scotland. They intended to take an estate for the grouse season and eventually leased a large house at Armadale on Skye, returning afterwards to their home in Swordale. There, in the late morning of 6 July, Annie accidentally shot herself with a revolver in the grounds of the house.

Meinertzhagen's subsequent diary entry, written more than three weeks after the event, revealed the circumstances of her death with tragic simplicity.

> I have not written up my story for some weeks not because I have had nothing to say but because my heart has been too full of sorrow my soul too overwhelmed with unhappiness. My darling Annie died on July 6th as a result of a terrible accident at Swordale. We had been practising with my revolver and had just finished when I went to bring back the target. I heard a shot behind me and saw my darling fall with a bullet through her head.[2]

The bullet had penetrated her skull and caused fatal injuries to the spinal cord and the lower part of the brain; according to her husband, 'Death was instantaneous'.

Because of the unusual circumstances of the tragedy and the fact that Annie was an expert in the use of firearms, some questioned whether her death had been deliberate. However, there is no solid evidence to support such an inference, while her husband revealed in his diaries a sense of loss so complete that it took him several years to recover. Eight months afterwards, in March 1929, he wrote:

> I have had to make a great effort for the children's sake to keep normal. I have not entirely succeeded for at Christmas I broke down, lost my memory and took to my bed. Since then I have hovered on the brink of despair and have suffered the blackest depression. It has been the

saddest time of my life and I am really no better than I was at Christmas
. . . A second winter like the last one would kill me.[3]

After five further months – time spent miserably wandering around the
country, moving from the home of one friend to another – Meinertzhagen
eventually broke down completely. In September he admitted himself to a
sanatorium at Ruthin in north Wales, where he seems to have regained
some strength. However, on the last day of 1929, and almost eighteen
months after Annie's death, he wrote: 'My life has been transformed into a
desert . . . Oh God let me die. Others can care for my children better than I
could do. Others will be happier with me away. Surely my mortal span is
near run out. I cannot believe, and certainly cannot hope, that it will last
much longer.'[4]

Yet, almost unbelievably, this sense of inescapable grief that pervades
the diaries is suddenly interrupted in the opening pages of the subsequent
volume with the following, rather confused, passage:

> I have had to come to Spain to try and terminate an intolerable situation
> and once and for all put a stop to the activities of Russian revolutionary
> activities in Western Europe and incidentally to my own personal
> security, a matter which I seldom speak about and have so far never
> mentioned in my diary. It is a secret well kept and only know[n] to a very
> few, that my main work during the past seven years has been the hunting
> down Bolshevic agents in western Europe and keeping in touch with
> their activities. It has been exciting enough, profoundly interesting and
> not without a spice of danger.[5]

According to Meinertzhagen, a cell of Soviet agents had been dislodged by
the Dutch authorities from their previous base in Amsterdam and had
moved to Spain. Here, they had taken up residence in Ronda, a small
mountain town in Andalusia, within easy reach of Seville, Malaga, and
Cadiz. The Spanish intelligence service had then informed the British of
the Soviet agents' carefully planned move, and since Meinertzhagen, in his
own words, 'was more conversant with the organisation than probably any
other man in Europe',[6] he was asked to co-ordinate and effect their arrest,
having at his disposal anything he should need.

By sheer coincidence, a group of his friends had invited him to a duck
shoot in the Marismas – a spectacular area of marshes in the delta of the
River Guadalquivir, south of Seville. Using this trip as a cover, he sailed to
Spain on 21 February and two days later arrived in the Marismas, where

the police kept him informed of developments in Ronda – a convenient 130 km away. The authorities were apparently increasingly concerned by the subversive activities of the Soviets and requested that the visiting British agent should capture them. Reluctantly, Meinertzhagen agreed, but confessed to his diary: 'I hate being hurried and do not wish any premature action to wreck the best chance I have ever had to crushing [*sic*] the whole Bolshy organisation in western Europe.'[7]

On the evening of 25 February he travelled by police launch to Sanlucar de Barrameda on the east bank of the Guadalquivir, and then motored across to Ronda, arriving at midnight. The Russians had apparently occupied a large house situated several kilometres outside the town amongst pine woodland, which he carefully reconnoitred in order to plan his arrest. This first assault, executed two days later, ended in failure when they were unable to force an entry into the building without alerting its occupants. However, after a further forty-eight-hour interval, having received another urgent summons from the Spanish police, Meinertzhagen decided to make a second attempt. On 2 March, the eve of his fifty-second birthday, he returned with some of his men and bivouacked for the night close to the small town of Grazalema, just west of Ronda. After spending much of the next day in search of spring flowers and birds, he and the others descended into Ronda and awaited nightfall in the police barracks. In the early hours of the following morning they drove to the house, walking the final kilometre in order not to disturb their targets. Meinertzhagen revealed that his initial intention had been to surround the house with eight men and then enter with the remainder, arresting the Russians as quietly as possible. Unfortunately, only the first half of the attempted arrest went according to plan.

The Soviets' Spanish servant, apparently a man in the pay of the police, unbolted the door for them, and having gained access, Meinertzhagen forced his way into two downstairs bedrooms and arrested, amidst a good deal of noise, the two sleeping occupants. This, however, seemed not to have alerted the remaining fifteen on the first floor and he and his men 'ascended the stairs like cats'. At this stage things went badly awry. Breaking into one of the rooms, they managed to handcuff and gag three men, only after one of them had given out a 'piercing shriek'. The result was pandemonium; according to Meinertzhagen 'a breathless, exciting moment' ensued.

Would they fight? If so it meant sudden death for many or all. Stegmann came out first, pistol in hand, a black-bearded giant. I shouted 'hands

up' but it was too late, he fired at me. I recollect the feeling of satisfaction like a flash, that he had fired first, giving us a free hand and putting himself and his whole gang in the wrong. I fired at once [*sic*] bringing him down with an angry snarl and not before he got his pistol off again. He was like a wild animal on the ground with ears back, teeth gleaming and eyes ablaze, though knowing death was fast overcoming him. It was horrible to see.

Two of my [men ?] were down and apparently dead. From that moment there was a scrimmage. Doors seemed to open in all directions, pistol shots rang out from every corner and angry shouts drowned any orders I was able to give. I yelled to my men to keep together, but they would not. The world seemed to revert to the jungle and jungle law. Social man became a savage beast. All our worst instincts surged up and I saw red, realising that it now meant a fight to the finish, so I let fly in every direction, placing bullet after bullet into those wretched Russians. All the vaneer [*sic*] of civilisation went in a flash, to be replaced by stealth, crouch, cat quickness, lightning spring and the steel claw which rips the jugular vein. The landing was soon a shambles and for a moment I thought we had got the worst of it but quite suddenly everything stopped except for defiant curses from one room. Our blood was up and we atonce [*sic*] took up the challenge and rushed in to despatch what remained of these men. Another man [went ?] down before we broke down their resistance and than [*sic*] someone threw two small bombs which exploded with apparently harmless results but in a moment their meaning was realised. I caught my breath as I smelt a burning gas. One gulp I swallowed before I realised the poison. I yelled to my men to get out and we hurried away dragging six dead and wounded with us.[8]

Once outside, Meinertzhagen gave orders for a cordon to be formed around the house. In the pause offered by their retreat he discovered that the five Russians arrested during the initial stages of the assault had been executed by their Spanish guards during the gun battle, and also that five of his own men had been killed and another badly wounded in the chest. While seventeen Russians were known to have been in the house, only fifteen could be accounted for. Meinertzhagen became anxious that if two remained alive the siege would drag on until after dawn, thus exposing them all to public and possibly press attention. With this in mind, he sent for the cars, removed all dead and wounded, and smashed all the windows in the house to disperse the toxic gas. After 'sitting round . . . like a lot of vultures' for some time, they re-entered the lower floor to clear the rooms of

valuable papers, and burned the building down with all its human contents. Towards 6.00 a.m. and the first signs of dawn the house had been reduced to 'a charred ruin', and Meinertzhagen, his throating burning badly from the poisonous gas, returned to the hospital in Ronda. The Spanish police had given undertakings to clear the derelict building of human remains, suppress the deaths of their five officers, and to transport all the Russian papers to Granada. At 7.00 a.m. Meinertzhagen checked into Ronda's Victoria Hotel 'feeling thoroughly done and very dejected'.

The following day he travelled on to Granada for a conference at the Spanish police headquarters, where his hosts expressed deep satisfaction with his work, and offered him all documents relating to England. 'These are illuminating,' he later wrote in his diary, 'especially some papers referring to myself and my movements and the organisation's intentions regarding myself. It is clear that they had no intention of leaving me alone and that they had a much higher opinion of my power, knowledge and abilities than was the case.' Shortly afterwards, following a brief visit to Gibraltar, Meinertzhagen's duck-shooting trip to Spain came to an end and he returned to England.

The Ronda episode is probably the most remarkable revelation in the entire life story of this incredible man. Certainly, the full details of it have never been revealed before. If one is to believe Meinertzhagen it seems that at the age of fifty-two he was still one of Britain's most experienced secret-service agents, capable of undertaking missions that one normally only encounters in the books and films of Ian Fleming's celebrated character – James Bond. The problem is: can one believe it? For there is a range of questions very difficult to answer.

Foremost amongst these concerns Meinertzhagen's claim in the opening paragraph of the diary that his main work 'during the past seven years has been the hunting down [of] Bolshevic agents in western Europe and keeping in touch with their activities'. On what level can this statement be true? Seven years would take Meinertzhagen back to 1923 and his period at the Colonial Office. In that year he made an extensive tour of Palestine and Mesopotamia as the inspector-general of Middle Eastern forces, and was deeply involved in Zionist issues, as his diaries and documents in the Public Record Office confirm. In 1924 the post terminated and, after an ornithological visit to Madeira, he spent four months in Cologne, where it is conceivable that he was engaged in counter-intelligence work. However, for all of 1925 and the first part of 1926 he was intensively birdwatching in the Indian subcontinent, primarily at very high altitude in uninhabited

portions of the Himalayas. Apart from a brief visit to Denmark and Germany in the spring of 1926 (to attend an ornithological congress in Copenhagen), and then an ornithological trip to Egypt two years later, Meinertzhagen does not record leaving Britain again until the Ronda episode itself. How could he have been hunting down Bolshevik agents in Europe if, as his personal journal indicates, he hardly visited the region? Out of twenty-seven months spent abroad in this period, twenty-two were spent east of Suez, largely engaged in ornithology – hardly the record of the most experienced intelligence agent on Russian communists based in Europe.

It might, of course, be possible that Meinertzhagen did not in fact need to leave Britain to be engaged in this work, but the diaries contain no supportive evidence for this at all. There are no records of meetings, of intelligence personnel that he met even on a social basis, or of any kind of official involvement whatsoever. On the contrary, they suggest a retired man, enjoying the company of his family and friends, fully engaged for the first time in his life in his principal interest – natural history. It is also important to bear in mind that for the eighteen months prior to his visit to Spain Meinertzhagen was completely unbalanced by the death of his wife – hardly the frame of mind conducive to stressful, even dangerous, involvement in the Secret Intelligence Service.

Possibly what Meinertzhagen meant by his claim was that the official work he did actually do, which may have absorbed only a portion of his entire work time, did in fact concern Soviet activities in Europe. But such a part-time or free-lance involvement, which actually seems most likely, does not really square with his later claim to be 'more conversant with the organisation than probably any other man in Europe'. This rather bold assertion, like his claim after the gun battle to have stopped Russian revolutionary activity for many years, seems rather wild and egotistical, even fantastic. For the implication is that Richard Meinertzhagen was fighting Soviet communism single-handed, and succeeding. Such extravagant language is barely credible and tends to weaken one's belief in the entire episode. In fact many of Meinertzhagen's descriptions of the events in Ronda have the ring of fiction. A sentence such as, 'All the vaneer [*sic*] of civilisation went in a flash to be replaced by stealth, crouch, cat quickness, lightning spring and the steel claw that rips the jugular vein', reads like an over-dramatised novel.

Equally difficult to swallow is the stilted and clichéd threatening letter that he received in May 1930, during a vacation in Jersey. This read:

So now we know. You swine, we shall get you. We know now that you did the killing in Ronda and murdered poor Michael Doronetz and many other of pou [our?] best friends. But you shall pay for it and it will not now be long before we get you. And we know all your movements and that you have been staying at Rogozan in Jersey and all your activities are closely watched. It will give us all so much pleasure when you are cold and still lying in a pool of your own blood, stiff and in Hell, curse you. It will avail you nothing that you can shoot straighter than any other man we know. We know you are brave and relentless, but the word has gone out that you must die, so be prepared. You of all men have done more to harm the greatest blessing which we are endeavouring to give the world, namely freedom from the oppression of your bloody class.

I am no Russian and you will never discover the writer of this letter unless in dying you recognise the hand which strikes you. You dirty cruel swine, in striking you down, I shall experience the greatest pleasure of my life. Nothing you can do will avert your much deserved fate.

One who knows you well and whom you may recognise.[9]

Meinertzhagen claimed afterwards that the author, whose identity he suspected, was a Pole involved in an organisation that spied on Soviet agents in England and worked directly under the Moscow Cheka. After examining specimens from the typewriters that the suspect had access to, they found that he had used one where he was accustomed to have lunch, and arrested him. Possession of unlicensed firearms, according to Meinertzhagen, ensured that he would serve a short prison sentence, after which he would be deported.[10]

However, aspects of the letter seem, at least, rather suspicious: for example, the fact that the author gives away that he is not a Russian and that Meinertzhagen might know him. Also interesting to note is that the final sentence of the first paragraph, in a curious way, confirms Meinertzhagen's own over-blown remarks about his rôle in stemming the flow of communism in Western Europe. The noun, 'Hell', is capitalised – a characteristic often found in Meinertzhagen's own writing; also typical of him is the fact that in the original typed letter, two words have been started at the ends of lines and then repeated in full at the beginning of the next. Given this evidence, is it conceivable that the author of the letter was Meinertzhagen himself?

The severest logic of such a theory would demand, in turn, that the

whole Ronda story be jettisoned with the letter, since a man capable of inventing one element of the episode is obviously capable of inventing the entire thing. This approach, however, is as unsatisfactory as aspects of Meinertzhagen's story itself. For any examination of the original text reveals a barrage of details that authenticate a number of key facts. The most important of these is that Meinertzhagen actually was in Spain in February and March 1930. The diary contains photographs of him in the Marismas and an extensive description of a camel-catching excursion that he went on – evidence that it would be very difficult and complicated to falsify. Small details also tend to confirm the veracity of the journal. The species of bird and flower that he recorded fit the locality and the season, the fact that the Alhambra Palace Hotel in Granada in which he stayed has, as he confirmed, 'fine views towards the snow-capped Sierra Nevada'[11], and also the fact that the lungful of toxic gas that he inhaled continued to trouble him (a fact he repeatedly recorded) for months after the raid. Finally, and most convincing, Meinertzhagen was awarded a Spanish medal – the Order of King Charles III – in 1930, which strongly suggests that he was engaged in military operations beneficial to the Spanish government at that time.

It seems certain that he did go to Spain, that he was involved in a raid in Ronda, that many were killed, and that he suffered some sort of lung and throat infection as a consequence of inhaling poisonous fumes. The constant claim that he was more or less the Soviets' most important opponent is obvious embroidery, but the basic fabric of the tale is probably as Meinertzhagen revealed it. The rather fanciful style that he used at times to describe the events does give rise to a certain amount of doubt in the mind of the reader. But Meinertzhagen's crime, if it can even be described as such, need be little more than a failure to give accurate expression to his heightened sense of awareness at the time of a life-or-death adventure. The language of fiction into which he lapses, and which indeed often colours elements of his diary, need not imply that the events described are themselves fictional.

The second revelation that he makes concerning his involvement in the secret service, though shorter and possibly less dramatic, has historical and political implications of a far more profound nature. It occurred in August 1918, a single 300-word entry that, like the Ronda episode, had no antecedents and afterwards received no further mention. It is possible to imagine that these two incidents, so rich and full of suspense, offer a brief, tantalising glimpse of a completely unknown life; and that if one were to

approach close enough one might see through the half-light a world of unparalleled excitement and adventure. Unfortunately, this appealing speculation about Meinertzhagen probably soars way beyond the more mundane truth. For if ever he should have left a chapter in his life undisclosed, it was that in which he became involved in the summer of 1918, and which, had it ever been discovered, would have left an incriminating trail all the way to the British throne. If Meinertzhagen was prepared to document – no matter how briefly – even this escapade, then surely he revealed everything in his diaries of significance? Furthermore, he treated this secret mission to Russia with a certain amount of nonchalance, for it even appeared in the index to his diaries, entitled 'Russia: attempt to rescue Tsar and family'.[12] The full entry, written shortly before his departure for France as one of Haig's staff officers, was dated 18 August and read:

Lenin was smuggled into Russia from Germany in April 1917. The Tsar and his children were arrested in March 1917 and remained in confinement at Tsarko Selo until August 1917 when they were taken to Tobolsk. In November 1917 they were removed from Tobolsk to Ekaterinburg where they remained until their murder on July 16th 1918. Even now I feel it a bit dangerous to disclose detail. Whilst at the War Office I had to visit the King at Buckingham Palace once a week to tell him about the campaigns in Iraq and German East. On one occasion I found my friend Hugh Trenchard there. Part of my work in the War Office was organising an intelligence service devoted to happenings in Russia. King George opened the conversation by saying he was devoted to the Tsar (his cousin) and could anything be done about rescuing them by air as he feared the whole family would be murdered. Hugh was very doubtful as the family must be closely guarded and there was no information regarding landing facilities for aircraft. I said that I thought I could find out about that and perhaps arrange for a rescue party to bundle at least some of the royal prisoners into an aircraft. But it was taking a great risk as failure would entail the murder of the whole family. Hugh and I talked it over and after a few days I was able to try and get some of the children out but the Tsar and his wife were too closely guarded. On July 1st everything was ready and the plane took off. Success was not complete and I find it too dangerous to give details. One child was literally thrown into the plane at Ekaterinburg, much bruised and brought to Britain where she still is. But I am sure that if her identity were known she would be tracked down and murdered as the heir to the Russian throne.[13]

The significance of this passage lies in two things: firstly it contradicts established opinion on the fate of the Romanovs, and secondly it points to royal involvement in measures that were probably unconstitutional.

The 'official' version of events at Ekaterinburg in the summer of 1918 maintains that Tsar Nicholas II and his family were lodged in the property of a merchant called Ipatyev – a building that became known ominously as the House of Special Purpose. Following the advances made by the White Russian army towards the city, the commissar of the Ural soviet, Golosh-chekin, travelled to Moscow to receive orders from his superior, Sverdlov. On 12 July, after his return, Goloshchekin reported to the Ural soviet, which took the decision that the entire imperial family, the personal physician, Dr Botkin, and their three servants should be executed. Towards midnight on 16 July the whole family was taken to the cellar, where the head of the Bolshevik guard, Yurovsky, and a gang of his men, brutally shot and bayoneted them to death. Their bodies were loaded onto a lorry and driven 20 km to an abandoned mine shaft near the village of Koptyaki. Here, the corpses were dismembered and dissolved in acid, and the remains thrown down the mine and sealed over.

However, this widely accepted version of history has not been without its opponents. An array of more romantic, although less well-documented, alternatives has been put forward, principally by the numerous claimants during the first half of this century to the title of the Grand Duchess Princess Anastasia. The most famous of these was Mrs Anna Anderson, whose long legal battle to establish her identity with the surviving members of the Romanov family was unsuccessful. Yet her uncanny and deeply intimate revelations about the imperial family, and also the fact of her persistence in a legal suit over several decades, give some credence to the possibility that she was a Romanov, and that all was not as it appeared at Ekaterinburg in those fateful weeks in July.

Others have also countered the official version. Richard Deacon in his book *A History of the Russian Secret Service*, contended that 'the exact fate of the Czar and the Imperial Russian Family remains a mystery'.[14] He claimed that the judge appointed to investigate the royal murders after White Russians had recaptured Ekaterinburg possibly conspired to sup-press the truth. The evidence, for example, found in the mine shaft at Koptyaki, on which the judgement was based, was curiously inadequate. The royal jewellery discovered, according to Deacon, could easily have been planted there; the bones, on the other hand, were not even definitely human; while a finger, alleged to be that of the Empress, was far too fresh to

be that of a woman killed more than ten months earlier. Moreover, Judge Sokoloff was assisted in his investigations by a member of the British secret service, Robert Warton. The latter apparently retained the original dossier on which the findings were based. 'The most sensational part of this document,' according to Deacon, was 'the evidence which Sokoloff for some reason saw fit to suppress in his final report, evidence which tells of the female members of the Imperial Royal family being seen at a date later than the alleged execution.'[15]

Much of this, while not confirming Meinertzhagen's story, introduces an element of uncertainty into what happened to the Romanovs in the summer of 1918. Other recent investigations also tend to suggest that one of the royal family did escape in an airborne rescue attempt. According to these findings Meinertzhagen masterminded a scheme that established fuel dumps at strategic points along a flight route between the Arctic port of Murmansk and Ekaterinburg, and then between the royal prison and along an escape route across Siberian Russia to Vladivostok. The plan had somehow gone wrong after arrival in Ekaterinburg and the rescue plane, a De Havilland Four, piloted by Captain John Poole, covered the 3,300 km journey to Vladivostok in over eight days, with only a single member of the family aboard – the twenty-one-year-old Grand Duchess Princess Tatiana. From Siberia the Tsar's second daughter was smuggled aboard a Japanese warship in a crate marked as diplomatic baggage, and then taken to Canada in the entourage of the King's uncle, Prince Arthur of Connaught. By sheer coincidence the latter happened to be on an official visit to Japan, to present the Emperor with a field marshal's baton. After her arrival in Canada and a subsequent visit to Britain, the Princess recrossed the Atlantic, at which point her trail grows cold.[16]

While the possibility of Tatiana's escape and a new secret life in the West are matters of profound interest, the other major question raised by this whole saga concerns the precise rôle played by King George. As with so many stories involving the intelligence service, the evidence is rather thin and at times contradictory. Meinertzhagen's diary entry indicates quite clearly that it was as a consequence of George V's passionate concern for the well-being of his cousin that the rescue mission was mounted in the first place. Kenneth Rose's biography, *King George V*, however, suggests a very different response on the part of the British sovereign to his Russian cousin's plight.

In March 1917, after the abdication of Nicholas II, the British cabinet responded positively to the request made by the provisional Russian

government that the Tsar and his family be offered asylum in Britain. According to Rose, the King at first gave enthusiastic support to such a scheme, but then later, exercised by fears of increasing republicanism in his own country and public resentment should he be seen to identify himself with Russian imperial autocracy, expressed considerable reservations. It was his doubts and then his opposition that delayed government consent to British acceptance of the Romanovs, until the rapid movement of events in Russia had completely excluded the possibility of their escape. If this were the case, then it would seem that by the time Meinertzhagen saw the King in the spring of 1918, the latter had performed a complete *volte face*, apparently involving himself in secret and possibly unconstitutional actions in order to secure the Tsar's release by the secret service. Rose's book alludes guardedly to this possibility:

> Having belatedly realized the danger to which his cousins were now exposed, he [George V] may have instigated or at least encouraged the British Secret Service to rescue them by bribery or force . . .
>
> All this is mere conjecture. No evidence exists to link the King with those abortive plans known to have been made by Russian refugees for the rescue of their ex-ruler. Yet it is significant that the Royal Archives at Windsor contain hardly any documents dealing with the imprisonment of the Imperial family between April 1917 and May 1918, precisely those months during which rescue must have been considered if not planned. The absence of such papers points less to the abandonment of the Tsar by the King than to an exceptional need for secrecy.[17]

Finally, in addition to this interesting circumstantial evidence there are notable omissions in the files of the War Office – documents that may well also have related to the Romanovs and the possibility of their rescue. Such careful weeding suggests that some kind of cover-up had been effected.[18]

There are clearly many aspects of this story, and indeed of Meinertzhagen's secret-service career in general, that remain unexplained. The other details which he provides in addition to these two adventure stories are even more fragmentary and confusing. In 1928 he seems to have undertaken work during his ornithological expedition to Egypt concerning hostile Italian activity on the Cyrenaican border. However, precisely what this involved is unclear.[19] In 1937, en route to Afghanistan, he was surprised by a telegram from the Governor of Bombay, Lord Brabourne, inviting him to stay at Government House. 'I am at a loss to understand why for I did not know he had ever heard of me', he later confided to his

diaries. Yet on arrival in Bombay he was 'met on board by an ADC and several scarlet-robed assistants who whisked off [his] luggage and guns and all . . . and left [him] gaping at their haste and audacity'.[20] Brabourne was apparently convinced, in spite of Meinertzhagen's protestations to the contrary, that the latter was going to Afghanistan on secret-service duty. It is unlikely, had this been the case, that he would have revealed anything about his intelligence connections, but even privately he maintained that he had not been involved in this work for many years. However, in the same entry he admitted that he had obtained information from the Russian Ambassador in Britain, Ivan Maisky, that the Soviets wished to advance their influence in Afghanistan through increased trade. This might suggest that he had, in addition to his ornithological goals, a number of other research objectives during his expedition.

It is one of the abiding anomalies of Meinertzhagen's life and, indeed, of his family in general, that so zealous, even violent, an opponent of Soviet communism should have had so many relatives with communist sympathies. In fact, these family contacts gave him access to some of the most influential socialists in Britain – contacts that he may well have used to pursue intelligence issues. Meinertzhagen also seems to have derived a deep personal satisfaction from finding himself surrounded by those whose views he strongly opposed. One of his most cherished forms of social intercourse, it seems, was violent argument, and on this perverse basis something akin to friendship and admiration for his antagonists often developed. Some sense of this is given in an account of a dinner party he attended in May 1934, along with his sister Bardie and her husband, Bernard Drake, Sidney and Beatrice Webb, Stafford Cripps, and the Russian Ambassador, Maisky. Meinertzhagen's diary entry later that evening, entitled 'A covey of communists', was overflowing with indignation at his relatives and fellow Britons:

> I have never heard so much sedition and disloyalty . . . in so short a time; and I thought it such bad form to revile one's own country in front of the representative of a country which has done her best to ruin us and has murdered over a million of her own innocent citizens in the past few years.[21]

In spite of this sense of moral outrage, he found Ivan Maisky 'a cheerful little man, a good revolutionary, spoke openly of everything in Russia and as a man I liked him'. Meinertzhagen had also found Mme Maisky attractive, making love to her, he confessed 'in the hopes of making an

impression and getting facilities for an expedition to Russian in the near future'. However, the sight of his sister and his aunt hero-worshipping 'at the feet of the blood-red ambassador' seems to have provoked him to rebellion:

> I . . . reminded them of the fact that if the socialists started to play havoc in this country, as they would inevitably do if they ever got into power, Fascism would take a firm grip, and would evict them. Teste Hitlerism. Explosion! The Ambassador went purple, Stafford became incoherent and glared at me. The Ambassador told me I must be a capitalist. I told him I was and intended to remain so, and would he like to visit me at Swordale and see my serfs and our feudal methods.

'I enjoyed it', he added with obvious relish before finishing the entry.[22]

Meinertzhagen's 'friendship' with the Maiskys and his subsequent visits to the Soviet Union, in 1934 and 1938, raise a number of questions concerning the kind of rôle he might have played in British intelligence. Since, if his activities in Ronda were known to the Cheka, as the threatening letter of the Polish agent indicated, then how easy would it have been for such a man to gain entry to the country? Also, it would seem logical that Maisky would have been informed of Meinertzhagen's true interests, and that their association, rather than being a possible source of data for the British, would offer opportunities for disinformation by the Soviets. Yet one might also expect that Meinertzhagen would be fully alerted to that possibility.

His diary accounts of his journeys to the Soviet Union reveal nothing other than the fact that he was meticulously searched at the border both on arrival and departure, that he worked in the Leningrad museums on birds and mallophaga, and that he loathed the country's political system and its agents. By sheer coincidence, his sister Bardie had visited Russia at the same time, accompanying her uncle, Sidney Webb, and a second cousin, John Cripps, the son of the future Labour minister. Their response to the host nation, as Meinertzhagen revealed it, could not have been more different to his own. 'They are wallowing in the bolshy trough,' he jeered, 'lapping down all they are told, collecting statistics given them by government officials, seeing all the sights they are meant to see and getting a real good innoculation of communism.'[23] For Meinertzhagen himself, Russia was the only country where

> One cannot get a visa under three to six weeks and sometimes not at all [sic].

Where the customs examine all private letters and turn out every package . . .

Where their own nationals cannot travel abroad.

Where such a large percentage of the persons are of the criminal type to look at,

Where all foreign newspapers are excluded.

Where foreign broadcasting is jammed.

Where religion has been replaced by blasphemy.

Where the only evidence against a prisoner is his own confession.

Where the individual has neither intellectual nor political freedom.

Where a reign of Terror has been in force for twenty years . . .

Where Truth is distorted and suppressed as part of the national policy.

Where the whole nation is enslaved.

And this is the only country in the world which many of our politicians would ask us to follow.[24]

The strength of his opposition to the Soviet Union and his fear of socialism at home pushed him in the 1930s into increasing support for authoritarian forms of government. 'One fact stands out clear,' he wrote in the summer of 1932. 'Democracy has failed dismally. Democracy as a system of government is a complete failure . . . Conference government is hopeless. We want some form of dictatorship which will do all the hard thinking.'[25] It was this sense of disillusionment with the British political system, coupled with his passionate disapproval of the French, and the universal disapproval of Nazism amongst his friends and relatives (with whom he enjoyed the role, once again, of solitary opponent) that formed the background to his enthusiastic endorsement of Adolf Hitler – an endorsement also indicative of his own deeply Germanic love of order.

However, it was his loyalty to a very different political philosophy – Zionism – that actually brought him face to face with the Führer. Weizmann, desperate to do something on behalf of German Jews, asked Meinertzhagen, as a leading member of the Anglo/German Association, to intercede on their behalf. And in the autumn of 1934, after his first visit to the Soviet Union, he travelled on to Berlin and a meeting with the Nazi leader on 17 October. An account of the day's events was eventually published in the *Middle East Diary*, Meinertzhagen describing how he and Hitler moved towards one another in the Chancellor's enormous office, and met in the middle of the room. Hitler, apparently, raised his hand and offered the customary Nazi salute; his visitor, thinking it 'rather odd'

that he should 'heil' himself, raised his own hand 'and said "Heil Meinertzhagen"'. According to the Meinertzhagen, 'nobody smiled'.[26]

A portion of the diary entry concerning this meeting that was not published, however, was the author's assessment of his host: 'I came away from Hitler convinced that the man was incapable of untruthfulness, deceit or unmanly actions. He has a large open face, a good nose and forehead and large penetrating eyes with Truth branded large on them.'[27] Meinertzhagen also showed increasing confusion on the issue of the Nazis' anti-Semitic policies. Only the year before, he had written: 'I have an immense admiration for everything Jewish', and that the proscription of the Jews had been 'a terrible blunder and has involved great cruelty'.[28] Yet, after the meeting he felt that 'International Jewry is out to destroy Germany.'[29]

With the benefits of hindsight, Meinertzhagen's persistent sympathy for the Nazi regime looks callous (particularly from a professed Zionist), or, at best, remarkably obtuse. However, given the strength of his opposition to communism and his peculiarly atavistic sympathy for the German people, such impercipience as he showed becomes almost inevitable. It is also important to note that in 1934 he was unaware of the Nazis' real intentions or of the extent of their anti-Semitic policies. Moreover, he had for many years condemned the Treaty of Versailles as one imposing unjust conditions on the German nation. He continued to believe until long after the Second World War that this agreement had given rise firstly to the Nazis and then to the war itself. In the 1930s, therefore, he felt that the British carried a burden of responsibility for developments in Europe, and that they should be willing to accommodate the German people – no matter how extreme their political leader or his methods.

For almost the only time in his life these views made him appear something like an appeaser – an attitude which he maintained even as Hitler invaded the Sudetenland.[30] It took another meeting with the architect of Aryan world supremacy, in June 1939, before he finally conceded what his friends had been telling him for years – that Hitler was 'a mad dog, hysterical, dishonest and determined to have his war'.[31]

This war at least was not to take him by surprise. From Hoy in Orkney, the venue for the family holidays in 1938, he had seen its thundercloud 'rolling up over Europe with astonishing rapidity'.[32] The following August found the Meinertzhagens at holiday in Lunna on the Shetland mainland. There, on 1 September he received a telegram from the War Office: 'General Wavell has written to my Directory suggesting that you would be useful to him in Cairo in the job that you filled with Lord Allenby.'[33] The

Admiralty's order for all ships to move southwards robbed Meinertzhagen of his passage to the Scottish mainland, and eventually, after hasty communications with the Royal Navy, he was brought aboard HMS *Iron Duke*. A night train from Inverness took him to London, where a medical examination revealed that 'he had the constitution and physique of a 20 year old' – an assessment that gave him a great deal of pleasure; in 1939 he was sixty-one.[34]

Unfortunately, Meinertzhagen was not to go to Cairo and a job with his old friend, Archie Wavell. Instead, he remained at the War Office in a range of posts that ill-suited him. 'I loathe the War Office', he wrote after less than a week, 'its noise, all the routine and the difficulties of getting decisions and matters settled. In addition, I am not so young as I was, and after work I am dog-tired both mentally and physically. At the moment I am hating every moment of it'.[35] He soon fell foul of the War Minister, Hore Belisha. For Meinertzhagen, the proper channels he was expected to pursue were too clogged with red tape. If he wished something doing at the Foreign Office he went directly to Lord Halifax, the Foreign Secretary, or his friend, Robert Vansittart, the FO's chief diplomatic adviser; at the Admiralty he saw Winston.[36] When he was unable to obtain a large number of photographs from the correct department, he saw Geoffrey Dawson, editor of *The Times*, had them made up, and sent the War Office the bill.[37]

His rôle as Home Guard commander responsible for the defence of Westminster and Downing Street was a tragicomic affair lasting less than twelve months. His troops were recruited from clubland, the British Museums, and the stock exchange. One platoon included five colonels, a general, ten knights, two earls, and a duke. 'I was amused to see a full general (Peck),' he noted, 'shouldering a rifle and being cursed into heaps by a Guard's sergeant for slackness in handling his arms.'[38] On one occasion when he went to the county hall to inspect troops at their battle stations he was amazed to find that they had only dummy rifles.

I asked if all the rifles were dummies and was told that that was the case. Dummy rifles, no ammunition, no bayonets or bombs, not even an axe or pike or sword or even a broom handle. And that is what these 187 brave men were going to use against an invading horde of German tanks and infantry when they tried to rush London. Had they sand bags? No. Any shot guns? No just dummies. Had he applied for real rifles? No. Had he made any effort to borrow or beg shot guns? No.[39]

Meinertzhagen phoned Alanbrooke, the Commander-in-Chief of Home Forces, to complain, visited several large gunmakers, and using the authority of the GOC London District borrowed 187 sporting rifles. From Wellington Barracks he poached a non-commissioned officer to train the men in the use of firearms. Alanbrooke was annoyed that his friend had done it in his name, and then argued about a blockhouse Meinertzhagen had built at the corner of Downing Street.[40]

In January a taxi ran over his foot, hurting him badly; in June, as he brought back his second boatload of war-weary troops from the beaches of Dunkirk, he was hit in the rump by a bomb splinter, which put him in bed for a number of days. However, the final blow came in March 1941. Meinertzhagen had heard that a certain commander had been freely discussing with his men an offensive in the Western Desert. Concerned by this totally improper behaviour, he informed his friend, John Kennedy, the Director of Military Operations. It transpired that the indiscreet officer had no actual knowledge of a forthcoming attack, but had simply invented a story to raise morale.

Ironically, however, it was Meinertzhagen's head that rolled.

Lord Cavan who as head of the Home Guard, sent for Meinertzhagen and asked him if it were true that he had been to see the DMO without the permission of his commanding Officer. Meinertzhagen freely admitted having done so, saying that experience had taught him that the fewer people who knew about such things, the better. Cavan was extremely angry, and so was Meinertzhagen; and after some sharp exchanges, the conversation ended by Cavan announcing, 'You're sacked, sir.' 'I am not going to be spoken to like that by an Irish field marshal', said Meinertzhagen, and left the room. He jumped into a taxi which was hit by a bomb on his way home, and when he emerged from semi-consciousness a week or so later, the battle was over.[41]

1945–54
Beloved Birds and Priceless Possessions

On the day after Germany's final surrender on 7 May 1945 Meinertzhagen was staying at the home of Willy Percy, at Catfield deep in the Norfolk Broads. 'Today is a day on which we offer up thanks to God,' he wrote in his diary.

> What am I thankful for. Above all I am thankful that Dan [his eldest son] was my boy and that for 18 years we loved each other. Again, I am thankful that I still have two children; and that my home was spared destruction. I am thankful that I had faith throughout the war and never contemplated defeat for a moment.[1]

His belief in final victory had indeed been unflinching. His niece, Teresa Rothschild (the daughter of his sister Bobo), who during a stint at MI5 had stayed much at Meinertzhagen's home, delighted in his wartime 'humour, high spirits and courage'. As early as April 1939 he had placed his bets. 'Hitler and Mussolini must know it is a foregone conclusion,' he had written during a visit to the United States; although he conceded that they might enjoy 'some preliminary triumphs'.[2] When those 'preliminary triumphs' were represented by Axis control from the Russian Caucasus to the island of Alderney, he was forced to admit that this 'was no small achievement for an obscure third rate artist from Vienna'. But even then his conviction was unwavering. Stalingrad was 'the turning point in Hitler's career'.[3]

While it was true that his faith had stood firm, none the less, the war had taken a severe toll. During the build-up to it, and the six years of conflict themselves, many of his links with the past had been severed. In 1937 his father's sister, Tid, the last of the Meinertzhagens from that generation, had passed on. His aunt, Beatrice Webb, his brother-in-law, Bernard Drake, and a younger brother and sister, Louis and Polly, had all died within seventeen months between 1941 and 1943. The loss of Ernst Hartert, Walter Rothschild, Claud Ticehurst, Harry Witherby and Hugh Whistler had substantially diminished his pre-war coterie of ornithologist colleagues; while the deaths of two of his closest associates, Percy Cox and

Freddie Guest – friendships that went back to the middle years of the Great War – were a profound blow. One would perhaps search in vain through Meinertzhagen's diaries for lines more gentle than those he wrote on hearing of Guest's death, during his expedition to Afghanistan:

> As years roll on these wonderful friends of mine, these most precious possessions drop away into the unknown, passing behind the curtain which bounds human vision. And as they pass the world unseen becomes more real than the world in which we live and I am beginning to feel that I should be more at home where my friends are now than here.[4]

Yet no loss had struck more deeply than the death of his elder son, Dan, at the age of nineteen. Dan had been with the Coldstream Guards during the Arnhem offensive in Holland, and had been killed by mortar fire on 2 October 1944. His father received the news in Scourrie in Sutherland. No sooner had he sat down to breakfast on the morning of 11 October 'than I was handed that sinister telegram envelope'.

> The moment I saw it I knew its contents and when I read the opening words 'Deeply regret' I knew my Dan had been killed. For the moment I reeled under the blow and must have been unconscious for a second or so for I awoke to hear Zip saying 'My dear Montezuma'. I just cannot believe it; I am sure as I am of anything that somewhere and at some time I shall see my Dan again, smiling and happy as he always was. I am still, late this evening, completely off my balance; it all seems so cruel, and so irreparable . . .
>
> My mind went back to that day of agony when my brother Dan died 46 years ago. Never since have I felt so overwhelmed with grief and an undescribable [sic] feeling of loss. When my Father and Mother died, when Annie died, when my friends fell one after the other in the First Great War I was miserable with the agony of bereavement but somehow the loss of a son, and such a son as Dan was, is the worst suffering I have ever experienced . . .
>
> My darling boy, so long as I live I shall remember you with gratitude and affection, with admiration and respect; your memory will for ever be green . . .[5]

Seven months later, as Meinertzhagen gave thanks at Catfield, he acknowledged that running through his jubilation at VE Day was 'a streak of bitterness that the war has taken my beloved Dan'.

Curiously, his wartime loathing of the Germans – 'I am in favour of ruthless war aiming at the complete annihilation of Germany and the German race'[6] – quickly subsided once the conflict ceased, as it had done immediately after the First World War, to be replaced by a strong sense of forgiveness. He was distressed, for example, by the news that German spies had been shot by American troops, and strongly disapproved of the Nuremberg Trials. Assisted by contacts in the highest places – Field Marshal Montgomery and the recently replaced Chief of Air Staff, Charles Portal – Meinertzhagen was given a VIP tour of occupied Germany in the spring of 1946, with a car at his disposal and accommodation at the Savoy. Ostensibly, this was a scientific visit. With Cyril Mackworth-Praed, a noted ornithologist and banker, he wished once again to see if Heligoland might be internationalised as a research station. However, in Berlin he took time off to examine the effects of British air raids. These aroused 'mixed feelings of pride in our airforce, thanksgiving that London was not similarly destroyed but mainly of shame that we should have been the agents of so much destruction and misery'.[7] In the German capital he also met his old friend, Erwin Stresemann, a man whom Meinertzhagen had called 'the most enlightened ornithologist in the world'.[8] Initially, affection for a personal friend out of touch for more than six years had become confused with bitterness for a nation that had executed his son. But the internal conflict was soon over. By October Meinertzhagen was sending food parcels to General von Lettow Vorbeck, the German commander he had opposed in East Africa in 1914–16, and who, by 1946, had been a good friend for almost twenty years. As if to mark this moral victory over himself, Meinertzhagen sent Stresemann a case of provisions also, on the second anniversary of Dan's death.

It was inevitable that his passion for travel, confined for six years to a mere quarter of a million square kilometres, should have been released in a ferment of activity at the close of hostilities. In March 1946 he stood on Cornwall's Atlantic shores; in April he could make out the Danish coastline from Heligoland; May was spent back in the British Isles – just – on the island of Tresco. The following month he travelled north to Scotland, then London, then on to Sweden. In November he watched the autumn sun rise not on the Victorian terraces of Kensington Gardens, but on the gorse-smothered hillsides of Cornwall. December was spent abroad – Berlin, with food parcels for the Stresemanns; Amsterdam for its Leyden Museum. His seventieth year maintained the same hectic pace: Ireland, London, the Breton isle of Ushant, Paris, the Bass Rock in the Firth of

Forth, North Uist, and then the first of three lengthy journeys to the Middle East and East Africa.

In 1946 a friend, Harry St John Philby, a noted explorer and orientalist, a Muslim and father to the spy – Kim Philby – asked Meinertzhagen to assist him in the preparation of a paper on Arabian birds. The former expressed himself 'only too delighted to do what I can to put your paper into shape', but admitted that with regard to Arabian avifauna his 'interest equal[led his] ignorance'.[9] Out of this contact, however, Meinertzhagen developed the idea of visiting Arabia himself. In the First World War Philby had joined a mission to the Sultan of Nejd, Abdul Aziz Ibn Saud, who was a rival to the Hashemite family for control of the entire Arabian peninsula. Having sensed in this formidable Wahabi leader the eventual victor, Philby had attached himself to the future king as an adviser, converted to Islam in 1930, and for a number of years wielded considerable influence in the desert kingdom.

Hoping to use Philby as an important contact and sponsor for his own journey, Meinertzhagen was deeply disappointed when the project collapsed and blamed his friend for reneging on earlier promises of assistance. There may have been some justification for Meinertzhagen's reproof. Philby, according to the former, was an unreliable correspondent and certainly helped very little when Meinertzhagen did eventually get out to Arabia. However, in 1946, Philby, himself suspect at the Arabian court because of his outspoken criticisms of the kingdom's internal affairs, argued that Meinertzhagen's known Zionist sympathies would present difficulties for both of them.

This altercation was more or less typical of a friendship that was, at best, intermittent. For both of them were strong, frank, uncompromising characters, intolerant of opposition and short-tempered. It is interesting that at times both found obedience to official superiors a burden too great to bear, and both had been dismissed from foreign posts more than once. Their political views, however, were almost diametrically opposed. Meinertzhagen was vehemently Zionist and strongly imperial in outlook; Philby, on the other hand, was a Muslim and often anti-British. In 1940 he had stood for parliament as an anti-war candidate and was detained en route to America under section 18B of the Defence of the Realm regulations. In 1941, in his diary, Meinertzhagen had written 'Philby has a passion for down trodden races and regards British rule everywhere as cruel humbuggery and tyrannous. Small wonder that he was gaoled for such views during war. He admits to anti British propaganda in Arabia.'[10]

Yet, despite these differences, friendship had developed as early as 1923, when Philby, then Chief British Representative to the Kingdom of Transjordan, had accompanied Richard and Annie for several days' travel to the ancient city of Petra. For the next twenty years the two men had enjoyed fairly regular contact, corresponding over their shared passion and expertise in the Middle East, its geography, and natural history.

Smooth and easy friendship might not have been a straightforward thing, but some respect between two very similar personalities was almost inevitable. Meinertzhagen's analysis of Philby's character is interesting, not only for its insights into this curious and, in many ways, remarkable man, but also because it could so easily have served as a self-portrait.

> Philby is a curious character. He is intellectually honest and uncompromisingly pugnacious. He has unlimited confidence in himself and in his judgement. He has a passion for speaking his mind irrespective of time, place, or personal or political expediency. This has led him into all sorts and kinds of trouble. He is no fool. Far from it. But he is a law unto himself.[11]

Eventually, in spite of Philby's inability to assist, permission to visit Arabia was received, letters of introduction from Hubert Young helping to smooth the path. After the 10th Ornithological Congress in Edinburgh, and the deaths of Meinertzhagen's brother-in-law, Robin Mayor (Bobo's husband), and his uncle, Sidney Webb, the team – comprising RM, Theresa Clay, and Willy Percy – set sail on the SS *Franconia* for Port Said on 17 November 1947. From the Egyptian port the trio then made their way south to Khartoum, and from there by boat to Jedda. The trip was to prove at times problematic. Obtaining camp assistants, for example, was more difficult than they had anticipated. A cook and a shikaree each demanded £12 a month. 'Ruinous and sheer robbery,' fumed the colonel, 'but we are at their mercy.'[12] Willy Percy, fractious even in his sweetest moments, argued ceaselessly with his friend, even when brought low by dysentery. At times the temper of their camp hands proved equally brittle, and on one occasion an argument escalated into a violent confrontation. 'Grumpy [the driver] and Mohamed the cook had a stand up row today', their employer recorded in his diary.

> Though we never ascertained the reason, they intended murder. Grumpy broadcast an iron crowbar and Mohamed rolling his eyes and with a murderous look on his face, cuddling a wooden club which he was

just itching to use. Omar and I kept them apart until they cooled down. I think the row had something to do with selling petrol. I fancy Mohamed threatened to split unless he got a better rake-off.[13]

On 20 February Willy Percy had departed, and a month after her thirty-seventh birthday, on 15 March, Theresa Clay also flew home, leaving Meinertzhagen to sail home via Israel, a country created only weeks earlier. In Jedda, before his departure, however, he had received a letter from Philby encouraging him to prepare a handbook on Arabian birds and informing him of the whereabouts of a manuscript drawn up many years before by a man called George Bates. These developments, little more than three weeks after Meinertzhagen's own birthday – his seventieth – would have significant consequences, for these were the earliest traceable origins of his *magnum opus – Birds of Arabia*.

On his way back to England he examined the copy of the Bates work that he had acquired in Jedda with a critical eye. 'It was crudely written and could never be published in its present form,' he wrote. 'The systematics are misleading, there is much irrelevant matter and many errors.'[14] None the less, the desire to produce a book had taken root, and in a letter to Philby the following month Meinertzhagen admitted that Bates 'had taken great pains to produce an accurate book . . . it must have involved a great deal of hard work'.[15] The original of this manuscript had been drawn up by Bates before his death in 1940, after many years of effort. According to Philby, three copies had been made – the author retaining one himself, the second going to the British Museum. (This was allegedly withheld from Meinertzhagen, largely as a consequence of long-standing enmity between him and the Director, Norman Kinnear). The third copy had been given to Philby in acknowledgement of his long co-operation with the author, and it was a typescript copy of this version that had eventually come into Meinertzhagen's hands. At second or possibly third hand, the manuscript was full of errors, but Meinertzhagen's qualified enthusiasm for the idea of publishing a book on Arabian birds clearly delighted Philby, and in his reply he wrote that it 'seems to bring a ten-year-old dream of mine appreciably nearer realisation'.[16]

There were, however, difficulties, largely of a financial nature. Meinertzhagen estimated that 500 copies would cost between £1,200–£1,500, and that with sales at £1 a copy they would recoup only £200, leaving a deficit of £1,000–£1,300. He would agree to pay a fifth of this but required Philby to find sponsorship for the remainder.[17] Eventually, the Saudi Arabian embassy promised £200 and there was 'a vague promise from

the King [Ibn Saud] of more'. But by June of the following year Meinertzhagen was writing to Dora Philby complaining that 'Jack [her husband] is an atrocious correspondent; he has never let me know anything about contributions to the book which he promised . . . I must have definite undertakings,' he insisted, 'and not vague promises.'[18]

There were also differences of opinion about what kind of book it was to be. Philby felt that it was 'impossible to produce such a work in the elaborate style of Nicoll's Birds of Egypt', and wished for 'a simpler handbook with a minimum (unfortunately) of illustrations' that would stimulate interest amongst the regular flow of American and English oilmen to Arabia.[19] Meinertzhagen, on the other hand, already had before him a vision of something quite different – in fact, something very similar to the eventual published book. 'I want it to be a good work,' he had written in his diary, 'illustrated and up to date much on the level with my Birds of Egypt.'[20] There would be introductory chapters on Arabian geography, history, and biological questions such as desert colouration, the origins of distribution of Arabian birds, and the African and Palearctic influences upon them.[21] In addition, he intended that its scope should be widened to include all of the Arabian peninsula and Sinai up to the settled areas of Jordan and Iraq, irrespective of political boundaries.[22] With typical wilfulness he insisted that the book be published in London, where he could 'exercise control and get first class workmanship'. Philby, however, had hoped to reduce costs by having it produced in Cairo by an English firm that had printed one of his books. But his partner would have none of it: 'Egypt is alright for a straightforward book like yours, but for a technical work the employment of an Egyptian firm would lead to endless muddle and failure.'[23]

While these differences of opinion were being resolved, Meinertzhagen had planned yet another visit to Arabia and Africa in the winter of 1948 – a journey that was destined to be long and difficult both for him and for the taxonomist and assistant who accompanied him, Phillip Clancey. The moment of departure could hardly have been less auspicious: emotional difficulties with his immediate family and the fact that his closest confidante, Theresa Clay, had only recently come out of hospital after an operation, had left him 'mentally bankrupt'. 'I feel the whole of my world is slipping away,' he had confessed in private, 'everything I care about is disappearing . . . It has left me with a feeling of benumbed apathy. I should welcome death in any form; that is cowardly and pure defeatism;

but that is what I have to contend with and I must fight it tooth and nail.'[24]

Almost certainly, this internal conflict exacerbated the violent clash of personality between Meinertzhagen and Clancey that dragged on for the whole of the seven months to the detriment of both men. According to the former, Phillip Clancey, later the Director of the Durban Museum for thirty years and a distinguished ornithologist himself, was in 1948, '30 years old, an enthusiast, first rate at his job, but very self-opinionated and inclined to regard anyone who does not subscribe to his views on systematics as a reactionary'.[25] The young assistant, however, felt that, apart from the age, this description applied more readily to his employer than to himself, and quickly discovered that the rôle of servant to so authoritarian and occasionally eccentric a master was not for him. On reaching Aden he felt abandoned as the colonel was whisked away by the governor's ADC to a palatial annex at government house, while he was left on the quayside with the luggage. Little more than a month after their departure, serious cracks had begun to appear in their previously positive relationship. Clancey wrote that on their way back to Aden from the Yemen they 'stopped on one occasion so that he [Meinertzhagen] could obtain an *Ammomanes deserti* lark':

> While he was pursuing the bird I stood in the shade of an acacia tree waiting his return. A little while later I heard him returning to the vehicle shouting at the top of his voice 'he's a bloody young fool – he thinks he knows everything (about birds) but is useless'. He marched by me without seeing me in the shade of the trees, his Hellis and Hellis 12 bore over one shoulder and his free arm waving madly.[26]

Ground in by months of uninterrupted and uncongenial companionship and by the exhausting life of safari in the African bush, differences of approach and opinion widened and deepened into an unbridgeable chasm. On one occasion in South West Africa, towards the close of their journey, a disagreement over the taking of black-throated bustards for their mallophaga escalated to a situation where both men had their shotguns trained on each other. According to the younger of the two, 'it was only when our driver – a Mr Bezuidenhout – . . . intervened was a shoot-out averted'.[27]

Phillip Clancey was not the only person Meinertzhagen fell out with on the journey. The latter had secured permission for both of them to travel in the Yemen – then a backward, almost medieval kingdom in the south-west corner of the Arabian peninsula that was ruled by a ruthless tyrant known

as the Imam. Before leaving Aden, Meinertzhagen had asked if their were
any special regulations he should adhere to, and was told not to photograph
Yemeni women or the Imam's palace, and not to wear shorts. Essentials
were some form of headwear, the removal of shoes before entering a house,
and the constant thought that they were 'in one of the most primitive
countries in the world and among a very suspicious people'.[28] An escort of
two majors was forced on Meinertzhagen's party, these soldiers writing
down everything that the visitors did. Excited by the English colonel's
offer to tell them the names of all the birds he and Clancey were shooting,
the two guards noted down those he gave them – ostrich, emu, great auk,
turkey, and the names of all of his sisters.[29] Shortly after Christmas the
Imam fell ill with earache and, according to Meinertzhagen, had several
boys whipped in the hope that their cries would distract him from his own
pain. 'No wonder the man is afraid of assassination', the latter noted, 'an
act which I would gladly perform if I had the opportunity'.[30] In a letter
to Philby he was equally unrestrained: Yemen's ruler was 'a sadistic,
syphilitic, merciless and narrow-minded monster'.[31]

The trip to Africa ended in Johannesburg in June 1949, on the same
uncertain note that it had started on. During the evening before his flight,
Meinertzhagen had been refused dinner at the Carlton Hotel, since his
outfit – corduroy trousers, wind jacket and a red scarf – offended the
sensibilities of the other guests. The following morning they had set off,
only to have one of the engines give out forcing the plane to return to
Johannesburg airport. Having set out again, the colonel was amazed to
discover that the pilot was Sandy Mackintosh, the young airman injured
when he and Meinertzhagen were forced to make a crash landing at Rafa in
1917. The two men had not seen each other for thirty-two years and it was a
delightful reunion. At 3.51 p.m. over Lake Rudolph, Mackintosh allowed
the seventy-one-year-old to take over, briefly, pilotage of the plane.[32]

Only three weeks after his return from South Africa, Meinertzhagen had
written to the secretary for the British Museum's trustees concerning the
disposal of his vast collections of natural-historical specimens. The ques-
tion of their eventual destination after his death had exercised him since the
closing years of the war for a variety of reasons, primarily because of his
lack of space. In a little more than half a century, a single acquisitive spirit
had accumulated more than a large Victorian house could comfortably
accommodate. Moreover, a half-serious promise by his daughter, Anne,
that she would destroy his diaries should they be left to her had caused him
considerable anxiety about these and also other aspects of his life's work.[33]

Only weeks after the close of the war he had finally sold a sizeable stamp collection bearing illustrations of animals. At auction this had raised £2,826 2s. 6d., all of which had been donated to establish a regimental chapel for the Royal Fusiliers in St Paul's Cathedral.[34] However, the disposal of hundreds of thousands of natural-historical specimens was far more problematic. In 1941 the Chicago Field Museum had offered him £15,000 for his bird collection alone, but he had declined to sell. It seemed most logical that all of them should eventually go to the British Museum – an institution with which he had been associated and whose facilities he had used for sixty years. But, unfortunately, Meinertzhagen had enjoyed a patchy relationship with the personnel at South Kensington that had, on occasions, deteriorated into open hostility. None the less, it was with them that he opened serious negotiations on 21 June 1949.

Ironically, by that date, his *bête noire* on the staff, Norman Kinnear, the previous keeper of zoology, had been appointed director of the whole museum, even though he had reached the age of retirement. Their enmity dated back to Meinertzhagen's expedition to Kenya in 1936, although Kinnear, and indeed other members of staff, had inherited a fund of suspicion towards Meinertzhagen that went back to as early as 1919. In that year, while working on birds obtained in Palestine, Meinertzhagen had 'borrowed' a small number of skins to work on at home – behaviour that had been contrary to the museum's regulations. One of the staff had intercepted him as he was leaving and then reported the misdemeanour. Meinertzhagen later confessed to the crime, apologised unreservedly, and pleaded as extenuating circumstances the fact that in his youth, under the more informal regime of Bowdler Sharpe, he had been accustomed to take skins home and then return them with impunity.[35] In spite of this, the trustees barred him from the museum for twelve months – a measure which caused very little inconvenience since Meinertzhagen had just been appointed chief political officer in Palestine, and on his return Walter Rothschild had interceded on his behalf and had the sanctions lifted.

However, for the next twenty years further problems were to crop up at almost regular intervals. In 1924 Meinertzhagen had asked the museum for official endorsement of his journey to Madeira and the Desertas Islands in order to smooth relations with the Portuguese authorities. By the 1920s the trustees had had long experience of the troubles caused by over-zealous British naturalists in foreign parts, and had therefore developed a strict policy of only endorsing expeditions if they were guaranteed rewards (in the form of specimens) that justified the potential repercussions. But when

asked for a high percentage of his catch in return for formal scientific endorsement, Meinertzhagen, almost inevitably, refused outright.[36]

In 1931 he had yet another disagreement with the museum's director, a man called Regan, over the collection he had acquired during his expedition to Algeria and the Ahaggar Plateau. Meinertzhagen wished to donate this material to the museum, on condition that it was worked out before he actually presented it to them, a measure, he believed, that would prevent the staff from describing only the new material and then leaving the remainder pigeon-holed and uncatalogued. Regan, according to Meinertzhagen's diary a 'fish expert, fish like, steeped in red tape and nourished on bureaucracy, without manners, a shrimp amongst mortals', refused the conditional offer and asked the donor to remove the collection from the museum. Meinertzhagen, however, through his friend, Walter Rothschild, one of the trustees, circumvented Regan's obstructions and secured satisfaction.[37]

Only four years later a more serious storm blew up over the disappearance of museum property. The staff in the entomological department had noticed that one of their books, volume XII of a journal called *Parasitology*, was missing, and an empty bookboard had been put in its place, while a number of pages had been torn out of volume VIII. Shortly after, it transpired that a copy of the first of these books had been noticed in Meinertzhagen's own personal library, while the missing pages from the other contained a short paper on the mallophaga found on kiwis – a species that Meinertzhagen had recently examined in the Leningrad Museum. The museum staff felt that the circumstantial evidence was sufficiently compelling to involve the police, who called at KPG and removed the volume in question. This was then examined by a government scientist who confirmed that an erasure had been made with a knife on a number of pages while the 'dimensions of the erased areas agree[d] with the Museum stamp'. In another letter the chief government scientist expressed the opinion of his staff 'that sufficient had been obtained to carry conviction in a court of law'.[38]

Meinertzhagen, when taxed about his possession of a 'valuable paper on lice, long out-of-print, and much sought after by students of this group of insects',[39] contended that he had bought it in a second-hand-book shop – a claim not confirmed by the booksellers themselves, but definitely by the company that had rebound the volume for him. Moreover, their invoice for the work – written on 23 April 1934 – predated by several months the last date on which the librarian had seen the museum copy.[40] On this evidence,

the British museum's case fell to the ground, but not their suspicions: the following year the trustees 'gave instructions that records with dates should be kept in all departments of all the books borrowed by Colonel Meinertzhagen'.[41]

Lingering animosity flared up once again in the first month of the Second World War when Meinertzhagen presented to the trustees' secretary a lengthy memorandum criticising BM practices and extolling the virtues of American museums, which he had recently visited. The ideas it contained were both reasonable and well argued (in fact, the museum, years later, initiated changes that accorded with some of Meinertzhagen's suggestions). However, his forthright language was sufficient to raise the hackles of both trustees and staff. Typical was his aside on the Rothschild collection, a vast assembly of bird skins which eventually went to the American Museum of Natural History after the British Museum was unable or unwilling to match the asking price. 'The one consolation,' Meinertzhagen argued, 'was the fact that it was superbly housed and cared for. To have crammed that unique collection into boxes and mixed it up with greasy rubbish would have been a criminal scandal.'[42]

The British Museum's opportunity for revenge came seven years later. Stretched severely by staff shortages, the then keeper of zoology, Norman Kinnear, refused Meinertzhagen permission to beat out birds for their mallophaga, arguing that it absorbed too much time for his overworked staff, while the actual process used to obtain them was potentially damaging to the bird skins.[43] Meanwhile a memorandum from the keeper of the entomological department also asked that Meinertzhagen's work on bird parasites be suspended. The former argued that his department could not keep pace with the work generated by the colonel's efforts, that he refused to be guided into lines of inquiry they wished him to pursue, and that although he had been collecting bird lice from BM skins (technically, therefore, they considered the lice museum property) for many years, none of this material had been returned to them.[44] If these arguments were insufficient to keep him at bay, a month later one of Kinnear's staff discovered that an Asian race of greenfinch had gone missing from a box that Meinertzhagen had been examining. On the basis of this evidence, the museum, with the assistance of two detective constables, intended to set traps to catch the culprit red-handed.[45]

Blocked from pursuing his private scientific inquiries, Meinertzhagen issued his *coup de main*. In a long letter complaining of the behaviour of Kinnear, he ended on an ominous note.

I have during my long life accumulated probably the best collection of
Palaearctic genera of birds ever collected by one individual including
dozens of types; I also have the best world collection of mallophaga . . .
These should naturally go in time to the British Museum. Should your
museum continue to deny me facilities accorded to others I shall be
compelled to alter these arrangements and with regret bequeath my
collections to the United States, placing on record my reasons.[46]

There is little doubt that the museum took this barely veiled threat
extremely seriously and the whole of this passage from his letter was
reproduced verbatim in a draft agenda for a meeting of the trustees, while a
full résumé of his thirty-year relations with the museum was given to the
chairman, Lord Hugh Macmillan. His conclusion, while vindicating the
museum staff, offered an olive branch to the offended party by allowing
Theresa Clay, who worked in the entomological department, to collect
mallophaga on his behalf.

This compromise situation obtained for a couple of years until Meinertz-
hagen, fresh home from his long haul across Africa, in his seventy-second
year, opened negotiations in earnest for a transfer of the entire bird
collection to the British Museum. Inevitably, there were strings attached:
he wished that the collection remain his property until his death, with
control over it, and the right to enrich it by exchange without reference to
anyone. He was to have access to it and accommodation where he could
work in relative comfort, while his was to remain separate from the national
collection until 'conditions . . . allow of a more satisfactory way of storing
well-preserved material'.[47]

Proposal and counter-proposal were batted back and forth for several
months until, in October, exasperated by delay, Meinertzhagen broke off
negotiations. He was annoyed that they had not offered him the accom-
modation he wanted and piqued, particularly, that Kinnear, then director,
had not bothered to get involved. In the former's eyes his proposed bequest
was sufficiently important to warrant the attention of the man in charge.
Ironically, Kinnear had hoped to assist the talks by keeping a low profile
owing to the history of antagonism between them. In 1950 there was a very
real chance that Meinertzhagen's birds – after Rothschild's collection
probably the most significant this century – would not, like his, be left to
the nation. In the BM itself there were even those who felt that 'it might be
better to refuse the gift which has so many embarrassing qualifications to its
acceptance'.[48] However, by the time this staff member had proposed

refusal, his gesture was already hollow, Meinertzhagen having decided to give his birds to the American Museum of Natural History.

There is no doubt that Meinertzhagen was a very difficult customer. His unwillingness or inability to show warmth to those he considered subordinate generated little affection or understanding amongst the museum staff. He was a remote figure whose eccentricities filtered down to them in a stream of bizarre and largely apocryphal legends. It was also inevitable that so whimsical and individualistic a temperament should have clashed with a highly structured chain of command like that in the museum. Sir Clive Foster Cooper, Kinnear's predecessor, caught the essence of these problematic relations in his letter to Lord Macmillan.

> I think that in his own eyes Colonel Meinertzhagen has the welfare and reputation of the Museum very much at heart but that he regards himself and his collections as being above the law or at least exempt from the limitations which the Trustees have devised to protect their collections from the undesirable attentions of lesser mortals.[49]

Macmillan concurred that the friction was 'largely due to his temperament and his over exacting sense of what is due to him'.[50]

And yet it is difficult to see how, with regard to the disposal of his bird collection, Meinertzhagen could have sought anything less than total satisfaction in the conditions he laid down. It was, after all, his pride and joy; in 1944 he had written: 'It is the best collection of its sort in the world. I should like to take it with me for I love it.'[51] Perhaps two or three private British collections had been larger; perhaps only one was of an equally high standard; but none treated in so systematic a fashion the birds of the Palearctic region – the Eurasian continent. Walter Rothschild's collection of 200,000 birds skins remains unsurpassed. But then Rothschild had financed armies of skinners and collectors to do much of the work for him. Meinertzhagen, on the other hand, had personally collected approximately fifty-five per cent of the 25,000 skins – a task involving decades of hard work. If any single achievement in his multifarious activities could totally express his personality, it was his collection. Embodied in tray upon tray of exquisitely prepared skins were the perfectionist's touch, his pantheistic love of and sensitivity to nature, and, paradoxically, his Wildean need to destroy the thing he cared for most. The bird skins, taken from localities as far apart as the southernmost tip of Africa, the borders of south-west China, and the Pacific coastline of North America, represented fully his passion for travel. And in his quirky manipulation of the labels that

ornithologists attach to the leg of each skin, in his willingness to swap and rearrange them, and in his sometimes bizarre errors and weird inconsistencies one can trace the broad streak of eccentricity that made Meinertzhagen so vital, so compelling, and at times so suspicious a character.[52] Given that this was his most cherished possession, how else could one have expected so fastidious a temperament to pass it on, except with supreme caution?

It was this quality that caused him to switch tack in April 1950 and offer it to the Americans. Ironically, another person's caution conspired to prevent the collection making any transatlantic journey: Dr Stanford, the director of the American Museum of Natural History, had at that time suffered a stroke but refused to delegate responsibility on negotiations. The appointment of a new director in South Kensington, meanwhile, swung the issue back in favour of the BM. Nothing did more to soften and temper the reservations of a touchy old colonel than the charming personality of Gavin De Beer. His tactful and fresh approach, unhindered by a history of suspicion and mutual recrimination, lifted the negotiations from being a quasi-legal affair between unfriendly parties into an almost private arrangement between colleagues. In a letter in September 1950, De Beer assured Meinertzhagen that he would 'leave no stone unturned to give [him] satisfaction'. The latter's reply started 'My Dear De Beer', and closed with the assertion that 'I am quite willing to come and see you any time'.[53] The new director substantially improved the museum's previous offer, proposing to have Meinertzhagen housed on the ground floor in the old bird room, rather than in the basement – a proposition that largely secured the issue.

In November 1950 Meinertzhagen bought thirty-eight new slide boxes for his mallophaga and since they fitted into the space taken by his herbarium cabinet he decided to donate the latter to the museum. This collection remained unincorporated into the museum's for the duration of his life, but the departure of his 'beloved plants' had been a 'great wrench'. On receipt of some 5,000 flowering plants, ferns and fern allies, and marine algae, some from remote parts of Africa and Asia, of which the BM had no previous material, De Beer replied promptly in acknowledgement of his generosity. He called them 'A very important addition to the national collection' and remarked on 'their exquisite condition and the fact that 'exceptional care had been taken in their preparation'.[54]

Less than six months later Meinertzhagen presented a second gift to the BM. Although he is probably better known for his donation of bird skins,

his entomological collection, comprising 587,610 specimens of mallo-phaga, flies, and mites – probably the largest and finest ever assembled – was equally outstanding. It contained no fewer than 1,791 type specimens and exceeded in number and volume the entire collection previously held by the museum. In addition, he donated a mahogany cabinet and 286 slide boxes in which to house it, together with 510 books and reprints, and a fifteen-volume index. Such benificence, broadcast by De Beer, inevitably drew the interest of the press, whose attentions Meinertzhagen feigned to loathe. To De Beer, whom he suspected of being responsible, he sent a postcard. 'The Sabbath has been made hideous by Fleet Street. Daily Mail, Daily Telegraph and Manchester Guardian telephoning and barging in at meals; all because of Mallophaga, such swineishness [sic] as theirs I have met for the first time. Please call them off.' As if to emphasise his point, the other side bore an illustration of *Hylochoerus meinertzhageni*.[55]

Another three years were to elapse before Meinertzhagen finally relinquished possession of his 'beloved birds'. The transfer, taking five days, was concluded on 19 May 1954. For Meinertzhagen, their departure had 'left the house forlorn and empty.[56] However, he was partly consoled by the magnificent gallery they had given him in the museum, which he had been permitted to decorate with his own paintings and trophies and to which, as a newly created Honorary Associate, he now held a key. This was particularly satisfying. In a letter to his friend, the director, he wrote:

> It was most kind of you to send such an appreciative letter: it is so seldom I receive reward for effort and when I do, I come as close to purring as a human can . . . I am much honoured at my new title . . . and am very proud of my key which enables me to bounce into rooms, where I previously had to knock and wait.[57]

In the same year as the transfer of his birds, Meinertzhagen's *Birds of Arabia* was finally completed. Six years had elapsed between the initial conception and the finished product – almost half of that time absorbed by Oliver and Boyd, his publisher, who had been painfully slow. In 1951 the author, sponsored by the American Arabian Oil Company, had made a final visit to Arabia for research purposes.

On arrival in Jedda he could hardly have wished for better treatment: all formalities concerning customs and currency had been waived. 'God knows what Trott [the British Ambassador in Jedda] must have said to the Saudis,' he wrote in his diary, 'but it appears that I am a most important person.'[58] At Al Hufuf, 200 km east of Riyadh, he was accorded much the

same treatment as a guest of the King. Cars and slaves were placed at his disposal, while the bedroom and sitting room in his accommodation were each the size of a small bungalow. The sitting room alone contained five huge sofas and eight enormous armchairs. The cuisine was equally opulent: a single meal 'comprised a table groaning with dishes piled with rice, four boiled chickens, whole joints of mutton and innumerable vegetable dishes'. As he sat dining alone, a crowd of household officials and slaves gazed on silently. 'I feel I am living in an oriental palace in medieval Arabia; and so I am,' noted the embarrassed guest.[59]

In Riyadh itself he was introduced to the King. Ibn Saud, 'now an old man, unable to walk without sticks', but with a mind 'as active as ever' and 'a fine face', offered his guest the use of a plane to transport him back to Jedda. Meinertzhagen demurred, pointing out that he had too much luggage. 'Then I'll give you two planes!' insisted his host. At the offer of a black slave boy Meinertzhagen made fresh protests: 'I told the king I would send him back from Jedda. "No", he said, "he is yours". More embarrassment. Whatever am I going to do with the child. "British Colonel has slave boy" I can see the headlines!'[60] Before his departure, Ibn Saud made one more presentation – three ostrich eggs from the Empty Quarter, an Arab cloak, a headress, and six tins of condensed milk.[61] 'He must have been a magnificent man in his prime,' concluded his appreciative guest.

Less than twelve months later Meinertzhagen had at last finished the book. In June 1952 he was correcting proofs, and by November he had already become impatient with Oliver and Boyd's progress. After having had the manuscript in their possession for almost a year, they had only just completed the galley proofs, and it was almost another two before the book was finally released. However, its reception possibly justified the delay. Shortly after seeing it James Fisher, the ornithologist, author, and broadcaster, wrote: 'Golly what a book! It is making me sweat with admiration and pleasure, and what a grand lumper you are. What an antidote this book is to the pestilential systematics of the past years. How you must have enjoyed writing it. How we shall all enjoy using it. My respectful congratulations.'[62] In the journal of the Bombay Natural History Society, Salim Ali spoke of the book's 'wealth of first-hand data', and of the author as 'an experienced and observant biologist refreshingly unfettered by orthodox views and dogmas and with the courage to differ from and criticize hide-bound notions'.[63] His old friend Erwin Stresemann and Dr Karel Voous, a Dutch ornithologist, endorsed Ali's judgement, Voous describing Meinertzhagen as a 'revolutionary scientist.'[64] The chorus of

high praise was joined by the journal of the East African Natural History Society. 'Colonel Meinertzhagen,' the reviewer wrote, 'is one of our most original . . . ornithologists, and a speciality of his . . . is to delve into what one might call the byways of ornithology . . . For instance, I mention some topics discussed in the book: bird collisions, fainting and feigning death; love of sweet food; pattering and puddling; variation in colour of eggs; animals drinking salt water; and recognition by birds of the Sabbath and the gun. You could hardly have a more catholic list than this one.'[65]

Yet not all its reviewers had been so positive. Reg Moreau had invited Charles Vaurie, an American of French extraction, to assess the book for *The Ibis*. His verdict was far more mixed. Less than halfway through his short essay Vaurie paused to sum up the work's good points: 'They represent a great accomplishment and the book will be for long the standard work'. Then followed a series of counterpoints. The author had made the book a platform from which to air highly controversial views. In Vaurie's opinion these should have been omitted or presented elsewhere. Many would dispute the author's views on cryptic colouration and his systematics, while his interpretations of certain phases of behaviour were often presented in a highly anthropomorphic and too colourful manner. Furthermore, the identification keys were deceptively simple and misleading. As a parting shot, Vaurie concluded that the exquisite illustrations by Thorburn, Lodge, and D. M. Henry were 'more than adequate'.[66]

Meinertzhagen was furious. Prompted by his friend, David Bannerman, and others who had criticised Vaurie's demolition work, he fired back. 'Vaurie complains that I have used the book to air highly controversial views. Why not?' he contended with the British Ornithologists' Union president, Landsborough Thompson. 'I am accused of anthropomorphism; he complains about the simplicity of my keys. Surely, the simplicity of a key is the essence of its value.'[67] Thinly disguised as a matter of principle, Meinertzhagen's sense of betrayal at his BOU colleagues resulted in the cancellation of a £7,000 bequest and a personal boycott of the Union. The president, anxious to retrieve the situation, admitted that the second half of the review had been 'feeble and petty'. Attempting to soothe wounded pride he continued: 'There was no special question of policy involved. There is no objection in principle to inviting a foreigner to write a review, for science is international. And it might have come off: a generous tribute from abroad to the doyen of British ornithologists would have been pleasing to all.'[68]

'Being wise after the event', however, he acknowledged that Vaurie was

not their man. Vaurie, originally a dentist, was a French-American of strongly republican sentiment, to whom the rigid English class structure and its chief beneficiaries were anathema. Moreover, he was noted for his intolerance of those who, like himself, held uncompromising views on ornithological taxonomy. Collision between Meinertzhagen and Vaurie, therefore, was logical, if not inevitable. Before his death in 1974, the eminent American bird man had started to investigate the relationship between the *Birds of Arabia* and the earlier Bates manuscript, moved possibly by the view widely held, particularly in the British Museum, that Meinertzhagen had not really written the book, but had simply poached Bates's work, revamping it as his own.

The belief was not entirely ill-founded. Meinertzhagen had indeed used Bates's manuscript extensively, admitting to Philby in 1949 that it was 'an excellent skeleton on which to build the structure'.[69] Yet to claim that Meinertzhagen simply polished it up into a finished product would be inaccurate. He brought to bear on the project his characteristic energy, thoroughness, and his considerable wealth. Bates, who had worked closely with Philby, was almost certainly in accord with the latter's view that the book should be a simple, non-illustrated, though seminal, handbook. Meinertzhagen's conception, however, was completely different. He had widened its geographical scope, authored a lengthy introductory section, and massively supplemented the systematic accounts. Probably no British ornithologist this century had published more or travelled more widely in the Middle East: none, therefore, was better qualified to write on this subject. And it seems difficult to resist the conclusion that he was entirely justified in placing his own name beneath the title.

And yet, while recognising his undisputed right to authorship, one might be puzzled by the fact that the seminal part played by Bates's manuscript went almost completely unacknowledged. In May 1948, Philby had written:

> I am glad that your study of the script has led you to commend Bates's devoted industry in collecting all the available material. I don't think that there is even any need of publishing the work under his name; it might be dedicated to his memory as a pioneer in the study of the subject and his work could be noticed in your introduction or preface.[70]

In reply Meinertzhagen had written that 'Bates must certainly get full credit, something more than mere mention in a preface'.[71]

But, apart from a cursory mention in a history of Arabian ornithology –

ironically, a portion of the text which drew heavily on Bates's work – Meinertzhagen never mentioned his debt either to the deceased author or, in some ways even more remarkable, to Philby himself. For without Philby's involvement the *Birds of Arabia* would have been today no more than a few dusty manuscripts in the cupboards at the British Museum and some half-forgotten rumours. Perhaps, Meinertzhagen, not wishing a reputation as an ornithological editor rather than as a primary producer, elided the part played by Bates. Possibly with regard to Philby, they had simply fallen out. Certainly, after 1952 they seem neither to have corresponded nor met, and in his description of his meeting with the Israeli president, Ben Zwi, the following year Meinertzhagen wrote: 'He was interested in Philby and Saudi Arabia. I regard Philby as a dangerous man, friendly on the surface but bitterly hostile at heart and in close touch with the Mufti of Jerusalem.'[72] In the preface to the *Middle East Diary* he had called him 'the Court Jester of Riyadh'.[73] Whatever the exact reason, Meinertzhagen's forgetfulness and lack of generosity at the moment of triumph was the one dark mark in his *magnum opus*.

1954–61
Enfant Terrible and Elder Statesman

On 16 January 1956, during Meinertzhagen's sixth visit to Kenya, he was spending his afternoon skinning birds caught earlier in the day, when a 'golden-haired woman appeared from nowhere, very slightly clad, very sunburned and with a magnificent black eye'.

> She started talking at once, told me she was . . . the wife of the local game warden and who was I. I told her and she went off in ecstasies – had always wanted to meet me, what a wonderful person I was . . . And she remained over an hour talking hard all the time . . . she is quite a character. Austrian by birth and is now living with her fourth or fifth husband. She terrified me.[1]

Meinertzhagen's vignette of his first encounter with the authoress of *Born Free* speaks volumes about Joy Adamson, but also says much about himself. By 1956 the sprightly seventy-eight-year-old colonel had become one of the elder statesmen in the field of natural history with an international reputation. In the same year, Sir Gavin De Beer had nominated Meinertzhagen for a CBE, for services to ornithology, an award he received in the following January. A year later he sported the octagenarian at the 15th International Congress of Zoology as his prize exhibit – the only naturalist still alive to have met Charles Darwin.[2]

Meinertzhagen was also something of a celebrity in other spheres, and his arrival in a country often drew the attention of the press. In Israel, particularly, he was fêted as a VIP. When his plane had touched down in Jerusalem in March 1953, the staff insisted on him leaving the craft first as a mark of his special status, and twenty-four hours later a reception was held in his honour at the university, while the *Jerusalem Post* carried an article – 'Allenby Sacked Zionist Colonel'. The following day, his hosts cajoled him into giving a national radio broadcast; celebratory dinners and introductions continued endlessly – with the foreign office minister, Shertok, the British Ambassador, the Israeli President, Ben Zwi, and the deputy speaker in the Knesset. And the whole time he was pursued by an 'intense and persistent' historian called Verité who grilled him on early Zionism. At

Haifa he inspected the Israeli navy, near Rehovot he met victims of the holocaust – women whose breasts had been sliced off and one whose tongue had been torn out 'because she refused to give up her daughter to be raped by guards'. 'It made me loathe Germans,' he later confided to his diary. At the end of his second week, an exasperated old man, celebrated to the point of exhaustion, sighed: 'God, how I hate ceremony, sightseeing and a surfeit of food.'[3]

In his old age it also seemed as if his military exploits had come home to roost. His adventures in the First World War had metamorphosed over the intervening forty years into some of the legends of the fifties and sixties. He must have been the only major participant from the Palestine Campaign to have witnessed that part of his life rendered as art. In 1960 he saw Terence Rattigan's play, *Ross* – a dramatic portrayal of T. E. Lawrence which was not entirely to his liking. Alec Guinness's version of the hero was poor – 'too sad and serious'. Lawrence, on the other hand, was 'always cheerful and inclined to rag at the least opportunity', having 'a great sense of humour' and not behaving at all 'like the tortured soul which Guiness gave him'.[4] Three years later, Meinertzhagen saw David Lean's epic version of T.E.L. – *Lawrence of Arabia*. However, even this £10,000,000 extravaganza was not without its faults. Allenby was badly portrayed. Jack Hawkins, who took the part, was 'a great heavy, loud-voiced, common-place heavyweight', lacking in 'character, determination and physical fitness, which were the essentials of the real Allenby'. Peter O'Toole in the title rôle was 'too tall and sad. Little Lawrence had a great sense of humour, and was always smiling even when angry.' None the less, the eighty-five-year-old had enjoyed the film since it 'brought to life some precious memories'.[5]

Meinertzhagen's 'precious memories' had been captured with unstinting discipline in a series of diaries that ran to seventy-six volumes and more than four and a half million words. Leather-bound and typed with a thorough index, they were ideal source material for historians, and requests to use them, particularly by those interested in the Middle East and Kenya, increased as he neared the end of his life.[6] Close friends too found them invaluable when recollecting the events of their own lives. Men as different as Chaim Weizmann and Salim Ali had used them in the preparation of their memoirs. Meinertzhagen, realising that his contemporary jottings had become a significant record of some important historical developments, turned to them as a statement of his own part in these events.

In the 1950s Meinertzhagen seems to have found his second wind – albeit

vitality with a rather curious origin. In his seventy-fifth year he became increasingly concerned about his heart. In Sikkim in February 1952 he had the first of what he referred to as 'heart attacks'. Midway up a Himalayan slope at an altitude of 4,500 m he had been subject to some kind of disturbing painful attack which left him unable to move for six hours.[7] Curiously, he was unwilling to reveal his condition either to Salim Ali or Theresa Clay, both of whom accompanied him, although he clearly took the illness very seriously. 'What I expected,' he wrote six days later, 'was, "On his 74th Birthday in Sikkim, Colonel Richard Meinertzhagen after a short illness . . ." but it has not materialised.'[8] Following two further attacks on his return to London, he consulted a Harley Street specialist, Sir John Parkinson, but 'all sorts of tests' revealed no serious problems. However, he seems to have had little faith in the words of his doctor, and exercised by visions of 'the little gentleman in black velvet', proclaimed himself in a 'Race with Death' to get everything done.

'Winding up' his life, as he called it, involved him in a final and remarkable bout of foreign travel and the publication of the *Kenya Diary*, *Middle East Diary*, *Army Diary*, and *Pirates and Predators* – a lifestyle hardly sustainable with a serious heart condition, and strong evidence that the doctor's diagnosis was more accurate than the patient's. None the less, this imaginary but sharp thong wrung from a life that was already highly disciplined five years of tremendous creativity. In March 1956 he complained of having too much to do. His task-list of the day included a book on big game in East Africa, a book on his early life, *Pirates and Predators*, and a host of other projects as varied as a paper on pectinated claws and a memorandum on the Middle East.[9] The first item on the list gradually passed into abeyance, to be replaced by a book which is probably Meinertzhagen's most famous and in many ways most controversial – *Kenya Diary*.

The autumn of 1957 seems to have been a period for doubt and reflection on Britain's imperial past, for the book enjoyed a mixed reception on its release. Candour, cruelty, and inconsistency were the watchwords of most reviewers. A friend and colleague, Reg Moreau, caught the mood of its readers in a single sentence: 'It is frank, forceful, amply spattered with blood, at times revolting, and at times remarkably sympathetic and also prescient.'[10] In many ways it is curious that one who frequently thought of himself as having a sensitive nature should have presented his experiences in East Africa in the manner he did, for the raw, unedited diaries were bound to draw criticism. Shorn only of a passage that revealed the unusual

sexual proclivities of a fellow officer, and a few details that rendered the Laibon episode in a less controversial light, the *Kenya Diary* bared the author's youthful soul with brutal candour. There were sufficient grisly details to condemn not only himself, but also the political regime he served, and even the Edwardian civilisation that could license such imperial subjugation. Elspeth Huxley, in an earlier analysis of the book, which was probably more penetrating than her later preface, thought that the diaries, 'if sometimes gruesome and uncomfortable reading, tell us something about the nature of man as well as about the history of Africa'. Was Meinertzhagen's delight in bagging niggers, she questioned, representative of a larger 'secret joy in killing' experienced by every male of the human species? And if so, what hidden frustration gnawed at the heart of all societies?

> And so the young male at his factory bench or cell-like office, takes a pathetic refuge in Edwardian clothes and razor blades, in strikes and plots and picketing, in rock 'n roll, in sex, in watching other people's action on the cinema. It is an unsolvable dilemma; and I would wager that Colonel Meinertzhagen, shocked as he may be by his youthful excesses, would not swap his past for their present and future.[11]

Less than a year later, prompted possibly by the success of the *Kenya Diary* and also the 'pathetic' insistence of a man called Dennis Cohen of Cresset Press, Meinertzhagen finally agreed to publish a book on his involvement with Zionism. At first he had been reluctant, preferring to use his usual publisher, Oliver and Boyd, but as it neared completion Meinertzhagen thought it 'rather fun writing a book about which a publisher is enthusiastic – very encouraging'.[12] The *Middle East Diary*, which appeared in 1959, like the *Army Diary* a year later, received an equal share of praise and criticism – praise for his unflinching honesty and his bone-hard singleness of purpose, criticism for his narrow indifference to opposing points of view. Taken as a whole, the three volumes of diary give a picture of the many-sidedness of Meinertzhagen's nature, and the sheer range of his talents.

Yet, equally, they have raised a number of important questions, especially in more recent times. The constant carping at the decisions and actions of those in charge that runs through all three, coupled with the remarkable accuracy of Meinertzhagen's prophetic vision, and the fact that the diaries were published as late as sixty years after the events, and that in their original form these 'diaries' were in typed and loose-leaf form, have begged questions concerning their authenticity. Why did three authors on

Lawrence doubt the validity of Meinertzhagen's testimony on their subject, and the official biographer reject him as a reliable source? Why did Elspeth Huxley ask of his prognostications on East Africa's future: 'Could he really have been so wise so long before the event?'[13] These doubts are perhaps best expressed by Jock Haswell in his book, *British Military Intelligence*.

> Unfortunately the only 'authoritative source' on [Meinertzhagen's] activities appears to be Meinertzhagen himself . . . Since he dwells much on the inefficiency of his colleagues and the incompetence of his superiors, and devotes a complete appendix in one of his books to recording laudatory excerpts from his own confidential reports written by such men as Lord Allenby, it is difficult – though for no easily defined reason – to accept all he says without confirmation from any other source.[14]

The author goes on to query even the haversack ruse prior to the Third Battle of Gaza. Haswell's analysis of this subject is not particularly well informed, yet, possibly as a result, his strong intuition becomes all the more interesting.

Not all these charges, however, are unanswerable. There is, for example, irrefutable proof of Meinertzhagen's uncanny ability to make very accurate political predictions. His memorandum to Lloyd George of 25 March 1919 foretold the Arabs' achievement of independence from Morocco to Mesopotamia within fifty years, the development of Jewish sovereignty in Palestine, the Arab-Jewish conflict, and the enormous superiority of Jewish armed forces in the face of Arab opposition. This comparison of their military ability is all the more remarkable when one considers that neither nation had any army to speak of in 1919. Although he was out on his date by a decade – 'with the loss of the Canal in 1966 (only 47 years hence) we stand a good chance of losing our position in the Middle East' – he seems almost to have anticipated the Suez Crisis.[15] In 1958 the Israeli Prime Minister, David Ben Gurion wrote to express his

> admiration for the penetrating vision that you showed in your letter . . . on the future contours of the Middle East and the relations between Israel and the Arabs, especially on the fate of Sinai. If your government had been wise enough to appreciate your far-seeing grasp of the situation, the whole of the history of the Middle East . . . would have been different.[16]

General Sir James Marshall-Cornwall, the director-general of air and coast defence at the outbreak of the Second World War, thought Meinertzhagen's 'amazing memorandum . . . the most wonderful example of geopolitical prescience which I have ever encountered'.[17]

And yet, ostensibly, only a few days after Meinertzhagen had written the 'amazing memorandum', he inserted in his diary a description of a lunchtime meeting between himself, Lloyd George, the Prime Minister's secretary – Philip Kerr, and Balfour. Here, Meinertzhagen claims to have said:

> I thought it a mistake to be too hard on the Germans once we had beaten them. It can only lead to another war. The Germans are the finest of Europe's continental people and we should help them to their feet and abandon our stupid friendship with France who is rotten. If we had been friendly with Germany and dropped France, this war would never have taken place but if we continue our friendship with France and try to keep Germany down, a *Second World War* [italics added] is inevitable. Lloyd George and Balfour were shocked but Philip told me he thought I was right.[18]

Meinertzhagen's analysis of Britain's 'true' European allies flies in the face of pre-war history and his own pre-war views. Could one so well versed in the military and political developments of his time really have lost sight of the current of events of only five years before? Moreover, his use of the expression 'Second World War' seems highly suspicious. To have predicted a second global conflict only months after the close of the first is remarkable in itself, but to use the very words by which the conflict came to be known and to capitalise them is incredible. The title, 'First World War', on which he might conceivably have been punning, was not current usage until the 1930s; and even in the 1939–45 war, the earlier conflict was still referred to as 'The Great War' or 'The World War'.[19] Adding to the suspicion is the fact that the whole page on which the passage occurs is in a different typeface to that of Meinertzhagen's usual italics typewriter, while the pagination is out of sequence, this text appearing on one of two page 55s. It seems almost certain, therefore, that he inserted the page bearing the description of the meeting at a different date to the rest.

This array of evidence presents a number of problems. Did the meeting take place, and did Meinertzhagen say these things? The first question can probably be answered in the affirmative, but unless the meeting had been minuted the second is impossible to answer. The sentiments he claimed to

express, however, do square with other contemporary statements, and his affection for the German people certainly did re-emerge soon after the war. The portrait of Philip Kerr as one opposed to the imposition of harsh reparations on the Germans also seems accurate. Moreover, Meinertzhagen often used capitals, in a Germanic style, for proper nouns or for emphasis. Yet, it remains impossible to exorcise the suspicion that the diaries had been tampered with later, possibly many years later, to present an image of the author as political visionary.

A much more famous incident that occurred in Haifa on 25 April 1948 also deserves some scrutiny. On this occasion, Meinertzhagen, anchored off the Israeli port after a journey to Arabia, claimed to have borrowed the uniform of a Coldstream Guard and to have sneaked ashore for a glimpse of the fighting between Arabs and Jews. After detaching himself from a unit of British troops, he made off for the front line, joined twenty Israeli Haganah, and fired all his 200 rounds killing or wounding at least five Arabs. Once again, the numbering of the pages on which the incident is described in the original diary is out of sequence. Moreover, the ribbon used at the time of typing it was new, but worn both before and after this date, while the text is without paragraphs, as if he wished to squeeze all the text onto two pages.[20]

The Haifa episode found its way into the *Middle East Diary*, and, more recently, even *The Oxford Book of Military Anecdotes*. Reviewers of the first work devoted more lines to the episode than to almost any other, while Meinertzhagen gave a fulsome account of it a decade later at a dinner to celebrate his eightieth birthday.[21] Is it conceivable, then, that it never took place? Do the inconsistencies in the numbering of pages and in the typeface suggest that he dreamt it up, and then, according to some quirk in his psyche, embroidered one more fanciful tale into his extraordinary life story? Many of his family seldom took Uncle Dick's stories at face value.[22] And yet they were reluctant to ignore them, since they believed, like many other people, that he was at least *capable* of almost anything, and certainly capable at seventy of going ashore and joining the fray on Israel's behalf. Only five days before his arrival at Haifa he had been attacked in Cairo by two toughs attempting to steal his wallet: one of them received a kick in the abdomen, the other was thrown against a lamppost by his throat.[23] It is possible, therefore, that the irregularities concerning the entry arose out of his unwillingness to commit himself to paper immediately after the events, in case the diary account provided incriminating evidence of what had been, after all, 'grossly irregular behaviour'.

In attempting to assess the doubts arising out of the diaries one must satisfy the question: if Meinertzhagen had wished to deceive others would he have left so much evidence of subsequent insertion? It is difficult to believe that an intelligence officer so skilled in forgery as he was would have made such elementary mistakes. Or is it conceivable that Meinertzhagen, well known for his rich and rather devious sense of humour, devised a set of journals where sifting fact from fiction becomes an elaborate game for the reader? Certainly, anyone studying them seriously, knowing Meinertzhagen's reputation, cannot fail to be drawn into an attempt to catch him out. However, anyone approaching them with the intention of discrediting him will inevitably find themselves throwing away much of the gold with the dross: for the author is the only source for a number of remarkable adventures. It is most widely believed that the author, revising them in old age, was simply careless, and that the finished product was an unintentional muddle of fable and reality. His relative by marriage, Malcolm Muggeridge, felt 'that they would prove to be a monument to his fantasy self'. Yet, the adventures Muggeridge cited from the *Kenya Diary*, which he felt 'would strain the credulity of schoolboy readers of Henty and Haggard', were absolutely typical not only of Meinertzhagen's period in Africa, but his entire life.[24] To disbelieve these would be to disbelieve everything – an approach that is perhaps as unreasonable as the stories are suspicious.

In conclusion, although it is possible to identify inconsistencies in some of Meinertzhagen's writings and irregularities in the sequence of the diaries, ultimately, in the absence of concrete evidence, one can only theorise why these should be so. However, it does mean that where his testimony provides vital evidence, it is valuable to corroborate his statements with external sources. But any blanket statement of disbelief in his entire journal owing to difficulties with a few passages would be both unfair and unnecessary. To the present author there seems little doubt that the overwhelming majority of his entries are entirely authentic.

Attempting to check the validity of some of the passages, particularly those of a prophetic nature, such as the 'Second World War' piece, in many ways diverts attention from an equally puzzling issue of how he was able to make such forecasts. This ability was undoubtedly one of the things which made him so interesting as a political and military thinker, and, initially, so successful. It was also possibly his undoing. General Thwaites, the post-war Director of Military Intelligence, reputedly once said to him:

The trouble with you Meinertzhagen is that you look just a little farther ahead than most of us, you know you are right and you persist in telling us all that we are wrong . . . if the team is to work smoothly, your unorthodox views must take second place even if they are perfectly correct. And if you can't fit into the War Office machine you run small chance of getting on.[25]

His predictions were not exclusive to his military career; it was something he delighted in throughout his life, the original diaries being littered with his oracular pronouncements. He could, of course, be completely wrong. On one occasion in the 1950s he was so convinced that war was imminent that he made preparations to leave London.[26] He also persisted in his belief in the inherent virtues of the German nation and their Fascist leader throughout the 1930s – a lack of judgement which gives a grimly ironic twist to his political opinions in this period. It was as late as June 1939 that he was forced to admit, in a letter to his friend, Frederick Bailey, that he had been 'very wrong in [his] diagnosis of Hitler and his minions'.[27] The fact that he was frequently wrong, however, tends to support rather than disproves the authenticity of his more accurate predictions. For, surely, had Meinertzhagen composed the diaries to confirm his prophetic gift, he would have eliminated the abundant errors.

Some of his judgements the accuracy of which he would never live long enough to test are particularly interesting. Of a young intelligence officer he met for the first and only time in 1953, he wrote: 'Peter Wright . . . was recently expelled from Kenya. I did not like him and am not surprised he was expelled. I thought him a dangerous, unreliable character.'[28] On another occasion, in 1954, he speculated that 'some new and deadly virus, for which there is no cure, will sweep over our crowded world'.[29] Had these diary entries been published thirty-five years later, how many reviewers in the *Spycatcher*-torn and AIDS-tormented 1980s would have felt tempted to question whether the old man had not touched his diaries up with hindsight?

On three notable occasions in his life Meinertzhagen was subject to uncanny dream experiences that may provide some clues to the whole issue of his prophetic gift. The first of these occurred in May 1905 while he was at Nandi Fort in Kenya. As he was dozing off to sleep one evening he 'experienced a sensation that someone was in the room . . . and that some force was working in my brain'. The dream had centred on his Aunt Blanche, one of his mother's sisters, who was urging him to look after her

daughter, Rosie. During his return to England in 1904, he and his cousin, Rosie Cripps, had been attracted to one another, but owing to the closeness of their blood relationship they had broken off. After the dream Meinertzhagen wrote: 'these curious hallucinations about Blanche have rather made me wonder whether my conscience is not pricking me and blaming me for doing the wrong thing'.[30] However, it was not until 2 July that Meinertzhagen received a letter revealing that his dream had coincided almost exactly with Blanche Cripps's suicide. The occurrence of the dream close to the time of death may have been simply fortuitous; equally, the dream never revealed anything of Blanche's fate. None the less, the coincidence of the events is at least interesting. Moreover, Meinertzhagen's dream image of a mother particularly solicitous for the well-being of her daughter was entirely consistent with her behaviour before her death. She had busily furnished and decorated the family's new holiday home in Scotland, and then returned to London to see all of her children, even sending one of her paintings to a niece, before hanging herself in the bathroom.[31]

On the night of 7/8 January 1925 Meinertzhagen was subject to another prophetic dream midway across the Arabian Sea en route to Bombay. On this occasion his wife, Anne, heavily pregnant with their second child and soon to give birth, was the subject of the dream, which he described in considerable detail.

Annie's room was lit by a brilliant light which showed red through her red curtains at Kensington Park Gardens, in fact the light seemed to be coming into the room from outside and appeared to be alive and dancing with a curious energy. Though there was a doctor in the room and a nurse they appeared unconscious of the light, but Annie was lying in bed and I recollect wondering at the red light on her golden hair . . . Annie would constantly smile at me and I would smile back. Nobody spoke. The red light got more and more brilliant, then suddenly it went out and I was afraid. I woke up at once in full consciousness with Annie's room and her head lit up by the red light photographed in my brain. And then an unheard voice said 'It is a son'.[32]

So convinced was he that the baby had been born at the very time of the dream that Meinertzhagen told another passenger on board that his wife had just had a son. And on arrival in Bombay he received a telegram – 'DAN BORN 7TH BOTH FLOURISHING'.[33]

Possibly the most dramatic of these dream revelations had occurred in

1911 in Mauritius after severe storms. Having been up all night salvaging company stores, Meinertzhagen went off into the forest to watch 'the great trees swaying in the gale and all the torrents swollen to roaring turbulent deluges, tree trunks and boulders being carried down in large numbers'. Later that morning, having fallen asleep, he experienced a dream in which he entered a small room where a baby with 'grey-blue eyes' was lying on a red blanket by an open fire. During the long dream sequence the child grew into a woman, accompanied Meinertzhagen until he descended into old age, and eventually comforted him as he lay dying.

> Then something in me seemed to break and I became ill. Lying down on the bed I could feel the storm shaking the house and the glow of the fire on the hearth. And my child told me I was dying and I smiled because she was also smiling. Her hands clasped mine and all the while she smiled with tears welling in her blue-grey eyes. Bending her head to kiss my forehead she said goodbye and I felt that I was dying . . . And I heard her say in her clear voice 'Never mind, Dick, we shall come together again'. And holding her head and with my lips upon her hair, I sank into death and abruptly awoke from my dream.[34]

What makes this last dream more significant is that Meinertzhagen, so captivated by its imagery, seems to have been convinced that it was true, and referred to his 'dream child' in 1914 and again in 1916, on the second occasion prompted by further dreams about the child.[35] Ten years after the initial vision, in 1921, he discovered for the first time through Felix Clay, his cousin by marriage, that the dream had coincided almost to the hour with the birth of Clay's third daughter, Theresa, who did, in fact, come to have a close relationship with Meinertzhagen until his death and who shared many of his scientific interests. Yet, curiously, on learning of the bizarre coincidence of dates Meinertzhagen claimed to disbelieve that 'dreams can foretell the future'. In spite of this, it is not difficult to entertain the idea that he was capable of some kind of second sight. Equally, while his political views were not manufactured in the same preconscious and paranormal manner, this gift may have had some bearing on them. Certainly, a propensity for psychic experiences fits much of the evidence, and simultaneously provides a key to the whole prophetic (and highly imaginative) cast of his mind.

Whether Meinertzhagen was ever tempted to enhance his image as political visionary through touching up the journals retrospectively, might remain one the principal problems with them, but, it is not an issue by

which they stand or fall. Only very briefly was he ever a pivotal figure in the events of his age: his testimony, therefore, is rarely of central importance. He moves through the pages of his diary more as a passionate, though largely helpless, witness of his times, than as a creator of them. Indeed, much of the richness and pathos of his writings derive from this gap between his fervently held ideals and the inexorable flow of events towards a quite different destiny. For it was Meinertzhagen's curious misfortune to have been born in an age when the British Empire had unfurled to its greatest extent – and to have luxuriated in that sense of power – only to have to watch it steadily shrivel to a handful of insignificant islands and largely irrelevant military bases. The fact that much of the time the diaries are a simple chronicle of private thoughts and actions, while not detracting from the document's interest, renders absurd the charge of falsification.

Yet, like all diaries, his catalogue of largely trivial and intensely personal events, in moving from the general to the particular, can give a fresher and greater emotional understanding of his period than a more conventional, retrospective account. Meinertzhagen's record of a dinner party in October 1931, after the 'great crash' of that year, reveals more about the distress and anxiety of a share-owning community suddenly stripped of its investments than any essay on economic statistics. 'Con Benson, his wife, the Sclaters, Betty Walkinshaw and her husband dined here last night. It was a depressing party. They are all penniless, the Bensons being very depressing, talking of Armageddon, revolution and the Dark Ages. Altogether I was heartily glad when they all left.'[36] Meinertzhagen, ever optimistic, concluded, 'I really think people should try and keep cheerful.' In an effort to anticipate further deterioration in his own finances he drew up an economic strategy divided into six phases. The first of these involved the resignation of his clubs, an end to travelling, taxis, tobacco, extravagant food, and ornamental clothing for the children. Falling back on phase two he would sell his car, give up tipping and shooting. Should phase four ever become necessary, he would move into a cottage without servants and close down his Scottish home, Swordale. The sixth phase anticipated the worst – it read: 'Survival of the fittest – fight to the finish'.[37]

The portions of the diary that remained unpublished were inevitably the most private and, in many ways, the most genuine. Some of his most moving and revealing responses to war, for example, had been written not as the tall, crisply dressed colonel, even less as some berobed knight of the desert, but as an ageing man trudging through London, burdened with baskets of shopping. Two days before the summer solstice in 1944, he was

'staggering home up Church Street just before lunch when I heard a robot [a V1 rocket] coming over'.

> I was carrying a large bag full of rations including a dozen eggs and a packet of biscuits, bacon, cheese and butter. The roaring hum of the robot came nearer and nearer, finally appearing about 300 feet up over Barkers. I atonce [sic] dashed into a small shop known as 'Dick Turpin's Cottage' and noticing that the robot had ceased to roar and must be falling I dashed thro' the outer shop and into the inner parlour where an old dame commenced to say 'And what . . .'. A terrific explosion [followed] and I was pushed as by a huge pillow in the hollow of my back into the arms of the dame. We both fell all of a heap . . . The crash of masonry and the cascade of glass amid black smoke and nauseating dust seemed to surround me. Then yells and shrieks. The robot had fallen on a house just opposite. I went out into the street which I had left a moment before full of shoppers returning home and the spectacle made me sick; the cruelty of it all appalled me; it seemed so utterly callous and brutal; women, men and children lying about, mostly still in death, others moaning or struggling; people rushing in all directions . . . One poor old lady, torn and gashed across the throat and breast, I lifted into a shop but I fear she was dead. I felt so dazed, shaken and disgusted, I left the scene to the trained men. Soldiers rushed up from the neighbouring barracks and I felt I could do no good by remaining so came home . . . I felt ashamed of my species . . . We have sunk below the level of wild beasts. If that is all that our miserable civilisation can give us then let us all go and drown ourselves for we are not fit to live on this planet; let us hand it back to Nature who is kind and merciful in comparison. And what a ghastly perversion of science. Think of the ability, the working hours, the valuable material and no doubt the zeal and zest with which humanity has devised this horrible robot to kill and torment its own.[38]

Comparing this passage with accounts of his earlier adventures in Africa, one can perhaps see how people found it difficult to identify in the old man who published the *Kenya Diary* the young officer whose exploits it recounted.

In the post-war volumes of diary there is an inevitable pathos as one who had been so vital and industrious became ever more circumscribed by physical limitations. From the age of seventy onwards a deafness ascribed to his constant use of a shotgun made it difficult for him to join in anything but one-to-one conversation. In Bahrain, having attended a talk by the

aviation engineer, Frank Whittle, Meinertzhagen wrote, 'I heard little of his lecture for he made the most profound remarks only to his shirt front and the water carafe on the table before him.'[39] On top of physical deterioration, he was increasingly distressed not only by the shift of political and military power away from Europe, but also by the enormous mushrooming of the human population and the massive environmental degradation that followed in its wake. Like many Victorians, he had tended to believe that the world of natural beauty and natural resources was inexhaustible. On discovering that this was not so his sense of disillusionment was immense, and at times this imparted to his writings a deep pessimism and desperation.

And yet, for all his apocalyptic vision, he remained immune to self-pity and fiercely determined to make the most of life. 'I take every advantage of the many prerogatives of the over seventies,' he announced at seventy-five, 'I am thoroughly enjoying myself.'[40] In his earlier life he had often found regulations an irritating curtailment of freedom – something not to abide by, but to rebel against. Seniority, however, loosened even further the last vestiges of constraint. He attributed his good health, for example, to regular morning exercise, cold showers, and a total disregard for medical advice. At seventy-six, a splinter he had received at the base of his spine during his visit to Dunkirk had worked loose and needed attention. After an operation in the morning to remove it, Meinertzhagen lectured that evening to the British Ornithologists' Club on grit in birds' stomachs, with the assistance of champagne and vintage port.[41]

His earlier inattention to dress lapsed even further with the years, but he was entirely unrepentant, with 'neither time nor money to waste on a fashionable outfit'. He was increasingly satisfied with simple pleasures; his favourite foods were milk, brown bread, cheese, and butter. At BOC dinners he would often leave his portion of meat, or give it to a younger and stronger carnivore. In Sweden he spent hours simply wandering and sitting in meadows of summer flowers. Peeping in at a nestbox in his garden, he could see a blue tit 'sitting on two eggs . . . all snug and not minding a bit'. For him this was 'a beautiful sight, rejoicing [his] heart'.[42] His age had also given licence to eccentricity. In the Gloucestershire countryside, approached by the leaders of a hunt, he sent them in a direction entirely opposite to that taken by the fox.[43] For a runaway schoolboy discovered in the woods, he prepared sandwiches and a flask to help him in his escape. In the winter of 1958 he was travelling by bus and fell into conversation with a Kenyan, a young Kikuyu. Treating him to tea in Harrods, Meinertzhagen

then drew up a transcript of their conversation and sent it to Sir Evelyn Baring, the Governor of Kenya, receiving a reply shortly after.[44]

In 1953 six of the ten Meinertzhagen children were still alive – their cumulative age mounting to 435 years. Richard was the second eldest at seventy-five, after his sister, Bardie. In their early adult life he had been separated from the others, particularly his sisters, by their close allegiance to Georgina, by temperament, and politics. In the second half of the twentieth century, however, their shared old age did much to close these divisions. Meinertzhagen, ever critical of his siblings for their Potter love of being the odd-man-out, took a perverse delight in seeing himself surrounded by a family of communists. Bardie was certainly a vehement socialist, a member of the Labour Party for more than fifty years, and a close confidante of Sidney and Beatrice Webb, accompanying the former to the Soviet Union in the thirties. Even on Christmas day brother and sister found it difficult to hold their peace. 'When off politics,' Meinertzhagen confessed that 'there is nobody so kind, so tolerant, and so considerate as Bardie. But during these awful moments of political fever the talk resembles the aggressive frequency of automatic rifle fire.'[45]

Three other sisters – Margie, who had married George Booth, a director of the Bank of England, Beatrice (Bobo), and Elizabeth (Betty) – had flirted on the edge of Bloomsbury. Bobo had been a longstanding friend of Virginia Woolf, featuring regularly in the latter's extensive diaries, and had had an affair with Woolf's brother-in-law, Clive Bell, in the twenties. Elizabeth, the youngest of the children, had been an ambitious although not especially successful actress under the stage name Betty Potter. She had died in 1948 at only fifty-six. Frederick (Fritz), the younger brother, had taken up medicine and then gone to South Africa to establish a career in the mines, and having failed at both took refuge in communism and the low life of the East End.

Together they formed an 'odd, queer lot'. 'The oddest and queerest thing about them', the elder brother noted, was their belief that 'the others are odd and queer whilst they themselves are unique in being normal'. It seems that family funerals, at which all of them were present, were a time for curious hilarity. On Christmas Day 1959 they drew straws to see which of them would die next. Richard had picked the longest straw and therefore the longest life, but in the previous year he had already written his own obituary for *The Times*. Family gatherings were frequently held at 17 KPG, although Meinertzhagen's response to these social events was a maze of contrariness. He claimed to delight in asking people to dinner, and

to feel disappointed when they refused. Just before their arrival, however, he regretted asking them, and yet the moment the door bell rang his second thoughts vanished in a fresh wave of delight. Within two hours this had waned once again to be replaced with a longing for their departure, and when they had actually gone, he was filled once again with remorse and pleasure that he had invited and entertained them.[46] Typical of his contrasuggestibility was the Christmas card he designed in 1958: beneath his illustration of a club-wielding beast – half man, half bird – was the caption, 'Man, the prime predator and the vilest vermin'.

This had been the logo to his final ornithological publication – *Pirates and Predators*. Like the *Birds of Arabia* it had come out much later than he had initially hoped, finally appearing towards the end of 1959. The book was a passionate statement of vigour in old age and of the author's disenchantment with his own species. 'The most dangerous disturber of wild life', growled the eighty-year-old colonel, 'and the greatest vermin of all is man himself. The sportsman, the egg-collector, the bird lover, bird photographer and bird-watcher are all greater disturbers of wild life than any wild predator.'[47] It was Meinertzhagen the *agent provocateur*, Meinertzhagen the wild old man of birds who drew attention. Max Nicholson, later chairman of the Nature Conservancy Council, felt that 'combining in his person the acknowledged status of both *enfant terrible* and elder statesman of British ornithology (in that order) Colonel Meinertzhagen shamelessly trades on the fact that he, like Sir Winston Churchill in a wider sphere, can now do no wrong or, alternatively, can get away with murder'.[48] Anyone reading the book without any foreknowledge of the author would perhaps have been forgiven for believing him a younger man. On one page he confessed 'I should dearly love to unleash six female goshawk in Trafalgar Square and witness the reaction of that mob of tuberculous pigeon'.[49] And yet, anyone reading the book would surely recognise that no brief span of years could encompass such vast knowledge and wide travels. For, as Nicholson pointed out, the book was also 'a rich and fascinating quarry' of facts and experiences accumulated over seventy years of ornithology. It was Meinertzhagen's provocative, beautifully produced, and beautifully illustrated swan song.

In his eighties he could hardly have been expected to remain at the forefront of ornithological inquiry. Yet his great age and experience and the many legitimate (and illegitimate) tall stories he had fathered had made him not only the wild old man, but also the grand old man of birds. At the centenary celebrations of the British Ornithologists' Union, Ernst Mayr,

an eminent taxonomist and the president of America's equivalent of the BOU, named his candidate as 'the doyen of British ornithologists – Colonel Meinertzhagen'.[50] In a letter to honour his eightieth birthday Mayr contended that it was Meinertzhagen who was 'maintaining in Great Britain the continuity between classical and modern ornithology'.[51] His own fellow Britons might not have been so generous: indeed, Meinertzhagen felt himself more appreciated abroad than in his own country.

Although he was one of the most senior and experienced ornithologists, he felt himself unsuited to official rôles, preferring a back-bench position. In the late 1920s he had sat on the council of the Royal Geographical Society, but resigned through boredom. In 1954 he had been persuaded to take on the chair of the British Ornithologists' Club, but two years later he was relieved to give it up, claiming himself 'unfit to run a girls' school'.[52] He took on the chair of a BOU sub-committee which deliberated on the taxonomy of British birds, on the understanding that none of its previous members was re-selected and the entire panel was no greater than four.[53] A letter to Reg Moreau on the issue of bird nomenclature offers a glimpse of Meinertzhagen as committee man. Here, he complained that his opponents on the issue, dubbed the 'Apostles of Instability', accused him 'of unfair methods and steam roller tactics'.[54] One gets some impression of the justice of their accusation from an earlier letter, where Meinertzhagen wrote: 'I intend to bounce the BOC into adopting changes.'[55] Although secretly he savoured the idea that he was 'a bit revolutionary', his shouts from the back-benches were often those of the 'old guard' for a long-vanished golden age. An ecological approach to bird study which quickly gathered pace in the 1930s was not entirely welcomed by Meinertzhagen. 'Counting gannets' nests, counting how many times a robin wags its tail in an hour or how many times a parent bird evacuates faeces from the nest,' he lamented, 'seems to interest the bird world more than anything else.'[56] With Moreau, the editor of *The Ibis*, he contended that 'the Oxford group are ecologists, the London Group are systematists. I regard systematics as of equal importance with habit etc. in fact often more so, for it is the basis of all work; without sound systematics the watcher flounders.'[57]

Privately he confessed to deeper fears: 'If the [British Ornithologists'] Union gets into the hands of the Oxford Group then God help us. Bird behaviour is not ornithology it is psychology.'[58] After the débâcle with the BOU over Vaurie's review of *Birds of Arabia* his relations with Moreau had perhaps cooled. Certainly he disapproved of the latter as BOU president – 'no character, all brains'; while David Lack, director of the ornithological

research centre in Oxford, the Edward Grey Institute, 'was extremely able but devoid of character'.[59] Relations with the latter had soured a little after Meinertzhagen had offered as a bequest to the EGI all his books, notes, and collections of grit, down and seeds; but Lack had been 'so unresponsive and lacking in gratitude' that the offer was withdrawn.[60] In happier days Meinertzhagen had drawn up a will leaving £3,000 to the BOU, £1,000 to the BOC, and £1,000 to the Fair Isle Bird Observatory, but by the time of his final will in 1965 all these had been cancelled.[61] One senses that by the latter date, Meinertzhagen, increasingly distanced by his infirmity from the new generation of ornithologists, lost emotional contact with an institution that had been a focal point of his social and intellectual life for more than half a century.

Meinertzhagen did not leave this life in harness, as would have been apt, and, no doubt, as he would have wished; his final years were long and painful. Almost as if aware of this impending fate he had crammed into the three-year period, 1958–61, six foreign journeys. In the spring after his eightieth birthday he attended the 12th Ornithological Congress in Helsinki. In the summer, he visited Spain, and less than a month later he flew to Israel for a four-week visit. His hosts told him that he was the first man over eighty to climb to the top of Masada, the ancient Jewish citadel on the banks of the Dead Sea. At Rehovot he met David Ben Gurion, the Israeli Prime Minister, and his wife. In his diary afterwards he recorded that with her he had had his shortest conversation on religion ever. As he was leaving 'she said "Do you believe in God?" I said "Yes I do but not in the son of God". "Neither do we" said Mrs Ben Gurion.'[62]

The following summer he made his eighth, and last, journey to Kenya. Hearing, however, of the general election in October 1959, Meinertzhagen decided to cut short the trip. But not before Louis Leakey, the human palaeontologist, had shown him the skull of *Australopithecus boisei*, a hominid more than 500,000 years old found in the Olduvai Gorge, and the thigh bone of a giant extinct ostrich that exceeded New Zealand's moa in size. 'What a world it must have been,' sighed the old bird man.[63]

The beginning of the end came sixteen months later, in Trinidad. While staying at a guesthouse Meinertzhagen fell over one of the five chows owned by the proprietress. On the night of his eighty-third birthday he had got up before dawn and, not noticing the dogs asleep around his bed, slipped and crashed heavily onto the hard floor. Cracking several ribs and damaging a right hand already badly affected by osteo-arthritis, he flew home to England a fortnight later. Home for less than eight weeks,

Meinertzhagen suffered another accident involving a dog, which belonged to his neighbours, the Bartons. One of their two boxers, Linda and Lucibell, leapt up at Meinertzhagen, who tried to ward it off with a stick. Barton, incensed by this behaviour, struck the old man on the chest, knocking him over. The resulting broken hip was the tragic denouement of a long and largely petty squabble between neighbours that had lasted for almost two years.

Meinertzhagen had fought a rearguard action against dogs in Kensington Park Gardens since the 1930s. In his view, they had 'become a privileged class, committing crimes for which the ordinary human citizen would go to prison'. They fouled pavements and doorsteps, and ran in front of traffic causing accidents. 'They can jump on strangers muddying their clothes, . . . fight and brawl in the streets; worry sheep, bite the postman, and if they receive a good kick from a man he is fined or imprisoned.'[64] In 1935 one poor hound living at number 16 had paid the price for irritating him by eating a bowl of food laced with strychnine. According to Meinertzhagen, this had killed not only the dog, but three cats, two wood pigeons, five sparrows, and a dunnock.[65] Against the Bartons, Meinertzhagen and other members of a committee for KPG's communal garden had sought a court injunction to force the couple to keep their pets on a lead during daylight hours. In 1959, however, Rita Barton had taken Meinertzhagen to court. He had been treating chickweed with weed killer when she had attempted to take the watering can off him, Meinertzhagen then rapping her wrist with two fingers.[66] Ill-feeling simmered on into the following year and involved a second, inconclusive court case lasting for five days and costing Meinertzhagen £1,000.[67] The row brewed afresh when the Bartons, apparently a childless couple for whom the boxers seemed to have served as a surrogate family, attempted to prevent cricket being played or bicycles being ridden in the gardens. Other residents in the street, the occupant of number 17 included, complained once again about the antics of the two frisky dogs.

Nine months later this childish business had left Meinertzhagen permanently disabled, with his right leg considerably shorter than the left, and his sight, particularly in his right eye, almost gone. For some time after he was subject to black-outs, while his daily treatment involved two injections and fourteen different types of drugs.[68] Remarkably, for one who could be so vengeful, Meinertzhagen recorded not a single word of recrimination against his neighbours; at eighty-three he had lost his first battle graciously.

1961-7
A Legendary Figure Without a Legend

Almost inevitably, the final years of Meinertzhagen's life were marked by a serious physical deterioration. Following hard on the period in hospital to treat his hip, possibly as a consequence of it, blindness and arthritis made cruel advances. Diary entries declined rapidly. Ornithology as a field pursuit became almost impossible; as a vehicle for socialising, extremely difficult. In 1964 he attended the Ornithological Congress at Oxford in a wheelchair.

And yet, even in old age he expressed something of his earlier style. His walking sticks he had cut himself years ago from the ebony heart of two acacias in Kenya; their handles were made from two fine tusks of *Hylochoerus meinertzhageni*.[1] Mau Mau parties – drawing their name from a cocktail of gin, lime, grapefruit juice, and brandy – were sometimes given every few weeks, and drew a characteristically mixed crowd of guests: Gavin Maxwell, Weizmann's old secretary, Samuel Landman, Joy Adamson, Julian Huxley, F. M. Bailey, Malcolm and Kitty Muggeridge, Peter Scott, Cyril Mackworth-Praed, Landsborough Thompson, and the head of Kenya's armed forces, Sir Gerald Lathbury. Photographs of him during this period, revealing either an inconsolable sadness or an eagle-like intensity, suggest the powerful emotions that sustained him and, ironically, that defeated his frequent wish to die.

In his eighty-seventh year Oliver and Boyd published his final book, a curiously arranged amalgam of childhood journals, letters, and reminiscences – *Diary of a Black Sheep*. Although it eventually appeared in 1964 much of it had been written over twenty years earlier, shortly after his dismissal from the Home Guard in 1941. This earlier manuscript had simply been revised and edited, largely with the help of a secretary, Grace Williams. The finished product, a rough, racy collection of barely connected essays (food at Harrow, school lectures, H. M. Stanley, Sir John Kirk, and Lord Salisbury's rabbits form a typical sequence), was nonetheless unified by the larger-than-life energies of its central character and his forceful, unsentimental prose style. And it was this no-nonsense readability that earned the book a surprise place amongst the *Daily Mail*'s best-of-the-year list.

Although the author's examination of his childhood – his time at Fonthill and his difficult relationship with his family, particularly with Georgina – was loaded with typical ambivalence, his final note was loud and clear.

> I feel that I belong to a world that is dead. The horse-drawn vehicles, classical education, emphasis on manners and convention, entailed estates and ancestral arms, an absence of violence and the blessing of Pax Brittanica have all been replaced . . .
>
> And yet I believe it to be true that a crowded world increases the truth that war, destruction, and suffering constitute the past, present and future of Man. Peace is but a dream – an interlude. Peace is the fruit of Christianity, not of war. We are now entering a world of indecision, dishonesty, and irresponsibility, a world I shall not be sorry to leave.[2]

The tranquil, unreal world he remembered, and the leisured style – the steam trains, the P&O cruise liners, the early, exciting aeroplanes and motor vehicles – in which he had once travelled to observe it were gone for ever. These had withered in the awesome heat of human progress. In the month of Meinertzhagen's dying – June 1967 – the British public enjoyed for the first time colour images on their television sets. To see the world now it seemed no longer necessary to travel at all. All of life could be compressed into a square box in the corner of one's lounge. Meinertzhagen, had he lived to observe it, would no doubt have loathed its technicolor distortions and its slick push-button facility. The advent of colour television was in many ways a measure of the gulf between the man and the age he had lived to see.

For, at the end of his long life, many of Meinertzhagen's worst fears had been realised. The Holy Land, the home for his most cherished dreams, was riven by war and embroiled in Super-Power politics. As he lay dying the armies of Israel crushed in a week-long campaign the combined forces of the Arabic-speaking nations. Yet such a staggering victory, while it had earned the Jews fresh territory several times the size of Israel, had set in train a series of political and demographic problems insoluble even today. For a decade he had watched successive British governments, latterly under a socialist, Harold Wilson, give back vast African lands to their indigenous populations. By the year of his death there was little more than a few islands to return. Soviet Russia, a country he had opposed sometimes at enormous risk to his own life, and whose history he might so easily have changed, in 1967 glared across the eastern gates of Europe, not at Britain, a

nation now beneath its watch, but at another great power far across the Atlantic.

Intermittently, Meinertzhagen speculated on what had been the significance of his own contribution to the events of his age. His response to this issue and to the question of his own renown was, as in so many things, highly mixed. Most of the evidence confirms the picture of a man uninterested in securing a reputation. When, en route to India in 1951, he received an offer of a knighthood, allegedly for his work in the secret service, his answer was unequivocal: 'I sent a very definite No in reply. It would be impossible almost ridiculous, I am no believer in medals, orders and other encumbrances'.[3] To his friend Frederick Bailey he gave as his reasons for refusal:

a) I disapprove of honours and rewards except in outstanding circumstances, such as Hillary and Tensing.

b) If I had accepted I would have found it difficult to explain without divulging the work on which I had been engaged.

c) Sir Richard Meinertzhagen sounds to me most ridiculous and I should never have outlived the ridicule of my family.[4]

His first reaction to the offer of a CBE six years later was equally indifferent.[5]

When the BOU conferred on him the Godwin-Salvin medal – an honour bestowed only nine times in almost forty years – Meinertzhagen's response was self-deprecating. 'The strains of publicity had completely upset me for several days', he wrote shortly after receiving it, 'and I felt quite ill through loss of sleep and appetite'.

Landsborough Thompson made some quite untrue and most flattering remarks when he gave me the bauble and I made some inane remarks in returning thanks. I have a strong dislike for all types of rewards and medals etc. and felt the most complete humbug in accepting this mark of esteem for I am by no means the most distinguished member of the Union; but I accept the medal not so much as a mark of appreciation, but as a gesture of friendship from the members of the BOU; and friends, next to ones family, are the most valuable asset I possess.[6]

He later had the medal cut into two halves and sunk into either end of a heavy gavel which he had donated to the BOC.

However, running in tandem with his eschewal of public notice was a sometimes prominent self-regard. Typical of this contradiction was the fact

that while he seemed to spurn press attention he invariably cut out and pasted into his diaries with great care the scribblings of 'these penny-a-line Fleet Streeters'.[7] Similarly, in his military career he claimed a significance for some of his actions which it would be difficult to substantiate. Representative of these exaggerations are his claims to have saved Zionism in 1920,[8] and to have 'put a stop to the activities of Russian revolutionary activity in Western Europe' in 1930.[9] His boast to Philby to have been more or less responsible for the appointment of Haj Amin el Husseini may also fit into this category.

In later life Meinertzhagen expressed some hope that his family would make 'a connecting story out of [his] not uninteresting life',[10] and in his final years gave permission for Jon Lord to go ahead with a biography. It is also interesting that Meinertzhagen, in recording publicly his connection with significant historical events, did so by reproducing verbatim extracts, and even entire volumes of his diary. This form of expression, of course, involved the least additional work. It was, then, a labour-saving ploy, but it also revealed the events in an intensely personal manner, suggesting, perhaps, a deep self-preoccupation.

On reading *The Mist Procession*, the book of an old friend, Robert Vansittart, Meinertzhagen was disquieted by a passage that referred to him as a 'quiet capable unremembered' man.[11] 'Am I second-rate,' he later questioned in his diary, 'insignificant and to be forgotten, buried in obscurity? Perhaps I am but it is a curious way of putting it.'[12] Malcolm Muggeridge, in a much later analysis, echoed to some extent Vansittart's words when he wrote: 'Richard Meinertzhagen was one of those legendary figures without a legend. As ornithologist, intelligence officer, traveller and writer he made his mark. Yet to most people he is a name floating about looking for a reputation.'[13]

It is difficult to resist Muggeridge's assessment: for, while Meinertzhagen was generally acknowledged as a man of rare parts, he could hardly be described as famous. Nor, some would argue, could he be called successful. The brilliant career that lay before him in 1917, or in 1920, or even in 1924, eventually came to nothing. Meinertzhagen had risen on the basis of his needle-sharp intelligence and unsparing discipline, but these qualities were apparently insufficient to sustain him in high office. For they carried with them a narrowness of outlook and an intolerance of those whose decision-making faculties operated less swiftly or certainly than his own. The value of wide-ranging and subtle intellectuals like Arthur Balfour, for example, was entirely overlooked by Meinertzhagen. In a

situation that demanded collective effort he found it increasingly difficult to function. Those he could, he dominated, with those whose personality or rank refused to allow it, he clashed, occasionally violently.

It was this same force of character that marred his achievements as a naturalist. The most frequent criticism made by those who knew his work was that if he believed a thing to be so, it was so.[14] In the introduction to the *Birds of Arabia* he wrote: 'Most readers will find much in this book with which they disagree. If I were to record views in full agreement with modern practice I should be writing nothing new; there would be no advance nor progress; I would be stuck in the orthodox groove.'[15] This challenge to debate was typical of Meinertzhagen. He savoured the idea that he was a provocative thinker, and, indeed, much of the time he was. The dialectic that he seemed to want to set in motion was a good route to the truth. Unfortunately, he was insufficiently tolerant for an opposing point of view to be pressed or, at least, pressed too hard. Having thrown down an intellectual gauntlet, he could take a show of opposition as a personal attack; and having been affronted he sought to triumph. The goal then ceased to be scientific truth, but private vindication. It was this intensely personal and often emotional approach to his subject that made his writings so interesting, although not always so accurate. To his detractors the digressions, anecdotes, personal interjections, and anthropomorphisms were unforgivable lapses from objectivity; to his admirers they were the essence of his appeal.

Those who have had little faith in him as an ornithologist have also pointed to a number of errors, the most famous of which concerned the Razo lark. This species is a single-island endemic from one of the Cape Verdes. In 1951 Meinertzhagen wrote of it in his 'Review of the Alaudidae', saying 'the short time during which I observed *razae* [Razo lark], they were constantly excavating for grubs and not surface-feeding for seeds'.[16] Meinertzhagen's comments on its feeding behaviour, while largely accurate, were entirely anomalous, for having never been to the Cape Verdes, let alone Razo Island itself, he could never have seen the species.[17]

For some, such inexplicable mistakes were sufficient to discredit him. Having found a fundamental flaw buried deep in his researches, they seem to have believed that in pulling it out, into view, they had toppled the entire edifice, like a house of cards. However, while there may be significant errors and inconsistencies in his ornithological work, the sheer size and quality of his donated collections, and the immense volume of his writings, are a sound bulwark for his reputation.

Yet, while he may comfortably survive the efforts of his critics, he was not the most outstanding ornithologist of his age. Internationally, his friends – Ernst Hartert, Erwin Stresemann, and Ernst Mayr – would in the eyes of most, including Meinertzhagen himself, have had prior claim. In Britain, David Lack and Reg Moreau, men Meinertzhagen had dismissed as characterless, would have also gone before him. There were also others who could claim equal status – a fact that he would have freely acknowledged. Indeed, in a letter to Sir Gavin De Beer he confessed himself not a scientist but a naturalist.[18] None the less, although he may not be the dominating genius in his field, he remains one of the most fascinating and probably the most controversial personalities in the history of British ornithology.

This characteral vigour, even eccentricity, has drawn a mixture of critics and admirers to his military career. And indeed much of the evidence of both parties is invariably compelling. The detractors point out his capacity to take life, both human and animal, his bitter, occasionally unnatural, vindictiveness towards individuals and nations, and his sometimes unscrupulous methods. Yet the cast-iron egoism from which this negative behaviour emanated also gave rise to a startling originality and almost illimitable self-confidence that could make him as a friend and servant unswervingly loyal and courageous. It was these latter qualities which earned him the respect and friendship of many eminent soldiers. While Meinertzhagen never rose above the rank of colonel, his diaries provide a roll call of British military top brass in the first half of the twentieth century. Allenby, Alanbrooke, French, Montgomery, Portal, Trenchard, Wavell, and Wilson: six field marshals and two air marshals would hardly have befriended the same lowly colonel if Meinertzhagen had not shown a strength and quality of personality equal to their own. At the same time, force of character by itself could not have commanded the attention and friendship of men and women so obviously and variously gifted as Joy Adamson, Churchill, Samuel Herbert, Lawrence, Lloyd George, Gavin Maxwell, Philby, Smuts, and Weizmann.

While Meinertzhagen may not have a single potent legend with which to secure his reputation, an array of stories combine to confirm his talent and his cult status – a status, incidentally, that maintains the scarcity and high price of his various publications. The prevailing quality that emerges from these exploits is a Machiavellian unpredictability, which in turn has given rise to a babble of persistent and almost legendary tales.

In the course of research the present author has come across the most

remarkable array of tales: his experiences at Fonthill, the controversial assassination of the Laibon, the running duel with the German agent, Franks, the celebrated haversack ploy at Gaza, the liberation of a Russian royal princess, the assassination of seventeen Bolshevik agents. These are the true ones, but the apocryphal and invented are just as interesting. At the outbreak of the First World War he was supposed to have gone to dinner with a German duke, enjoyed an evening of Prussian entertainment, then shot his host. Another persistent fable concerned the murder of his wife. Many others are hopelessly distorted. One of these concerned his visit to Fair Isle, where a controversy over the identity of a short-toed lark was resolved by Meinertzhagen when, at the evening log call, he drew the hotly contended bird from his pocket – dead. Different versions of this anecdote are legion. According to some, Meinertzhagen stole the credit for another man's book, and reinvented his life in a series of bogus diaries. These stories hold an almost inexhaustible supply of satisfaction for both audience and story-teller alike, and in many ways it ceases to matter whether they are true or untrue, for such was the man that they could so easily have been so.

Notes

Chapter One: A Silent Laughing Masterful Man

1 Meinertzhagen Diaries, Volume LXVIII, 9/6/1958.
2 Meinertzhagen Diaries, Volume LXXI, 25/2/1960.
3 *The Seven Pillars of Wisdom*, 1935 edition, T. E. Lawrence, page 384. For Meinertzhagen's disapproval of the Lawrence description see Meinertzhagen Diaries, Volume XXI, 20/7/1919.
4 *A Prince of Our Disorder*, J. E. Mack, page 502.
5 *Lawrence of Arabia – A Biographical Enquiry*, R. Aldington, page 201.
6 *The Seven Pillars of Wisdom*, 1935 edition, T. E. Lawrence, page 38.
7 Preface in *Middle East Diary*, page x.
8 Meinertzhagen Diaries, Volume XIV, 24/4/1914.
9 Meinertzhagen Diaries, Volume XIII 25–6/5/1913.
10 Meinertzhagen Diaries, Volume XVI, 24/6/1915.
11 Meinertzhagen/Moreau Correspondence, letter dated 30/4/1954.

Chapter Two: 1878–91 Annie Maria, She Sat on the Fire

1 *The Diary of Beatrice Webb*, Volume Four, Edited by Norman and Jeanne Mackenzie, page 147. Clearly, this is a mistake on the part of the editors.
2 *Destined to be Wives*, Barbara Caine, page 20.
3 *My Apprenticeship*, Beatrice Webb, page 11.
4 *My Apprenticeship*, Beatrice Webb, pages 25–33.
5 The nine sisters in order of age are: 1) Lawrencina, 2) Catherine, 3) Mary, 4) Georgina, 5) Blanche, 6) Theresa, 7) Margaret, 8) Beatrice, and 9) Rosalind. The four who married politicians are 2), 6), 7) and 8); their respective husbands being Leonard Courtney, later Baron Courtney of Penwith, Charles Alfred Cripps, first Baron Parmoor, Henry Hobhouse, who was a Privy Counsellor, and Sydney Webb, Baron Passfield. The three other men, in addition to Daniel Meinertzhagen, whose incomes exceeded £100,000, are Robert Holt, William Cripps, and Charles Cripps; their respective spouses – 1), 5), and 7). (Robert Holt was also gazetted for a baronetcy, but declined it on Lawrencina's insistence.)
6 *Destined to be Wives*, Barbara Caine, page 185.
7 *The Diary of Beatrice Webb, Volume Two*, Edited by Norman and Jeanne Mackenzie, page 29.
8 See *Diary of a Black Sheep*, page 29, for Meinertzhagen's interest in Huth's Spanish connections. I am grateful to Nicholas Meinertzhagen for the information on Manuela Felipa Mayfren's true origins; see also Murray, A. J., *Home from the Hill*, London, 1970, pages 70–82 and *passim*.
9 Richard Bowdler Sharpe, 1847–1909, was probably the most dynamic British ornithologist of the nineteenth century. After serving for five years as the librarian of the Zoological Society of London, he became senior assistant in the Department of Zoology

Richard Meinertzhagen

at the British Museum in 1872. He continued in the museum for the rest of his working life, and was promoted to keeper of the birdroom in 1895. His output was staggering. He supervised and edited the museum's *Catalogue of Birds*, a work comprising twenty-seven volumes of which he personally wrote half. The first volume alone ran to more than 500 pages. While working on the *Catalogue* he also found time to finish, edit, and see through publication the uncompleted works of John Gould, the famous bird artist, and Henry Seebohm. Under his guidance the British Museum's collection of bird skins increased from fewer than 35,000 when he took office to 400,000 by 1905. In 1892 he founded the British Ornithologists' Club and presided over a number of international Ornithological Congresses.

10 Henry Eeles Dresser, 1838–1915, took advantage of his position in the family timber business to travel widely in Scandinavia, Russia, and most of Southern Europe. The most important of his five works was his *History of the Birds of Europe*, which ran to eight volumes. His large and valuable collection of bird skins was donated to the Manchester Museum.

Sir Lionel Walter Rothschild, 3rd Baronet and 2nd Baron Rothschild, 1868–1937. Although he was a Conservative MP for a number of years, Walter's main interest in life was natural history, which he pursued on a grand scale. At his own expense, he established an immense zoological collection and museum at Tring, which was later bequeathed to the British Museum. In London, Walter achieved a certain infamy by appearing in Hyde Park driving a team of zebra. His younger brother, Charles, was a contemporary and friend of Richard Meinertzhagen at Harrow.

11 *Diary of a Black Sheep*, pages 270–81.
12 *The Story of Aysgarth School*, Erica Thompson, n.d.
13 *Diary of a Black Sheep*, page 139.
14 *Diary of a Black Sheep*, page 138.
15 *Diary of a Black Sheep*, page 158.
16 *Diary of a Black Sheep*, page 159.
17 *Diary of a Black Sheep*, page 134.
18 *Diary of a Black Sheep*, page 156.
19 Sir Edward Charles Blount, 1809–1905, had been a Parisian banker and developer of French Railways. He retained his passion for horse-racing right into old age, and when Richard Meinertzhagen visited Imberborne Manor, Blount, then in his eighties, was still a skilled and vigorous driver of cart and team.
20 Meinertzhagen Diaries, Volume LXXII, 21/8/1962.
21 Meinertzhagen Diaires, Volume LXVIII, 5/3/1958.
22 *Diary of a Black Sheep*, page 168.
23 *Diary of a Black Sheep*, page 164.
24 *The Diary of Beatrice Webb*, Volume Two, Edited by Norman and Jeanne Mackenzie, page 130.
25 Meinertzhagen Diaries, Volume LXXII, 21/8/1962.
26 *Diary of a Black Sheep*, page 161.
27 *Diary of a Black Sheep*, page 173.

Chapter Three: 1891–99 A Black Sheep

1 *Diary of a Black Sheep*, page 188.
2 *Diary of a Black Sheep*, page 76.
3 Henry Hobhouse, 1854–1937, MP for East Somerset 1885–1906 and pioneer of local government.
4 *Diary of a Black Sheep*, page 90.

5 *Diary of a Black Sheep*, page 91.
6 *Diary of a Black Sheep*, page 338.
7 *Diary of a Black Sheep*, page 292.
8 Henry Seebohm, 1832–1896, was a widely travelled naturalist and author. Much of his important ornithological work was done in Europe, but he also made extensive journeys to Siberia, Asia Minor, and South Africa. His experiences in the former resulted in his travel book, *Siberia in Europe: a Visit to the Valley of Petchora*, published in 1880. This was followed by a companion volume in 1882 – *Siberia in Asia*.

 Howard Saunders, 1835–1907, like so many ornithologists of the nineteenth century, combined his work as a banker with an interest in birds. He travelled extensively in South America between 1855 and 1860, and on his return to England became centrally involved in the world of natural sciences. The most important of his various rôles were vice-president of the Zoological Society of London, secretary and editor of the British Ornithologists' Union, secretary and treasurer of the British Ornithologists' Club. He enjoyed a world-wide reputation as an authority on gulls and terns.

9 *Diary of a Black Sheep*, page 202.
10 *Diary of a Black Sheep*, page 170.
11 *Diary of a Black Sheep*, page 110.
12 *Diary of a Black Sheep*, page 325.
13 Thomas Lyttleton Powys Lilford, fourth Baron Lilford, 1833–1896. Until rheumatic gout confined him to a bathchair, he travelled widely in southern Europe, particularly Spain and Italy. In later life he maintained enormous aviaries at his country house in Northamptonshire, and was president and a generous benefactor of the British Ornithologists' Union.
14 *Diary of a Black Sheep*, page 218.
15 *Diary of a Black Sheep*, page 219.
16 *Diary of a Black Sheep*, page 328.
17 Sir Henry Morton Stanley, 1841–1904, explorer, administrator, author and journalist; this controversial self-publicist was most famous for his epic expedition to discover the whereabouts of Dr Livingstone. His account of that journey was published in 1871, under the title, *How I Found Livingstone*. He also helped establish Anglo-Egyptian dominion of the Upper Nile, and explored areas of the Congo and British East Africa. In 1890 he published his well-known book on his African exploits – *In Darkest Africa*.
18 Sir Harry Hamilton Johnston, 1858–1927, explorer and administrator. Johnston was a person of remarkably diverse talents – scientific, artistic, and linguistic. He made exploratory journeys to parts of southern Angola and British East Africa. From 1884 to 1901 he held a string of diplomatic and administrative rôles, culminating in his post as special commissioner in Uganda.
19 John Denton Pinkstone French, Earl of Ypres, 1852–1925. French was Chief of Imperial General Staff at the outbreak of the First World War and assumed command of the British Expeditionary Force. After two years without significant success he was replaced by Douglas Haig in December 1915.
20 Edmund Henry Hynman Allenby, Viscount Allenby of Megiddo, 1861–1936, was Meinertzhagen's commanding officer in Egypt. He would introduce the latter as the 'only officer who has jumped over me brandishing a sword'.

 Sir Douglas Haig, first Earl Haig, 1861–1928; like Allenby, he was serving at Staff College at the time of his first encounter with Meinertzhagen. Haig was the latter's commanding officer in 1918 when Meinertzhagen brought him his copy of the German surrender.
21 In the *Diary of a Black Sheep* Meinertzhagen claimed that the ghost was supposed to

reside in a large image of the Buddha, which Meinertzhagen subsequently bought when the house contents were sold. In addition to the deaths of the three eldest sons, of which Dan Meinertzhagen was one, Claude Vaudrey also died in his twenties, while Richard Meinertzhagen's own eldest son, another Daniel, was killed in the Second World War at nineteen. This made a series of five. Richard's son, Ran, to whom the Buddha figure was left, later returned it to Mottisfont Abbey.

22 *Diary of a Black Sheep*, page 355.

Chapter Four: 1902–06 The Kaidparak Hill Incident

1 Meinertzhagen Diaries, Volume 0, 23/3/1899.
2 *High Noon of Empire*, Michael Edwardes, page 65.
3 *Army Diary*, page 20.
4 *Army Diary*, page 15.
5 *Curzon in India*, David Dilks, page 31.
6 *Army Diary*, page 16.
7 Meinertzhagen Diaries, Volume 0, 5/1/1901.
8 Meinertzhagen Diaries, Volume 0, 4–5/9/1901.
9 *Army Diary*, page 22.
10 *Kenya Diary*, page 3.
11 *Kenya Diary*, pages 23–7.
12 *Kenya Diary*, pages 51–2.
13 *Kenya Diary*, page 141.
14 *Kenya Diary*, page 74.
15 *Kenya Diary*, Elspeth Huxley, Preface to 1983 edition, page v.
16 *Kenya Diary*, page 218.
17 *Kenya Diary*, page 178.
18 *Kenya Diary*, pages 60 and 152.
19 *Kenya Diary*, page 181.
20 *Kenya Diary*, page 163.
21 PRO CO 533/2, 26/7/1905.
22 *Kenya Diary*, pages 194–6.
23 *Kenya Diary*, page 216.
24 *Kenya Diary*, page 230.
25 *Kenya Diary*, page 232.
26 *Kenya Diary*, page 234.
27 Meinertzhagen gave a total of 70,000 captured goats and sheep in *Kenya Diary*, while in the official 'Final Report on the Nandi Expedition' a figure of only 18,000 was recorded.
28 *Kenya Diary*, page 275.
29 Meinertzhagen Diaries, Volume VI, 19/10/1905.
30 Meinertzhagen Papers, Appendix B, British East Africa 1902–6, No. 4c.
31 *Army Diary*, page 25.
32 PRO CO 533/14, 25/5/1906.
33 PRO CO 533/13, Final Report on Nandi Expedition, 26/4/1906.
34 PRO CO 533/13, CR30674/05.
35 *The King's African Rifles*, Lieut. Col. H. Moyse-Bartlett, page 202.
36 *British Rule in Kenya, 1895–1912*, G. H. Mungeam, Ch. 8, page 136.

Chapter Five: 1906–14 A Prelude to War

1 Meinertzhagen Diaries, Volume LXX, 10/1/1959.
2 Meinertzhagen Diaries, Volume V, 18/7/1906.

3 Meinertzhagen Diaries, Volume V, 27/12/1906.
4 *Army Diary*, pages 291–2.
5 Meinertzhagen Diaries, Volume VIII, 24/11/1906.
6 *Kenya Diary*, pages 319–324.
7 Meinertzhagen Diaries, Volume V, 22/11/1906.
8 Meinertzhagen Diaries, Volume I, 8/5/1901.
9 Meinertzhagen Diaries, Volume IX, 10/9/1909.
10 See Meinertzhagen Diaries, Volume VIII, 18/10/1908. It is typical of the problems associated with Meinertzhagen's personal testimony, and also, possibly, of the huge distortions created by his faulty memory, that in a volume of memoirs entitled 'ME', probably drawn up in 1942–3, he gave a completely different version of the meeting with Mary Bridson. Here, he and Sir Alfred Sharpe had carefully planned the trip prior to departure; equally, his time together with Mary in the bush had been a month, not a few days as in the original diaries. See 'ME', pages 96–8.
11 Meinertzhagen Diaries, Volume VIII, 22/10/1908.
12 Meinertzhagen Diaries, Volume XII, 17/12/1911. This version of Amorel's family history seems starkly at odds with the facts. See Burke's *Landed Peerage*, 1921.
13 Meinertzhagen Diaries, Volume XI, 29/5/1911.
14 Meinertzhagen Diaries, Volume XII, 28/9/1911.
15 Meinertzhagen Diaries, Volume XII, 24/2/1912.
16 Meinertzhagen Diaries, Volume XIII, 23/11/1912.
17 *Army Diary*, pages 68–9.
18 *Army Diary*, page 77.

Chapter Six: 1914–16 The East African Campaign

1 *Army Diary*, page 82.
2 *Official History, Military Operations, East Africa Volume One*, Charles Hordern, page 101.
3 *Army Diary*, page 85.
4 *Army Diary*, page 96.
5 *Army Diary*, page 95.
6 *Army Diary*, page 93.
7 Aitken was reduced to the substantive rank of colonel and relegated to unemployment on half pay until the end of the war. In 1920 after a review of the case he was exonerated by public statement in parliament. He was allowed to retire on the maximum pay of a colonel and given the honorary rank of Brigadier-General.
8 Meinertzhagen Diaries, Volume L, 3/3/1942.
9 *Army Diary*, page 98.
10 In the *Army Diary*, page 104, Meinertzhagen claimed that sixteen machine guns were lost, although the Official History of the campaign recorded only eight.
11 *Army Diary*, page 102.
12 *Army Diary*, page 109.
13 *Army Diary*, page 109.
14 *Army Diary*, page 124.
15 *Army Diary*, page 124.
16 *Army Diary*, page 125.
17 *The Battle for the Bundu*, Charles Miller, page 99.
18 *Army Diary*, page 127.
19 *Army Diary*, page 128.
20 *Army Diary*, page 148.

21 *Army Diary*, page 142.
22 *Army Diary*, page 143.
23 *Army Diary*, page 172.
24 *Army Diary*, page 108.
25 *Army Diary*, page 159.
26 Meinertzhagen Diaries, Volume XX, 18/2/1918.
27 *Army Diary*, page 167.
28 Meinertzhagen Diaries, Volume XXIX, 6/12/1929.
29 *Army Diary*, page 107.
30 *Army Diary*, page 166.
31 *Army Diary*, page 205.
32 *The Battle for the Bundu*, Charles Miller, page 146.
33 *Army Diary*, page 191.
34 Frederick Edward Guest, 1888–1937. Third son of Baron Wimborne; Churchill's
 cousin. Private Secretary to Churchill, 1906. Liberal MP, 1910–29. Treasurer, HM
 Household, 1912–15. ADC to Sir John French, 1914–16. On active service in East
 Africa, 1916–17. Patronage Secretary, Treasury, 1917–21. Secretary of State for Air
 1921–2.
35 *Army Diary*, page 196.
36 *Army Diary*, page 199.
37 *Army Diary*, page 200.
38 Meinertzhagen Diaries, Volume XXIX, 6/12/1929.

Chapter Seven: 1917 The Palestine Campaign

1 Meinertzhagen Diaries, Volume XIX, 29/1/1917.
2 Meinertzhagen Diaries, Volume XIX, 9/4/1917.
3 Meinertzhagen Diaries, Volume XX, 12/2/1918.
4 Meinertzhagen Diaries, Volume XIX, 12/3/1917.
5 Meinertzhagen Diaries, Volume XIX, 23/4/1917.
6 *Army Diary*, pages 207–12.
7 *The Times*, 19/6/1967, page 10.
8 *The Palestine Campaigns*, A. P. Wavell, page 92.
9 *War Memoirs*, D. Lloyd George, page 1085–6.
10 *Allenby*, B. Gardner, page 87.
11 *Allenby*, B. Gardner, page 127.
12 *Army Diary*, page 219.
13 *Army Diary*, page 216.
14 *Army Diary*, page 216–19.
15 Meinertzhagen Diaries, Volume XX, opposite entry dated 13/7/1917.
16 Major-General Sir Arthur Lynden Bell, KCB, 1867–1941. He was Director of Staff
 Duties, 1918–21.
17 The final episode in the Franks story occurred five years later in Cologne, where
 Meinertzhagen was serving with his new regiment, the Duke of Cornwall's Light
 Infantry. While dining in a restaurant he noticed Franks at one of the tables, his old
 adversary apparently bowing to him out of mutual recognition. Meinertzhagen later
 informed his intelligence section and discovered that Franks headed the German secret
 intelligence bureau at Cassel. Taking precautions lest the German agent wished to settle
 his old score, Meinertzhagen invariably kept a loaded rifle by his bed. Two days after
 their first meeting, while Meinertzhagen was walking in local woodland, he claims to

have seen somebody of Franks' build dressed as a peasant and deliberately averting his face from Meinertzhagen's eyes. There were also, according to Meinertzhagen, many other Germans in a wood that was usually deserted. Fearing this to be Franks' move to shoot him Meinertzhagen informed GHQ, but an immediate search of the woods by six British personnel revealed nothing suspicious. However, Meinertzhagen had a plain-clothed detective attached to him whenever he wished and carried a loaded revolver at all times. See Meinertzhagen Diaries, Volume XXIV, 10/8/1924.

18 *Army Diary*, pages 221–2.
19 *Army Diary*, pages 222–3; also pages 283–4.
20 *Army Diary*, page 223.
21 *T. E. Lawrence*, B. Liddell Hart, page 238.
22 *Official History, Military Operations, Egypt and Palestine*, Volume Two, C. Falls & A. Becke, page 31.
23 Meinertzhagen Papers, Appendix D, Palestine and the War Office 1917–8, Item 6.
24 *The Times*, 19/6/1967, page 10.
25 The most accurate version of how he planted the haversack occurs in his own *Army Diary*, pages 222–3, and 283–4. The Official History of the campaign also reported the incident accurately, the author consulting Meinertzhagen specifically on the issue. (See page 31.) Curiously, Meinertzhagen asked Falls not to mention his name in connection with the incident. See letter from Falls to Meinertzhagen, dated 24/5/1922, in Meinertzhagen Diaries, Volume XX. Other more or less accurate versions occurred in the *Spectator* of 16 March 1956.
26 *Army Diary*, page 294.
27 *War Memoirs*, D. Lloyd George, page 1923.
28 *Official History, Military Operations, Egypt and Palestine*, Volume Two, C. Falls & A. Becke, page 35.
29 *Official History, Military Operations, Egypt and Palestine*, Volume Two, C. Falls & A. Becke, pages 5–7.
30 *Army Diary*, page 224.
31 *Allenby*, B. Gardner, page 160.
32 *Allenby*, B. Gardner, page 160.
33 *The Seven Pillars of Wisdom*, T. E. Lawrence, page 462 (Penguin edition, 1962).
34 Meinertzhagen Diaries, Volume XX, 30/12/1917.
35 Meinertzhagen Diaries, Volume XX, 30/12/1917.
36 *Army Diary*, page 226.

Chapter Eight: 1918–19 With Lawrence in Paris

1 *Army Diary*, page 247.
2 *Army Diary*, page 243.
3 *Army Diary*, page 244.
4 *Army Diary*, page 247.
5 Meinertzhagen Diaries, Volume XXI 30/1/1919.
6 *Army Diary*, page 242.
7 *Army Diary*, page 244.
8 *Army Diary*, page 246.
9 Meinertzhagen Diaries, Volume XXI, 27/5/1919.
10 *Backing Into the Limelight*, M. Yardley, page 116.
11 *Middle East Diary*, pages 28–9.
12 Meinertzhagen's attitude to homosexuality seems to have been typical of his age – a

mixture of moral condemnation and physical repugnance. However, on one occasion in the 1930s when he stumbled on a friend in bed with another man he seems to have treated the matter with sympathy and discretion.

13 Meinertzhagen Diaries, Volume XX, 17/12/1917.
14 See, for example, Meinertzhagen Diaries, Volume XX, 17/12/1917, for Meinertzhagen on Lawrence; and *The Seven Pillars of Wisdom*, page 384, for Lawrence on Meinertzhagen. Aldington in *Lawrence in Arabia – A Biographical Enquiry*, pages 201–2, cited Lawrence's description of Meinertzhagen, and its apparent zeal for the latter's ferocity as evidence of Lawrence's own bloodlust. Mack, however (*A Prince of Our Disorder*, page 502), thought Lawrence's description highly critical of Meinertzhagen.
15 *Army Diary*, page 247.
16 *Middle East Diary*, pages 15–16.
17 *Middle East Diary*, page 30.
18 *Middle East Diary*, pages 30–32.
19 *A Prince of Our Disorder*, J. E. Mack; see page 501, note 42; also page 502–3, note 58.
20 *T. E. Lawrence*, D. Stewart; see page 225.
21 *Backing Into The Limelight*, M. Yardley; see page 141.
22 *A Prince of Our Disorder*, J. E. Mack, page 501, note 42.
23 *A Prince of Our Disorder*, J. E. Mack, page 270.
24 Meinertzhagen Diaries, Volume XXI, 8/4/1919.
25 *The Seven Pillars of Wisdom*, pages 562–3. (1935 edn)
26 See *Middle East Diary*, pages 250–51.
27 *T. E. Lawrence*, D. Stewart; see page 225.
28 In addition to the three Lawrence biographers, Elspeth Huxley has also cast doubt on Meinertzhagen's prescient statements about the Kikuyu in the *Kenya Diary*: see the preface to the 1983 edition (Eland Press). Wilfred Thesiger also questioned the contemporaneity of some entries there and in the *Army Diary*: interview, 12/1/1988.
29 Meinertzhagen Diaries, Volume XX, 10/2/1918.
30 *Middle East Diary*, page 40.
31 Meinertzhagen Diaries, Volume XXI, 8/4/1919.
32 *Army Diary*, page 88.
33 Meinertzhagen Diaries, Volume LX, 13/11/1951.
34 *Peacemaking, 1919*, Harold Nicolson, page 216.
35 Meinertzhagen Diaries, Volume XXI, 20/7/1919.
36 *Middle East Diary*, page 38.
37 *The Secret Lives of Lawrence of Arabia*, P. Knightley & C. Simpson, page 214.
38 *Middle East Diary*, page 27; also page 37.

Chapter Nine: 1919–20 The Best Lack All Conviction

1 *The Letters of T. E. Lawrence*, ed. D. Garnett, pages 281–2.
2 *Documents on British Foreign Policy 1919–1939*, E. L. Woodward & R. Butler, Volume IV, pages 340–49.
3 Meinertzhagen Papers, Appendix E, Peace Conference, Memorandum on the Reconstitution of the Turkish Empire including Syria, Iraq, Arabia, Egypt, Cyprus and Thrace, 23/6/1919.
4 *Observer*, 21/2/1960.
5 *Middle East Diary*, Preface page ix.
6 *The British in Palestine*, B. Wasserstein, pages 51–2.
7 Meinertzhagen Diaries, Volume XX, 17/12/1917.

8 Meinertzhagen Diaries, Volume LXVIII, 30/1/1949.
9 *Middle East Diary*, page 17.
10 Interview with Derek Goodwin, 7/3/1987; Interview with Dr David Snow, 7/7/1987.
11 Meinertzhagen Diaries, Volume XLIX, 1/6/1949.
12 Meinertzhagen Diaries, Volume XV, 2/8/1914.
13 *The Seven Pillars of Wisdom*, page 38 (1935 edn).
14 *Diary of a Black Sheep*, page xix.
15 Meinertzhagen Diaries, Volume XIV, 23/1/1914.
16 *Middle East Diary*, page 247.
17 *Middle East Diary*, page 18.
18 Meinertzhagen Papers, Appendix E, Peace Conference, Memorandum: The Present Unsatisfactory State of Affairs in Palestine, 9/4/1919.
19 Meinertzhagen/Weizmann Correspondence, letter dated 11/2/1918.
20 *Documents on British Foreign Policy 1919–1939*, E. L. Woodward & R. Butler, Volume IV, page 272.
21 *Documents on British Foreign Policy 1919–1939*, E. L. Woodward & R. Butler, Volume IV, page 281.
22 *Documents on British Foreign Policy 1919–1939*, E. L. Woodward & R. Butler, Volume IV, page 326.
23 *Middle East Diary*, page 43.
24 *Middle East Diary*, pages 49–53.
25 *Middle East Diary*, pages 51–2.
26 Meinertzhagen Diaries, Volume XXI, 4/11/1919.
27 *Trial and Error*, Chaim Weizmann, page 313; see also *Middle East Diary*, pages 47–8.
28 *Middle East Diary*, page 85.
29 *Middle East Diary*, page 54.
30 *Middle East Diary*, page 54.
31 PRO FO 371/5119/E5638; also see 5121/E8677.
32 *Middle East Diary*, page 55–6.
33 *Middle East Diary*, page 55.
34 *Orientations*, Ronald Storrs, page 329.
35 PRO FO 371/5119/5716. See also Ronald Storrs *Orientations*, pages 329–31, for general account of Nebi Musa Riots.
36 PRO FO 371/5121/Final Report of Enquiry, page 134.
37 *Trial and Error*, Chaim Weizmann, page 320.
38 Meinertzhagen/Weizmann Correspondence, letter dated 1/4/1920.
39 PRO FO 371/5203/3928.
40 PRO FO 371/5119/E4316.
41 *Middle East Diary*, page 88.
42 PRO FO 371/5121 Final Report of Enquiry.
43 Meinertzhagen/Weizmann Correspondence, letter dated 13/5/1920.
44 *The Making of a New Eastern Question*, D. E. Knox, page 119.
45 *Middle East Diary*, page 82.
46 Meinertzhagen's imputation of Storrs's complicity in the riots hardly squares with the latter's professed (and possibly over-dramatised) response given in *Orientations*. 'My orderly Khalil murmured softly behind me in Arabic: "There has been an outbreak at the Jaffa Gate and a man has been wounded to death." It was as though he had thrust a sword into my heart. Even now the mere memory of those dread words brings back the horror of the shock.' (See page 330.)
47 *Middle East Diary*, page 79.

48 Meinertzhagen Papers, Appendix F, Palestine 1919–20, Allenby to Curzon 18/3/1920.
49 *Middle East Diary*, page 84.
50 Meinertzhagen Papers, Appendix F, Palestine 1919–20, Meinertzhagen to Allenby 16/4/1920.

Chapter Ten: 1920–24 The Most Inhuman Machine in the World

1 PRO FO 371/5119/E4221.
2 PRO FO 371/5119/E4316.
3 In the *Middle East Diary* (see page 89) Meinertzhagen gives the date of arrival on Crete as 6/6/1920; however, in a paper in *The Ibis* the date of arrival given is 4/6/1920.
4 PRO FO 371/5119/E7492.
5 Meinertzhagen Diaries, Volume XXII, 5/8/1920.
6 Meinertzhagen Diaries, Volume XXII, 8/2/1921.
7 Meinertzhagen Diaries, Volume XXII, 15/11/1920.
8 Meinertzhagen Diaries, Volume XXII, 3/12/1920.
9 Meinertzhagen Diaries, Volume XXII, 20/12/1920.
10 PRO FO 371/5357/2869.
11 Harry Forbes Witherby, MBE, FZS, FRGS, MBOU; 1873–1943. Witherby was a publisher by profession, but also an ornithologist of enduring reputation who had made numerous collecting expeditions to Europe, particularly Iberia, also to Russian Lapland, the White Nile, Iran, and Algeria. In 1907 he founded the journal *British Birds*, which he edited until his death. He was secretary and treasurer of the BOC from 1904 to 1914, then chairman from 1924 to 1927, and president of the BOU from 1933 to 1938. Amongst a number of publications on British birds was his most celebrated work, the five-volume *Handbook of British Birds*, written in conjunction with F. C. R. Jourdain, B. W. Tucker, and C. B. Ticehurst.
12 There is some confusion in Meinertzhagen's diaries concerning the date of the first meeting between him and Anne Constance Jackson. He claims to have met her for lunch in November 1920, but throughout October and the following month he was in Scotland, firstly on the Outer Hebrides, and later with Brooksbank at Taynish.
13 Meinertzhagen Diaries, Volume XXII, 8/2/1921.
14 Meinertzhagen Diaries, Volume XXII, 20/12/1920.
15 Meinertzhagen Diaries, Volume XXI, 17/2/1919.
16 Meinertzhagen Diaries, Volume XXII 8/2/1921.
17 Meinertzhagen Diaries, Volume XXII 11/2/1921.
18 Colonel Lord William Richard Percy, 1882–1963, was the second son of the seventh Duke of Northumberland. In the First World War he served in the Grenadier Guards, in 1917 in Egypt, where he and Meinertzhagen collected birds together. Percy had been educated at Oxford and had then been called to the Bar at the Inner Temple. After the war he lived in Norfolk, firstly in Catfield in the Broads, moving later to Horstead House, near Norwich. He had a wide reputation as a skilled fieldsman and ornithologist, although he seems to have published almost nothing on his subject.
19 *Orientations*, Ronald Storrs, page 431.
20 *Winston Churchill*, Volume IV, Martin Gilbert, chapter 27 – *Turkey in Defeat*.
21 *Winston Churchill*, Volume IV, Martin Gilbert, pages 502–3.
22 *Dictionary of National Biography 1951–1960*, page 884.
23 *Winston Churchill*, Volume IV, Martin Gilbert, page 528n.
24 *Winston Churchill*, Volume IV, Companion Part III, Martin Gilbert, page 1296.

25 *Middle East Diary*, page 94.
26 *Middle East Diary*, page 95.
27 *Winston Churchill*, Volume IV, Martin Gilbert, page 555.
28 *Middle East Diary*, page 100.

It is interesting to note that in the *Middle East Diary*, page 100, Meinertzhagen inserted a note on this issue prior to publication, which read: 'I think I was mistaken. Though Transjordan was included within Palestine Mandated Territory it was not part of the country allotted to the Jews for their National Home, the eastern boundary of which was the River Jordan.'

However, in 1964, when Meinertzhagen was eighty-five and almost completely blind, he wrote in one of his last available letters to Samuel Landman: 'Both Lloyd George and Balfour told me that in giving the Jews their national home in Palestine they meant the whole of Biblical Palestine, that is to say the whole of the country occupied by the Jewish tribes, including Moab and Ammon. But Churchill, encouraged by Lawrence, gave the whole of Transjordan to that miserable Abdullah, thus depriving Israel of a vital territory and allowing a complete encirclement of Israel by Arabs. At the time (1921) I was working in the Colonial Office (Churchill was Colonial Secretary) and I remonstrated. He put on that ridiculous bull dog expression but nothing could be done to remedy Churchill's stupidity.

'I do not share the general admiration for Churchill. No living man has done so much harm to this country as Churchill and yet he is venerated as a God.' See Meinertzhagen letters: St Antony's College Middle East Centre, Oxford.

29 *Middle East Diary*, pages 97–8.

A curious sidelight on Meinertzhagen's response to the Mufti is cast by a letter addressed to Dora Philby, the wife of the famous Arab expert and explorer, Harry St John Philby, dated 28 July 1946. In this Meinertzhagen wrote: 'I hope Jack [Harry St John Philby] sees that archvillain the Mufti, a cheery rogue whom I like as a man but a dangerous opponent and best strung up on a lamp post. I shall surely call on him in Cairo for I was more or less responsible for his appointment in 1919.'

The Mufti, who proved a ruthless and violent enemy of the Jews, had collaborated with the Nazis during the Second World War, broadcasting pro-Nazi propaganda throughout the Arab world, and pledging Arab support against the 'English-Jewish' coalition. After escaping from imprisonment in France, the Mufti fled to Egypt in July 1946, where he was welcomed by the country's king.

Although there is a possibility that Meinertzhagen's letter refers to another mufti, somebody who was appointed in Cairo in 1919, at the latter's instigation, it seems highly likely, given the coincidence of dates, that he was actually referring to Husseini. If so, how can one interpret this apparent *volte face*? Possibly he was attempting to play down his strongly pro-Zionist, anti-Muslim convictions to a man whose allegiances were the complete opposite. At that time Meinertzhagen wished Philby to arrange political clearance with King Ibn Saud for his ornithological expedition to Arabia. Meinertzhagen, possibly known to be involved with political intelligence work, wished to allay Philby's suspicions. In fact, in an earlier letter he had written, 'You seem a bit suspicious of my motives and my political views.' Notwithstanding this possible explanation, Meinertzhagen's claim to be responsible for Husseini's appointment seems bizarre. See Meinertzhagen/Philby Correspondence, St Antony's College Middle East Centre.

30 Meinertzhagen Diaries, Volume XXII, 1/5/1922.
31 *Middle East Diary*, page 124.
32 *Winston Churchill*, Volume IV, Companion Part III, Martin Gilbert, page 1570–1.
33 Guest, Hon. Oscar (Montague); b. 1888; fifth son of 1st Baron Wimborne, brother of

Frederick Guest. Educated Trinity College Cambridge. At the outbreak of war joined the Lothian and Border Horse, later transferred to the Royal Flying Corps, later Staff Officer in the Air Ministry. MP (C.L.) Loughborough Division of Leicestershire 1918–22; MP (U) NW Camberwell, 1935–45; died 8/5/1958.

34 Meinertzhagen Diaries, Volume XXII, 14/11/1921.
35 *Middle East Diary*, page 99.
36 *Middle East Diary*, pages 101–2.
37 *Middle East Diary*, page 102.
38 *Middle East Diary*, page 116.
39 *Middle East Diary*, page 116.
40 Concerning Meinertzhagen's leakage of information to the Zionists, see Central Zionist Archive, Jerusalam, Israel, file A18/43/11; also *The Letters and Papers of Chaim Weizmann*, Series A, Volume XI, pages 343–5.
41 *Middle East Diary*, page 130.
42 Meinertzhagen Diaries, Volume XXIV, 1/8/1923.
43 Meinertzhagen Papers, Appendix G, Colonial Office 1921–4, Meinertzhagen to Samuel, 18/7/1923.
44 Lloyd George wrote of Meinertzhagen: 'I met him during the Peace Conference and he struck me as being one of the ablest and most successful brains I had met in any army. That was quite sufficient to make him suspect and to hinder his promotion to the higher ranks of his profession. See the *War Memoirs*, page 1923.
45 Meinertzhagen Diaries, Volume XXIV, 21/2/1924.
46 Meinertzhagen Diaries, Volume XXIV, 31/1/1924.

Chapter Eleven: 1924–30 The Killing Age

1 Meinertzhagen Diaries, Volume XXV, 6/1/1925.
2 Meinertzhagen Diaries, Volume XXV, 9/11/1924.
3 Meinertzhagen Diaries, Volume XXV, 6/1/1925.
4 Meinertzhagen Diaries, Volume XXIV, 10/7/1923.
5 Review in *Country Life*, 14/7/1983, by Hugh Seymour-Davies.
6 Review in *Geographical Magazine*, December 1983.
7 Review in *North Eastern Evening Gazette*, 24/5/1983.
8 Review in *Business Traveller*, June 1983, by Auberon Waugh.
9 Review in *The Times Literary Supplement*, 24/6/1983.
10 *Kenya Diary*, page 178.
11 Antony K. Amo in *West Africa*, 4/7/1983.
12 On 30/10/1957 Meinertzhagen gave higher figures for his total Kenyan bag in his diary. There he wrote, 'excluding lion, leopard, hyoena [sic], cheetah and pig, I killed 227 head of big game; that works out at about eight animals a week; considering we had no beef and very little mutton and that I often had to feed over a hundred men doing hard work, it is not excessive'. While his total of 227 seems reasonable, the weekly average is puzzling: even eight animals a month would work out at 336.
13 *Kenya Diary*, page 178.
14 *Big Game Hunting in Central Africa*, W. Buckley, page 49.
15 *Churchill 1874–1915*, Ted Morgan, page 229.
16 *The Life of My Choice*, Wilfred Thesiger, page 273.
17 *Kenya Diary*, page 156.
18 Meinertzhagen Diaries, Volume IX, 30/10/1909.
19 Meinertzhagen Diaries, Volume I, 13/5/1901.
20 Meinertzhagen Diaries, Volume VIII, 9/9/1908.

21 *The Ibis*, 1955, page 375.
22 The single new species he discovered was Theresa's Snowfinch, *Montifringilla theresae*, which was named after Theresa Clay and was discovered in northern Afghanistan in 1937.
23 Meinertzhagen Diaries, Volume XI, 20/9/1910.
24 *Proceedings of the Zoological Society of London*, 1904, Volume II, pages 193–9.
25 Meinertzhagen Diaries, Volume VI, 9/6/1907.
26 Meinertzhagen Diaries, Volume VI, 21/2/1907.
27 *Kenya Diary*, page 2.
28 *Kenya Diary*, page 171.
29 Meinertzhagen Diaries, Volume XXIV, 28/6/1924.
30 Meinertzhagen Diaries, Volume XXV, 30/12/1924.
31 Although there is little doubt that Meinertzhagen carried out this experiment. The three very different descriptions he gave of it, are illustrative of the wider difficulties involved with assessing his work. In the different versions the area of the estate varied from 30,000, to 25,000 or 40,000 acres. The vermin species he allowed to be killed were respectively, 'only . . . gulls nesting on the moor'; 'rats and lesser black-backed gulls'; and 'stoats, crows, black-backed gulls, and rats'. The measures increased raptor populations, depending on which version one reads, to: two pairs of eagles, one pair of peregrines, two pairs of buzzards; or to one pair of golden eagles and four pairs of buzzards; or two pairs of eagles, two pairs of peregrines, four pairs of merlins, and seven pairs of buzzards. The total grouse bag on the other hand altered from 600 to 1,000 to 500 brace. See *Pirates and Predators*, page 5; *Diary of a Black Sheep*, page 304; Meinertzhagen Diaries, Volume LV, page 148.
32 *Pirates and Predators*, page 83.
33 The National Society for the Protection of Birds was the forerunner of the Royal Society for the Protection of Birds, now Europe's largest voluntary conservation organisation with almost 500,000 members.
34 Meinertzhagen Papers, Appendix E, Paris Peace Conference, Mrs Lemon to Foreign Secretary, 11/3/1919.
35 Meinertzhagen Papers, Appendix E, Paris Peace Conference, Memorandum dated 27/3/1919.
36 For an overview of the developments in taxonomy up to the end of Meinertzhagen's ornithological career, see *The Ibis*, 1959, pages 293–336.
37 One of those Meinertzhagen enlisted was Sir Alec Kirkbride, who was acting as an intelligence officer in Haifa. In his book, *An Awakening: The Arab Campaign 1917–1918*, he wrote: 'I found some occupation . . . in helping the new chief political officer to collect bird specimens. Clayton had been succeeded by a Colonel Richard Meinertzhagen, who was an enthusiastic Zionist . . . He took advantage of his tours to indulge in his principal interest in life – ornithology. I drove him round Galilee and joined in the butchery. This gave me an opportunity of discovering in bird life, a new and lasting interest. Meinertzhagen lectured me on his hobby just as Lawrence had taught me the elements of archaeology as we had passed through the ruined towns of Hauran.'
38 *The Ibis*, 1920, pages 920–36.
39 *Bulletin of the British Ornithologists' Club*, 1987, pages 189–91.
40 Meinertzhagen Diaries, Volume LXIX, 7/4/1958.
41 Meinertzhagen Diaries, Volume XXIV, 23/6/1925.
42 *Birds of Arabia*, pages 5–7.
43 *Birds of Arabia*, page 6.
44 *Birds of Arabia*, page 24.
45 *The Ibis*, 1921, page 127.

46 *The Ibis*, 1924, page 98.
47 *Nicoll's Birds of Egypt*, Preface, page vi.
48 Meinertzhagen Diaries, Volume XXIV, 28/6/1924.
49 *Journal of the Royal Geographical Society*, 1931, page 275.
50 *British Birds*, 1930, page 375.
51 *Nicoll's Birds of Egypt*, page 4.
52 *Nicoll's Birds of Egypt*, page 85.

Chapter Twelve: 1918–39 Silence, Solitude and Space

1 *Diary of a Black Sheep*, page xix.
2 *The Fall of a Sparrow*, Salim Ali, page 93.
3 Meinertzhagen Diaries, Volume XXII, 12/6/1922.
4 Meinertzhagen Diaries, Volume X, 4/2/1910.
5 Meinertzhagen Diaries, Volume LXVIII, 17/1/1958.
6 Meinertzhagen Diaries, Volume III, 10/2/1905.
7 Meinertzhagen Diaries, Volume XX, 24/1/1918.
8 Meinertzhagen Diaries, Volume XX, 30/12/1917.
9 Meinertzhagen Diaries, Volume XLI, 20/4/1937.
10 Meinertzhagen Diaries, Volume XIX, 24/5/1917.
11 Meinertzhagen Diaries, Volume XXVIII, 4/2/1928.
12 Meinertzhagen Diaries, Volume III, 10/2/1905.
13 Meinertzhagen Diaries, Volume XXX, 8/3/1930.
14 Meinertzhagen Diaries, Volume X, 8/3/1910.
15 There is little or no evidence to substantiate Meinertzhagen's claim that he was of
 Danish and Viking origin – a myth that seemed to satisfy the old warrior's rather
 romantic imagination. It is almost certainly the case that the settlement of Meinerz-
 hagen (from which the family name derives) was originally established not by Danes but
 by Franks, in the second half of the tenth century. There is a possibility that it was later
 invaded by northern incomers, but this is far from being the basis for claiming one had
 Danish forebears, as Meinertzhagen invariably did. (A rough equivalent would be for
 an English person of long-established East Anglian stock to claim that they also were of
 Danish origin.) The traceable origins of the Meinertzhagen family point to largely
 German ancestry, with some Dutch and Walloon blood.
 There are many inaccurate statements about Meinertzhagen, but none is more
 frequently encountered than that concerning his Danish ancestors. I am very grateful to
 Nicholas Meinertzhagen for this information.
16 Meinertzhagen Diaries, Volume LXIII, 29/11/1953.
17 Meinertzhagen Diaries, Volume LXVI, letter dated 7/12/1955, opp. page 2.
18 Meinertzhagen Diaries, Volume VII, 10/10/1907.
19 Meinertzhagen Diaries, Volume XVIII, 27/11/1916.
20 Meinertzhagen Diaries, Volume LXXI, 25/3/1960.
21 *The Fall of a Sparrow*, Salim Ali, page 93.
22 Meinertzhagen Diaries, Volume LIX, 17/7/1950.
23 Meinertzhagen Diaries, Volume XXVIII, 18/3/1928.
24 Meinertzhagen Diaries, Volume XLIV, 7/3/1939.
25 Meinertzhagen Diaries, Volume XXIII, 4/2/1923.
26 Meinertzhagen Diaries, Volume XXIII, 22/11/1922.
27 Meinertzhagen Diaries, Volume XXIII, 18/1/1923.
28 Meinertzhagen Diaries, Volume XXXI, 15/2/1931.
29 Meinertzhagen Diaries, Volume XXVII, 1/1/1926.

30 Meinertzhagen Diaries, Volume XLI, 30/4/1937.
31 Meinertzhagen Diaries, Volume XXIII, 18/1/1923.
32 Meinertzhagen Diaries, Volume XXXI, 18/2/1931.
33 Meinertzhagen Diaries, Volume LIX, 24/4/1950.
34 *The Diary of Beatrice Webb, Volume IV*, Edited by Norman and Jeanne Mackenzie, page 331.
35 Meinertzhagen Diaries, Volume XXVIII, 19/1/1928.
36 Meinertzhagen Diaries, Volume VIII, opposite page 108, 9/10/1908.
37 Meinertzhagen Diaries, Volume XXV, 28/3/1925.
38 Meinertzhagen Diaries, Volume VIII, 11/4/1909.
39 *The Fall of a Sparrow*, Salim Ali, page 95.
40 Meinertzhagen Diaries, Volume XXVI, 2/6/1925.
41 Meinertzhagen Diaries, Volume XXXIX, 22/4/1936.
42 Meinertzhagen Diaries, Volume XXIX, 2/3/1928.
43 Meinertzhagen Diaries, Volume XLI, 22/5/1937.
44 Meinertzhagen /F. M. Bailey Correspondence, letter dated 26/6/1931.
45 Meinertzhagen Diaries, Volume VIII, 6/10/1908.
46 Meinertzhagen Diaries, Volume XXXIII, 5/4/1923.
47 Meinertzhagen Diaries, Volume LXXIII, 20/4/1963.
48 Meinertzhagen Diaries, Volume LXVII, 8/4/1957.

Chapter Thirteen: 1928–45 *My Other Work*

1 Meinertzhagen Diaries, Volume LX, 8/12/1951.
2 Meinertzhagen Diaries, Volume XXIX, 1/8/1928.
3 Meinertzhagen Diaries, Volume XXIX, 3/3/1929.
4 Meinertzhagen Diaries, Volume XXIX, 31/12/1929.
5 Meinertzhagen Diaries, Volume XXX, 23/2/1930.
6 Meinertzhagen Diaries, Volume XXX, 23/2/1930.
7 Meinertzhagen Diaries, Volume XXX, 25/2/1930.
8 Meinertzhagen Diaries, Volume XXX, 4/3/1930.
9 See Meinertzhagen Diaries, Volume XXX, page 66; the letter (undated) was received by Meinertzhagen on 13 May 1930.
10 See Meinertzhagen Diaries, Volume XXX, pages 66–7.
11 Meinertzhagen Diaries, Volume XXX, 5/3/1930.
12 Meinertzhagen Diaries, Volume entitled INDEX.
13 Meinertzhagen Diaries, Volume XX, 18/8/1918.
14 *A History of the Russian Secret Service*, Richard Deacon, page 515.
15 *A History of the Russian Secret Service*, Richard Deacon, page 516.
16 See *Armour Against Fate: British Military Intelligence in the First World War*, Michael Occleshaw.
17 *King George V*, Kenneth Rose, pages 216–17; see also pages 208–18.
18 See the *Daily Mail*, 25/7/1988, page 7.
19 Meinertzhagen Diaries, Volume XXIII, 21/1/1928.
20 Meinertzhagen Diaries, Volume XL, 11–12/2/1937. More than two years later, when Meinertzhagen was staying with his friend, General von Lettow Vorbeck, the German commander who had opposed him in East Africa in the First World War, he wrote:

> They are . . . convinced that I am employed by the Secret Service, collecting birds being mere camouflage to cover clandestine operations. They said I was in Czechoslovakia during the September crisis; and it is useless my denying all this rubbish. There are people in England who think the same. It is remotely founded on fact but it

is very far from the truth nowadays. I have no influence anywhere neither do I still work for the Government in any capacity.

See Meinertzhagen Diaries, Volume XLIV, 23/6/1939.

21 Meinertzhagen Diaries, Volume XXXVII, 2/5/1934.
22 Meinertzhagen Diaries, Volume XXXVII, 2/5/1934.
23 Meinertzhagen Diaries, Volume XXXVII, 20/9/1934.
24 Meinertzhagen Diaries, Volume XLII, 15/2/1938.
25 Meinertzhagen Diaries, Volume XXXIV, 13/7/1932.
26 *Middle East Diary*, page 149–50.
27 Meinertzhagen Diaries, Volume XXXVII, 17/10/1934. There are further interesting anomalies in Meinertzhagen's diary entries concerning Hitler. For example, an account of a meeting with Hitler and Ribbentrop on 15 July 1935, which appeared in the *Middle East Diary*, pages 154–5, contained a substantial amount of material that did not appear in the original. See Meinertzhagen Diaries, Volume XXXVIII, 15/7/1935. As with the Lawrence passages, the conclusion one might easily draw is that he fleshed out these portions prior to publication because of their historical significance.

Perhaps the most remarkable aspect of Meinertzhagen's contact with the Nazi leader was his claim to have concealed a loaded automatic in his pocket prior to their final meeting so that he 'could prove "opportunity" to kill the man'. In the original, which is identical to the version that appeared in the *Middle East Diary*, he wrote:

> I had ample opportunity to kill both Hitler and Ribbentrop and am seriously troubled about it. If this war breaks out, as I feel sure it will, then I shall feel very much to blame for not killing these two; on the other hand I am quite sure that if I killed them both there would be no war and I should be written off as a madman. But I did satisfy myself that I had the opportunity to kill them both.

28 Meinertzhagen Diaries, Volume XXXVI, 28/6/1933.
29 Meinertzhagen Diaries, Volume XXXVII, 17/10/1934.
30 This event seems to have been the turning point in his response to Hitler. On 14 September 1938, he wrote:

> I really cannot see that the integrity of Czechoslovakia is worth another million lives or another £8,000,000,000 on to our debt, nor the risk of bolshevism throughout Europe. I do not believe that Hitler has other aims beyond all Germans and German territory and I believe he is quite sincere when he says that the Sudeten area is the last claim in Europe.

> Yet on the 27 September he wrote: 'I have been wrong, very wrong, in my estimation of Hitler and Germany. I never believed Hitler would deliberately involve Europe in war for his own ends.' And at the side of his grimly ironic assessment of the Führer, made in October 1934, there is a hand-written entry, which reads: 'My God, how wrong I was, 1938.'

31 *Middle East Diary*, page 160.
32 Meinertzhagen Diaries, Volume XLIII, 27/9/1938.
33 Meinertzhagen Diaries, Volume XLV, 1/9/1939.
34 Meinertzhagen Diaries, Volume XLV, 5/9/1939.
35 Meinertzhagen Diaries, Volume XLV, 8/9/1939.
36 Meinertzhagen Diaries, Volume XLV, 6/10/1939.
37 Meinertzhagen Diaries, Volume XLV, 6/10/1939.
38 Meinertzhagen Diaries, Volume XLVII, 12/7/1940.

39 Meinertzhagen Diaries, Volume XLVII, 21/6/1940.
40 Meinertzhagen Diaries, Volume XLVII, 23/6/1940.
41 *The Business of War*, John Kennedy, pages 68–9.

Chapter Fourteen: 1945–54 *Beloved Birds and Priceless Possessions*

1 Meinertzhagen Diaries, Volume LIV, 8/5/1945.
2 Meinertzhagen Diaries, Volume XLIV, 1/4/1939.
3 Meinertzhagen Diaries, Volume LI, 24/11/1942.
4 Meinertzhagen Diaries, Volume XLI, 26/5/1937.
5 Meinertzhagen Diaries, Volume LIII, 11/10/1944.
6 Meinertzhagen/Bailey Correspondence, letter dated 25/6/1939.
7 Meinertzhagen Diaries, Volume LV, 16/4/1946.
8 Meinertzhagen Diaries, Volume LIX, 26/10/1949.
9 Meinertzhagen/Philby Correspondence, letter dated 25/1/1945.
10 Meinertzhagen Diaries, Volume L, 12/12/1941.
11 Meinertzhagen Diaries, Volume LVII, 10/6/1948.
12 Meinertzhagen Diaries, Volume LVII, 4/1/1948.
13 Meinertzhagen Diaries, Volume LVII, 10/3/1948.
14 Meinertzhagen Diaries, Volume LVII, 1/4/1948.
15 Meinertzhagen/Philby Correspondence, letter dated 20/5/1948.
16 Meinertzhagen/Philby Correspondence, letter dated 25/5/1948.
17 Meinertzhagen/Philby Correspondence, letter dated 22/6/1948.
18 Meinertzhagen/Philby Correspondence, letter dated 28/6/1949.
19 Meinertzhagen/Philby Correspondence, letter dated 20/3/1948.
20 Meinertzhagen Diaries, Volume LIX, 1/2/1950.
21 Meinertzhagen/Philby Correspondence, letter dated 15/8/1948.
22 Meinertzhagen/Philby Correspondence, letter dated 26/5/1948.
23 Meinertzhagen/Philby Correspondence, letter dated 1/8/1949.
24 Meinertzhagen Diaries, Volume LVII, 7/10/1948.
25 Meinertzhagen Diaries, Volume LVII, 10/11/1948.
26 Phillip Clancey to author, letter dated 13/8/1987.
27 Phillip Clancey to author, letter dated 13/8/1987.
28 Meinertzhagen Diaries, Volume LVIII, 19/12/1948.
29 Meinertzhagen Diaries, Volume LVIII, 21/12/1948.
30 Meinertzhagen Diaries, Volume LVIII, 28/12/1948.
31 Meinertzhagen/Philby Correspondence, letter dated 1/8/1949.
32 Meinertzhagen Diaries, Volume LIX, 2/6/1949.
33 Meinertzhagen Diaries, Volume LII, 21/1/1944.
34 Meinertzhagen Diaries, Volume LIV, 13/6/1945.
35 BM (NH) DF/1004/CP/225/1, Meinertzhagen to Secretary of Trustees, dated 9/8/1919;
 see also Meinertzhagen Diaries, Volume XXI, 27/8/1919.
36 Meinertzhagen Diaries, Volume XXIV, 29/4/1924.
37 Meinertzhagen Diaries, Volume XXXII, 2/7/1931; also BM (NH) DF/1004/CP/225/1,
 Memorandum by Austen, dated 12/6/1931, and Memorandum by Colman, dated
 11/6/1931.
38 BM (NH) DF/1004/CP/225/1, Sir R. Robertson to Herbert Smith, dated 22/1/1935.
39 BM (NH) DF/1004/CP/225/1, Memorandum dated 23/1/1935.
40 BM (NH) DF/1004/CP/225/1, Memorandum dated 21/2/1935.
41 BM (NH) DF/1004/CP/225/1, Memorandum dated 25/1/1936.

42 BM (NH) DF/1004/CP/225/1, Memorandum dated 27/10/1939, page 9.
43 BM (NH) DF/1004/CP/225/1, Meinertzhagen letter dated 5/1/1947.
44 BM (NH) DF/1004/CP/225/1, Memorandum by K. D. Riley, dated 8/1/1947.
45 BM (NH) DF/1004/CP/225/1, J. D. MacDonald to N. Kinnear, dated 25/2/1947.
46 BM (NH) DF/1004/CP/225/1, Meinertzhagen letter, dated 28/3/1947.
47 BM (NH) DF/1004/CP/225/1, Meinertzhagen letter, dated 21/6/1949.
48 BM (NH) DF/1004/CP/225/1, F. C. Fraser to Keeper of Zoology, dated 29/11/1949.
49 BM (NH) DF/1004/CP/225/1, C. Foster Cooper to Lord Macmillan, dated 22/4/1947.
50 BM (NH) DF/1004/CP/225/1, Lord Macmillan to C. Foster Cooper, dated 27/4/1947.
51 Meinertzhagen Diaries, Volume LXII, 21/4/1944.
52 A number of ornithologists have felt that Meinertzhagen's abuses of conventional scientific practice were so great that they discredited his entire *oeuvre*. One of these, Charles Vaurie, wrote (to F. E. Warr, dated 16/12/1974) on the subject before his death. The letter warrants extensive quotation.

MacDonald . . . asked me one day what should be done with Meinertzhagen's collection. I forget what I said, but not what MacDonald said, which was 'that it should be burned'. He was very serious but probably did not dare to antagonize the trustees of the BM.

I can say *upon my oath* that Meinertzhagen's collection contains skins *stolen* from the Leningrad Museum, the Paris Museum, and the American Museum of Natural History and perhaps other museums but the three I mentioned were verified by me. He also removed labels, and replaced them by others to suit his ideas and theories.

Just one brief example along these lines. The type of Columba livia dakhlae Meinertzhagen 1928 should be in the Rothschild collection, hence in New York but it is in Meinertzhagen's collection that you are now registering.

When I failed to find the type in New York I wrote to Meinertzhagen asking him if he could help. He replied that he had no idea about its whereabouts, but that to help me out, he was sending on loan a specimen of the form *from his own collection*.

I saw the specimen took good note of it, and I have a photographic eye and memory. Not too long after that I was in London and asked if I could examine more specimens of this form as Meinertzhagen had given me the impression he had several. Meinertzhagen had authorized me to inspect material, and Pat Hall gave me the key. I found only one specimen of *Columba livia dakhlae* in Meinertzhagen's collection – the type, the whereabouts of which were allegedly unknown!! This was the specimen Meinertzhagen had lent to me, writing a new label for it for my benefit, which he had replaced by the type label when the specimen got back to him.

Macdonald had also complained of specimens from your national collection 'borrowed' and relabeled [sic] to suit by Meinertzhagen. Berlioz told me also that Meinertzhagen 'borrowed' birds from the museum here and asked M. to return them – which he did not, but sent in 'exchange' a number of skins equal to the number he had 'borrowed'.

The animosity between Vaurie and Meinertzhagen is, of course, well-established. After his death it seems the former took every opportunity to criticise the latter's work. See, for example, the introduction in Vaurie's *Tibet and Its Birds*, 1972. With regard to the accusations contained in the above letter, Meinertzhagen had given his type of the *Columba livia dakhlae* to the Tring Museum, no doubt in the belief that Rothschild would eventually leave his collection to the nation. The motive behind Meinertzhagen's 'retrieval' of 'his' skin from New York is evident if dishonest. However, the bulk of Vaurie's accusations concerning theft, backed by similar charges made by the staff of

the British Museum and also by Phillip Clancey, are difficult to meet. Clancey, in an article in *Bokmakierie*, volume 36, 1984, pages 32–5, wrote:

> Of recent gifts to the Tring collection that of the Colonel R. Meinertzhagen is certainly both the most extensive and technically excellent, though the most recent findings that many specimens in it bear labels with questionable localities and dates makes its use in research projects far from easy. The finding of a specimen of the Pinkthroated longclaw said to be from Isandhlwana, Zululand, a Zululand specimen of Cape Longclaw *Macronyx capensis* labelled from just north of Cape Town, and an obvious Natal or Zululand skin of the small bee-eater *Merops pusillus meridionalis* stated as from Middleburg in the Karoo immediately aroused my suspicions that I was dealing with material questionably acquired and now provided with fictitious data. This was confirmed when, during a study of variation in the northern races of *Acanthis flammea*, I found a neatly prepared pair of specimens made up by the same expert pair of hands at the one time, one skin bearing a Bowdler Sharpe label with a date in the 1880s and a south-east England locality, and the other of the pair in Meinertzhagen's hand stating that it had been shot in 1954 at Blois in France. Now Meinertzhagen did not visit Blois to collect birds in 1954, while both skins of the Lesser Redpoll pair very clearly came from the same locality in the south-east of England. What a tragedy that such a magnificent gift as that of the Meinertzhagen collection should be so flawed as to impair its worth as a research tool to the scientific community. It seems that ornithological 'gods', like some of the Old Testament ones, can have feet of clay.

53 BM (NH) DF/1004/CP/225/1, Meinertzhagen to De Beer, dated 20/9/1950.
54 BM (NH) DF/1004/CP/225/1, De Beer to Meinertzhagen, dated 27/11/1950.
55 BM (NH) DF/1004/CP/225/1, Meinertzhagen to De Beer, dated 27/5/1951.
56 Meinertzhagen Diaries, Volume LXIV, 20/5/1954.
57 BM (NH) DF/1004/CP/225/1, Meinertzhagen to De Beer, dated 2/7/1954.
58 Meinertzhagen Diaries, Volume LX, 9/1/1951.
59 Meinertzhagen Diaries, Volume LX, 1/2/1951.
60 Meinertzhagen Diaries, Volume LX, 9/2/1951.
61 Meinertzhagen/R. E. Moreau Correspondence 12/2/1951.
62 Meinertzhagen Diaries, Volume LXIV, 3/9/1954.
63 *Journal of the Bombay Natural History Society*, 1955, page 908.
64 Meinertzhagen Private Papers, Karel Voous to Meinertzhagen, letter dated 6/9/1954.
65 *Journal of the East African Natural History Society*, 1955, page 204.
66 *The Ibis*, 1955, pages 162–3.
67 Meinertzhagen Private Papers, Meinertzhagen to Landsborough Thompson, dated 28/1/1955.
68 Meinertzhagen Private Papers, Landsborough Thompson to Meinertzhagen, dated 4/8/1955.
69 Meinertzhagen/Philby Correspondence, letter dated 1/8/1949.
70 Meinertzhagen/Philby Correspondence, letter dated 25/5/1948.
71 Meinertzhagen Philby Correspondence, letter dated 26/5/1948.
72 Meinertzhagen Diaries, Volume LXII, 18/3/1953.
73 *Middle East Diary*, Preface, page x.

Chapter Fifteen: 1954–61 *Enfant Terrible* and Elder Statesman

1 Meinertzhagen Diaries, Volume LXVI, 16/1/1956.
2 Meinertzhagen Diaries, Volume LXIX, 16/7/1958.

3 Meinertzhagen Diaries, Volume LXII, 26/3/1953.
4 Meinertzhagen Diaries, Volume LXXI, 9/11/1960.
5 Meinertzhagen Diaries, Volume LXXIII, 7/1/1963.
6 Amongst the other people who had used his diaries were W. E. Hancock in his biography of Smuts; Weizmann's secretary, Samuel Landman,; Charles Hordern, the official historian of the East African Campaign; Cyril Falls, the official historian of the Palestine Campaign; Leonard Mosley for *Duel for Kilimanjaro*; Mungeam in *British Rule in Kenya*; Cecil Woodham Smith for background material for her books on the Crimea; A. T. Matson for *Nandi Resistance to British Rule 1890–1906*.
7 See Meinertzhagen Diaries, Volume LXI, 25/2/1952. It was almost certainly the case that these were not cardiac arrests or heart attacks as Meinertzhagen called them, but paroxsymal tachycardia. This condition, often brought about by emotional stress, tobacco, alcohol, or caffeine, such as in strong tea, is characterised by vastly accelerated heart beat, weakness, pains in the chest and breathlessness. Fatalities do occur rarely, although it is possible to survive any number of attacks. The drug, quinidine, which Meinertzhagen was prescribed, is still an effective treatment for the condition. I am grateful to Dr Paul Coathup for this information.
8 Meinertzhagen Diaries, Volume LXI, 3/3/1952.
9 Meinertzhagen Diaries, Volume LXVI, 29/3/1956.
10 *Time and Tide*, 28/9/1957.
11 *The Ibis*, 1958, Volume 100, page 129.
12 Meinertzhagen Diaries, Volume LXVIII, 27/5/1958.
13 *Kenya Diary*, Preface, page vii.
14 *British Military Intelligence*, Jock Haswell, pages 142–3.
15 Meinertzhagen Diaries, Volume XXI, 25/3/1919; see also *Middle East Diary*, pages 17–19.
16 David Ben Gurion to Meinertzhagen, 26/8/1958: see Meinertzhagen Diaries, Volume XXI, pages 54–6.
17 General Sir James Marshall-Cornwall to Meinertzhagen, 9/5/1958: see Meinertzhagen Diaries, Volume XXI, page 55.
18 Meinertzhagen Diaries, Volume XXI, 26/3/1919.
19 I am grateful to T. C. Charman of the Department of Printed Books in the Imperial War Museum for this information.
20 See Meinertzhagen Diaries, Volume LVII, 23/4/1948; also *Middle East Diary*, page 222–3.
21 Meinertzhagen Diaries, Volume LXVIII, 5/3/1958.
22 Typical of the stories that have passed into the family repertoire was one from the 1930s, recounting Meinertzhagen's arrival at a country house, to which he was an invited guest. On opening the door to let him in, the butler was asked to call Meinertzhagen's host, and he was then handed a freshly fired pistol without any explanation. On Meinertzhagen's departure the pistol was handed back to him, once again, without the guest offering any explanation of why he should have discharged the gun. I am grateful to Nicholas Meinertzhagen for this information.
23 Meinertzhagen Diaries, Volume LVII, 18/4/1948.
24 'Richard the lion-heart', in the *Observer*, 28/3/1971.
25 *Army Diary*, page 296.
26 Meinertzhagen Diaries, Volume LXVIII, 27/12/1957.
27 Meinertzhagen/Bailey Correspondence, letter dated 25/6/1939.
28 Meinertzhagen Diaries, Volume LXII, 10/3/1953.
29 Meinertzhagen Diaries, Volume LXIV, 2/3/1954.
30 Meinertzhagen Diaries, Volume IV, 18/5/1905.

31 *Destined to be Wives*, Barbara Caine, pages 189–90.
32 Meinertzhagen Diaries, Volume XXV, 8/1/1925.
33 Meinertzhagen Diaries, Volume XXV, 11/1/1925.
34 Meinertzhagen Diaries, Volume XI, 7/2/1911.
35 Meinertzhagen Diaries, Volume XV, 12/6/1914. Also Meinertzhagen Diaries, Volume XVI, 18/2/1915, and Volume XVII, 3/3/1916.
36 Meinertzhagen Diaries, Volume XXXIII, 12/10/1931.
37 Meinertzhagen Diaries, Volume XXXIII, 4/10/1931.
38 Meinertzhagen Diaries, Volume LII, 19/6/1944.
39 Meinertzhagen Diaries, Volume LX, 17/1/1951.
40 Meinertzhagen Diaries, Volume LXII, 12/2/1953.
41 Meinertzhagen Diaries, Volume LXIV, 17/11/1954.
42 Meinertzhagen Diaries, Volume LIX, 22/4/1950.
43 Meinertzhagen Diaries, Volume LXIII, 25/11/1953.
44 Meinertzhagen Diaries, Volume LXX, 31/3/1959.
45 Meinertzhagen Diaries, Volume LIV, 25/12/1945.
46 Meinertzhagen Diaries, Volume LXVIII, 2/7/1958.
47 *Pirates and Predators*, page 3.
48 *British Birds*, 1960, pages 36–7.
49 *Pirates and Predators*, page 25.
50 *The Ibis*, 1959, page 284.
51 Ernst Mayr to Meinertzhagen, 27/2/1958.
52 Meinertzhagen Diaries, Volume LXVI, 17/4/1956.
53 Meinertzhagen Diaries, Volume LXIV, 1/1/1954.
54 Meinertzhagen/R. E. Moreau Correspondence, 13/1/1953.
55 Meinertzhagen/R. E. Moreau Correspondence, 28/11/1952.
56 Meinertzhagen Diaries, Volume LI, 30/6/1943.
57 Meinertzhagen/ R. E. Moreau Correspondence, 7/5/1952.
58 Meinertzhagen Diaries, Volume LXXI, 10/4/1960.
59 Meinertzhagen Diaries, Volume LXXI, 10/4/1960.
60 Meinertzhagen Diaries, Volume LXVIII, 27/3/1958.
61 Meinertzhagen Diaries, Volume LXVIII, 27/3/1958.
62 Meinertzhagen Diaries, Volume LXIX, 5/10/1958.
63 Meinertzhagen Diaries, Volume LXX, 3/9/1959.
64 Meinertzhagen Diaries, Volume LXVIII, 25/9/1957.
65 Meinertzhagen Diaries, Volume XXXVIII, 1/4/1935.
66 Meinertzhagen Diaries, Volume LXX, 10/7/1959.
67 Meinertzhagen Diaries, Volume LXXI, 11–15/10/1960.
68 Meinertzhagen Diaries, Volume LXXII, 31/12/1961.

Chapter Sixteen: 1961–67 A Legendary Figure Without a Legend

1 Meinertzhagen Diaries, Volume LXXII, 28/3/1962.
2 *Diary of a Black Sheep*, page 358–9.
3 Meinertzhagen Diaries, Volume LX, 8/12/1951.
4 Meinertzhagen/F. M. Bailey Correspondence, letter dated 19/7/1953.
5 Meinertzhagen Diaries, Volume LXVII, 2/12/1956.
6 Meinertzhagen Diaries, Volume LXII, 19/11/1952.
7 Meinertzhagen Diaries, Volume LXV, opposite page 14, 18/1/1955.
8 *Middle East Diary*, page 87.
9 Meinertzhagen Diaries, Volume XXX, 23/2/1930.

10 Meinertzhagen Diaries, Volume LII, 21/1/1944.

11 *The Mist Procession*, Robert Vansittart, page 261.

12 Meinertzhagen Diaries, Volume LXVIII, 22/5/1958.

13 'Richard the lion-heart', in the *Observer*, 28/3/1971.

14 I am grateful to a number of ornithologists for their informed and not necessarily unfavourable opinions of Meinertzhagen. Amongst those who saw him at close quarters and have had reason to question the accuracy of his methods are Dr W. R. P. Bourne, Dr P. A. Clancey, Derek Goodwin, Dr C. J. O. Harrison, J. D. Macdonald, and Effie Warr.

15 *Birds of Arabia*, Introduction, page v.

16 'Review of the Alaudidae', *Proceedings of the Zoological Society of London*, page 94.

17 See *Threatened Birds of Africa and Related Islands*, N. Collar and S. N. Stewart, page 380; I am also grateful to W. R. P. Bourne for valuable information on this issue.

18 BM(NH) DF/1004/CP/225/1, Meinertzhagen letter, dated 27/12/1956.

Bibliography

Unpublished Material by Richard Meinertzhagen

Meinertzhagen Diaries and Papers, 1899–1965, 76 Volumes plus six appendices, B, C, E, F, G, J, Rhodes House Library, Oxford.

Meinertzhagen Papers, 1889–1957, in the possession of Ran Meinertzhagen.

Catalogue of his bird collection, 42 Volumes, plus ecological notes on birds, British Museum (Natural History), Tring.

Correspondence with Sir John Dunnington-Jefferson, 1914–15, Imperial War Museum, London.

Correspondence with Chaim and Vera Weizmann, 1918–52, Weizmann Archive, Rehovoth, Israel.

Correspondence with Frederick Marshman Bailey, 1928–60, India Office Library and Records, London.

Correspondence with David Lack, 1941–66, Edward Grey Institute, Zoology Dept, Oxford.

Correspondence with Harry St John and Dora Philby, 1945–52, Middle East Centre, St Antony's College, Oxford.

Correspondence with Reg Moreau, 1951–4, Edward Grey Institute, Zoology Dept, Oxford.

Correspondence with Samuel Landman, 1960–64, Central Zionist Archive, Jerusalem, Israel.

Published Material by Richard Meinertzhagen

Books

Nicoll's Birds of Egypt, Hugh Rees, London, 1930.

The Life of a Boy, Oliver and Boyd, Edinburgh, 1947.

Birds of Arabia, Oliver and Boyd, Edinburgh, 1954.

Middle East Diary, 1917–56, Cresset Press, London, 1959.

Pirates and Predators, Oliver and Boyd, Edinburgh, 1959.

Army Diary, 1899–1926, Oliver and Boyd, Edinburgh, 1960.

Diary of a Black Sheep, Oliver and Boyd, Edinburgh, 1964.

Kenya Diary, 1902–06, Eland Press, London, 1983.

Journal Articles and Papers

On the birds of Mauritius. *Ibis*, Vol. 6 (9), 1912, pages 82–108.

Notes from Mesopotamia. *Ibis*, Vol. 2 (10), 1914, pages 387–95.

Migration and Aviation. *Ibis*, Vol. 1 (11), 1919, pages 366–7.

A Preliminary study of the relation between geographical distribution and migration with special reference to the Palaearctic region. *Ibis*, Vol. 1 (11), 1919, pages 379–92.

Birds of Quetta. *Ibis*, Vol. 2 (11), 1920, pages 132–95.

Birds of Southern Palestine. *Ibis*, Vol. 2 (11), 1920, pages 195–259.

Some preliminary remarks on the altitude of the migratory flight of birds. *Ibis*, Vol. 2 (11), 1920, pages 920–36.

Thirteen new subspecies. *Bulletin of the British Ornithologists' Club (Bull. BOC)*, Vol. 41, 1920, pages 18–25.

Notes on some birds seen in South Uist in October and November 1920. *British Birds*, Vol. 41, 1920–21, pages 276–8.

Breeding birds of Crete. *Ibis*, Vol. 3 (11), 1921, pages 126–39.

Some preliminary remarks on the velocity of migratory flight among birds. *Ibis*, Vol. 3 (11), 1921, pages 228–38.

Notes on some birds from the Near East and from Tropical East Africa. *Ibis*, Vol. 3 (11), 1921, pages 621–71.

Notes on some birds from the Near East and from Tropical East Africa. *Ibis*, Vol. 4 (11), 1922, pages 3–74.

Three new races of passerine. *Bull. BOC*, Vol. 43, 1923, pages 147–8.

New species and subspecies. *Bull. BOC*, Vol. 43, 1923, pages 156–60.

An account of a journey across the Southern Syrian Desert. *Ibis*, Vol. 4 (11), 1924, pages 87–101.

Notes on a small collection of birds made in Iraq in the winter of 1922–23. *Ibis*, Vol. 4 (11), 1924, pages 601–25.

A Contribution towards the birds of the Aden Protectorate. *Ibis*, Vol. 4 (11), 1924, pages 625–42.

Birds at Egyptian lighthouses. *Ibis*, Vol. 4 (11), 1924, pages 643–4.

A further contribution to the ornithology of Palestine, Transjordania, and Petra. *Ibis*. Vol. 1 (12), 1925, pages 305–24.

The Distribution of the Phalaropes. *Ibis*, Vol. 1 (12), 1925, pages 325–44.

On the birds of Madeira. *Ibis*, Vol. 1 (12), 1925, pages 600–621.

From the deserts of Jafura and Jabrim. *Journal of the Royal Geographical Society*, Vol. 65, 1926, pages 135–6.

Review of the genus *Corvus*. *Novitates Zoologicae*, Vol. 33, 1926, pages 57–121.

Systematic results of birds collected at high altitude in Ladak and Sikkim. *Ibis*, Vol. 3 (12), 1927, pages 363–422, 571–633.

Ladakh, with special reference to its natural history. *Journal of the Royal Geographical Society*, Vol. 70, 1927, pages 129–63.

Some biological problems connected with the Himalaya. *Ibis*, Vol. 4 (12), 1928, pages 480–533.

New subspecies of Wren and Francolin. *Bull. BOC*, Vol. 54, 1933, pages 20–21.

The Relation between plumage and environment. *Ibis*, Vol. 4 (13), 1934, pages 52–61.

The Biogeographical status of the Ahaggar Plateau. *Ibis*, Vol. 4 (13), 1934, pages 528–71.

Ornithological results of a trip to Syria. *Ibis*, Vol. 5 (13), 1935, pages 110–51.

The Races of *Larus argentatus* and *Larus fuscus*. *Ibis*, Vol. 5 (13), 1935, pages 762–73.

Some notes on the birds of Kenya Colony. *Ibis*, Vol. 1 (14), 1937, pages 731–60.

On the birds of Northern Afghanistan. *Ibis*, Vol. 2 (14), 1938, pages 480–520, 671–717.

Winter in Arctic Lapland. *Ibis*, Vol. 2 (14), 1938, pages 754–9.

New species of Snowfinch and new subspecies of Desert Warbler. *Bull. BOC*, Vol. 58, 1938, page 10.

New species and races from Morocco. *Bull. BOC*, Vol. 54, 1939, pages 63–71.

A Note on the birds of Hoy. *Ibis*, Vol. 3 (14), 1939, pages 258–64.

Autumn in Central Morocco. *Ibis*, Vol. 4 (14), 1940, pages 106–234.

The Bird-Room of the British Museum (Natural History). *Ibis*, Vol. 4 (14), 1940, pages 382–4.

How do larger raptorial birds hunt their prey. *Ibis*, Vol. 4 (14), 1940, pages 530–35.

August in Shetland. *Ibis*, Vol. 5 (14), 1941, pages 105–17.

The Colour of birds' fat. *Bull. BOC*, Vol. 68, 1947, pages 13–33.

The Birds of Ushant, Brittany. *Ibis*, Vol. 90, 1948, pages 553–67.

On *Otus scops*, with special reference to *Otus brucei*. *Bull BOC*, Vol. 69, 1948–9, pages 162–5.

Notes on Saudi Arabian birds. *Ibis*, Vol. 91, 1949, pages 465–83.

A new race of *Melierax gabar*. *Bull. BOC*, Vol. 69, 1949, pages 82–3.

On the status of *Parisoma leucomelaena*. *Bull. BOC*, Vol. 69, 1949, pages 109–10.

On the genera *Erythropygia*, and *Agrobates*. *Bull. BOC*, Vol. 69, 1949, page 110.

On the genera *Athene* and *Speotyto*. *Bull. BOC*, Vol. 70, 1950, pages 8–9.

On *Oenanthe tractrac* and *Oenanthe albicans* and the development of the 'sickle wing'. *Bull. BOC*, Vol. 70, 1950, pages 9–10.

The Goshawk in Britain. *Bull. BOC*, Vol. 70, 1950, pages 46–9.

The Record of the Moustached Warbler breeding in Great Britain. *Bull. BOC*, Vol. 70, 1950, pages 54–5.

Some relationships between African, Oriental, and Palaearctic genera and species, with a review of the genus *Monticola*. *Ibis*, Vol. 93, 1951, pages 443–59.

A new race of *Alectoris melanocephala*. *Bull. BOC*, Vol. 71, 1951, page 29.

Review of the Alaudidae. *Proceedings of the Zoological Society of London*. Vol. 121, 1951, pages 81–132.

A new geographical race of Shrike, *Lanius excubitor*. *Bull. BOC*, Vol. 73, 1953, page 72.

Shorter titles. *Ibis*, Vol. 95, 1953, pages 152–3.

Checklist of the birds of Great Britain and Ireland. *Ibis*, Vol. 95, 1953, pages 365–9.

The education of young Ospreys. *Ibis*, Vol. 96, 1954, pages 153–5.

Some aspects of spring migration in Palestine. *Ibis*, Vol. 96, 1954, pages 293–8.

Grit in birds. *Bull. BOC*, Vol. 97, 1954, pages 97–103.

The speed and altitude of bird flight. *Ibis*, Vol. 97, 1955, pages 81–117.

Birds in Greenland. *Bull. BOC*, Vol. 76, 1956, pages 17–22.

Nineteenth century recollections. *Ibis*. Vol. 101, 1959, pages 46–52.

Other Unpublished Sources

Public Record Office, London.
Colonial Office Files CO 533, CO 537, CO 733.

Foreign Office Files FO 371.

British Museum (Natural History), London
Archive File DF/1004/CP/225/1

General

Aldington, R. *Lawrence of Arabia – A Biographical Enquiry*, London, Collins, 1955.

Ali, S. *The Fall of the Sparrow*, Oxford, Oxford University Press, 1986.

Allen, R. *Imperialism and Nationalism in the Fertile Crescent*, Oxford, Oxford University Press, 1974.

Andrew, C. *Secret Service*, London, Heinemann, 1985.

Barber, L. *The Heyday of Natural History*, London, Jonathan Cape, 1980.

Bentwich, N. & H. *Mandate Memories, 1918–1948*, London, Hogarth Press, 1965.

Bond, B. *The Victorian Army and the Staff College, 1854–1914*, London, Eyre Methuen, 1972.

Buckley, W. *Big Game Hunting in Central Africa*, London, Cecil Palmer, 1930.

Bryant, A. *The Turn of the Tide 1939–1943*, London, Collins, 1957.

Caine, B. *Destined to be Wives*, Oxford, Oxford University Press, 1985.

Cohen, M. J. *Churchill and the Jews*, London, Cass, 1985.

Deacon, R. *A History of the Russian Secret Service*, London, Frederick Muller, 1972.

Dilks, D. *Curzon in India*, Two Volumes, London, Rupert Hart-Davis, 1969.

Edwardes, M. *High Noon of Empire*, London, Eyre & Spottiswoode, 1965.

Elliston, D. E. *The Naturalist in Britain: A Social History*, London, Allen Lane, 1976.

Falls, C. & Becke, A. F. *Official History Military Operations, Egypt and Palestine*, Volumes One and Two, London, HMSO, 1930.

Fitter, R. *Wildlife for Man*, London, Collins, 1986.

Friedman I. *The Question of Palestine, 1914–1918*, London, Routledge & Kegan Paul, 1973.

Gardner, B. *German East*, London, Cassell, 1963.

———. *Allenby*, London, Cassell, 1965.

Gilbert, M. *Winston Churchill*, Volume IV, *The Stricken World, 1917–1922*, London, Heinemann, 1975; Companion Vol. IV, parts 2 and 3, 1919–1921, London, Heinemann, 1977.

———. *Exile and Return*, London, Weidenfeld and Nicolson, 1978.

Gooch, J. *The Plans of War: The General Staff and British Military Strategy, c1900–1916*, London, Routledge & Kegan Paul, 1974.

Grey, I. *The First Fifty Years – Soviet Russia 1917–67*, London, Hodder and Stoughton, 1967.

Hordern, C. *Official History, Military Operations, East Africa*, Volume One, London, HMSO, 1941.

Graves, R. *T. E. Lawrence and the Arabs*, London, Jonathan Cape, 1927.

Haswell, J. *British Military Intelligence*, London, Weidenfeld & Nicolson, 1973.

Huxley, E. *White Man's Country: Lord Delamere and the Making of Kenya*, Two Volumes, London, 1935.

Ingrams, D. *Palestine Papers 1917–1922: Seeds of Conflict*, London, John Murray, 1972.

Kedourie, E. *England and the Middle East: The Destruction of the Ottoman Empire, 1914–1921*, London, Bowes and Bowes, 1957.

Kennedy, J. *The Business of War*, London, Hutchinson, 1957.

Kirkbride, A. S. *An Awakening: The Arab Campaign, 1917–1918*, London, University Press of Arabia, 1971.

Knightley, P. & Simpson, C. *The Secret Lives of Lawrence of Arabia*, London, Times Newspapers Ltd, 1969.

Knox, D. E. *The Making of a New Eastern Question*, Washington, The Catholic University of America Press, 1981.

Lawrence, T. E. *The Seven Pillars of Wisdom*, London, Jonathan Cape, 1935 (revised edn).

———. *The Letters of T. E. Lawrence*, London, Jonathan Cape, 1938.

Liddell Hart, B. *T. E. Lawrence*, London, Jonathan Cape, 1934.

Lloyd George, D. *War Memoirs*, Two Volumes, London, Odham Press, 1936.

———. *The Truth About the Peace Treaties*, London, Victor Gollancz, 1938.

Lord, J. *Duty, Honour, Empire: The Life and Times of Richard Meinertzhagen*, London, Hutchinson, 1971.

Lunt, J. *Imperial Sunset: Frontier Soldiering in the Twentieth Century*, London, Macdonald, 1981.

Mack, J. E. *A Prince of Our Disorder*, London, Weidenfeld & Nicolson, 1976.

Marshall Macphee, A. *Kenya*, London, Ernest Benn, 1968.

Matson, A. T. *Nandi Resistance to British Rule 1890–1906*, Nairobi, 1972.

Meinertzhagen, G. *From Ploughshare to Parliament*, London, John Murray, 1908.

Miller, C. *The Battle for the Bundu*, London, Macdonald and Jane, 1974.

Monroe, E. *Britain's Moment in the Middle East, 1914–1956*, London, Chatto & Windus, 1963.

Morgan, T. *Churchill, 1874–1915*, Granada, 1984.

Mosley, L. *The Duel for Kilimanjaro*, London, Weidenfeld and Nicolson, 1963.

Moyse-Bartlett, H. *The King's African Rifles*, Aldershot, Gale & Pollen, 1956.

Mungeam, G. H. *British Rule in Kenya, 1895–1912*, Oxford, Clarendon Press, 1966.

Nevaikivi, J. *Britain, France and the Arab Middle East, 1914–1920*, London, Athlone Press, 1969.

Nicolson, H. *Peacemaking, 1919*, London, Constable, 1933.

Occleshaw, M. *Armour Against Fate: British Military Intelligence*, London, Columbus, 1989.

Porter, B. *The Lion's Share*, London, Longman, 1975.

Rose, K. *King George V*, London, Weidenfeld & Nicolson, 1983.

Rose, N. *Chaim Weizmann – A Biography*, London, Weidenfeld & Nicolson, 1987.

Rothschild, M. *Dear Lord Rothschild: Birds, Butterflies & History*, London, Hutchinson, 1983.

Sachar, H. M. *A History of Israel, from the rise of Zionism to our time*, New York, Alfred A. Knopf, 1976.

———. *The Emergence of the Middle East, 1914–1924*, New York, Alfred A. Knopf, 1969.

Samuel, H. *Memoirs*, London, Cresset Press, 1945.

Stearn, W. T. *The Natural History Museum at South Kensington*, London, Heinemann, 1981.

Stewart, D. *T. E. Lawrence*, London, Hamish Hamilton, 1977.

Storrs, R. *Orientations*, London, Nicholson & Watson, 1943.

Stresemann, E. *Ornithology From Aristotle to the Present*, Cambridge, Massachusetts, Harvard University Press, 1975.

Sykes, C. *Crossroads to Israel*, London, Collins, 1965.

Thesiger, W. *The Life of My Choice*, London, Collins, 1987.

Thompson, E. *The Story of Aysgarth School*, pamphlet, n.d.

Vansittart, R. *The Mist Procession*, London, Hutchinson, 1958.

Wasserstein, B. *The British in Palestine: The Mandatory Government and the Arab-Jewish Conflict 1917–1929*, London, Royal Historical Society, 1978.

Wavell, A. P. *The Palestine Campaigns*, London, Constable, 1928.

Webb, B. *My Apprenticeship*, London, Longmans Green, 1926.

———. *The Diary of Beatrice Webb*, Four Volumes, Eds. Norman and Jeanne Mackenzie, London, Virago, 1982–5.

Weizmann, C. *Trial and Error*, London, Hamish Hamilton, 1949.

Weizmann, C. *The Letters and Papers of Chaim Weizmann*, Series A, Volume XI, Ed. B. Wasserstein, Jerusalem, Israel University Press, 1977.

Wilson, H. *The Chariot of Israel*, London, Weidenfeld & Nicolson, 1981.

Winstone, H. V. F. *Gertrude Bell*, London, Quartet Books, 1980.

Woodward, E. L. & Butler, R. *Documents on British Foreign Policy 1919–1939*, London, HMSO, 1952.

Yardley, M. *Backing Into the Limelight*, London, Harrap, 1985.

Index

Kaidparak incident, dismissal,
 55–60, 61–2
returns to England (1906), 60, 62–3
to South Africa (1907), 62–5
soldierly qualities, 64–5
returns to England (1909), 65
espionage work in Crimea, 65–7
relations with women, 67–70
first marriage (1911), 69–72, 95,
 144
shooting accident, partially
 blinded, 73
to Quetta Staff College (1913),
 73–4
with Indian Army contingent in
 East African Campaign
 (1914–16), 75–94
at War Office (1917), 95
feels 'middle-aged', 96
GS02 Intelligence Officer with
 Egyptian Expeditionary Force,
 Allenby's Palestine campaign,
 96–107
GS01 at War Office, 107
security posting in Paris as
 lieutenant-colonel, military
 adviser to Peace Conference,
 108–11, 113, 124, 129–30
and T. E. Lawrence, 110–16, 117,
 119, 120–2
Chief Political Officer in Cairo,
 124, 131–40, 141
visits Crete (1920), 140, 141–2
returns to England, 142–3
post in Japan mooted, 143, 148
second marriage (1921), 143–6
military adviser in Churchill's
 Middle East Department,
 148–55
leaves the Army, to pursue
 ornithology, 155, 156–7
council member for Royal
 Geographical Society and

British Ornithologists' Union,
 172
first book, 172–3
intelligence work, secret service,
 175–6, 191–205
house in Kensington Park Gardens,
 176
death of his second wife (1928),
 192–3
receives Spanish decoration, 199
visits Hitler (1934), 206–7
and Second World War, 208–9,
 210–11
death of his son Dan, 211
works on *Birds of Arabia* (q.v.),
 215–16, 225–6
visits Arabia and Africa (1948–9),
 216–18
gives collections to British
 Museum, 218–25
offered knighthood, 191, 251
receives CBE, 230, 251
visits Israel (1953), 230–1
publishes his diaries, 232
last years, 242–52
his will, 247
death, 250
2) INTERESTS AND ACTIVITIES,
 1–2, 4
diaries, 37, 231, 240–2; destruction
 of originals, 20, 25; typed,
 not hand-written, 118, 160;
 few references to first
 marriage, 71–2; few
 references to his intelligence
 work, 191; published versions,
 109, 110, 120, 232, 233 (see also
 Army Diary; *Kenya Diary*;
 Middle East Diary); queries
 concerning, 20–1, 114–22,
 178–9, 233–7
hunting, shooting, 28, 42, 158–61,
 163